teach yourself

Digital
Photography

in **14**
days

Carla Rose

Hayden
Books

President
Richard Swadley

Associate Publisher
John Pierce

Publishing Manager
Laurie Petrycki

Managing Editor
Lisa Wilson

Director of Marketing
Kim Margolius

Acquisitions Editor
Jawahara Saidullah

Development Editor
Jim Chalex

Production Editor
Michael Brumitt

Copy Editors
Erik Dafforn and Marta
Partington

Technical Editor
Bill Vernon

Publishing Coordinator
Karen Flowers

Cover Designer
Aren Howell

Book Designer
Sandra Schroeder

Manufacturing Coordinator
Brook Farling

Production Team Supervisors
Laurie Casey
Joe Millay

Production Team
Dan Caparo, Daniela
Raderstorf, Laure Robinson,
Christy Wagner

Indexer
Sandy Henselmeier

Teach Yourself Digital Photography in 14 Days

©1997 Hayden Books

Library of Congress Catalog Number: 97-72160
ISBN: 1-56205-912-2

Printed in the United States of America 1 2 3 4 5 6 7 8 9 0

Warning and Disclaimer

Trademark Acknowledgments

About the Author

Carla Rose started her photography career at the age of eight with a Brownie Hawkeye. A graduate of the School of the Museum of Fine Arts in Boston, she has been a TV news photographer and film editor, as well as advertising copywriter and graphic artist, before discovering the Macintosh. She has written all or part of about 20 computer books, including *Maclopedia*, *The Whole Mac*, *PageMaker 6.5 Complete*, *It's a Mad, Mad, Mad, Mad Mac*, *Turbocharge Your Mac*, *Everything You Ever Wanted to Know About the Mac*, and the forthcoming *Teach Yourself Photoshop in 24 Hours*. She lives near Boston, MA with her husband, audio guru Jay Rose, two sons (both away at college), and a fluctuating number of cats.

Acknowledgements

No project this big could ever get started, much less completed, without help from a lot of wonderful people. I'd like to thank the folks at Hayden, especially Jawahara Saidullah, who had faith in this book when it was just an idea. And extra special thanks to my patient development editor, Jim Chalex; to production editor Michael Brumitt; to copy editors Marta Partington and Erik Dafforn; and technical editor Bill Vernon.

A big thank you to the camera manufacturers who generously let me borrow their equipment to try out: Agfa, Apple, Canon, Casio, Kodak, and Ricoh. (I hated to send them back.) Also, to the software companies who were equally generous with their fine products.

Thanks also go to all the people who gave me picture-taking opportunities: Linda Standart and Sally Compton, my tour guides in South Carolina; Les and De Ila Meyer of Saluda Farms, whose llovable llamas appear here; to everyone attending the third annual ABC's convention in Las Vegas; to researcher *par excellence* Judy Storgaard; to my cheering squad on Delphi, and to whomever I've missed.

Finally, hugs and eternal gratitude to Josh and Dan, who still managed to smile after the hundredth picture, and to Reebok, Alfie, and Hacker, the cats who grace these pages and enrich our lives. And the biggest hug and deepest gratitude of all (and Happy 25th Anniversary!) to my wonderful husband, Jay, who does what needs to be done.

Dedication

This book is dedicated to the memory of M. Lee Broman, photography instructor at the School of the Museum of Fine Arts in Boston. Thanks for teaching me how to see.

And to Jay, Josh, and Dan for giving me so much to look at.

Hayden Books

The staff of Hayden Books is committed to bringing you the best computer books. What our readers think of Hayden is important to our ability to serve our customers. If you have any comments, no matter how great or how small, we'd appreciate your taking the time to send us a note.

You can reach Hayden Books at the following:

Hayden Books
201 West 103rd Street
Indianapolis, IN 46290
317-581-3833

Email addresses:

America Online: Hayden Bks
Internet: hayden@hayden.com

Visit the Hayden Books web site at http://www.hayden.com

Contents at a Glance

Table of Contents

Introduction

I hope you're the kind of person who reads introductions. Not all books need them, but this one really does. I'll keep it short.

The name of this book is *Teach Yourself Digital Photography in 14 Days*. And there are a couple of things to notice in the book. The first is, "Teach Yourself..." I can, and will, give you the facts and describe the tools, but I can't make you learn to see. That has to come from you. You have to train your own eyes and develop your own style and taste. It comes with practice—with taking a lot of bad pictures and a few good ones, and with being able eventually to see the difference.

Now, I said there were a couple of things to notice in that title. The second one is "14 Days." Not two weeks. Not even 14 consecutive days for most people. If you're in a major hurry to master digital photography, you can blast through this book in half the time. However, you won't get as much out of it as you would if you spent time between chapters working on what you've learned.

The book is organized into two weeks' worth of lessons. The first week is all about cameras, digital and otherwise, and taking good pictures. The second week is about improving your pictures after you've taken them, and all the things you can do with digital darkroom programs like Photoshop. In the back you'll find a glossary of terms that pop up in digital photography—some computer terms and some photographic ones. You're straddling two worlds here, and you need to speak both languages. You'll also find a list of cameras and camera makers. The list is accurate as of 5/97, but this is an expanding industry and new models come out every few weeks. Check your local dealers, mail order catalogs, and computer and photo magazines to keep up with the latest.

This book uses a few conventions that you should know about. The path for menus is in the format: Menu>Submenu>dialog box... Whenever you see those symbols, you need to look for the submenus. I've attempted to provide Windows equivalents for all of the Mac commands I've mentioned, but if you're not clear about how to do something, check

1

the manual that came with your computer or operating system. Each chapter has an assignment at the end, which will help you practice some of the skills taught in the chapter. You don't have to complete each assignment before you go on, but you should find them helpful. Even if you don't actually do them, think about how you *might* apply the techniques.

Unfortunately, the book doesn't cover every possible camera and every possible image manipulation program that you might encounter. If it did, it would be several thousand pages long, and we'd have to change the title to something like *Teach Yourself Digital Photography in 14 Years!* Also, it would be obsolete before it ever reached the shelves. Manufacturers bring out new cameras almost every week. Instead, I've given you an overview of the kinds of cameras you'll find, the kinds of image programs you'll probably use, and some of the wonderful things you can do with these tools. Also, the figures in this book were done with a digital camera, which is a medium still in development, so make the most of what is included here.

I'll tell you right up front that my favorite cameras are the Casio and Kodak models, and my favorite digital darkroom program is Adobe Photoshop. That doesn't mean that I don't use others, but Photoshop is pretty well accepted as the "industry standard" for image handling; so we've focused on it here as the program you'll probably want to use, eventually, if not right away. The techniques carry over from one program to another, so what you learn to do with PhotoDeluxe, or PhotoEnhancer, will eventually help you master Photoshop, too.

Ready? Let's get started.

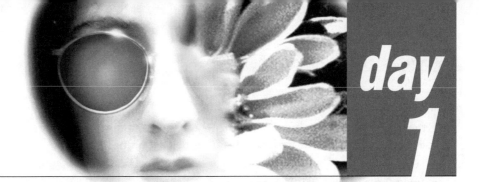

The Goal of a Photograph

- Defining the photograph
- Understanding film and paper photography
- Learning about the digital revolution
- Considering computers as a photographic tool
- Learning about how photos are used today

For the next two weeks, your digital camera, your computer, and this book will be your companions as you explore the world of digital photography. Bring along your creativity, curiosity, and willingness to experiment. Leave behind your doubts, worries, and preconceived notions. Above all else, have fun!

What Is a Photograph?

What is photography? Is it an art, or a science? Is it a tool? Or is it magic? It can be any or all of these, depending on your approach. Photography can be a lucrative career, an engaging hobby, a means of self-expression, and an all-consuming passion. It can also be "none of the above" if you simply point the camera, press the button, and drop the results off at the drugstore for processing. At the very least, photography is the act of creating a photograph.

This brings us to the next obvious question: What is a photograph? We used to be able to define it as an image formed on light-sensitive material, chemically stabilized and projected on a screen for viewing or printed, negative to positive, on light-sensitive paper. That's not, if you'll excuse the pun, the whole picture.

Digital photography doesn't use chemicals, and your digital photo may never end up on paper. The process of making the picture has changed, but some of the basics are still true. You still need light and a lens to collect it. You need a sensitive surface on which to form

the image. You need a shutter to control the amount of time the light enters the camera. Why do you need these tools? Let's start at the beginning.

A Brief History of Photography

Photograph comes from two Greek words meaning "light" and "writing." A photograph, then, is the result of a process that converts light to an image. Over the past 170 years, the process has undergone a tremendous number of changes. The earliest known experiments in capturing an image with light-sensitive materials were performed by a French lithographer and inventor, Joseph-Nicéphore Niepce in 1826. He coated a pewter sheet with asphalt containing a silver solution and placed the resulting plate inside an artist's *camera obscura*, a device then commonly used for tracing landscapes and architecture in correct perspective. Figure 1.1 shows a diagram of the camera obscura.

Figure 1.1

The light passed through a crude lens, often just a pinhole, and hit an angled mirror, which reflected the image on a sheet of ground glass.

Niepce left the camera obscura on a windowsill at his home in central France, and eight hours later had captured a fuzzy but recognizable picture of his yard and outbuildings. Eventually, Niepce pooled his knowledge with that of Jacques Daguerre, a Parisian scenery designer who had also been experimenting with light-sensitive chemicals.

By 1839, Daguerre had devised a much improved photographic plate. He coated copper sheets with silver, and then exposed them to iodine fumes to make silver iodide. After exposure, the plate was developed to bring out the image by placing it over a pot of heated mercury. The mercury bonded with the silver, producing a positive image. These early "daguerreotypes" could be used only for architecture and scenery or post-mortem portraiture (see Figure 1.2). No person could sit still for the half hour exposure required.

Get a Lens, Friends...

Continued experimentation brought better images faster. The Austrian mathematics professor, Joseph Petzval, realized that Daguerre's crude camera simply needed a good lens. He designed a combination of convex and concave lenses that could be focused to produce a sharp image. Petzval had a sample lens ground and mounted in a telescope-like brass housing by the Voightlander optical company. The result was a camera that reduced exposure time to less than 60 seconds. This made the camera a reasonable tool for capturing images of people as well as landscapes and buildings.

Figure 1.2

The Prophet Daniel. Simulation of an early daguerreotype. (Digital photo altered in Photoshop.)

The Voightlander company produced thousands of cameras using Petzval's lens design. Other optical companies began producing lenses, and the camera design evolved into a wooden box with a leather bellows on the front. The bellows made it possible to move the lens back and forth to focus the image on a piece of ground glass. The photographer threw a black cloth over himself and the camera body to block out unwanted light while he focused and replaced the ground glass with a glass photographic plate when he was ready to make the picture. This was the view camera, used by both professional and amateur photographers for most of the 19th century, and well into the 20th. It was large,

heavy, and clumsy. The plates were extremely fragile, and until about 1880, they had to be made on the spot. The photographer carried his darkroom with him, coating the glass plates with silver salts in collodion (a glue-like substance). They had to be used wet, and developed before they dried.

Mr. Eastman's Invention

Meanwhile, the early motion picture camera made use of the same sort of photographic emulsion on long reels of cellulose acetate film. The film emulsion was more sensitive, and exposure times were only a fraction of a second. In 1888, George Eastman put the two ideas together and produced the first handheld camera, the Kodak #1, which used rolls of film instead of glass plates (see Figure 1.3).

It was small enough to carry around, about seven inches long by four wide, and four inches high. It held enough film for a hundred pictures, and when the roll was finished, the owner sent the camera back to Eastman so the film could be processed and printed, and the camera reloaded. Eastman's snapshot camera turned many thousands of people into amateur photographers, recording everything from family picnics and trips abroad to train wrecks and other news events.

Figure 1.3

The Kodak #1 had a 1/25-second shutter, a fixed focus lens, and two rollers that moved the film. It took round pictures.

The pocket Kodak was an idea whose time had come. Within a few years, other manufacturers, including Ermanox and Leica, introduced compact cameras. Because cameras could easily be carried to news events, photographs replaced etchings and lithographs in magazines and newspapers. Despite all this, the only really drastic change in photographic methods occurred in the 1950s when Edwin Land introduced the "Picture in a Minute" Polaroid. Impatience, coupled with technological advances, brought us a step closer to the digital camera. The Polaroid incorporated developing chemicals into the film. After you took the picture, you pulled the film past a roller which squeezed developer over the exposed film. A minute later, you peeled off the picture and coated it with a combination hardener and fixative. Today's Polaroid isn't that much different. You needn't coat the pictures, but they still take a minute to develop.

Space Frozen in Time

Sensitive film and the mechanical shutter brought about the first big revolution in photography. Instead of the long exposures that Daguerre's plates required, the photographer could freeze a runner in motion, a crashing wave at the seashore, or a fleeting expression on a young girl's face. (See Color Plate 1.1.) He or she could literally make time stand still. It was, and still is, magic. Typical digital cameras today use shutter speeds of up to 1/4000th of a second. That's fast enough to freeze almost any action. You can catch a hummingbird's wings in mid-flap, or a cat in mid-pounce.

The concept of freezing time is an important one. A fast shutter speed can capture motion that the eye can't see. For this reason, high-speed photography is often used to document industrial processes that happen too quickly for the naked eye, such as the candy-making machine shown in Figure 1.4. The digital camera will be a tremendous help with this kind of photography, as many have faster shutters than conventional cameras. Digital cameras also can be placed in otherwise inaccessible places and triggered electronically. There's even a camera (the Minolta Dimáge V) with a detachable (tethered) lens that can shoot around corners, inside a box, or up to a meter away from the camera body.

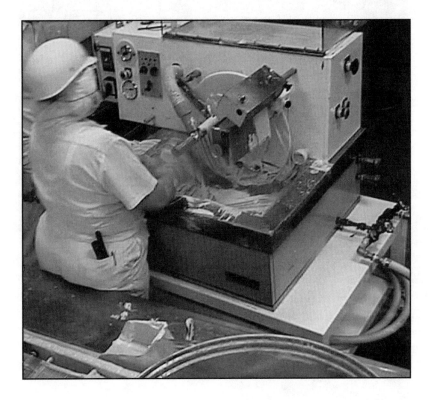

Figure 1.4

Pictures help pinpoint the cause of mechanical failure.

Freezing time also makes it possible to keep records of features that change over time. To a parent, few things are as valuable as those pictures of baby's first step, first birthday, and all the other "firsts" on the way to growing up. As adults, we all love to go back in time with the family album, looking at the scenes and familiar faces of many years ago. The camera can reproduce the past more faithfully and more permanently than our memories. Even when the pictures are fuzzy, poorly composed, or badly exposed, they are still precious to us because of the times and people they represent. They have frozen an instant in time which had a particular meaning to us. However, unless the picture is clear enough to speak to someone who doesn't know the people in it, or who wasn't at the event, it may be perceived as a failure. If your pictures will be viewed by a wider audience than your family and friends, you must make the "message" as clear as possible. In Figure 1.5, the photographer has included the sign and some of the surrounding area to establish the location and situation.

Figure 1.5

Documentary photography: Hot soup is served to the homeless on Boston Common.

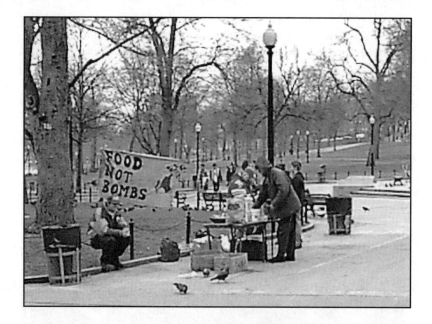

Magic Moments

Finding the right moment to click the shutter is often what makes the photograph a success or a flop. In taking pictures that are time-dependent, the trick is to catch what *Life* magazine photographer Henri Cartier-Bresson referred to as "the decisive moment." It's that split second when the action is at its peak, when history is made, or when the revealing expression crosses the subject's face.

To the photojournalist, it's the second when the assassin's bullet strikes, when the plane explodes in mid-air, or perhaps when two world leaders reach agreement and shake hands at the summit meeting. Some of these moments can be planned for. Others depend on luck—on being in the right place at the right time—with the camera aimed toward the action. Amateur photographers, as well as the professionals, can sometimes catch these "lucky" shots. The photographs of President Kennedy's assassination are a case in point. All were taken by amateurs who happened to be there and have their cameras ready.

The Photograph as a Communications Tool

As the saying goes, "A picture is worth a thousand words." Pictures speak to us. They have meaning. They represent reality. They convey emotions. They may speak of joy or loneliness, of pain, of friendship, or of good times shared. They may simply tell us what the recipe should look like prepared, how the sweater looks on the model, or what's inside a can of peas.

The difference between photojournalism and social documentation is often blurred. The photojournalist attempts to record what's there, what's happening, without imposing his or her feelings about it. Social documentary, however, has an attitude. The documentary photographer shoots a particular subject or scene because it may help to convince others of the need to either preserve or change the situation. In Figure 1.6, for example, the subject of the photo is the trash. The picture was used to convince the owner of the property to clean it up.

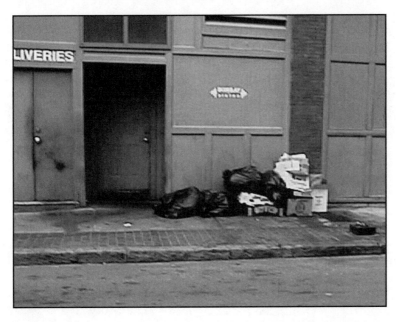

Figure 1.6

Dumping trash on the sidewalk is a violation of city ordinances. The picture proved his guilt.

An example of this social documentation is the work of photographers Margaret Bourke-White and Dorothea Lange in the 1930s. They photographed scenes of poverty in rural America—they showed the agony of a mother watching her children starve, defeat on the faces of the men in the Depression-era bread line, and the sorrow of a dustbowl farmer forced to pack up his family and leave his land in search of work. Their pictures, many of which were published in *Life* magazine, were a major factor in bringing about unemployment insurance and other programs to aid the poor and homeless. It was photo-journalism, in that it documented conditions at the time, but it became a social commentary as well because the subjects were selected specifically to make a point about the unacceptable conditions with which they lived.

When you take a picture, you need to be clear about the purpose of creating it. Are you recording a scene for posterity, or are you sharing your feelings about the subject? Are you simply documenting what's there, or are you pointing out something that's particularly interesting or beautiful?

The Photograph as an Abstraction of Reality

Most pictures are of something—a person, a place, a thing—recognizable as what it is. Others fit more into the category of abstract art. Depending simply on how it's cropped, the object in Figures 1.7 and 1.8 is either an abstract shape in shades of red or a red pepper waiting to be chopped up. The object itself hasn't changed. What has changed is the perspective from which we view the object.

Figure 1.7

Red Pepper #1, digital photograph.

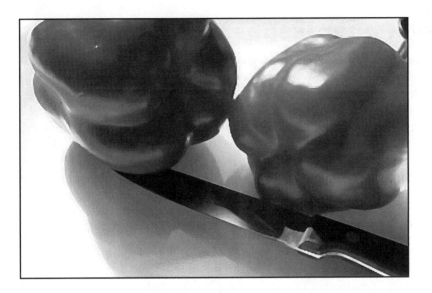

Figure 1.8

Red Pepper #2, digital photograph.

To a certain extent, all photographs are art, and all photographs are abstract. The nature of reducing a three-dimensional object to a two-dimensional image is by definition an abstraction. Reducing a color image to shades of gray is another abstraction. To an artist, however, abstraction implies something a bit more complex. The tightly cropped pepper in Figure 1.7 is an abstraction of the quality of "pepperness." It has colors and curves, but it's not a specific, identifiable pepper, as is the other one in Figure 1.8. By removing some of the identifying detail, we have reduced it from an object to an abstraction of that object.

The key to successful abstraction is to consider the composition of the picture. The lines and patterns and shapes of the objects photographed must be made to relate to the shape of the picture. It must appeal to the viewer. Abstract art, according to photographer Edward Steichen, appeals first to the emotions, and then to the intellect.

The sensuous curves and shiny skin of the pepper are aesthetically pleasing. They catch the viewer's eye simply because they are pleasant to view. The pleasure, in turn, leads the viewer to wonder what the abstract object represents. We might find ourselves comparing the shape and texture to other familiar objects and asking ourselves, "Is it a flower? No. Is it some piece of human anatomy? No. Is it..." and so on, playing a game of "Animal, Vegetable, or Mineral" until we finally realize that it is indeed, a vegetable.

Looking again at the curves of the pepper, if it were some other color, perhaps a deep blue or the color of tanned skin, we would see it very differently—we would try to impose some other reality on it. We might see it as a polished stone, or as the curve of a hip and thigh.

Film and Paper Issues in Photography

From its beginnings, photography depended on film and paper. Some images were positive, such as early daguerreotypes, or such as 35mm slides for projection or the large Kodachrome color transparencies used today by commercial photographers for magazine and print work. Others, such as Eastman's Kodak #1 and most of today's "snapshot" cameras, used negative film that was contact-printed or enlarged onto photographic paper. The quality of the photograph depended on many factors beyond the technical competence of the photographer. Specific to the camera, the quality of the lens and the evenness of the film plane were critical. It was important that the photographer measured the light correctly and used the right shutter speed and lens opening to give the film proper exposure. It was equally critical that the film must be fresh, and not exposed to extremes of temperature, or its packaging torn so that light might leak in.

After the pictures were taken, the next critical steps were developing and printing. Black-and-white film and paper went through a five-step developing process (see Figure 1.9). The developer brought out the image. A stop bath kept it from over-developing, and a solution of hypochlorite "fixed" the image, rendering it insensitive to light. After that, a bath in hypo-clear neutralized the fixer. Finally, the film and paper had to be thoroughly rinsed to remove all the remaining chemicals.

Figure 1.9

Follow the steps from the film camera to the computer, in only 15 steps.

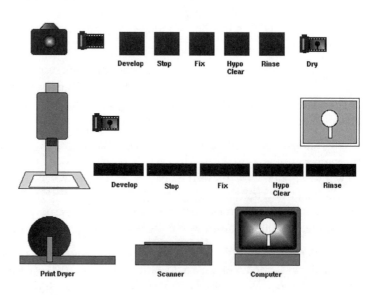

Such variables as the age and temperature of the chemicals used in processing, the time the film or paper spent in each vat of chemical, or even the amount of agitation in the developer bath affected the finished picture. Color processing has several more steps and is even more time- and temperature-sensitive.

Color Is Complicated

Making prints from black-and-white or color negatives requires as much (or more) technical know-how than taking the picture. Color printing uses combinations of filters to control the color balance in the finished print. Each batch of paper is different and comes with a recommended filter combination to use when choosing filters and exposure time.

A few serious amateurs and many professionals do their own color darkroom work, but most people settle for "machine" prints from the one-hour photo finisher or mail-in processor. The advantages of machine prints are speed and cost. The disadvantages are those of the "one size fits all" suit. The film is processed and printed by the machine. If the chart says this kind of film gets four minutes in the developer, that's all it gets. If the roll of printing paper calls for a combination of 40M (magenta) and 20Y (yellow) filters, that's what will be used for the prints; no matter whether they were shot outdoors at the beach, inside a candlelit cathedral, or using studio lighting.

Unless you're prepared to pay for custom processing and printing, or ready to spend the money to build yourself a color darkroom and spend months or years mastering the chemistry and art of darkroom work, your results may be less than satisfactory.

Understanding the Digital Revolution

Long before there were digital cameras, there was digital darkroom technology. Adobe Photoshop and Letraset ColorStudio first appeared in 1989, but even before that, there was a black-and-white image-editing program called Digital Darkroom from Silicon Beach Software. (It's shown in Figure 1.10.) It enabled you to adjust the brightness and contrast of a scanned photo, as well as crop, rotate, and posterize the image. You could even use the paintbrush to retouch spots that needed it. At that point, it wasn't really any more than you could do to a real photo in a real darkroom. But, as people began to explore the possibilities, the market grew for this kind of software. They soon learned that Digital Darkroom was limited to 8-bit grayscale, which translated into 8-bit color. This simply wasn't good enough for professional photographs.

Figure 1.10

Digital Darkroom was an early photo-retouching program.

Almost as soon as Apple introduced a Mac with 24-bit color, Photoshop and ColorStudio were released. Because of the cost (ColorStudio originally sold for $1995), these weren't programs for the hobbyist, but rather for the commercial art studio, television production facility, or ad agency. ColorStudio was often used for color prepress work and was often compared to computerized imaging systems from Scitex, Crosfield, and Hell, which cost many times more.

Digital cameras have been around longer than you might think. Apple's QuickTake 100, introduced to an eager market in 1994, was the first affordable digital camera for the average person, but there were high-end (a fancy way to say high-priced) models a couple of years earlier. Hollywood had already discovered the effectiveness of shooting both film and video at the same time, using a lens with a prism that sent one image to the film camera gate and the other to the video camera. By this time, there were also many video-capture systems that took single frames from a videotape, or from a "live" image on a camcorder or video camera.

Advantages of Digital Photography over Film

The advantages of digital photography are many. Digital cameras are light weight and easy to carry. You don't need to buy film or pay for processing. You don't need to set up a darkroom to do your own photo finishing, so you don't need to deal with the mess and smell of chemicals, the stains on your fingers and clothing, and the expense of building and furnishing a darkroom. You won't contribute to the chemical pollution of the environment by pouring used developer, fix, or other potentially hazardous waste into the sewer or sending them into the regional water supply.

There's no waiting for film to process or prints to be made and scanned. You can look at your digital photos as soon as you've taken them. If there's a TV set handy, you can display your pictures on the TV screen just by plugging in a cable that's included with the camera. Transferring the photo from the camera to the computer takes only a few seconds. Unlike the 15-step process shown in Figure 1.9, all you do is plug a cable from the camera into the computer, open the program that came with the camera, and choose the picture to import. Figure 1.11 shows the difference.

Figure 1.11

Fifteen steps for film and paper; one step digitally.

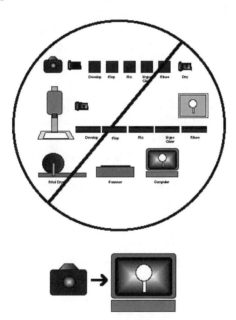

Most digital cameras also let you throw away the bad shots, so they don't waste memory. The good ones will last as long as the hard disk, floppy, CD-ROM, or other storage medium you save them on...virtually forever, without scratching, fading, or color shifting.

Some digital cameras save pictures to a flashcard, a piece of plastic about the size of a business card, only a little thicker. You can pack 20 of these flashcards in the space occupied by just two rolls of 35mm film, and carry as many as 2100 high-quality pictures, instead of the 72 that the film holds. Flashcards aren't cheap, so you might think twice about buying that many, but they are reusable. If you carry only a couple and have access to a computer, you can upload your pictures and recycle the flashcard to hold more, an ideal situation for the world traveler or roving photojournalist.

After you're past the initial investment—the camera, the computer, image-manipulation software, and a color printer—your pictures don't cost you anything. You'll never run out of film, and you'll never need to buy any.

Disadvantages of Digital Photography

Only a few disadvantages to using a digital camera exist. The major one is cost. High-end digital cameras such as the Nikon e2n are quite expensive. The highest of the high-end, the T2 Filmless Digital back for a 4×5 studio viewcamera, will set you back $35,000. Backing down from the stratosphere to something in the $500–600 range, you get a camera that's technically comparable to a 35mm snapshot camera that you could buy for less than $100.

You won't be paying for film, but you might want to find a place to buy AA batteries by the case. Typical of these cameras, the Casio QV-100 claims to squeeze 150 minutes of continuous operation, or about 96 images (at one per minute) from each set of four alkaline AAs. Your mileage may vary. Whenever possible, run these cameras from their AC power packs. Lithium batteries will give you longer service, but because they cost more, it's a toss-up to whether you'll save anything by using them. A couple of sets of rechargeable batteries and a charger are definitely a wise investment.

A couple of the less expensive cameras, specifically the Apple QuickTake 150 and the Kodak DC-20, have very limited storage. The Kodak will hold only eight pictures, and the Apple 150 holds 16. If you use either of these cameras, you need a laptop nearby so you can download your favorite shots and erase the camera's memory before you take more pictures.

If you ever need to take several pictures of something in rapid sequence, choose your digital camera very carefully. Only a few of the more expensive models can handle this process. Most require a delay of anywhere from 3–10 seconds or more between pictures while the camera compresses and stores the image it has just captured. A better way to take a sequence of pictures is to use a video camera. It freezes the action every 1/30th of a second, enabling you to analyze a golf swing or watch a figure skater take off and land the triple Salchow.

Computers as Photographic Tools

The computer, with the help of programs such as Photoshop and Live Picture, can incorporate your photographs into any kind of document, from a printed catalog or report to a multimedia presentation, as well as a lavishly illustrated web page. Despite the disadvantages, one overwhelming advantage that a digital camera has over a

conventional camera is that, within a matter of a minute or two after you've shot a picture, you can open it in a program such as Photoshop and crop, color correct, and place it where you want it. You can handle the entire process yourself (see Figure 1.12). You don't need to send the pictures to be processed, and then off to a service bureau for color scanning. Just plug the camera into the computer, save the pictures, and carry on.

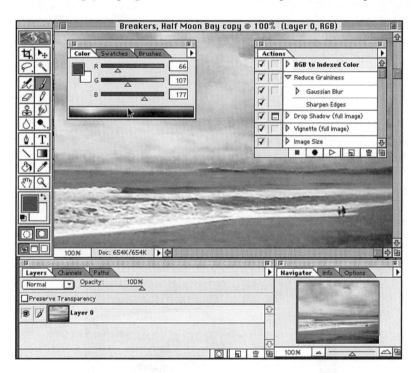

Figure 1.12

Importing and editing a picture in Photoshop.

Because programs such as Photoshop are actually bitmapped paint programs, they are capable of extremely subtle, pixel-by-pixel corrections as well as quick, all-over changes. You can achieve effects with these programs that you couldn't possibly manage any other way, certainly not with traditional photo techniques. Retouching is much easier. Standard color correction can be done automatically, or if you're looking for something out of the ordinary, you can try as many variations as you like. "Undo" is just a keystroke away, and you're not wasting expensive photo paper and chemicals experimenting.

That's the second major difference. Because you're not constrained by the technical limits of the photographic process or the need to economize on materials, you're free to try as many different versions of the picture as you can invent. Save them, print them, or dump them in the trash and start over. All you've spent is time.

Making versus Taking a Picture

When you use a conventional camera, you "take" a picture. You shoot what's there. When you get involved with the image-manipulation possibilities of the digital photo/ digital darkroom combination, you're not taking a picture, you're making a picture. Sometimes you'll know ahead of time exactly what elements you need to make a picture. Other times, you'll start with no particular concept and experiment until you create a satisfactory picture. It works either way.

When you look at images in ads, on magazine covers, on software packages, and practically everywhere else, most of the photos you'll see are made, rather than shot. It's not always convenient, or even possible, to set up some of the shots art directors ask for.

Assume, for example, that you're asked to provide a picture of a hand pointing upward, balancing a large metal cube on one finger, against a background of blue sky and clouds. You can put out a casting call for a juggler who can balance objects on a fingertip, have a scene shop construct the cube, and wait for a day with perfect sky and clouds. You set everything up, shoot from a low angle, and hope the juggler doesn't drop the cube until you get a good shot. Or, you can find any acceptable hand, shoot it digitally against a seamless background, and open it up in Photoshop. You create the cube in a program like Extreme 3D, and the clouds perhaps in MetaTools Bryce 2. Then, you put all three pieces together in Photoshop. The final result is shown in Figure 1.13.

Figure 1.13

Creating a big business box.

Or suppose you needed a location shot of a carton of milk in the middle of a field of clover. Last summer you found and photographed the perfect field. Now, all you need to do is photograph the milk carton and add it to the picture, possibly also shooting a few random pieces of greenery from the local florist to stick in front of the carton.

How Photos Are Used Today

If you sit down and try to make a list, as I did, of the uses of digital photography, you better have a sharp pencil and a long sheet of paper. The traditional uses—magazines, newspapers, advertising, multimedia, web publishing—are just the tip of the iceberg. Insurance companies, real estate offices, hospitals and doctor's offices, industries of all kinds, schools and colleges, farms, and small businesses are among the markets that digital camera makers are targeting in 1997.

In order to purchase auto insurance, many states require the company take pictures of your vehicle at the time the insurance goes into effect. It's an anti-fraud measure—to prevent new claims on any old damage. The digital "before" pictures go into a computer file. If you have an accident and file a claim, a digital "after" picture showing the damage can be compared to the picture on file, and both put into the computerized claim form.

Real estate agencies can sit potential buyers in front of a computer and let them do their looking from a digital catalog of available homes. They need not drive all over town looking at properties that don't interest them. It's even more of an advantage for the long-distance buyer, who can look at possible properties on a web site or be sent an Acrobat file with pictures and descriptions of everything in the area. Using a digital camera, these documents can be prepared quickly and easily by anyone in the office (see Figure 1.14). It doesn't take an expert to do the job.

Medical uses of digital photography include imaging for patient charts, recording procedures for use in journal articles and a great deal more. Dermatologists are using digital cameras to photograph suspected skin cancers, to check for changes over time. They take "before" and "after" pictures of certain conditions such as acne or eczema to see how treatment is progressing. Plastic surgeons take "before" pictures, and alter them in a program like Photoshop to show patients how the proposed new nose or chin will look. For accident victims requiring extensive reconstruction, surgeons can use any existing photographs of the patient. These will be scanned, and often shown on a monitor in the operating room, enabling the surgical team to see exactly what they're trying to reproduce.

Figure 1.14

Buying a house is easier when you can decide which ones to look at.

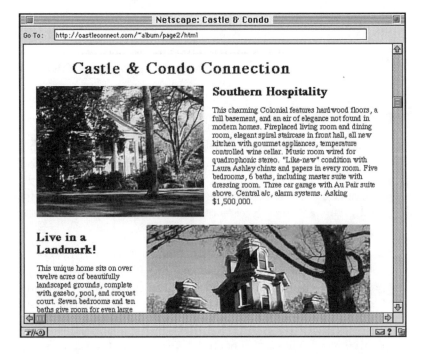

Digital photos are ideal for any kind of an identification system. In fact, Casio makes a color printer that prints your digital pictures on stickers the right size for ID cards (see Figure 1.15). The photo can also be saved in the computer as part of a student's or employee's record, and updated whenever a change in hairstyle or color, or some other identifying characteristic, makes it necessary.

Figure 1.15

Using digital photos to create an ID badge.

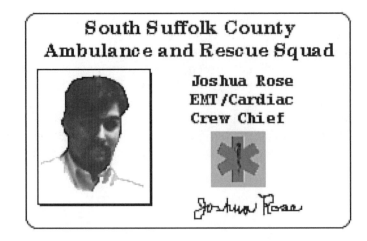

The digital camera makes it easy to document all kinds of activities and situations. Because most consumer models are lightweight and extremely simple to use, they can be made accessible to plant foremen, safety inspectors, supervisory personnel, and others who might need to file reports in case of injury or machine failure. Special purpose digital cameras are used in agriculture to determine vegetation index using infrared and near infrared spectroscopy. The Dycam Agricultural Digital Camera uses the same camera body as Dycam's other digital models, but with filters to pass only red and infrared light. The resulting images are evaluated with software supplied with the camera, to enable "precision farming."

Magazine and Newspaper Photographs

Pick up any newspaper, from the *Wall Street Journal* to the *National Enquirer*. You'll find that many photographs, particularly those in the more sensational tabloids, have been digitally altered. (How do you *think* they got that photo of the President shaking hands with the Space Alien?) The same holds true of magazines. Perhaps the model for the cover shot was having a "bad hair" day, or his face broke out, or she added five pounds—all of it under the chin. The art director can do a little digital magic and everything is perfect again. A certain amount of retouching is allowed and expected, especially in portraiture. There's no reason a picture can't be flattering.

This technique can backfire, though, if the model is someone well-known. *Time* and *Newsweek* caught heavy flak a couple of years ago when they both featured the same cover shot of a certain retired athlete who had become a central figure in a double murder investigation. One magazine had used the photo "as is," the other had "juiced it up," so to speak. By altering the skin tones a little and emphasizing the contrast and skin texture, one of the publications made the gentleman look quite sinister. Trial by Photoshop?

Pyramid Shift

Digitally revising a photo is a relatively new technique, but it has always been possible to paint out parts you didn't want or to move bits of the scenery around. In 1983, *National Geographic* did a cover story on Egypt. When it sent a photographer to get shots of a camel train and pyramids, he stood in the wrong spot. The art director liked the shot but thought the pyramids were too far apart for the magazine's vertical cover format. So, he took a pair of scissors, and moved them. Of course, he did it neatly, airbrushing and retouching as needed. But, as soon as the story and photo appeared in print, the magazine started getting letters from people who had been there and knew the shot was impossible. Eventually, they had to admit taking artistic license. In another photo the same year, they electronically added the top of a Polish soldier's cap, which had been hidden in the original photo.

Many magazines use these tricks. Some, like *National Geographic*, may not admit it until someone catches them. Others make a special point of "creatively" editing and combining photos, type, texture screens, and what have you. Look at *Wired* magazine as an example of digital wizardry pushed to the max.

Is this kind of image manipulation ethical? There's an ongoing debate about this issue. In the field of photojournalism, the question is especially important. Most publications have a policy of not allowing photo manipulation of news, sports, or "hard feature" photos. These pictures have to be used "as is." Non-news pictures or photo-illustrations, however, may be retouched, combined, and electronically enhanced as necessary. The Associated Press, one of the major news wire services providing photographs to newspapers all over the world, issued the following statement on electronics and photo ethics: "The content of a photograph will NEVER be changed or manipulated in any way." (Quoted in *The Oregonian*, 4/28/91.) Not all publications think this way, of course. Supermarket tabloid newspapers, like the *National Enquirer*, use edited photos frequently and don't identify them as such. You can't always believe what you see in print.

Advertising/TV Photography

The point of advertising photography, particularly product photography, is to make the advertiser and product look good. Like the people and scenery in the editorial pages of the magazine, the ads are full of models who've typically been made to look thinner, younger, more glamorous.

And what about the product itself? Chocolates can be sprayed with varnish so they look shiny under the lights. Soup may be shown served in a bowl full of marbles to raise the chunky veggies up where they can be seen. The can of spinach will probably have the green brightened. (Nobody would buy it if they saw what it really looks like.) Food stylists have a full arsenal of tricks to make the groceries glow. (You'll learn many of them on Day 5.)

No matter whether the product is a disposable diaper, a diamond ring, a hub adapter, microtome, or a flange bearing, tricks exist to make it more appealing. A dab of glycerin helps make the highlight glisten. Shooting it at a particular angle might make it look bigger, fluffier, whiter, or whatever. Is it misleading? Perhaps. Is it putting your best foot forward? Absolutely. If you're doing product photography, don't hesitate to use as many tricks as you can. The competition does.

Photos in Web Publishing

Digital cameras and web publishing go together like peaches and cream…no, more like aspirin and a headache. Using digital photos is the solution that enables anyone to have attractive, attention-grabbing, informative web pages. Digital photos don't need to be scanned. When you upload them from the camera, they're ready to edit, or even to paste in as they are. Of course, you may need to convert them to GIF or JPEG, but that's easy enough with shareware utilities if you don't even want to open them in an editing program such as Photoshop. Figure 1.16 shows a simple Mac utility called GIFConverter, which can translate almost any graphic format into any other graphic format. Similar utilities, such as Lview, exist for Windows users.

Figure 1.16

Converting a digital photo PICT to a GIF.

Assignment: Studying Photos on the Web and in Print

For your first assignment, you'll need a pile of magazines and/or an Internet connection. (A magnifying glass or loupe is helpful for the printed materials.) Find pictures you like, and analyze them:

- How were they done, digitally or conventionally?

 How can you tell?

- Have they been digitally enhanced?

 Why might this have been done?

 Is it "cheating"?

- Can you find images created from more than one photo?

 Are two pictures better than two thousand words?

Check out the following URLs for interesting images:

```
http://www.auroraquanta.com

http://www.wp.com/SCINC/online.html#d

http://www.icp.org/
```

The Digital Camera

- Understanding how conventional cameras work
- Understanding how digital cameras work
- Summarizing current digital cameras
- Understanding snapshot cameras
- Understanding intermediate cameras
- Understanding professional cameras
- Using flashcard storage media
- Using video cameras for still photos

Imagine yourself in a tent, in the desert. The year is not known—at least not to you, but it is some four centuries before the birth of Christ. The sun is beating down without mercy, as it always does here in the Middle East. Before you crawled into the tent, you noticed that some animal has chewed a small hole in the goat skin. Or, perhaps it is a just a nick in the skin from when the hair was plucked out and the hide tanned. No matter. It is but a tiny hole. Your eyes become accustomed to the darkness inside the tent. There is a splash of light on the far side, from that small hole. Your eyes are drawn to it. As you watch, a pair of shadowy forms move from one side to the other. Suddenly you gasp with horror. What manner of witchcraft is this? You realize that what you have just seen is a man leading a camel. The figures are upside down, to be sure, but you know what you have seen. You fling up the edge of the tent and crawl outside. There, just a few cubits away, is a man with a camel. You peek under the tent flap. He's upside down. Outside the tent, he's right side up. Witchcraft, to be sure. Convinced your tent is haunted, you seize a burning twig from the cooking pit and set it on fire. You could have no way of knowing you've just been inside the world's first camera.

How to Make a Simple Camera

A camera is nothing more (or less) than a lightproof box with a hole in one side and a flat side opposite the hole. If you have access to a darkroom for photographic processing and printing, you can try making a very simple camera from an empty box. A round oatmeal box is traditional, but any kind of covered light-tight box will do. You'll also need a piece of (black and white) negative film and the chemicals to process it. Figure 2.1 shows how an oatmeal box becomes a camera.

Figure 2.1

A pinhole camera can be made from any lightproof container.

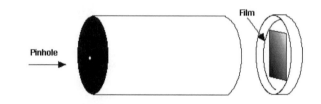

First, make a small hole in the bottom of the oatmeal box with a hat pin, small nail, or something similarly sharp and thin. Hold your finger over this hole or block it with a piece of black tape or cardboard. Working in total darkness, attach a piece of unexposed photographic film to the cover (inside of course). When you're sure that the box is tightly closed and will allow no light to enter, you can turn on the lights. Aim your camera at whatever you want to take a picture of, and uncover the hole for less than one second. Cover it again, and return to the dark room. Remove the film and process it. You should have a somewhat fuzzy, but recognizable negative of whatever you photographed. If you were careful to notice which edge of the film was up, you'll probably be surprised to discover that it's the bottom of the picture. The light rays entering through the pinhole or lens are inverted, as in Figure 2.2, and transposed (flipped left to right).

Figure 2.2

The image is both inverted and flipped.

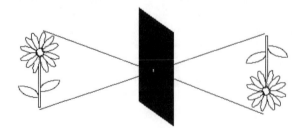

How the Camera Works

The oatmeal box is a basic camera: a box, with a hole to allow light; a shutter, to control the light; and a light-sensitive surface to receive the light. No matter how sophisticated the camera becomes, it still has those four parts. The light admitting hole, which as you've seen, need be nothing more than a pinhole, usually contains a lens. The shutter can be mechanical, electronic, or even "digital" (yes, fingers are digits). The light-sensitive surface may be film, or in the case of a digital camera, an array of electronic image receptors.

Lenses and Focusing

The lens and the shutter were the major refinements that made photography a tool rather than an interesting gimmick. Lenses serve two functions. They gather more light than a simple pinhole can admit, so the exposure can be shorter. More important, lenses focus the rays of light so that the image produced on the focal plane (the surface where the film is) is sharper.

The lens itself may be made of finely ground and polished glass or it might be cast from transparent plastic. Inexpensive "fixed focus" cameras often have a plastic lens, designed to provide an approximately correct focused image at anywhere from about four feet to infinity. Better cameras can be focused by changing the distance between the lens and the focal plane. The most modern "autofocus" camera systems use either sonar or an infrared light beam to measure the distance from camera to subject and adjust the focus automatically. The shorter the distance between the subject and the lens, the longer the relative distance between the lens and the film. Determining the distance can be accomplished in any of several ways. Many cameras have calibrated marks on the lens mount, perhaps at increments such as 2 feet, 5 feet, 10 feet, and infinity. Turning the barrel of the lens to match the indicator with the approximate distance to the subject provides a reasonably accurate focus.

Some cameras have a rangefinder, which also serves as a frame to help you compose the picture. It's like a small window that shows you a view similar to what the lens will capture. These are called, appropriately, rangefinder or viewfinder cameras. The Leica is perhaps the best known of these. Some of today's digital cameras, including the Apple QuickTake 150 and the Kodak DC 50, use a similar system. The lens and the viewfinder are related to each other only by proximity. The viewfinder is usually an inch or so above the lens, and may be to the side of it as well, as it is in Figure 2.3. When you look through the viewfinder you see approximately what the lens sees, but because you're not looking through the lens, it's not exactly the same view.

Figure 2.3

The viewfinder camera is commonly used for snapshots.

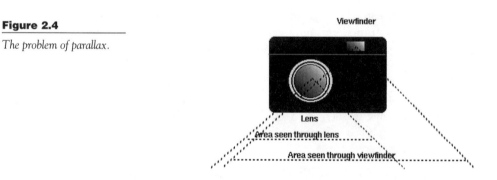

Camera Pros and Cons

The advantages of the viewfinder camera are that it's lightweight and easy to carry around. It can be made inexpensively (disposable cameras are viewfinder cameras), but the more sophisticated and expensive models have coupled rangefinders, which enable the user to focus quite accurately by lining up top and bottom of the picture. The main disadvantage is that the camera has a built-in defect called parallax error. Because the rangefinder is located above and to the left or right of the lens, it doesn't see quite the same view as the lens, so critical compositions can suffer (see Figure 2.4). For a quick test of parallax error, look straight ahead and close your left eye. Notice where the bridge of your nose cuts off your view of objects to the right. Now, close your left eye and open your right. The view is quite different, even though your eyes are separated by only a couple of inches.

Figure 2.4

The problem of parallax.

Other cameras use a prism and mirror arrangement to let you look through the lens and manually adjust the focus until the image projected on the focusing screen looks sharp. These are called single lens reflex cameras, or SLRs for short, because they use only one lens. (The lens is actually a combination of lens elements, as shown in Figure 2.5.) Light falls on the image and is reflected toward the camera. It passes through the lens, and bounces off an angled mirror up into the prism. It then reflects from one side of the prism to the opposite side, taking a path parallel to the mirror. From here, it is reflected back, through the eyepiece, where the image can be seen, right side up and correctly oriented.

The chief advantage of an SLR like the one shown in Figure 2.5 is that you're looking through the same lens that takes the picture. No parallax problem exists. Focusing is quick and easy, so these cameras are good for candid photography. Many of the current crop of digital cameras use the same principle, but instead of looking through a peephole to see what the lens sees, you simply look at the LCD display. With regard to conventional film cameras, the SLR has several disadvantages. It's heavier than the rangefinder camera because of the weight of the mirror and prism, and with more moving parts, it's more vulnerable to injury. It's also noisy. The mirror and the shutter make clanking sounds as they activate.

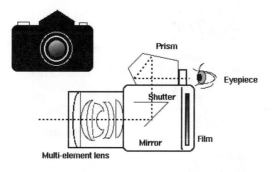

Figure 2.5

The single lens reflex camera.

The twin lens reflex uses two lenses, like the rangefinder or viewfinder cameras, but it provides a focusing screen for the viewing lens, with marks etched onto it to help with composing the picture. The lenses are, again like the rangefinder camera, related by proximity. They are also coupled together, so that focusing the viewing lens also focuses the "taking" lens. These cameras are rugged but awkward to use. As Figure 2.6 shows, you must look down at the viewing screen. They are subject to parallax error, like the viewfinder cameras, and the image on the viewing screen is flipped left to right. Lenses on these cameras are rarely interchangeable, so you are limited as to how wide an angle or how far away you can see.

View cameras are the most like the pinhole camera. The lens admits light to a viewing screen. You move the lens back and forth using the bellows, until the image on the screen is sharp. (You're seeing it upside down and backward, but at least you can see it.) Then you slide in a plate or a film holder, and take the picture. The major disadvantage of this kind of camera is the size and weight. These are not snapshot cameras by any stretch of the imagination. In fact, the equipment, shown in the diagram in Figure 2.7, has changed very little since the days of Daguerre and Matthew Brady. Today, these cameras are used chiefly for architectural photography, because the bellows-mounted lens can be used to compensate for perspective distortion in the photograph.

Figure 2.6

The twin lens reflex camera.

Figure 2.7

The view camera.

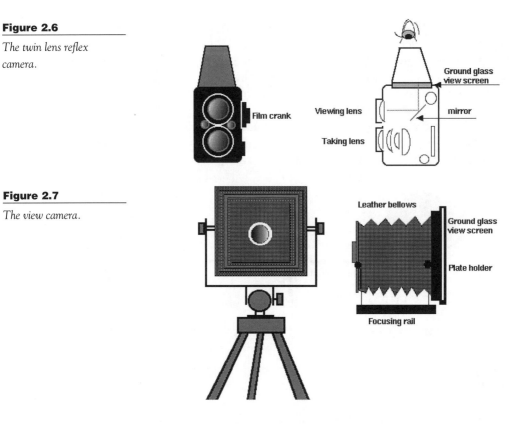

How Digital Cameras Work

The only serious difference between a digital camera and any of the film cameras we've just reviewed is the presence or absence of film. The digital camera replaces the film with a specialized semiconductor—a bit of silicon that conducts some, but not all, of the electricity that reaches it. This particular kind of semiconductor is called a charge coupled device, or CCD for short. It's made up of thousands of separate photosensitive elements arranged in a grid that usually correspond to the shape of the viewfinder. The image passes through the lens and strikes the CCD, which converts the light into electrical charges. The intensity of the charge varies depending on the intensity of the light that strikes each element. In that respect, it's very much like film. Replace the elements with dots of light-sensitive emulsion on a piece of film and you're back where you started, with a film camera.

When you press the button on the digital camera, the CCD passes the information from each element to an analog to digital converter, which encodes the data and sends it to be stored in RAM for later downloading, or stores it to a more permanent flashcard memory. Flashcards are explained in greater detail later in the chapter.

Types of CCDs

There are two kinds of CCDs. The linear CCD found in high-resolution studio cameras captures the image one line at a time. It's shown in Figure 2.8. As the CCD scans the scene, it paints each line of pixels in the image in the same way that a flatbed scanner scans a photo. It's slow. Very slow. Some high-resolution scanning cameras need as much as 12 minutes to capture a complete image. You can't use a linear CCD on a moving subject, and you can't use it on anything, including people, that suffer during a slow exposure under hot, bright studio lighting. Studio lighting, or bright sunlight, is a must with these cameras. Strobe (flash) lights won't work, because they're only turned on for a fraction of a second instead of the many minutes needed to scan and record the image.

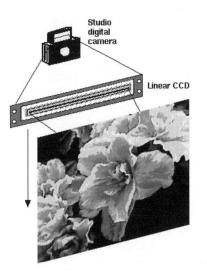

Studio digital camera

Linear CCD

Figure 2.8

For a camera with a linear CCD, you need a subject that will hold still.

"Real-time" cameras contain a grid of photosensitive elements instead of a single line of CCD elements, as shown in Figure 2.9. Each element in the grid represents one pixel of the image. When you press the button, the entire image is exposed and captured at once.

Figure 2.9

Real-time cameras can photograph anything.

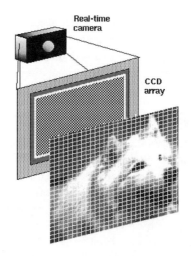

Obviously, the more pixels in the grid, the better resolution you get in the captured image. Typical low- to mid-priced digital cameras have a 640 × 480 dpi maximum resolution. These cameras also let you choose to shoot and save at a lower resolution. The advantage is that you conserve storage space. The Casio QV100, for example, saves 64 pictures at high resolution but 192 pictures at what it considers "normal" resolution. Professional cameras generally capture megapixel images—images with more than 1,000,000 dpi or pixels. At the very high end, studio digital cameras can capture images at resolutions up to 7,500×6000 dpi, averaging about 26 MB in size. These cameras, however, don't attempt to save multiple images. They send the data directly to the computer, for storage on its hard drive.

Color and the CCD

To save the incoming image in color, the light must pass through a set of color filters before it reaches the CCD. Each color filter blocks one of the three primary light colors (red, blue, and green) that make up the color image. Color film, for comparison purposes, uses three different layers of emulsion, sensitive to the three colors of light. Blue is on top, then green, then red. But at any given point on the negative you have the information from all three layers. This isn't possible to do in digital photography. Each picture element, or pixel, can be sensitive to only one color at a time. Color can be achieved by taking three separate exposures of the scene, one for each of the three color filters, and then combining the three exposures electronically to produce the final image. This works

well, providing that the subject doesn't move between exposures. Registration problems can occur even if the image is still. The biggest drawback, however, is that this process is slow. Given the slowness of the linear CCD anyway, making three separate exposures through it is going to be not just slow, but very, very slow.

The Color of Light

Back a million years ago when I went to grade school, every child was given two pencils, a ruler, an eraser, and a box of crayons at the start of the school year. The size of the crayon box was determined by the grade you were in. Kindergarten and first grade got flat boxes with eight big thick crayons per box: the primaries, the secondaries, and brown and black. That was how we learned them, even back then. The primaries were yellow, red, and blue. The secondaries were what you got when you mixed any two primaries: orange, from yellow and red; green, from yellow and blue; and purple, from red and blue. Brown was the mix of all three primaries, and black was... well, black was black.

That's how we knew them, until high school. By then, we'd outgrown crayons, of course. We filed into our physics class and threw the previous nine years of learning out the window. The primary colors, according to the physics teacher were red, green, and blue. And if you mixed them you got, not brown or even the mysterious black, but... white!

Those of us still taking art classes listened to the physics lecture skeptically, and we went down to the art room to try mixing red, green, and blue paint. We got, inevitably, brown... or at least a messy brownish, greenish, reddish, ugly mess. We asked the art teacher about this, and were sent upstairs to the drama department for a demonstration. The stage lights had filters in red, green, and blue. When all of the lights were on, the result was, sure enough, white light. Why? When you're dealing with light, the drama teacher explained, colors are subtractive. They cancel each other out. When you're dealing with paint, the colors add to each other, giving that muddy brown mess. Aha! We were enlightened.

When you bought your computer system, you had to deal with this issue, whether or not you knew it at the time. Your monitor uses light to produce color. That's why it's called an RGB (red, green, blue) monitor. Your printer uses ink to produce color. Not red ink, green ink, and blue ink, but a set of colors called Cyan, Magenta, and Yellow, along with our old standby Black. This color system is known by its initials, CMYK. Why K for black? Black is *still* mysterious.

Fortunately there are better ways to manage color images. If a linear CCD is required, it can be what's called a trilinear CCD. This has three rows of filters actually embedded in the CCD elements (see Figure 2.10). Each filter blocks a different primary color, but the CCD can capture all three at once, eliminating registration problems and speeding up the actual picture-taking. These systems are still slow, and are used in studio cameras rather than in snapshot cameras.

Figure 2.10

The trilinear CCD.

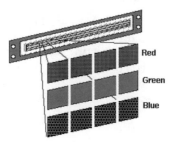

Red

Green

Blue

"Real-time" cameras, the ones that use the grid of CCD elements, manage the color in one of two ways. One way embeds the color filters in the CCD array, with adjacent pixels having different filters. Figure 2.11 shows one possible arrangement. In the process of recording the picture, the microprocessor inside the camera takes the signal from each pixel and averages it with the closest ones of the same color, making an educated guess as to what's supposed to be in between them.

Figure 2.11

Embedded color filters in the CCD array.

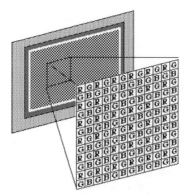

This method *does* allow instant exposure. Microprocessors can "think" very quickly. The only drawback is that the image produced has a very slight fuzziness, because of the math involved. If you try, for example, to photograph a card with a black square in the middle, you won't see an absolutely clean edge to the square. The pixels that happen to be where the image of the edge lands try to average the difference between the 100 percent black

and the 100 percent white, and therefore represent a 50 percent gray. Those immediately adjacent to the 50 percent gray will try to average between it and the ones on the other side, and so on. A single pixel is quite small—about 12 microns or so. For comparison purposes, a typical human hair is about 60 microns, or five times the width of a pixel. So even though each pixel is averaging what's adjacent to it, by the time you are five pixels away from the edge, you're up to 98.4 percent black. The difference between that and 100 percent black is imperceptible to the human eye. But the difference over the spread of five pixels is slightly noticeable. And you see it as a very slight fuzziness.

Is a non-fuzzy digital image possible? Yes. The other way of handling color uses a prism, which directs the incoming light from the lens into multiple arrays, each of which has a different embedded pattern scheme for filtering the three primary colors (see Figure 2.12). These images are then combined to create a single image with a high-resolution and accurate color. The averaging is still part of the process, but because so much more information is available to average in, the results are much more precise. The chief difficulty with this method is that there's a lot of data involved. It fills the camera's RAM buffer, and you must save the image to clear the buffer before you can take another picture. These cameras must be attached to a computer, which generally means they can be used only in the studio. They are also extremely expensive.

Figure 2.12

The multiple array system.

Overview of Current Digital Cameras

It's not necessarily price that determines what you get, but price is as good a place as any to begin. You can spend as little as $400 for a digital camera or as much as $40,000 or more. Before you shop, consider how you plan to use the camera. Is it a new toy for the family, or are you investing in photo equipment for business reasons? If you're a doctor or dentist, you need accurate color and the ability to take close up pictures. If your business is real estate, you may need a wide-angle lens, but high resolution and perfect color are less important. If you're going to use the camera for travel, will you bring a laptop to download your day's collection of pictures onto, or should you consider a model that accepts flash cards, and fill up several of those instead?

Although I mention specific models in the pages that follow, digital cameras are just like any other piece of computer equipment. The day after you buy one, manufacturers will

announce a new model that does more and costs less. These are the cameras on the shelves as of May, 1997. Expect to see newer and better ones announced at every major computer and/or photography trade show. Camera manufacturers usually introduce new products at Comdex, MacWorld, the Consumer Electronics Show (CES), and the Photographic Marketing Industry show (PMAI). Of course, as the new models appear, prices go down on the older ones, so you may be able to find a bargain.

Snapshot Cameras

Cameras at the low end of the price scale are adequate for taking pictures of your family, friends, pets, and vacation trips. You'll be able to view your pictures on the TV screen, save them on tape to your VCR, import them into your computer, and try all the fancy digital tricks you'll learn next week. You'll certainly be able to use the pictures on your web site or print them on your color inkjet printer. You might not be thrilled with the clarity, and you might not want to try to use these cameras for business or professional purposes. Still, they take pretty good pictures. There are at least a dozen different makes and models as of this writing, and more coming along.

Typical of these cameras is the Casio QV100, shown in Figure 2.13. It has an LCD display screen instead of a viewfinder, and it uses a fixed focus lens. The lack of a viewfinder takes some getting used to for those of us who are accustomed to pressing the camera against our noses. But it has some advantages, especially for those who have trouble seeing through a viewfinder, for "grab" shots when you don't have time to compose carefully, and for those times when you don't want your subject to know that you're taking a picture. It has a low light setting, which enables you to take pictures indoors or in the shade.

The Casio is remarkable for two reasons. First, its built-in macro lens enables you to take pictures up as close as four inches from the camera. Second, it has better-than-average storage, without needing a flashcard. The Casio handles 64 high-quality images (640 × 480) or 192 normal (320 × 240) images. In a camera that weighs only nine ounces with batteries installed, that's amazing.

The Fuji DS-7 and Olympus D200L are similar in size and price to the Casio QV100. The D200L has both an optical viewfinder and a built-in LCD screen. It stores 20 images in high-quality mode, and 80 images in standard mode. Unlike the Casio, it has a built-in flash, which activates when needed. The Olympus is a bit heavier than the Casio, but it still fits into a coat pocket, handbag, or belt pack. The Fuji DS-7 is even lighter than the Casio and Olympus. It holds up to 30 images on a 2 MB card, and it can accept a 4 MB

card as well for greater storage capacity. Like the Casio models, it has a low light setting instead of a flash and has a screen instead of a viewfinder. Currently, all of these cameras are priced at less than $600.

Figure 2.13

The Casio QV100 and 300.

Casio has less expensive models, the QV 10 and QV 30, as well as a newly introduced QV300. The lower numbered Casio models have a smaller image size, 320 × 240, and are recommended only for snapshots. The QV 300, however, is an excellent all-around camera. It has a moderate telephoto lens, as well as a normal lens, making it good for portrait photography as well as for general purpose work. Its LCD display has a 2.5-inch diagonal measurement, noticeably larger than the QV 100's 1.8-inch screen. Like the QV 100, its maximum resolution is 640 × 480, and it can hold 64 of these high-quality images or 192 normal (320 × 240) ones. All of these cameras come with appropriate image transfer software and cables for Mac and Windows and a copy of Adobe PhotoDeluxe, a simplified version of Photoshop, which helps you edit and fine-tune your digital photos.

Similarly priced to the Casio QV 100, the Apple QuickTake150 is shown in Figure 2.14. It has a fixed-focus lens. An LCD display panel shows how many pictures you've taken, the status of the battery and flash, and whether you're using high or normal resolution. It comes with Apple's own PhotoFlash software for editing and saving your pictures. The Apple QuickTake also transfers images to a Windows computer using the RS 232C serial connection.

Figure 2.14

The Apple QuickTake 150.

In March of 1997, Apple introduced a new and improved QuickTake 200, shown in Figure 2.15, which looks and feels much more like the Casio or Fuji cameras described earlier. It accepts a 2 MB flashcard and saves up to 40 of its high-quality 640 × 480 images or 80 standard quality (480 × 240) images. Instead of the viewfinder, it now uses an LCD display, and enables you to choose among three focus ranges. Close-up shots are 3.5 to 5 inches. Portraits are in focus from 17 to 35 inches, and the standard lens setting covers the distance from 3 feet to infinity.

Figure 2.15

Apple QuickTake 200.

Intermediate Cameras

There's such a fine line between the fancier snapshot cameras and what I call the intermediates that it's tempting to lump them all together. Still, they have differences, and the most obvious one is price. Anything that costs over $1,000 is automatically out of the snapshot camera class, no matter how badly it performs or how limited it is.

Ricoh's RDC-1 and RDC-2 add another dimension to your picture taking. They also capture sound! These cameras are good enough to be considered intermediates, even though the RDC-2's base price, if you shop carefully, is under a thousand dollars. The most noteworthy aspect of these cameras is the resolution. At 768 × 576, it's definitely a step ahead of the cameras we've previously described. The LCD viewscreen is optional (and costs extra…), but the camera has a clear viewfinder as well. The RDC-1 can record short bursts of full motion, with sound, just like a camcorder. It can save up to 20 seconds of action on a 24 MB PC card. Or, you can record 492 still images, 90 minutes of audio, or any combination, including 10 seconds of audio with each still picture. The RDC-1 has a 3× zoom lens, equivalent to a 50mm normal to 150mm telephoto on a 35mm camera, and a price tag of about $1,800.

The RDC-2 (shown in Figure 2.16) has the same ability to record sound, although it doesn't capture motion. It offers a choice of wide-angle or normal lens, and like the RDC-1, saves 10 seconds of sound with each picture, or 90 minutes of straight audio. The cameras have 2 MB of internal memory, which holds up to 19 images, and accept type I or II PC cards. Both cameras can be triggered with an included cordless remote control device, so you can compose the group picture, put yourself in it, and shoot when ready. You can also use the remote to trigger the audio record function, enabling either camera to eavesdrop on a conversation in another room. The LCD monitor, as noted earlier, is optional, but it's a worthwhile addition. The RDC-2 has two very bright LEDs situated directly below the viewfinder, which blink as you shoot to indicate autofocus and flash in use. I found that they left me temporarily blinded and unable to compose the next shot.

Polaroid considers its PDC 2000 to be an entry-level camera. At a list price of $2,995–$4,995, depending on storage capacity, all I can say is watch out, the first step's a doozy! There's no denying that the Polaroid is a nice camera, and the new, improved Polaroid that will appear in late summer or early fall of 1997 will probably be even nicer.

However, the PDC 2000 is not without its faults. The camera weighs a bit over two pounds, which is heavy for a digital camera. It's bulky and somewhat awkward to hold, and won't fit in your pocket or fanny pack. If you've opted for the lowest-priced model, you won't be taking it more than six feet from your computer anyway. Because this edition (PDC 2000 T) has no internal storage, it must be tethered to the CPU with a SCSI cable ($99 extra). The camera end of the cable has a non-standard SCSI connector, so you *must* buy Polaroid's connector.

Figure 2.16

The RDC-2 with LCD display.

If you're using it in a laboratory or some similar situation, in which you can mount it on a tripod or copy stand and leave it plugged into the computer, it's a fine choice. The resolution is more than twice that of the snapshot cameras, at 1600 × 1200. The PDC 2000/40 and /80 will hold, respectively, 40 and 80 high-resolution images.

There's an appealing alternative to the Polaroid, particularly for anyone who's already made an investment in 35mm Minolta, Nikon, or Canon camera equipment. These companies produce very good digital cameras that can use your existing lenses. Priced anywhere from $10,000 – $16,000, they're not for the beginner. The digital models look and feel much like their non-digital counterparts. Figure 2.17 shows a typical high-end digital camera. The Canon models are built on the Canon EOS body, and use standard Canon lenses. The Nikon E2 series n are built on the Nikon F4 body using the Nikon AI, AI-S, AF, and AF-1 lenses. Because Nikon has already marketed non-digital SLR systems with special purpose lenses, strobes, and other add-ons to medical, industrial, law enforcement, and military users, the E2n camera body is a logical next step for owners of these systems. It saves high-resolution (1280 × 1000 pixel) images to standard flashcards. The Nikon EC-15 flashcard holds 15 MB of data—five uncompressed images, or up to 84 images in Basic mode.

Figure 2.17

The Canon EOS DCS-3 is a thoroughly professional digital camera.

Kodak, in conjunction with Nikon and Canon, has produced a digital photography system using the Nikon N-90 body or Canon EOS 1-N body and a custom Kodak digital camera back. These systems are intended for the professional photographer on location, and for news gathering. The Kodak/Nikon DCS-460 and the Kodak/Canon DCS-1 are currently the world's highest resolution portable digital cameras, using a 3060 × 2036 pixel CCD. These cameras can also record digital sound for tagging or identifying the images, and even for gathering short sound bites at a news event. For pros who prefer the medium format Hasselblad and Mamiya cameras, Kodak makes a DCS-465 digital back that replaces the film magazine back for these cameras. The digital camera back stores images on a type III PCMCIA flashcard, and can store 26 images per 170 MB card. The price is steep, however. Add $28,000 to the cost of the Hasselblad or Mamiya for a digital back.

The Minolta RD-175 uses the prism and multiple array capture system for superior color contrast, and has an effective resolution of 1528 × 1146 pixels with software interpolation. The camera is based on Minolta's Maxxum 4si camera body and is compatible with over 40 AF lenses and records to a Type III PC card. It can save 114 images on a 130 MB card, and also has a SCSI connection for direct interface with the Macintosh. At $10,000, it's almost a bargain.

Professional Studio Cameras

If you're reading this book, you're probably not ready to invest in a professional digital system just yet. Digital backs for studio cameras sell for as much as $50,000 and require a good deal of expertise as well as an SGI or very high-end Mac graphics workstation. Many digital studio cameras lack the capability to store images internally and must be attached by a cable to the computer. The advantage to this seemingly awkward situation is that photographer, client, model, and anyone else involved can see the photo on the computer screen and can decide immediately whether it's right or wrong. This saves time and money, to the point where such systems can actually pay for themselves within a fairly short time in a busy commercial studio. Typical of these is the Leaf Systems DCB II digital camera back. It can be used with Hasselblad, Mamiya, Camerz, Fuji, Sinar, and Cambo bodies, and provides three exposure color or single exposure black and white pictures in a 2048 × 2048 square format. It also requires an Apple Quadra or Power Macintosh computer with at least 64 MB RAM, and an unoccupied NuBus or PCI slot for its interface card. (Sorry, PC owners. Like many professional graphics systems, it doesn't do Windows.)

The highest resolution camera to date is the Dicomed "Big Shot," with an incredible 4096 × 4096 pixels (total 16,777,216). It's shown in Figure 2.18. This camera uses a CCD chip that was originally developed for satellite imaging, so that our national security people could see what their counterparts at the KGB were having for breakfast. With the end of the Cold War, there's no more defense department need for such high-resolution devices, so they've been released to the public. The monochrome version sells for about $35,000 and requires a Power PC Macintosh, as does the Big Shot 4000, a "live" color camera. Big Shot 4000 is a single shot camera back, which capture a full-color 48 MB file within the timeframe of a single flash exposure. Filters embedded in the chip gather the RGB data, which is downloaded by an SCSI connection to the Mac. This gives an instant preview of the photo onscreen, from which it may be saved, printed, or imported into other graphics or DTP programs, or retouched. A Windows NT version of the camera will be available before the end of 1997. The Big Shot 4000 is ideal for commercial fashion and food photography, because it images instantly, and provides an incredibly clear image.

Figure 2.18

Dicomed Big Shot.

Flashcards

Having read this far, you've encountered many references to flashcards or PCMCIA cards. The initials stand for Personal Computer Memory Card International Association, the group who developed the specifications for these cards. Not long ago, the association changed its name to the PC Card Association, and changed the card initials to ATA, for AT Attachment. (AT refers to the IBM PC/AT, for which it was originally developed.) If you've never seen one you may wonder what they are and what they do. Quite simply, they're a storage device. Figure 2.19 shows two, next to quarter, which gives you a sense of its actual size. The cards are still called PC cards as often as they're called ATA cards.

Figure 2.19

PC card.

There are three different types of PCMCIA cards. The length and width of all PC Cards are 85.6 × 54mm, but their thickness varies. Type I cards are 3.3mm thick and are generally memory cards. Type II cards are 5mm thick and are usually I/O devices such as modems. Type III devices are 10.5mm thick and tend to be data storage or radio devices. Laptop/notebook computers generally come with several different sized slots for PCMCIA devices to be placed. A PC Card fits in any slot either its own size or a larger size. For example, a Type II card fits in a type three slot. Digital cameras tend to use either type two or type three cards, which may contain anywhere from 1–170 MB of data.

PC cards first appeared around the time the Apple Newton and similar PDA's (Personal Digital Assistants) came on the scene. They are about the size of a credit card, and slide into a slot in the device using them, which today might be a Newton, a digital camera, or a laptop computer.

If you'll be working with PC cards much of the time and expect to have many images to download, it may be worthwhile to invest in a PCMCIA card reader. This device plugs onto the SCSI port and enables you to retrieve your pictures from the PC card without plugging the camera into the computer. It transfers data faster, too.

The Kodak DC-25 uses a smaller card, sometimes called a CompactFlash card, which plugs into a camera slot just like the PC card. Figure 2.20 shows an example. The Kodak Picture Card holds 2 MB of data, or 13–24 pictures depending on resolution, and it comes with an adapter that enables it to fit into a standard PC reader or other PC Card device.

Figure 2.20

*Kodak's flashcard is smaller
than standard cards.*

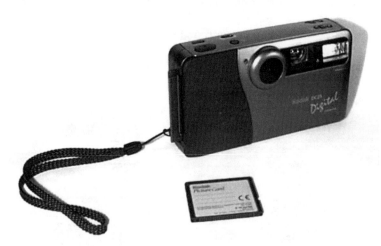

When you attempt to use any of these cards, be sure they're fully seated. It takes a firm push, at least the first few times, to seat the 68 pins into their sockets. Don't insert or remove the card while the camera is on.

Using Video Cameras for Still Photos

Before there were digital still cameras, there were video cameras. Several different "frame-grabber" systems were developed to enable you to import a frame from your videotape or a "live" image from your camcorder. These are apt to be much less satisfactory as photos, although they might be useable as a basis for digital "art." For one, the resolution is not as good as even the low-end digital cameras. It's difficult to compose a picture properly through a video camera's viewfinder, because it's designed to compensate for the part of the picture that is cut off when you display the image on a TV screen. But it's possible. Under some circumstances, it might be better than using a digital snapshot camera.

If you have an AV Mac, you can connect your video camera or camcorder directly to it. Otherwise, you'll need an interface, such as the DigitalVision ComputerEyes or Radius VideoVision digitizer. The ComputerEyes system works with a PC as well as with a Macintosh. The company web site (`www.digvis.com/index.html`) includes updated drivers for all systems.

You'll need a cable from the camera to the computer. AV series Macs give you a choice of two kinds of video input: "S" video (also called SVGA) or RCA (composite) video. They use different plugs. Drawings of both are shown in Figure 2.21. The RCA plug has a single thick pin, with four metal leaves surrounding it. The S-video connector is a round plug with several thin metal pins. It looks very much like an ADB plug or modem plug. Be careful not to confuse it with other connectors, and don't attempt to plug it into the wrong socket. They're not interchangeable and you can damage the connectors. Whenever possible, use the S-video cables and connectors instead of the composite. You'll find that S video is much better quality.

One advantage that camcorders have over digital cameras is that they usually have lenses that zoom and macro focus down to a few inches. If you have a sturdy tripod or copy stand on which to mount your camera, you can use it to copy pictures or to photograph very small objects such as stamps or coins.

Copy stands can be purchased from camera stores, or converted from an old enlarger. You can even build one, if you're handy with tools. It's simply a flat board with a vertical pipe mounted at one end. A platform slides up and down the pipe and can be clamped steady at any point. The platform contains a mounting plate and screw that attach to the tripod mount on the camera. Some copy stands include a pair of gooseneck lamp mounts to illuminate the scene. Otherwise, you can use clip-on lights from the camera shop or hardware store, with flood bulbs.

Figure 2.21

SVGA and RCA plugs.

To get the best possible image, disable the camera's autofocus, and focus by hand, viewing the image on your monitor rather than through the viewfinder. Be sure that the object you're copying is well lit. Using two photoflood lights on either side of the copy stand provides bright shadowless lighting. Figure 2.22 shows the ideal arrangement for this type of copying. Aim the lights so that the "spill" from both overlaps on the thing you want to copy. Placing them equidistant, and at an angle between 30 and 45 degrees from the table top, assures even illumination.

Figure 2.22

The copy stand.

You'll need software to capture the images, of course. The digitizer will probably have a basic capture program included. Apple's Video Player, included with AV Macs, can perform this function, as can such programs as Adobe Premiere.

Assignment: Read Your Camera's Manual

Read your camera's manual. Learn what each button does, what kind of lens it has, and what the storage capacity is. Find out how to erase pictures you don't want, and how to view them in the camera, if yours can do that. Find out how to toggle between normal and high resolution.

Be sure you know how to install the batteries and flash card, if any. Take some pictures, just for practice, and then erase them. If your camera has a built-in flash, practice turning it on and off. Take pictures with and without the flash. If your camera has a self-timer, mount it on a tripod and take a picture of yourself.

Technical Details

- Understanding lenses
- Manipulating exposure controls
- Understanding aperture
- Changing shutter speed
- Finding work-arounds for focus, aperture, and exposure problems
- Caring for digital cameras
- Using batteries and AC adapters

It's important to understand the differences between telephoto, wide-angle, and normal lenses, and how shutter speeds affect the photograph, even if your camera doesn't enable you to control these functions. At the very least, you'll know why your pictures come out the way they do, and at best you will learn how to use the factors you *can* control to make up for those factors you can't do much about.

Understanding How Lenses Work

The lens is the camera's eye. Like the human eye, some focus better than others. Some see farther away; others can read the fine print. Camera lenses can be made of many individual polished glass elements, or cast from a bubble of transparent plastic. Its function is to focus light rays onto the light-sensitive surface. The better it does the job, the clearer your picture is. The simplest type of lens is a single element convex lens, the same kind used in a magnifying glass. In profile, it is thick in the middle and tapered at the ends, as shown in Figure 3.1.

Figure 3.1

The convex lens is thick in the middle and tapered at the ends.

As you learned in the description of the pinhole camera, light travels in a straight line through a transparent medium. However, when light passes from one transparent medium to another, for example, through a lens, the light rays can be bent or *refracted*. This means that more light rays from each point on the subject are gathered and refracted toward each other so that they meet at the same point.

In Figure 3.2, you can see some of the light rays from a specific point on the tree passing through the lens and converging to form that point on the image of the tree.

Figure 3.2

Refraction happens when the light is slowed down by the density of the glass.

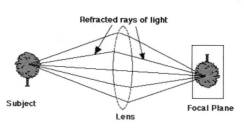

Refracted rays of light

Subject

Lens

Focal Plane

This point of convergence is called the *focal plane*. Conventional cameras are designed so that the film is held in position precisely on the focal plane, to get the best possible picture. Digital cameras direct the light to the CCD, which replaces the film at the focal plane.

Focusing

In a fixed focus camera, the ideal distances between the lens, the average subject, and the focal plane have been mathematically calculated. The lens and film holder are positioned according to this measurement and can't be changed, regardless of whether you're photographing a distant mountain or a nearby flower. In a variable focus camera, there's a mechanism to move the lens forward and backward, while still keeping it centered on the focal plane. This enables you to compensate for a subject that's closer to, or farther away from, the lens.

Typical autofocus snapshot cameras send out a beam of sound (sonar) or infrared light. Most digital cameras use the infrared light method, with the exception of the Polaroid

PDC-2000 which, like conventional Polaroid cameras, uses sonar. These cameras count the time it takes for the beam to bounce back to the camera and compute the distance from the camera to the subject, so that they can move the lens in and out accordingly. Many digital cameras have built-in autofocus.

> **TIP**
>
> When a scene is brightly lit, it's easier to determine whether the depth of field (area in focus) is shallow. Use "flat lighting" (general over-all illumination) to lower the contrast if you are concerned about keeping foreground and background relatively in focus.

High-end professional digital SLR cameras use a system called *passive autofocus*, which "reads" the image, comparing the contrast of adjacent areas of the frame as it appears in the viewfinder. Focusing with this system is quite precise, and there's no problem switching lenses because the focus measurement is done through whatever lens is mounted.

Using autofocusing provides no guarantee that what you want in focus will be so. Autofocusing is difficult when the subject is very close. If the camera can't focus, you may need to move back. Focusing is also difficult if the subject has very low contrast, like a white wall, sky, or the side of a building with very little detail.

Subjects that move fast or flicker, such as a fluorescent light or candle flame, can cause focusing problems. Subjects under low lighting conditions or strongly backlit, like the statue in Color Plate 3.1. can cause problems for both focus and exposure metering. In this case, I exposed for the sky, allowing the statue and the branches to be in silhouette, and focused on the bridge of the statue's nose. Because it was a bright day, the small aperture provided acceptable focus on the branches to the left of the picture, which were about 50 feet away. The branches on the right were more than 100 feet distant, and are definitely less sharp.

Some autofocus cameras include a focus lock. If you can lock the focus, you can resolve many of the problems discussed here. Simply find something else that you can focus on that is the same distance away as the difficult subject. When it's in focus, enable the focus lock, recompose your picture, and shoot it. If possible, do this with the camera connected to an external monitor so that you can confirm the focus. If not, remember, you're not paying for film. Just keep trying until you get it.

Focal Length

You've heard lenses discussed in terms such as normal, telephoto, and wide-angle. What do these terms really mean? Lenses vary in focal length. A "long" lens is a telephoto lens, and a "short" lens is a wide angle lens. Focal length is an important concept, because the focal length determines the size of the image projected on the film or CCD at a given distance from the camera, and it also determines the width of the area in front of the camera included in the picture.

In conventional camera terms, a "normal" lens is one that has a focal length approximately equal to the diagonal of the picture's negative area. Normal on a 35mm camera, which uses a 24×36mm negative, is approximately 43mm, which could be determined from the Pythagorean Theorem, if you were so inclined. (Trust me. It works.) On a typical digital camera, the area of the CCD is much smaller than the area of a 35mm negative, so "normal" is much smaller, too. The standard lens on the Ricoh RDC-2 is a 5.6mm lens (equivalent to a 55mm lens on a 35mm camera). The lens on the Casio QV100 has a 4.9mm focal length.

To determine the focal length of a lens, the lens designer or optical engineer focuses the lens on infinity and measures the distance from the optical center of the lens to the focal plane (see Figure 3.3). Fortunately, you don't need to do this. If you have a camera that uses interchangeable lenses, they're labeled. Some cameras, such as the Casio QV 300, don't have a "normal" lens, but instead let you flip back and forth between a wide-angle and telephoto. Because the wide lens isn't extremely wide, and the telephoto lens isn't extremely long, one or the other suffice for most normal shots. If your camera has only one lens built-in, assume it's a "normal" lens. A few special purpose cameras, such as the disposable panoramic ones, have a wide-angle or moderate telephoto lens instead.

Figure 3.3

This is the way it's done in physics class.

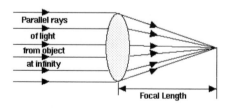

Visual Angle

A normal lens is curved to a degree that admits light from about the same angle of view, or visual angle, that our eyes do. A wide-angle lens has a greater curve and "sees" more of the scene than we do. The "peep-holes" sometimes found in doors, especially in hotel rooms, are a good example of a wide-angle lens. Objects within the scene are smaller than they would be if seen through a normal lens. A telephoto lens has less of a curve and "sees"

a narrower angle of view. Because it's seeing less of the scene, however, objects appear much larger. They are magnified as if seen through a telescope, hence the name. Doubling the focal length of the lens actually doubles the size of the image. Figure 3.4 shows examples of all these lenses.

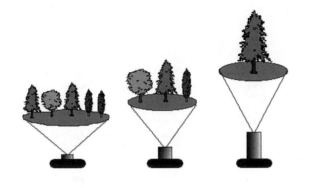

Figure 3.4

Wide, normal, and telephoto lenses and how their visual angles vary.

TIP

The most important rule to remember about focal lengths is that a "short" lens (that is, any lens with a focal length *less* than normal for the camera format) is a wide-angle lens. A "long" lens (that is, any lens with a focal length *greater* than normal for the camera format) is a telephoto lens.

Zoom versus Prime Lenses

A lens that has a single focal length is called a prime lens. A zoom lens is a lens that can shift its focal length. Because most modern lenses are made up of several individual lens elements, it's a fairly easy matter to build the lens in such a way that rotating the barrel moves one of the elements back and forth, thus changing the focal length. The barrel itself may even telescope in and out becoming longer or shorter as needed. Zoom lenses cover a range of focal lengths. Common zoom lenses for 35mm applications are 30–70mm (wide-angle to slight telephoto); 70–300 (slight to definite telephoto); and so on. Of course, you're not limited to the ends of the spectrum here. The 30–70mm lens can be used as a 30, 35, 50, 70, or anywhere in between. Instead of carrying a set of prime lenses and changing them, you can carry just one and zoom in and out as you shift your attention from the distant forest to the nearby tree. Figures 3.5 and 3.6 show the same scene as photographed with a wide-angle and telephoto lens.

Figure 3.5

Photograph taken with a wide-angle view.

Figure 3.6

The same scene, through a telephoto lens.

A few of the digital cameras currently available have zoom lenses, notably the Ricoh RDC-1, Kodak DC50 (3X or 7–21mm), and the Sony DKC-1D1 (12X). Other digital cameras, such as the Casio QV300 give you a choice of a wide-angle or telephoto lens, but nothing in between. If your camera has only a normal lens, you may be able to use an auxiliary lens with it. Tiffen makes wide, super-wide, telephoto, and close-up lenses with a mounting system that attaches them to a Casio, Epson, Apple, or Kodak digital snapshot camera. If you're fortunate enough to be using one of the camera systems that use interchangeable lenses, such as the Nikon E2n or Minolta RD-175, you have literally dozens of lenses to choose from—all the way from an 8mm fisheye (ultra wide angle), to a 1000mm extreme telephoto. Portrait photographers generally use a short to moderate telephoto, or zoom telephoto in the 70–135mm range (for 35mm cameras).

It used to be true that zoom lenses were not as sharp as prime lenses, but testing shows the differences in the current crop of lenses to be so minor that it's not worth worrying about.

Distortion

There's one difficulty that all photographers must face. When you send light, which wants to travel in a straight line, through a piece of curved glass, you inevitably get distortion. This is particularly obvious when you use a wide-angle lens on a very close subject (see Figure 3.7). Objects at the edge of the scene may look as if they'd been stretched. Objects closest to the camera are enlarged.

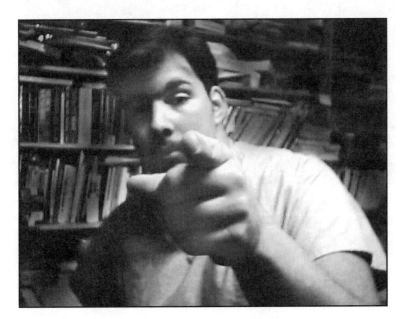

Figure 3.7

Notice how large the pointing finger is, compared to the face.

You can work around this by either cropping the picture to remove the distorted parts, or by switching to a normal lens. Wide-angle lenses shouldn't be used for portraits, because they tend to make noses and chins appear grotesquely large, but they're good for catching the action at a sporting event. When you shoot you can be fairly certain that the ball or hockey puck is somewhere within the picture, and you can crop until you have a reasonable composition.

Telephoto lenses have their own set of problems. They must be held steady when you shoot, as they accentuate any camera movement. They appear to compress perspective, producing a flat, two-dimensional effect. This works to your advantage in portraiture, as does the fact that you can stand a bit farther away from your subject and not crowd him or her.

Depth of Field

Depth of field is sometimes called depth of focus, perhaps a more accurate term. It refers to the extent of the scene, from close to far, that is in focus in the picture (see Figure 3.8).

Figure 3.8

Depth of field is the extent of the scene in focus in the photograph.

Area in focus

Several factors influence depth of field, but the most important is the viewer's tolerance for fuzziness. When the lens is focused to provide a sharp image of a particular object within the scene, objects closer and farther away are less sharp. Because the decline in

sharpness is gradual, when you look at the photo you may not be conscious of the blur. Some lenses, notably wide-angle lenses, provide sharp focus over a greater depth of field than others. Any well-made "normal" lens should also have acceptable depth of field.

Of course, sharp focus is, itself, a relative term. The lens reproduces an image of a point as a small circle. Pictures are made up of millions or even billions of these circles. They're called *circles of confusion*. When the lens is focused on an object, it means that the circles that make up the object are as small as they can possibly be. The unassisted eye can't discern fine detail.

Even a person with excellent close vision can't see circles smaller than 1/100th of an inch in diameter. They look like dots, and they merge to form the image. At the sharpest point of focus the circles are the smallest. As you get farther away from that point, the circles get bigger, so that eventually you see them as circles rather than as points. At this point, you're aware that the image is blurred. Depth of field, therefore, is the area in which the circles of confusion aren't large enough to be noticed. Figure 3.9 shows a greatly magnified (theoretical) view.

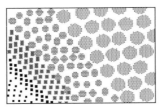

Figure 3.9

What's in focus, and what's not.

In general, the depth of field is divided in thirds so that one third of the area in focus is in front of the focal point (object in focus), and two-thirds of the focused area is behind it. As the camera moves nearer to the object, the depth of field narrows and becomes more evenly divided, up to halfway on either side of the focal point, when the object is close enough to give an image equal to the size of the original object, or at a distance equal to twice the focal length of the lens. At this point, the depth of field is extremely shallow, on the order of an inch or less on each side of the point of focus. This is important to remember if you are using a macro lens to photograph small objects such as stamps or coins.

Manipulating Exposure Controls

The lens admits light. The diaphragm and shutter control how much. In a conventional camera, or in a digital camera that's based on a conventional camera body, these are mechanical devices. The diaphragm controls the brightness, or *intensity*, of the light. The shutter controls the *duration* of the light.

Aperture

Aperture means opening. It refers to the opening or hole left by the diaphragm that allows light to pass through the lens. Essentially, the diaphragm is a set of metal plates or leaves that open and close to make a larger or smaller hole. The diaphragm is mounted in between the glass elements of a lens. When it's open all the way, the lens admits as much light as possible. When it's a tiny hole, obviously, it doesn't admit much light at all. The diaphragm openings, or apertures, are called f/ numbers or f/stops. They're assigned numbers according to the diameter of the diaphragm opening, expressed as a ratio of the focal length of the lens.

Confusing? Maybe an example will help make this clearer. Let's say you have a 50mm lens. That means the focal length, or the distance from the optical center of the lens to the film plane, is 50mm (see Figure 3.10). The widest aperture possible on that particular lens is 25mm. That gives you a ratio of 1:2, usually expressed as f/2. A different 50mm lens can have a bigger piece of glass and a wider aperture. It might be, for example an f/1.8 lens.

Figure 3.10

Because the focal length is twice the aperture, this is an f/2 lens.

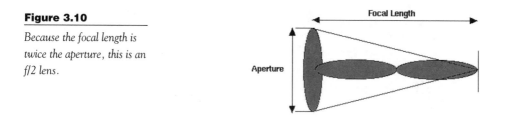

Diaphragms would be useless if they were always wide open, so the lens has settings for smaller apertures. When you change the f/stop, the blades of the diaphragm move apart or together to produce a larger or smaller hole. To make matters more confusing, the smallest numbers are the largest openings, and the largest numbers are the smallest openings. It works this way because the f/ stops represent fractions of the focal length of the lens. Just as 1/4 is twice as large as 1/8, f/4 is twice as wide an aperture as f/8.

Digital cameras, such as the Casio QV 100 and QV 300, give you a choice of two f/stops or apertures for bright or dim light (see Figure 3.11). Other digital cameras measure the light and adjust automatically, turning on an internal flash if necessary.

Figure 3.11

On the Casio, the dark circle represents the smaller aperture (f/8) and the light circle indicates the larger aperture (f/2.6).

Nevertheless, aperture is a consideration for the digital photographer because it affects several other camera functions including depth of field. When the lens is set at a smaller aperture (higher number f/ stop), the light rays that enter it are doing so through the flattest, optically best part of the lens. Therefore, there is less "fuzziness" (smaller circles of confusion) and better depth of field than when the entire lens is admitting light. To increase the depth of field, use the smallest possible lens aperture. This may require a very long exposure, or adding more (artificial) light to the scene.

Shutter Issues

In a conventional camera, you must deal with two different mechanisms for controlling the amount of light that reaches the film. The aperture is the first variable. The shutter is the second variable. The shutter opens for a fraction of a second to allow light to reach the film.

Exposure is, therefore, a function of the intensity of the light and the time the light is allowed to strike the sensitive surface. When there's more light, less time is needed. When there's less light, more time is needed. The relationship between these two variables can be expressed as an equation:

Exposure (E) is the product of (=) Intensity (I) multiplied by (×) Time (T).

This equation, E= I×T, is called the *Reciprocity Law*. I and T are reciprocals, which means if you increase one and decrease the other by the same factor, the result is the same.

Of course, you must use some sort of measuring system to determine how much light is falling on the subject. Many conventional cameras and all digital cameras are equipped with light meters that measure the amount of light reflected from the subject to the camera. A microchip inside the camera takes the light measurement and computes a suitable combination of aperture and shutter speed to expose the film correctly. If your picture requires a certain shutter speed, it calculates the correct aperture. If you want to use a very small aperture to gain as much depth of field as possible, the camera sets itself to the appropriate shutter speed.

In a camera with a fixed aperture lens, the shutter speed varies according to how much light is available. Digital cameras use an electronic shutter instead of the mechanical ones found in conventional cameras. Effective electronic shutter speed can be anywhere from 1/2 to 1/4000th of a second. When you must use a fast shutter speed to capture something in motion and your camera doesn't enable you to set the shutter speed, you can trick it by setting the aperture to its widest opening, and by making sure the subject is brightly lit. This forces the electronic shutter to open and close very quickly, so as not to overexpose the picture.

White Balance

Digital cameras have a capability not possessed by the conventional camera. In addition to measuring how much light falls on the subject, most digital cameras also measure the color temperature of the light and adjust accordingly so that any white objects in the picture will be white, rather than yellow, green, or some other color. Color temperature is measured on the Kelvin scale, and can best be explained if you think of a piece of metal being heated. When it's cold, it is black. As it is heated, it eventually glows a dull red, and then a bright cherry red, and then orange, yellow, on up to a brilliant blue-white. Table 3.1 shows the color temperature of some typical light sources.

Table 3.1 Color Temperature of Typical Light Sources

Light Source	Approximate Color Temperature (in Degrees Kelvin)
Candle flame	1930° K
Dawn sunlight	2000
Household light bulb	2760–2960
"Warm-white" fluorescent lamp	3000

Light Source	Approximate Color Temperature (in Degrees Kelvin)
Photoflood bulb	3400
"Daylight" fluorescent lamp	4500
Sunlight at noon	5400
Average daylight (sun and sky combined)	6500
Blue sky	12000–18000

As you can see, daylight is a lot bluer (higher on the Kelvin scale) than indoor light. That's why pictures taken outdoors may have a bluish cast, or pictures taken inside may seen to have a warm, orange tone. Most, but not all, digital cameras, attempt to find something white in the scene and compare it to their internal reference on what white should look like. They then adjust their levels to match. If the camera can't compensate for the quality of light, you can adjust it when you upload your pictures to the computer. Sometimes, though, the effect of unadjusted whites can be very helpful.

In the picture in Figure 3.12, the cat was lit only by daylight coming in the window. It was, as you can see, a snowy, overcast day. Even though the sky was gray rather than blue, the color temperature was close to that of blue sky. The cold tones made the black and white cat even more black and white. The softly diffused light illuminates him evenly, avoiding highlights and shadows, and adding a slightly hazy, romantic quality to the portrait.

Figure 3.12

The light in this photo creates a pensive pussycat.

Learning Work-arounds for Camera Settings

Digital photographers at all levels have an advantage shared only by those professionals who do their own color darkroom work. If you have to make compromises when you shoot your pictures, you can almost always improve your work after you upload it to the computer. Having said that, I should also point out that you'll be able to do much more with a picture if it's good to begin with.

Focus Work-arounds

Rule number one for keeping your pictures in focus, no matter what kind of camera you use, is to hold it steady. If your exposure is likely to be longer than 1/60th of a second, find something to brace yourself against, use a tripod, or at the very least, learn the *photographer's crunch*.

This is a position that becomes second nature after a while. Begin by standing with your feet a little wider apart than normal, so you've got a good firm footing under you. Hold the camera with both hands, and press your upper arms and elbows into your ribs as in the Figure 3.13. If you need a low angle, sit, kneel, or lie down, with your elbows firmly braced. As you look through the viewfinder, rest the camera against your nose. If your camera uses an LCD view screen instead of a view finder, hold it a comfortable viewing distance away, but again with your elbows and upper arms pressed tight to your body. Just before you press the shutter, stop breathing for a second or two.

If your camera has a fixed focus lens, you're going to need to do some experimenting. Start by memorizing the information that came with the camera about focus distances. You'll probably find something like "Focus Distance: two feet (0.5 m) to infinity." Common sense tells you that nothing is going to be in perfect focus at both two feet and infinity. You can safely assume that they're referring to reasonably acceptable depth of field, rather than focal point. Knowing that, you can therefore determine that the actual focal point is probably somewhere around 6–8 feet.

Take a few test pictures with a subject at that distance, and see if they're acceptably sharp. Then try a couple at 4 feet and 10 feet, and see what differences, if any, you can notice. You can "sharpen" pictures in the computer, too, by using the tools in a program such as Photoshop, Photo Deluxe, or Picture Easy.

Figure 3.13

Holding the camera steady.

Auto focusing cameras have their own set of problems, as previously noted. The main thing to remember when you use an autofocus camera is that the focusing mechanism is aimed at the center of the frame. If you're shooting a couple, it's entirely possible that the camera may try to focus through the gap between the people. Focus on one or the other, lock the focus if possible, recompose and shoot before you let go of the focus lock, so the subjects stay in focus.

If you know that your autofocus camera uses sound, such as the Polaroid PDC-2000, don't try to take pictures through a closed window. The sound waves bounce off the glass, and give you a perfectly focused window, with a blur beyond it (see Figure 3.14). This sometimes happens with infrared autofocus cameras, too, although a few seem to be able to look past the glass. The best work-around for this: open the window!

Figure 3.14

My son Joshua took this picture through a (closed) bus window, with a Casio QV-100.

TIP

If you must shoot through a closed window, as on a train or bus, hold the camera so it's at an angle to the glass. Then, infrared or sonic waves from the focusing device will bounce away from the camera instead of back at it, and the camera will autofocus at infinity, which is exactly what you want it to do.

If you're shooting a group of people or a scattering of objects such as a field of flowers and need as much depth of field as possible, focus about a third of the way back. Doing so will take advantage of as much sharpness as your lens can provide. Similarly, if you have two subjects—one at six feet away and the other at 12 feet—your focus should be at eight feet, in order to take full advantage of the rule that depth of focus extends one-third in front of the focal point and two-thirds behind it.

Flash Work-arounds

Cameras with built-in flash are very useful in certain situations. Obviously, when you're shooting indoors and haven't enough light, the flash fills in. You can also use it outdoors when you need a little extra light on a subject that's backlit or in shade. Some

photographers are reluctant to use built-in flash, for several reasons. Having the flash mounted on the camera produces a flat, head-on light with no modeling effect. The roundness of the subject is lost. This isn't so bad if the subject is a piece of furniture, but if you're shooting a portrait, the effect may make it look more like a mug shot (see Figure 3.15).

Figure 3.15

Notice the shadow directly behind his head.

No shadows can add contour to the face. In fact, the only shadow you'll see is cast on the background right behind the subject's head. It may even merge with the head to the point where you can't tell what's hair and what's wall. The cure for this is quite simple. Place the subject between three and six feet in front of the background. This gives room for the shadow to fall harmlessly out of the way, and still sheds enough light on the background so that your subject won't appear to be looming out of a hole (see Figure 3.16).

Figure 3.16

Moving the subject away from the background keeps the shadow out of the picture.

TIP

Use the same trick described in Figure 3.16 if you're shooting outdoors in the sun. Move the subjects far enough away from vertical surfaces so that their shadows aren't part of the picture.

Another problem with the built-in flash is that it casts bright highlights on reflective subjects. Occasionally, this effect is good, but sometimes the highlight is just too much glare. To soften it, tape a single layer of tissue over the flash, taking care that the tape and/or tissue doesn't interfere with the lens, meter, or anything else. The tissue should diffuse the light just enough to block the glare, without darkening the picture noticeably. Figure 3.17 shows before and after examples.

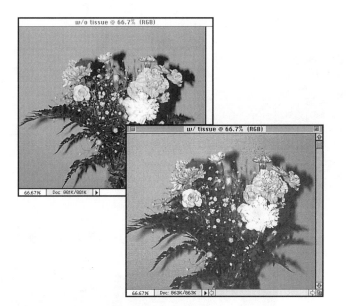

Figure 3.17

The picture on the left was shot without tissue. The one on the right used the tissue to diffuse the light.

A related problem is called "red eye" when it affects people and "green eye" when it affects cats. If the subject's pupils are wide open, as they tend to be in dim light, and you take a flash picture, the light reflects off the backs of the retinas and into the lens (see Figure 3.18).

Figure 3.18

Red eye is caused by light bouncing off the subject's retinas.

Exposure Work-arounds

In general in digital photography, it's better to underexpose than to overexpose. If your pictures are a little too dark, you can usually lighten them enough to bring out the detail. If you have overexposed your picture, there's usually no way to save it. The detail just isn't there. Use these pictures to experiment with special effects. The photo in Figure 3.19 was shot about 20 minutes after sunset. In the uncorrected version on the left, the details are lost in the darkness. Photoshop's auto correct brought back most of the detail, and saved this one.

Figure 3.19

Golden Gate bridge at dusk,
fixed, with Photoshop.

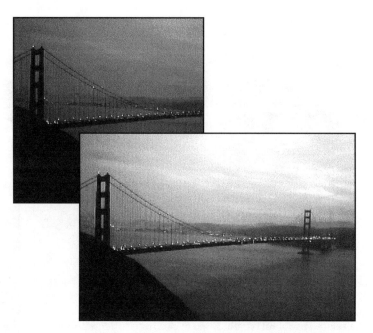

Remember that you can correct for color temperature. If all you have available is fluorescent light, use it. If your subject's skin tones pick up a greenish cast from the lights, you can fix it later. If you have a couple of clip-on lights, but only standard household bulbs, go ahead and use them. A warm portrait is better than a dark one.

If you're planning to shoot pictures outdoors, be sure to consider the time of day and angle of the sun. You won't get a flattering portrait at high noon with the sun directly overhead, but you get better architectural shots then. Shoot the scenery midday, and save the people pictures for later, as the sunlight warms up and the sun's angle casts shadows.

If your camera enables you to see what you have shot, always stop and check after one or two pictures in a particular setting. You may decide to turn on another light or open a curtain. If you're outdoors, you may decide to move from sunlight to open shade, or to move so that the sun is over your shoulder.

Caring for Digital Cameras

You've made an investment in equipment. It is smart to take care of it. Not many things can go wrong, as long as you keep your camera dry and away from extreme temperatures. Use a wrist strap or neck strap at all times. Digital cameras contain delicate electronic parts and aren't meant to be dropped or thrown around. Keep your camera in a protective

case when you aren't using it. Some cameras come with cases. Other companies sell the case separately, or send it to you as a premium when you return the registration card (see Figure 3.20).

Figure 3.20

The well-equipped photographer.

Even if you use the case that came with your camera, investing in a photographer's shoulder bag, fanny pack, or backpack is a smart idea. After all, even with the simplest snapshot camera, you'll want to carry around a notebook and pencil, spare batteries, an extra flashcard, and lens cleaning tissues. You may eventually add lenses and filters and perhaps a folding tripod. You need a convenient way to keep it all together; the shoulder bag is probably the best choice.

Lens and Screen Cleaning

Sooner or later, you'll get fingerprints or dust on the lens or viewscreen and have to clean the camera. If the maker has provided a lint free cloth, use it. (Be sure you keep the cloth in its plastic bag when you aren't using it. It can pick up grit otherwise, and do more harm than good.) If you don't have a special cloth, go to a camera store and buy a package of untreated lens-cleaning tissues.

> **⚠ WARNING**
>
> Never use the chemically treated tissues made for eyeglass cleaning. They may damage your camera lens.

To remove visible dust from the lens, tear out one sheet of tissue. Roll it, and then tear the roll in half, so the jagged edges of the tissue make a sort of paper brush (see Figure 3.21). Use this to brush dust very gently from the center out to the edges. If the dust seems stuck, breathe on the surface of the lens. The moisture from your breath loosens the dust. Follow manufacturer's directions regarding the use of lens-cleaning fluids.

Figure 3.21

Making a brush from tissue.

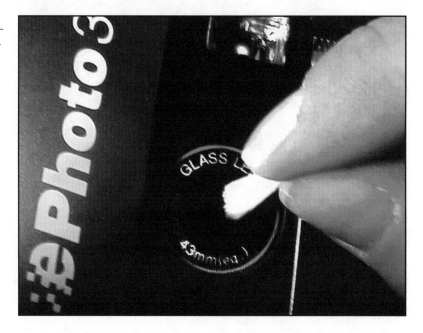

LCD viewing screens can be cleaned in the same way. These are more prone to fingerprints. (Also prone to nose prints…I keep forgetting that the Casio doesn't have a viewfinder.) You may have to use gentle pressure on the screen to remove oily fingerprints.

Batteries and AC Adapters

Digital cameras don't just run on batteries. They *eat* them! I never go out for a day of picture-taking with fewer than three sets in my bag. Batteries can get expensive, to say nothing of being wasteful and bad for the environment. Disposal of dead batteries is a problem municipalities are beginning to recognize. If you incinerate them, they explode, sending chemicals into the air. If you bury them, they corrode and leak chemicals into the ground, where they eventually end up in the water supply.

Alkaline batteries are the least expensive, but lithium batteries last longer. Rechargeable nickel-cadmium (NiCad) batteries are the best alternative, although they cost the most initially. It pays to have several sets of batteries, so you can switch when necessary. Of course, you also need a charger. It pays for itself in about 10 photo sessions.

A couple of tricks are necessary when working with NiCad batteries. To get the most use out of them, discharge them completely before you recharge them. If you put half-charged batteries into the charger thinking to "top them off," you'll discover a strange effect. The battery tends to remember the amount of charge it took, and next time you try to charge it, it accepts only half a charge.

NiCads eventually wear out. If you number the batteries and keep a notebook to remind you how many times you've recharged each set, and approximately how many pictures you were able to take after each charge, you'll have some advance warning when they're wearing out, and can plan accordingly.

Assignment: Experiment with the Settings on Your Camera

Start a notebook, recording the settings for a series of pictures. See what differences you can notice. Shoot under differing light conditions and both indoors and outside. See what works best in daylight, and what to use inside.

Seeing Photographically

- Comparing what you see and what the lens sees
- Organizing perception = composition
- Framing a picture
- Discovering perspective—the illusion of reality
- Applying line
- Using pattern and texture
- Incorporating space and scale
- Finding balance and symmetry
- Building relationships

Whoever said the camera doesn't lie was lying. The camera can exaggerate certain features and ignore others. It can compress perspective. It can stop time and freeze motion. Learning to see the way the camera sees will make you more aware of what's around you. It doesn't matter, in this case, whether there's film or a CCD and flashcard in your camera. Conventional cameras and digital cameras are alike in every way except recording media.

"Thinking photographically" is a process that happens within you, not inside the camera. In this chapter, you're going to learn to compose and design good pictures. The same rules apply, whether your medium is digital photography, "film" photography, or even painting or drawing. Mastering the basics will make you a much better artist in any medium in which you choose to create.

Comparing What You See and What the Lens Sees

How do you see the world around you? It's there when you open your eyes, but what's really happening? The process of seeing begins with light. Light strikes the objects that make up our world: walls, floors, furniture, trees, grass, people, animals, sky. It's reflected back from them in different amounts. Our eyes respond to the light rays that bounce off the objects around us. First, we see shapes, distinguishing them from the background. Next, we see color, and finally detail. Only then can we process the information to know whether we've seen a black cat or a red flower. It all happens in a fraction of a second. As soon as we can gather enough information to identify one object, we move onto the next, and so on. When there's less light, it takes longer to decode the signals. That's why, in the middle of the night, clothes thrown over a chair can look like an intruder. We see the shape and try to reconcile it with other similar shapes. Then, if there's enough light to add color and detail to the equation, we quickly realize that it's the T-shirt and jeans we tossed aside earlier. If not, we may experience a rush of adrenaline that will finally wake us up enough to realize it's just the chair.

Like our eyes, the camera needs light. Unlike us, it doesn't need to understand what it sees. It just needs to record the points of reflected light. Making sense of the picture is up to us. We do so by sorting out the information and comparing the unknown shape to known ones, interpreting and generalizing as we go. The black shape in Figure 4.1 matches our previous experiences of cat and black. We haven't seen this black cat in this position before, but other cats sleep in similar positions. So, this must be a picture of a sleeping black cat.

Figure 4.1

Shape = cat, position = lying curled up, color = black; must be a black cat asleep.

In two dimensions, the cat has a shape. In three dimensions, it has mass. Although you see the picture on the page or on the screen as a cat-shaped lump against a light background, your mind redefines it as a cat on a pillow. You've added back a dimension that's present in reality, but not in the photo. You've added depth.

There's a reason why we have two eyes, and it isn't just in case one is injured. The reason is to allow us depth perception. Depth perception keeps us from bumping into the furniture. It helps the outfielder figure out where to stand to catch the ball that's moving toward him at 60 miles per hour. It's telling me how far I have to reach to pick up my coffee mug and where to move my arm so that I can put it down again without spilling. It lets the cat jump from chair to desk without landing on the floor (usually).

Depth perception in humans is a function of having two eyes that see slightly different, but overlapping images. Why different? The pupils of your eyes are about two and a half inches apart and therefore each eye is looking at the world from a slightly different angle. Things that are close to you appear more similar in the view from each eye than things that are further away. Your brain processes the information, judging the degree of difference between the two images and interpreting the information as perspective and depth. If you close one eye, you lose your depth perception. With only one image to process instead of two, your brain can't interpret the amount of space between objects. Try it.

The camera has, in effect, only one eye. It "sees" in two dimensions, not in three. This is entirely appropriate, since you're seeing the pictures you take either on a flat screen or printed on a piece of flat paper. By using light and shade, perspective, contrasting colors, and as many other techniques as necessary, we can create the illusion of a third dimension in our pictures. And maybe that's the real magic of photography.

Organizing Perception = Composition

When you open your eyes, you see what's there. If you really want to look at something, you tend to block out the stuff around it. You focus in on the particular thing that interests you. You might not notice anything else, or you might be vaguely aware of your surroundings. But most of the time, you're not particularly intent on any one thing. You're simply taking it all in, and that works fine for walking around without tripping on the furniture. But if you want to describe the scene to someone else, you probably start by describing the space, and then one or two of the things in it. You select just a few from all of the possible details that help describe the scene. You're imposing a structure on it. You're organizing it in your narration, by choosing what to put in and what to leave out. When you take a photograph of the scene, you need to do the same thing. You need to organize the space, to find the important elements to include and the unimportant ones to ignore.

Creating a picture, in this sense, is much like telling a story. You've heard, or read, well-told stories, and probably bad ones as well. Good ones always describe the events and surroundings clearly, in coherent order, with just enough detail to give a sense of the scene. Bad ones wander, bringing in irrelevant bits, backtracking through the plot, and generally telling you more than you want to know but leaving out something significant. When you look at a good picture, you know right away what it's about. A bad picture tends to bury the subject in too much background, or hide it with a setting that's the same color, or find some other way to make it obscure.

Just as you learn to be selective in describing a scene, you need to learn to be selective in looking at it. One of the best ways to learn to see selectively is to look at smaller parts rather than at the whole picture. It's easiest if you have a way to block out the things you're *not* looking at. A cardboard frame can be a big help.

You need a couple of L-shaped pieces of plain mat board, like the ones in Figure 4.2. These were a mat from a 5 × 7 photo, simply cut into two L's. If you don't have spare mats lying around, you can buy precut ones at an art supply, photo, or stationery store, or cut them out of whatever's available. Hold them so that they form a frame, and slide them to change the frame shape as you wish, from horizontal to vertical, to square.

Figure 4.2

The frame needn't be very big.

If you hold the frame up about a foot or so in front of you and look through it with one eye, you're turning yourself into a camera. You have given yourself a viewfinder and a single lens. Now you can see what the camera sees.

As you look through the frame, you might find yourself moving it around to block out parts of objects, to create compositions of lines and textures, and to select small areas that are visually interesting. The more of this you do, the more you're training your eyes to see selectively.

As you grow accustomed to this way of looking at the world, you'll start to notice that much of what catches your eye is not the objects themselves, but a line or texture, or a patch of color, or perhaps a pattern of repeated lines. These patterns and textures can make fascinating "abstract" photos. See Color Plates 4.1 and 4.2 for some examples.

Framing a Picture

The frame defines the edges of the picture. The relationship of the edges to each other defines the shape or *format* of the picture. Is it tall and thin? Square? A perfect 3:4 rectangle? Is it a portrait or a landscape? Two factors influence the format of the picture. The first is how it is displayed. The second is the shape of the subject. Will this photo be shown full-frame on your monitor? Is it a product shot of a small round object for a catalog or web page? Is it art? Is it advertising? Is it just for fun?

Sometimes the display medium determines the format. If you're shooting a picture for a magazine cover, you know that it's going to be a certain shape and size, eight inches wide more or less, and about 11 inches high. That's the format you have to work within. If you're shooting pictures for the inside pages, your format may be the same, or it may be different. The art director may specify a certain part of the page to fill or ask for a two-page spread. If you're illustrating a catalog of machine parts, your photos will be quite different from the ones you'd take for a catalog of fashions. If you're photographing a tall, narrow floor lamp the picture needn't be the same shape as if it were a long, low couch.

The Shape of the Image

Most digital cameras don't use the same format as the standard 35 mm camera, which is a ratio of 2:3. Instead they use the 3:4 format, which is the same ratio as a TV screen or video monitor. Figure 4.3 shows a comparison of the two. It can be either horizontal or vertical. The image format you'll be working with is most likely to be the 3:4 format.

There are also what's called medium format cameras, for professional use, which have a square format similar to that of a 120 mm film negative. These are much less common within the digital photography scene, due to their astronomical prices.

Figure 4.3

The digital frame is higher in relation to its width.

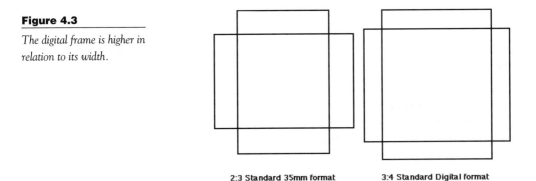

2:3 Standard 35mm format 3:4 Standard Digital format

Remember that (unless you have a square format camera) you can turn the camera to shoot vertical pictures. Some photographers get stuck in a rut of always holding the camera horizontally. It seems to fit naturally in our hands this way, and the view is one we're used to, after years of watching TV or staring at computer screens, which are usually oriented horizontally.

The horizontal format produces a feeling of tranquillity. It's stable and calm, like a landscape on a warm summer day. It's not going anywhere. The vertical format is more dynamic. It suggests dignity and pride, people on the move, or growth in an upward direction. Use these emotions when you compose a picture. What are you trying to say with the picture? Will the subject work in either direction? If so, shoot both. You may be able to use them at different times, or for different purposes.

No matter what size and shape your pictures end up they'll start out the same, except that you may hold the camera sideways to shoot a lamp, the Eiffel Tower, or any other tall object. That doesn't mean they have to stay in that format. Very often you'll improve a picture by cropping it to a different shape. A long, thin strip of landscape may be just what your web page needs. The interesting tree may tell its story more effectively when you're not seeing the playground equipment alongside it. When you look at a subject, before you pick up the camera, think about how you're going to use the picture. If there are parts of it that you know you will crop out, don't worry about making them look good.

The Shape of the Subject

The format is a shape—a rectangle. Within that, you must fit the shape of the subject. But these shapes are abstractions. There are really only three shapes: the rectangle, the circle, and the triangle. Everything we see can be reduced to these. The sleeping cat is

a mass of circles. The apple is a circle. The pine tree is a triangle. Buildings, clouds, rocks, bananas—everything you might possibly point the camera at can be reduced to one, or a combination, of these shapes. Shapes contain lines, and the diagonals and arcs created for us by circular and triangular subjects add movement and flow to the picture. Sedate horizontals and verticals lend solidity.

One person in a picture may form a circle or a triangle or a rectangle, depending on the pose. Three people often make a triangle, in art as in amour. Use the triangle shape to position your subjects, and you've created a dynamic and interesting group portrait. Similarly, one piece of fruit in a still life, one flower, or one object of any kind is a single shape. Combining several objects combines their mass, visually, into what may be a quite different shape. This is the shape that needs to relate to the shape of the frame.

Figure 4.4

One round shape fits nicely in a square.

The shape of the actual subject may suggest a shape for cropping the photo. The apple shown in Figure 4.4 doesn't look right in a "normal" horizontal frame, but if we crop it to a square, it becomes a more interesting picture. If we then challenge the geometry of the arrangement by taking a bite out of the apple, as in Figure 4.5, we knock the picture slightly off balance. Now the fruit is more rectangular and not as comfortably centered in the square. Allowing a little more space to the right of the apple and less to the left would keep the square cropping and restore the balance.

Figure 4.5

By moving the apple to the left, we balance the bitten edge.

The Shape of the Space

Tall subjects suggest tall pictures. Wide ones fill wide frames, but sometimes the "point" of the picture isn't the subject *per se*; it's the space around the subject. Consider the lone tree in Figure 4.6. If I crop the picture down to show just the tree, I have a decent picture of a tree. If I shoot the photo with as much horizontal space around it as I can manage, I've made a very different statement about the tree. If I shoot it at a low angle, showing a big open sky behind the tree, I've made yet another statement. In this case, the space is the real subject of the picture. The tree just adds emphasis.

Figure 4.6

Lonely tree.

You must learn to consider space as an element of your photographic compositions, whether you're using a digital camera or a conventional one. With a single subject, you have a lot of options for where you place it in space. It can be right in the middle, off to the side, up high, or down low. It can fill the frame, or it can occupy a small corner of the picture. The setting may actually be the subject, with a point of interest somewhere in it, like the tree above, or any typical mountains at sunset photo.

When you add a second subject, the space in between the two becomes more important to the picture. It helps to establish the relationship (or possibly lack of relationship) between them.

Artists often speak of the concept of positive space and negative space. Positive space is the area occupied by the object. Negative space is the area around the object, or not occupied by it. Learning to see in terms of negative space takes practice, but can be mastered. Betty Edwards' book, *Drawing on the Right Side of the Brain* introduced this concept and remains the best work on the subject. Figure 4.7 shows a drawing of a chair, in terms of negative space.

Figure 4.7

The space around my chair.

Dealing with Print and Screen Formats

It would be nice if all of our work ended up beautifully color-printed and hung on gallery walls. Then we could crop our pictures as we wished, use whatever format appealed to the eye, and not have to deal with the realities. Few photographers have that luxury. Mostly, we're taking pictures for a reason, and the reason dictates not only what we shoot but how we have to look at it.

Magazine covers have to be vertical. The best panoramic photo ever taken isn't going to make it onto the cover of *Travel*, unless you can convince the editors to go for a foldout. And that just doesn't happen. What can you do to make a horizontal scene vertical? Add

more foreground. Add more sky. Preferably one or the other, not both, since the horizon shouldn't be placed right in the middle of the shot. Or apply your frame and find an interesting vertical composition within the panorama, and use that instead.

Computer screens are horizontal. (Okay, I know about the full-page and pivoting ones, but *most* computer screens are horizontal.) At worst, you'll lose some sky or some foreground from your vertical landscape. However, within the computer/video screen format you have more options. Maybe the picture doesn't have to fill the screen. Maybe you can float a square picture in the middle of the screen. Perhaps you can add type. It all depends on the purpose of the picture. If you're putting photos on a web page, smaller is better. Viewers hate to sit and wait for a full page image to load. It can take several minutes, depending on the connection speed. And, while a picture may indeed be worth a thousand words, it's seldom worth a thousand seconds.

If you're photographing items for a catalog, why worry about format at all? Shoot them on a white background, as I did in Figure 4.8, and crop away everything that's not part of the product.

Figure 4.8

Sometimes no format is the best format.

Before you shoot a picture, teach yourself to look at the edges of the frame, too. Are you chopping off the tops of heads? Have you cut off someone's feet? Is there something on the edge of the frame that either shouldn't be there at all or should be shown more? Would your picture be improved by stepping backward or forward a foot or two?

Learning the Rule of Thirds

Most pictures have what is called a *center of interest*. In a portrait of a single person, it's the face. In a group of people, one person dominates, while the rest are subordinate. The dominant one, because of position, size, or placement, is the center of interest. In a landscape or still life, the center of interest is the part of the picture to which the viewer's eye is attracted first. Your first step in composing a picture should be to find the center

of interest. Most of the time, it's obvious. It's the dominant feature of the landscape. It's the one yellow flower in the field of red ones. It's the widget that goes next to the catalog description, or the house that's for sale, or the cat asleep on the bed. It's why you're taking the picture.

Once you locate, or decide upon, the center of interest, you should look for anything in the scene that detracts from it. Is there something behind the portrait subject that interferes with him? Does he have a lamp, or a window, or some other object in the room that appears to be growing out of his head? If so, change your camera position, or else move him to a more neutral background.

The center of interest generally shouldn't be right in the middle of the picture. (The exception to this rule is, of course, the catalog picture, where nothing matters but the object you're photographing.) The center of interest also shouldn't be right at the edge of the picture, because this tends to draw the viewer's eye away from the rest of the scene, and usually right off the page. It knocks the viewer off balance.

If you analyze a number of successful pictures, you'll probably find that in more cases than not, the center of interest falls in one of only four spots within the frame. These spots can be defined, and even turned into a rule that artists and designers know as the *rule of thirds*. Quite simply, you divide the frame into thirds, vertically and horizontally, as in Figure 4.9. The four points where the lines intersect are the approximate "best" locations for the center of interest. Color Plate 4.3 shows a city scene that makes good use of this rule.

Figure 4.9

Any of these four intersections is a good place to put the center of interest.

Like all good rules, it's meant to be broken occasionally. (Think how much better the chocolate cake tastes after a week of dieting.) But if you follow it more often than not, your pictures have greater impact. Break the rule when the subject has so much impact it needs to be in the center, like the apple we showed earlier, either because it's the only thing in the picture or because it contrasts very dramatically with its background. Break it when the photo is "about" symmetry. For instance, the impact of a sunset reflected in a pool of water is less if it's *not* right in the center of the picture. Break the rule whenever you know it's right to break the rule.

Discovering Perspective—The Illusion of Reality

Some pictures appear to jump out of their frames and come toward us. Others pull us in and seem to take us back behind the frame into another universe. Why? It's because the photographer has created for us a world that extends beyond the two dimensional plane of paper or screen and—however briefly—given us the illusion of a third dimension. The illusion works due to some fairly simple tricks, all of which come under the general heading of perspective.

Using any or all of these five perspective tricks conveys the illusion of space on a flat plane:

- Linear perspective
- Aerial perspective
- Contrast in sharpness
- Vertical location
- Overlapping figures

Art schools teach courses in perspective, either separately or as part of a drawing class. Reluctant students armed with T-squares and triangles feel as if they're suddenly majoring in geometry rather than painting or sculpture, as they learn the differences between one point and two point perspective and the ins and outs of vanishing points, eye level, and horizon lines. What they're learning is *linear* perspective. You can reduce linear perspective to a series of rules and formulas like those taught in the math department.

Linear Perspective

Linear perspective is the kind you're most aware of in the real world. You see it every time you look at railroad tracks or look down a long road. Tracks, the edge of the highway, and fences all contain parallel lines. We know that parallel lines, although they are physically always the same distance apart, appear to meet at the horizon, as in the diagram in Figure 4.10. We also know that lines at right angles to the parallel ones appear to diminish in size as they recede, as do the fence posts and railroad ties in the figure. We *know* this, so any time we see a picture of what appears to be parallel lines meeting, we mentally add distance to the picture. When we see objects that we believe to be similar, in diminishing sizes, we assume that they are the same size and far apart.

Figure 4.10

The point at which the parallel lines meet is the vanishing point.

TIP

Whenever your picture includes a horizon, be sure it's level unless you have some very good reason for tilting it. We're all accustomed to seeing the ocean or the prairie as a flat line. If it's even a few degrees off, the effect is unsettling and uncomfortable.

Aerial Perspective

Aerial perspective is a another "real world" effect. You see it when you look off into the distance, especially on a hazy day. Whatever is close to you is relatively dark, while the distant city skyline, mountains, or horizon is light and indistinct. The effect is caused by smoke, haze, dust, or fog in the air, or sometimes all of them mixed together. I took the picture in Figure 4.11 just after a rainstorm. The sun broke through for just a minute. The mountain was a very delicate shade of purple in the late afternoon light, and the bushes at the side of the road appeared so dark green they were almost black. (See it in color as Color Plate 4.4.)

Figure 4.11

Even the clouds are lighter further away.

You can often heighten the effect of aerial perspective in a landscape by including a piece of something very close to you in the shot. You might position yourself beneath a tree limb, so you have a few leaves and a bit of branch sticking down into the shot. You could use a doorway, a porch railing, or some other architectural detail. The foreground elements create a frame for the background, and contrast with it, both in the amount of detail and in the range of tones. The viewer's eye is drawn from the close objects back into the distance.

Contrast in Sharpness

Contrasts in sharpness are a natural effect for most people. The fact is, most of us see better up close than we see far away. Nearsightedness is more common than farsightedness in the general population. When we see something that's in focus, we assume it's closer than something that's not in focus. You can use this trick to create depth by focusing on a near object and letting the background go out of focus. Figure 4.12 shows an example. If you have the option of using a telephoto lens, it may be easier to focus on the close elements of the scene, because telephoto lenses, (as you learned yesterday in our discussion of lenses on Day 3) naturally have less depth of field.

Figure 4.12

The closer piece is the one that's in focus.

Sometimes you'll want to use the contrasting sharpness trick, but for one reason or another, you won't be able to do it in the camera. Perhaps the lighting conditions aren't right, or the background just isn't far enough away to be out of focus. You can still apply the technique, by deliberately blurring the background in a program such as Adobe Photoshop. Remember that your picture isn't necessarily complete when you press the button. Unlike photographers using conventional cameras and film, you have lots of options after the picture is uploaded to the computer.

Vertical Location

Vertical location is a psychological trick. People are conditioned to looking up, rather than down, into the distance. Therefore, when something is placed higher within the frame, it appears further back. When something is low, it appears right down by your feet. Placing an object higher up in the picture frame and making it smaller in relation to the surrounding area makes it appear further away. Chinese artists have known this for centuries. Although you can see museums full of beautifully drawn landscapes from dynasties almost two thousand years old, you'll almost never see one with anything like Western perspective. Instead they use a system of recessive diagonals, (see Figure 4.13) which lead the viewer's eye up and back into the scene (also see Color Plate 4.5).

Figure 4.13

This is an ink and watercolor copy of a silk embroidered panel from circa 450 AD.

Because this trick hasn't become a cliché like most of the others have, it's even more effective. When you have the option of arranging your subjects in this way, try it. You'll be pleasantly surprised at how well it works.

Overlapping

Overlapping one object with another always makes the one in back seem further back. Logically, it has to be since it's behind the closer one. This is the same in principle as the trick of including a piece of shrubbery or some other up-close object to make the background recede.

In Figure 4.14, there are several examples of overlapping. The brush in the foreground hides the shoreline, so we perceive the water as further away than it really is. The steamer overlaps the distant shore; the darker cliffs overlap the lighter mountain behind them, pushing it still further back.

Figure 4.14

Overlapping can literally move mountains.

Be especially careful about unintentional overlaps. Sometimes it seems that items sneak into the picture. You aren't aware of them until much later, and then you may have to spend hours in Photoshop removing them. Of course, they're not always accidental. I once saw a remarkable portrait of the CEO of a large corporation. He apparently enjoyed

hunting and had a trophy deer head mounted and hung on a wall in his office. The photographer who was sent to shoot a portrait for a business magazine was an animal lover and managed to position the CEO so that he appeared to be wearing the deer's antlers. The CEO looked idiotic. What was *most* remarkable about the picture was that the magazine editor allowed it to run.

Applying Line

When I discuss the line as an element of composition, I'm actually talking about two different kinds of lines. The first is obvious—lines that are part of something, such as the edge of a building, the wires and posts of a fence, or railroad tracks and roads that vanish at the horizon. The second type of line is perhaps harder to see, but no less present. It's the invisible line formed between a child's pointing finger and a runaway balloon, or the directional line you know the sailboat will take as it heads for the race marker. These lines, which are called implied lines, can be even more powerful than the concrete lines that we can trace with our fingertip.

Actual lines separate shapes from each other and create perspective. They are the paths by which the viewer's eye travels around the page. Implied lines can appear through an extension of actual lines, as in the case of the pointing finger or a dramatically gesturing arm. Implied lines are almost always "one way streets." Your eye is drawn from point A to point B, and not from B to A. Similarly, a picture of a sailboat with its sails spread shows not only that it is moving, but in which direction it is most likely going. We see the direction as an implied line through the water, even more so if the picture shows a buoy to be rounded or another boat to catch up to. This is equally true of anything in motion— a vehicle, an animal, or a thrown ball. (Almost anything in motion—babies, cats, and boomerangs are unpredictable.)

You also can create implied lines by having a human or animal subject look in a particular direction. Human nature is curious, and we're immediately drawn to see what it is that the subject is looking at. In Figure 4.15, you can see an implied line between the cat's eyes and the toy he's just missed catching. Even though his outstretched paw is well below the target, his eyes and full attention are locked on it. So, we also follow the implied line from the eyes to the object of attention. Be careful using this method. If the object isn't in the frame, we still follow the implied line and look away from the picture. Implied lines should be contained entirely within the frame for best results.

Figure 4.15

Implied lines are every-where.

Lines should guide the viewer's eye toward, rather than away from, the center of interest. Lines can sneak up on you, especially those in a building or other human-made structure that might be hiding in the background of the picture. You may not realize it in the viewfinder, but a roof line or the sharp edge of a shadow might be slicing your picture in half. You need to learn to watch out for these kinds of lines so that you can make them work for you instead of against you.

TIP

Be especially careful to avoid lines that appear to grow out of people's heads or slice them across the neck, guillotine style.

Utilizing Pattern and Texture

Patterns are repetitive. Textures are random. Patterns are generally flat, while textures are, by definition, three-dimensional. Aside from those relatively minor differences, you can consider them together as surface attributes. Pattern and texture can add interest to a composition or detract from it, depending on how you make use of them. Sometimes, the pattern or texture *is* the subject.

Texture

Texture is a particularly strong trigger for emotional responses. That makes sense, if you remember that, as babies, touch was one of the first senses that functioned reliably. Taste and smell take a while to develop, because infants aren't exposed to enough different tastes and smells to gather information about them. A baby's eyes don't really focus for several months. Hearing also phases in gradually, lest the baby be too startled by the daily cacophony of TV, radio, street noises, household appliances, and so on. But touch is with us from day one—the softness of a fleecy blanket, the smooth plastic of a toy, the fuzzy stuffed bear.

We're instinctively drawn to look at textures, even when we can't touch them. That's why abstract photos of textures work so well. We make an emotional connection to the picture first. Then we develop an intellectual connection as we begin to analyze what we're looking at. Textures, like the tree bark in Figure 4.16, photograph most effectively when they're sidelit. The play of light and shadow enhances the viewer's perception of the texture as being three-dimensional.

Figure 4.16

The bark on a pine tree is a natural texture.

Pattern

Like textures, patterns are everywhere. In fact, much of what we see is both texture and pattern at once. Consider something as ordinary as a shelf full of books. The spines form a texture. They also make a strong pattern of vertical lines. Patterns hide in the bricks on a wall, the shingles on a roof, and the panes of a window. Any emotional response that a single object evokes in the viewer is magnified many times when the object is part of a pattern. This is true in music, in poetry, and even in dance and drama, as well as in the graphic arts. The glory of a Bach fugue or a Shakespearean sonnet is in the repeated patterns, the rhyme and rhythm of the notes or words.

The example in Figure 4.17 contrasts several different patterns made by stacks of fruit in the local grocery store. There's just enough irregularity to make the results interesting. If all of the apples and lemons were perfectly round and aligned in straight rows the picture would be less engaging.

Figure 4.17

Found art, patterns in fruit.

If the pattern is the picture, it must be obvious. Patterns work best when they fill the frame. Be careful about photographing a pattern with a wide angle lens. The shift in perspective and size as the pattern recedes detracts from the visual impact. Patterns are most effective when photographed with a macro lens or a telephoto lens. Either one compresses the depth of field to lessen the effects of perspective, and this is one instance where you want as little perspective as possible.

> **TIP**
>
> If you have a strong light source, such as the sun, and a picket fence, you have a pattern of shadows that turns a boring lawn or plain sandy beach into a strong design element. If the shadows don't fall where you want them, wait a bit or come back another day at an earlier hour. Remember that the sun moves, and shadows move with it.

Incorporating Space and Scale

In almost any picture, there are some parts of the scene in which nothing is happening. They might be empty sky, or lawn, or backdrop, or even the plate on which the apple is sitting. These empty spots are what we mean by "space," and they're as important to the composition as the subject. How much space should there be? That depends on what else is in the picture. Space and scale are dependent on each other.

The Importance of Scale

If you see a picture of a silver ball on a plain background, you have no way of knowing whether it's a ball bearing, a silver-plated baseball, or a science fiction illustration of a strange planet. Nothing provides a visual reference about the size of the object. It could as easily be a quarter-inch or a thousand miles in diameter. If you place a screw or a paper clip next to the silver ball, you can then recognize it as being the size and shape of a ball bearing. Sometimes the visual ambiguity of not knowing what you're seeing or how big it is can make the picture more interesting, but if you want the picture to communicate, you need to give the viewers some cues about what they're looking at. Size is the easiest clue to provide.

When you're setting up a still life, include at least one recognizable object that the viewer can quickly identify. We all know, for instance, how large a typical banana is. Seeing it in the otherwise abstract assembly of shapes in Figure 4.18 tips us off that these are probably apples, oranges, and lemons that we're looking at.

When you photograph your company's widgets, consider that even though it's a catalog shot, the viewer might not know what he's looking for. If you can show the product in position or in use, that's one good way to identify it. Another is to show someone holding one, or a handful. If you want to be a little more creative, think about other ways to indicate size. You could spill them out of a paper cup or a crystal goblet as in Figure 4.19, point to one with a sharp pencil, set down a couple of pennies next to them to show they're inexpensive, and so on.

Figure 4.18

*Without the banana would
you know these shapes were
fruit?*

Figure 4.19

*These widgets were the color
of a good burgundy, so that
suggested the wineglass.*

Scale isn't a problem with portraits. We *know* how big people are. If it's really critical to know that someone is 5' 9", and someone else is 6' 2", there will probably be a wall behind them with the height marks painted on it. (In addition, the subjects probably have handy identification numbers on their chests and guilty expressions.) If you're photographing a landscape, however, and you don't want your majestic mountains to look like molehills, be sure to include something in the shot that tells us what we're supposed to be seeing. Include a tree, a person, a house, a fence, or something in the picture to indicate the scale. Placing any one of these objects in the foreground serves the additional purpose of pushing the background further back.

Using the Horizon

In landscape photography, and even more so in seascape photography, the position of the horizon line can be a major factor in creating a sense of space within the picture. Putting it down low makes the sky very big and important. A high horizon line makes the land the major element in the picture. The worst placement for the horizon is right in the middle of the frame, unless you're trying to point out symmetry between sky and land or water. If the horizon just happens to land in the middle, it makes the picture appear too carefully balanced and therefore less interesting. Figures 4.20 through 4.22 show the effects of different horizon placement, within the same general scene.

Figure 4.20

The low horizon emphasizes the sky.

Figure 4.21

The high horizon emphasizes the beach.

Figure 4.22

There's no emphasis here. Boring horizon.

Choosing Your Viewpoint

Placing the horizon is a function of which way you point the camera: up or down. Where you place the camera, and yourself, is what really makes the picture. Choose your "spot" carefully. Do you want a low angle, shooting up at the subject, or do you want to get up high and shoot down? How close should you be? The worst mistake that beginning photographers usually make is to stand too far away. They seem to think that the more they include in the frame, the better. This just isn't so. Including too much material takes

the emphasis off the subject of the picture and places it on the background instead. By moving in closer, you crop out unwanted parts of the picture and give the viewer a better look at the subject.

Changing your angle can really open your eyes to the possibilities of a subject. Most of the time, we take our pictures standing up. Suppose you set aside your dignity and sprawled on the floor or stretched out on the grass. What if you climbed a ladder, or shot from a balcony or upper story window? You could even try just tipping the camera a little bit if your scene has strong diagonals and you want to make them stronger. Look for the angle that makes your picture most effective. Walk around the subject if possible. Sometimes the back is more interesting than the front.

Thinking that you can shoot at random and then do your composing in Photoshop is usually a mistake. For one thing, digital pictures shot at snapshot camera resolution (640 × 480) don't enlarge as well as similar frames from a conventional film camera. Figure 4.23 shows what happens to an over-enlarged digital image.

Figure 4.23

The rocks appeared sharp in the picture, but at 16X magnification they're reduced to squares.

Many times, you don't even realize what's going on within the frame in addition to the subject of the picture. It's easy to get involved, especially if the subject is something that may change at a moment's notice, such as children at play, or a deer grazing in a meadow that may get frightened and run away. If your camera has a telephoto lens, that helps a

great deal. Otherwise, expect to do a great deal of cropping and enlarging in the computer, and realize that there are some scenes, such as the deer in the meadow, that you can't photograph. In such a case, set the camera aside and just enjoy the moment. In the long run, doing so is much more satisfactory than taking a bad picture of a great subject.

Finding Balance and Symmetry

The beginning of this chapter discussed shapes—the frame shape, the shape of the subject, and the shape of the space around the subject. Shapes have another attribute that you need to consider—visual weight. Dark shapes are heavier, visually, than light shapes. Large shapes are heavier than small ones. This is worth considering because you usually want to achieve a sense of balance in your compositions. Perfectly symmetrical compositions are always balanced, by definition. One side is the same as the other, but a picture needn't be symmetrical to be balanced. For example, a large empty space has a shape and an implied weight that can balance a small object in the corner of the frame. Imagine a plate with a single piece of fruit on it, or look at Figure 4.24 if you're getting tired of imagining things.

Figure 4.24

A square meal, and a symmetrical composition.

You could place the fruit right in the middle of the plate and the plate right in the middle of the frame. It would look fine there, and the composition would be balanced. No question about that. But suppose we moved the fruit to the corner of the plate (see Figure 4.25) and added some more space on two sides of the plate. We have a totally different composition, arguably more interesting and more dynamic. But it's still balanced, even though it's no longer symmetrical.

Figure 4.25

A balanced meal needn't be symmetrical.

If you think of the frame of the picture as sitting on a seesaw, it's obvious that any single subject in the middle of the frame is balanced. Two subjects, for instance a picture of two people side-by-side or face-to-face, are also balanced. They're of about equal size and complexity. More complicated pictures are harder to balance, unless you reduce them to collections of abstract shapes and lines. In general, asymmetric balance is more difficult to achieve, but more interesting.

Pictures needn't always be perfectly balanced. You may compose a picture that's deliberately a little bit off-balance because it's more dynamic that way, or because it leads the viewer's eye in a particular direction. Chances are that the viewer will attempt to find balance in it anyway. We all try to impose our own preferred structure on things we look at. If my interest is in color and texture, and yours is in light and shade, and strong directions, we could look at the same photograph and see two entirely different pictures.

Building Relationships

Whenever you have two or more objects in a picture, you've established a relationship between them. Probably the relationship was there all along. When you discovered it, you made it the reason for the picture. Or perhaps you created the relationship by moving one object close to another. In either case, you emphasize the relationship by placing the frame around the objects and by making a picture of them. The primary kind of relationship is *proximity*. When two things are close together, we perceive them as being related to each other, even if they're otherwise not. Consider Figures 4.26 and 4.27.

In the first scene, the two animals are on opposite sides of the picture. Essentially, no relationship exists between them. In the second version, the two objects form a triangle. We can see them as one shape rather than two. When you compose a picture, you need to be aware of the relationships that develop between nearby objects. Their tendency to form a single mass can sometimes overpower the rest of the composition. More often, though, that tendency is a useful tool that gives you large, simple, visual masses to work with, rather than small bits of visual clutter.

Figure 4.26

There's no relationship here.

Figure 4.27

There's a close relationship.

When you have objects that are spaced too far apart to be related by proximity, you tend to search for another way to relate them. Another effective way is to find a relationship in similarities. Objects may be similar in size, shape, color, texture, or direction of movement. Similarity in any one of these attributes is enough to form a relationship. Similarity in two or more enforces it. The relationship usually takes the form of a pattern, with the shape, curve, line, or interval between the objects repeated again and again. This can become too predictable and therefore monotonous. Try interrupting the pattern by turning one of the related elements sideways, or change it in some other way. The surprise factor of having one piece of the pattern out of line or in a different color or shape makes the difference between a boring picture and an interesting one.

Assignment: Training Your Eye

Pick a subject and study it with the frame you built at the beginning of the chapter. After you've found a dozen different ways to see it, photograph them. Study these images and see how many more you can think of.

Keep notes and sketches to remind yourself which of these views "works" and which doesn't, and why. Look at where the emphasis lands, and how you use space and scale.

Visual Communication

- Communicating with pictures
- Using symbols and shared experiences
- Utilizing color and monochrome
- Creating a mood
- Working with tonality
- Making the most of bit depth and resolution
- Telling a story

Photographers, like writers, are in the business of communication. To succeed in what is after all, a risky business, you need a good vocabulary, a knowledge of idiom and metaphor, and the ability to turn clichés into fresh ideas. There's a grammar of images, just as there is of words. Fortunately, it's an easy language to learn.

How Does a Picture Communicate?

What is it that gives a picture meaning? How does it communicate? Let's start by looking at how people communicate with words. We agree on meanings, on definitions of particular words and phrases. If I say, "It's a nice day," you probably expect the sky to be blue and the temperature to be moderate. We have a shared basis of experience that defines "nice" weather in a certain way.

Images work the same way. If you saw a door with a silhouette of a man on it, you'd probably recognize it as the men's rest room even though no words told you so. The standing stick figure in trousers means men, and the similar stick figure in a skirt means women, even though women wear pants almost as often as men do. In Scotland, where men still wear kilts on occasion, the symbol on the door is the same as it is in Chicago or Mexico City. Fortunately for the traveler in a hurry, these symbols compose a universal language.

Symbols

In photography, and in all of the graphic arts, we often use symbolism as a kind of shorthand to simplify communication. Lines are a particularly useful symbol. Horizontal lines imply stability or tranquillity, in both positive and negative ways. The flat horizon line in the seascape in Figure 5.1 suggests a calm sea and a peaceful day. A horizontal barrier, however, says "Stop! Stay where you are. You can't come in here."

Figure 5.1

The horisontal horizon, beach, and wavelets all suggest tranquillity.

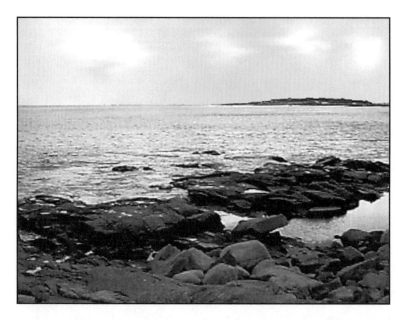

Jagged lines connote danger, as in a barbed wire fence, a broken pane of glass, or a bolt of lightning. They also suggest nervous energy. Diagonal lines suggest movement and speed, such as objects blowing in the wind. Curved lines indicate graceful movement.

Some symbols are much more concrete. Babies and small animals are cute and helpless. They bring out a positive emotional response in most viewers. Can you look at the little boy in Figure 5.2 without smiling? I can't.

Snakes and spiders bring out an equally strong negative emotional response in many people. A sunset is almost always peaceful. A rainy day is generally sad, perhaps because people tend to think of rained out games and picnics. Mountains have dignity. Deep green forests and babbling brooks are relaxing.

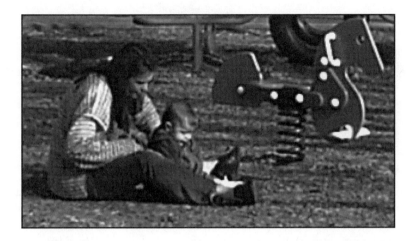

Figure 5.2

Babies and children usually evoke strong responses in the viewer.

Shared Experiences

Some places are so frequently photographed and painted that, even if you have never seen them in person, you have a strong response to the image. The Statue of Liberty has the same meaning to people who consider themselves hyphenated-Americans, whether the nationality in front of the hyphen is Irish, Arab, Swedish, Mexican, Chinese, or any other. We all respond to a picture of Disneyland's trademark castle, or to the Grand Canyon, or to the familiar New England scene in Figure 5.3. (See it in Color Plate 5.1 as well.)

Figure 5.3

Motif #1, Rockport.

You can use these "shared experience" symbols to reinforce your message. If, on the other hand, they're not part of the message, they may simply confuse the communication. Putting the cute little girl on the lawn of the house that is for sale might add to its appeal, but it also may turn off potential buyers who don't want to take away her home. Consider the potential negative effect of a shared experience, as well as the positive effect. The peaceful sunset indicates the end of the day, but it could be an unfortunate reminder of other endings to someone unwillingly facing retirement or illness.

Creating a Mood

In photography, mood is a function of light and contrast. When you want to communicate a mood or elicit a particular emotional response, look at the amount of light in the scene and the relative values of the brightest and darkest areas. Light makes objects visible, but it does more than that. It defines them. It displays their qualities—their surface textures, their translucency or reflectiveness, their lumps and bumps.

Mood also defines the atmosphere that surrounds the object. When you see a picture of a bridge emerging from the mist, you sense a very different mood than that suggested by another picture of the same bridge in bright sun. Adding fog to the scene changes its mood because it changes the contrast ratio between the bridge and the surroundings. In this case, it dims the colors and lowers the contrast.

The contrast ratio, quite simply, is a way of expressing the degree of difference between the lightest and darkest tones in the picture. Contrast ratios are the result of several factors. The color and the amount of light that reflects back from the surface of the subject influence the relative brightness at which you see it, but so does the lighting ratio. The lighting ratio, again in simple terms, is the difference between light and shade. On a sunny day at a high altitude, it can be as much as 20:1.

That means that 20 times more light falls on the parts of the subject that are directly lit than falls on the parts that are in shadow. You see very white highlights and very black shadows, because the ratio is so large. Under these lighting conditions, you are aware of very sharp edges and well-defined lines, but any details in the shaded areas are hard to decipher.

Figure 5.4 shows an interesting range of contrasts. I shot this picture through the front window of a cabin, looking diagonally out the side window at the sunlit woods beyond. It was an extremely bright day, and even though the front of the cabin was in deep shade, it was lit well enough to show quite a bit of detail. Inside the cabin, almost no detail is visible. You can just barely make out the highlights on the interior window shutters and window sill. The woods have almost too much contrast.

Figure 5.4

Notice the variation in contrast inside and outside.

Average outdoor scenes closer to sea level tend to have a medium-low lighting ratio. As you descend from the mountains, more of the sun's rays are absorbed by the air itself, and by the pollution that's unfortunately part of it in most of the world. The ratio here tends to be more like 8:1 to 5:1. The advantage to this ratio range is that you retain more shadow detail.

Hazy skies, or bright overcast, will lower the ratio even more, also lowering contrast. Therefore, you see much less actual shadow and fewer darks and lights in the picture. Figure 5.5 shows a picture I took on a hazy day. Shadows are present, but soft-edged, and the lighting in general appears much more even. This low-contrast light is extremely flattering for portraiture. It's especially good for photographing teenagers and anyone with wrinkles, because it tends to diffuse the lines and wrinkles that age provides and evens out blotchy skin tones.

As the clouds settle in and the fog rolls across the landscape, contrast practically disappears. There's a feeling of mystery, as the lighting seems to come from all over instead of from a single source. The lighting ratio, technically, is 1:1.

Thanks to the computer and digital camera, you can create these lighting conditions and contrast ratios even when nature doesn't cooperate. Two examples of the same scene appear in Figures 5.6 and 5.7. The first was shot on a sunny day (Figure 5.6). The second is obviously the same bridge in fog (Figure 5.7). Rather than wait for an appropriately foggy day, I simply edited the picture in Photoshop to reduce the contrast and remove

most of the saturated color. Then, to enhance the fog effect, I added a slight blur to the outlines and a more pronounced blur to the reflection of the bridge in the water. (See it in the color section as Color Plate 5.2.)

Figure 5.5

This hazy day picture shows soft-edged shadows and even lighting.

Figure 5.6

A sunny day photo has medium-high contrast.

Figure 5.7

Reducing the contrast in Photoshop gives us the bridge in fog.

Although it is difficult to do these tricks in a regular darkroom, the digital medium lends itself to this kind of adjustment. Because you're working digitally, you can manipulate contrast ratios and alter the mood of your pictures as you want.

Using Color

Color is exciting. It's fun. It's especially interesting when you're working on a computer, simply because you can do so much with it. The current range of graphics software for both Mac and Windows platforms provides you with the tools to perform amazing feats of image manipulation magic. More important for photographers intent on improving their work, the same digital tools can be used to adjust exposures, edit out unwanted objects, and generally enhance pictures that aren't as good as they could be.

Colorful scenes, whether they're staged in the studio or discovered in real life, imply pleasure. The more colors you use, the more gaiety and excitement there seems to be. Color Plate 5.3 shows a scene from the Las Vegas Strip, where you'll probably find more color, and certainly more colors of neon light, than anywhere else on the planet. Figure 5.8 shows the same scene in black and white. It's still interesting, but just not as exciting.

Figure 5.8

Compared to the color version (Color Plate 5.3), this image is somewhat flat.

Pure colors speak to us differently from "muddy" colors. If you're shooting "what's there" you may not have much opportunity to do anything about the color. There's no way to make a street scene in Brooklyn, or Seattle, or Dubuque look as exciting and colorful as Las Vegas Boulevard, unless you paint in some neon lights in Photoshop or dress everyone in the scene in the brightest colors you can find. Consider, though, that the lack of color in a scene also makes a statement.

If, on the other hand, you're doing a portrait and want to make the subject more "important," have him or her wear a pure red or blue necktie. A woman executive might wear a brightly colored suit, or a gray, navy, or black suit with a bright blouse or scarf. To emphasize a person's "softer" side, stay with more muted colors.

Color Defined

When artists talk about color, they generally define it using a particular set of parameters called HSB. Photoshop uses the same color model. H stands for *hue*, which is the basic color from the color wheel, for example red, blue, or yellow. It's expressed in degrees (0–360 degrees), which correspond to the positions on the color wheel of the various colors. S is *saturation* or the strength of the color, and it's a percentage of the color minus the amount of gray in it. Pure color, with no gray in it, is 100 percent saturated. Gray, with no color, is 0 percent saturated. Saturated colors are found at the edge of the color wheel and saturation decreases as you approach the center of the wheel. *Brightness*, the relative

tone or lightness of the color, is also measured as a percentage, from 0 percent (Black) to 100 percent (White).

Color definition models exist, as well. The CMYK model, used for printing, defines colors according to their percentages of Cyan, Magenta, Yellow, and Black. The RGB model, which computer monitors and TV screens use for display, assigns values on a scale of 0–255 for each of the three (RGB) additive primaries. Color Plate 5.4 shows Photoshop's Color Picker, with the selected color described in different color models. You won't really need to know the differences in the color models or when to apply which one, until you start working with Photoshop or a similar image manipulation program.

Adding Color

Ambient color is the color that's naturally in the scene. The color that your camera sees is partially what's there, and partially what's added or influenced by the lighting conditions. You'll find that outdoor light in late afternoon or early morning adds a golden quality, whereas fluorescent lights (unless they're the daylight equivalent type) may add greenish or even purple overtones to some colors.

You can add color to a scene in either of two ways. Because you're working in the digital realm, you can add or subtract color using the computer. You can also achieve interesting effects with colored theatrical gel filters over your lights, or with filters mounted over the camera lens.

Tiffen makes filter adapters for some, but not all, digital cameras. As of this writing, you can get Tiffen filter holders for the Kodak, Apple, and Casio cameras. High-end digital cameras, such as the Canon and Nikon professional models, accept the same filters made for their 35mm lenses. You have an incredibly wide range of filters and trick lenses to play with, including:

- Star filters to make star shaped highlights
- Selective focus filters to blur everything but one spot
- Colored filters of every possible hue

If there's no filter holder made for your camera, experiment with taping a piece of filter gel over the lens. See Figure 5.9 for an example.

Be careful not to let the tape touch anything but the camera body. In this example, I used a piece of Roscoe theatrical gel from a sample book. Color Plates 5.5a and 5.5b show the effects of adding this pink filter to the scene. In the first example (5.5a), there's no filter. The second shot has the pink filter in place. The pink and red objects are unchanged, while the blue and green ones are considerably darker.

Figure 5.9

A makeshift filter.

Choosing a Filter

When choosing a filter, consider the effects you're trying to achieve. A skylight filter removes excess blueness on a cloudy day or in the shade. It also cuts down on the blue haze effects when you shoot distant mountains. Polarizing filters remove glare, just as polarized sunglasses do. You simply hold up the polarizing filter and rotate it until you see the glare disappear, and then attach it to the camera in that orientation.

Working with colored filters for special effects is a bit more complicated and demands an understanding of how the filter actually works. When you shine white light through a green filter, only the green light passes. Red and blue light are blocked. Remember that combining red and blue light produces magenta, which conveniently is the complementary color to green. (Complementary colors, in case you've forgotten, are colors that are opposite each other on the color wheel.) Therefore, you can think of the green filter as absorbing magenta. So the rule is: A filter passes its own color and absorbs or blocks its complement. A blue filter passes blue and absorbs red and green. If you combine red and green light, you get yellow. Therefore, a blue filter blocks yellow light, the complement of blue. Red filters pass red light and absorb cyan, which is a combination of blue and green. Combinations of filter colors block more light.

Using Limited Palettes

If you're trying for dramatic effects, consider limiting your color palette. This is especially effective when you are photographing a still life or a fashion shot. Suppose you are setting

up a still life with fruit. Rather than grabbing one each of everything in the market, how about trying an arrangement of only red, yellow, and orange, or even just yellows? Some golden apples, a grapefruit, a couple of lemons, and maybe something unusual like a slice of yellow melon could be an interesting composition (and a nice fruit salad afterward). See Figure 5.10 for an example of a limited palette.

Figure 5.10

A study in limits teaches you that less can be more.

Earth tones—tans, browns, cream white, yellows, and greens—are an example of a moderately limited palette. Sticking with only pastel shades of pink, blue, and green gives you a different, yet also limited, palette. Colors have strong emotional appeal and impact. Limiting your picture to a particular range of colors or tones is a definite "attention-grabber." It can make the communication much stronger.

In fashion photography, in which the major purpose is to make the clothes look good, look for backgrounds that accentuate the colors and fabrics. If the dress is red, a black and white or medium gray background will set it off better than a garden full of red flowers. If, on the other hand, your goal is a portrait or a landscape with someone in it, the red dress and red flowers could work very well together.

If you're shooting accessories, it's even easier to find backgrounds to set off the merchandise. They needn't be neutral. The black patent leather shoe stands out nicely from a red brick floor, or from a silver metallic panel, or even from a piece of white Styrofoam. Never throw anything away that might make a good photo background.

Working with Tonality

Tone, which may also be called value, brightness, or lightness, is another factor that helps to establish a mood. Technically, tone refers to the amount of light the particular color or gray reflects. Tones are generally divided into three groups: darks, middles, and lights. These groups correspond to the steps on a gray scale, on which 10 = black and 0 = white. Colors have the same tonal range as grays, from full strength down to the palest possible tint.

Limiting the tonal range is not the same as limiting the palette. Limiting the palette means restricting yourself to a few related colors. Limiting the tonal range means limiting your picture to only dark tones, only light tones, or only medium tones. Tones, of course, are relative. Within the range of darks, there's still a middle and a light. Middle gray is either dark or light depending on what's next to it. If the picture is dark, a middle gray might be the highlight. If the picture is very light, the middle gray tone may be the darkest shadow in it. You can make whites appear whiter by surrounding them with darker tones, and conversely, darks will seem darker if surrounded by white. White areas also appear larger than black ones of the same size, when offset by a contrasting tone. Figure 5.11 shows what may be a familiar optical illusion. Both inner squares are exactly the same size.

Factors that influence what you actually see include not only the tonal range of the subject, and its colors or lack of color, but also how well the digital camera can record the image, how well the computer monitor can display it, and how accurately your color printer can reproduce it. Understanding the limits of the technology will help you get the most from your equipment.

Figure 5.11

The white square definitely looks larger than the black one, even though both are the same size.

Monochrome

Monochrome is the most limited palette. Whether you reduce the picture to black and white or shades of gray, or perhaps to shades of ocher, olive, blue, or sepia, you have made a very powerful statement about the nature of the subject. By removing color from its characteristics, you force the viewer to see the subject in a different way, perhaps as pure shape or texture, or as an arrangement of shapes in space.

Consider J. M. Whistler's famous painting of his mother, *Arrangement in Gray and Black*. This is an example of monochrome at work. We remember it as the old woman sitting in a rocking chair, but we also remember the black triangles of her dress, the square wall behind her, the scarf over her hair, and the absolute lack of movement and life in the picture. Monochrome can do that. It can also reduce a dramatic scene to raw, gut-wrenching emotional content by taking out the "vividness" of the colors and leaving the viewer with only stark form and features.

You can see the effect of monochrome in many of the pictures in this book. Figure 5.12 shows a scene turned into monochrome. By removing the color from this picture of an old shed, and tinting it sepia instead, we've added years to its age and turned it into a more interesting piece of architecture. Sepia toning is an effect photographers have used in the darkroom for a long time, because it simulates the brownish quality of the early daguerreotypes.

Figure 5.12

This picture in monochrome adds years to the barn's appearance.

Bit Depth and Resolution

When you take a picture with a conventional camera and good-quality color film, you can reproduce nearly as many colors as the human eye can see. Depending on the quality of the printing job and the speed of the film, you may or may not be aware of the little tiny dots of emulsion that make up the grain of the film. Today's fine grain, high-speed films and papers make it almost impossible to see grain with the naked eye, unless the picture is enlarged a great deal.

When you scan the conventional photo print in order to display it on the computer, it may not look quite as good as it did on paper. Depending on the scanner you use, you may find that the color transitions don't seem to be as smooth as they were in the original picture. You may notice a sort of striped or spotted effect in large blocks of solid color. The same thing may happen when you look at a picture taken with a digital snapshot camera.

Digital images, including those generated by a scanner and by a digital camera, are described in terms of resolution and color bit depth, which may also be called pixel depth. Let's look first at bit depth.

You know that the computer thinks in *bits*, or binary digits. All data is processed in terms of either ones (1) or zeros (0), regardless of whether it's a photograph, the novel you're writing in your spare time, or your checkbook data. The basic choice for a single pixel on the monitor screen is, therefore, one or zero, on or off, black or white. The black or white pixel has a color resolution, or bit depth, of one bit (2^1). As soon as you move up to a 2-bit bit depth, the colors increase exponentially (2^2). Instead of black or white, you have four colors. In a 3-bit system (2^3), each pixel can have eight colors, and so on. Table 5.1 shows the possible number of colors for common bit depths.

Table 5.1 Color as a Function of Bit Depth

Binary	Bit depth	Number of colors
2^1	1 bit	2 colors
2^2	2 bit	4 colors
2^3	3 bit	9 colors
2^4	4 bit	16 colors
2^5	5 bit	32 colors
2^6	6 bit	64 colors
2^7	7 bit	128 colors
2^8	8 bit	256 colors
2^{16}	16 bit	32,768 colors
2^{24}	24 bit	16,777,216 colors
2^{32}	32 bit	more than 4 billion colors

If a camera or scanner captures an image at 8 bits, it will have only 256 colors. This may or may not be a problem, depending on what the image is being used for. When you use 8-bit color, each pixel selects one of 256 colors. To further complicate matters, digital cameras and monitors mix the three channels of colored light that they receive (RGB,

remember?). So on top of the 256 pixels in 8-bit color, each one of the pixels has three channels: red, green, and blue. The color of each pixel is determined by the intensities of red, green, and blue it's displaying, from 0–255. A value of 0 means that there's none of that channel's color in the pixel. For example, a pixel with channel values of 0 green, 150 red, and 100 blue will be reddish purple.

The colors are defined using either 16 or 24 bits per pixel, so the 256 colors can actually be chosen from a palette of either 262,144 or 16.7 million possible colors. This kind of color palette is also called a color lookup table, and the system that applies it is called indexed color. It works very well under some circumstances. If you're displaying a single picture (GIF) on the web, for example, the color palette will be oriented toward the colors needed in that particular picture. If it's a landscape with many greens and browns, the palette will be mostly green and brown. Under other conditions, it's not so great. For instance, if you add a second picture to the same web page, it will use the same palette even though it's a portrait of a girl in a red and blue dress. The result is that, instead of having one acceptable picture, you can end up with two that are unsatisfactory.

If your video monitor is capable of displaying only 8-bit color, it doesn't matter whether the original image is 8 bits deep or 24 bits deep. The final output is limited by the monitor's capabilities. Actually, in most cases, it's not the monitor that holds you back, it's the video card. The VGA cards found in older PCs can't display more than 256 colors regardless of the monitor. SVGA cards do better, as does Macintosh. Current Mac models can display 32-bit color with their built-in video. In 32-bit color, in addition to the 24 bits of color information, there's an additional 8 bits of grayscale added to the colors. Some PCs use an intermediate mode, 16-bit color. Each pixel takes up two bytes, or 16 bits. Five each are used for the red and blue color value. Six bits are used for green, because the human eye is more sensitive to colors in the yellow-green part of the spectrum, and can therefore make better use of the information.

Resolution

Resolution refers at different times to the number of pixels per inch of the monitor display, the number of dots per inch that the printer can output, or the number of pixels in the original image. Confusing? Yes. Think of them as image resolution and device resolution, and they may be easier to understand. Image resolution is measured in pixels per inch (ppi).

Typically, digital snapshot cameras give you a choice of two settings for resolution. They call these Normal and Fine, or Normal and High Quality, or some similar variation. High resolution or fine quality simply means that the image appears to be made up of continuous tones rather than individual dots, because more pixels, and therefore less space, are between the dots. It's more like a "regular" photograph. Of course, a lot depends

on whether the image is enlarged. Even the best quality film has grain, which is close in appearance to magnified pixels.

Bottom line... you can choose between 640×480 ppi and 320×240 ppi. What difference does it make? The more pixels, the better the image quality. It's that simple. If you're going to display your pictures on the Web, in postage stamp size, Normal is adequate. If you're planning to do anything more with them, Normal isn't good enough.

Figure 5.13 shows a picture shot at Normal resolution with the Apple QuickTake 150. Even at a small size, you're aware of the slightly patchy quality of the image. When you enlarge it, as in Figure 5.14, you see how quickly the image deteriorates. Recommendation: Forget Normal. Always use the best resolution available. After all, if you had a choice between a sharp pencil and a dull one, you wouldn't choose to write with the dull one.

Figure 5.13

Normal resolution, not enlarged.

For commercial purposes, you need something better than 640×480, which means something better than a snapshot camera. The high-end cameras are capable of resolutions as high as four million pixels. The pictures these cameras take are incredibly detailed (see Figure 5.15).

Figure 5.14

Normal resolution, enlarged to 400 percent.

Figure 5.15

Detail of Dicomed photo enlarged 12 times.

Device resolution is measured in dpi, or dots per inch. When you transfer an image from the screen to the printer, the pixels on the screen must be converted to dots that the printer can print. A given number of pixels makes a given number of dots on the page.

Here again, the greater number of dots on the page means a better quality rendition. Today's inkjet and laser printers generally use a 600 dpi resolution, which is adequate for most uses. Fine quality printers and imagesetters can provide a 1200 dpi or better resolution. Such devices are intended for use by printshops and service bureaus, but not ordinarily for home or office.

Pixel Width

Pixel width on the monitor display is critical when you're concerned with image size and file size. File size increases as the number of pixels increases. A single image from the Dicomed 4000, saved as a Photoshop file, requires 48 MB of storage. That's because the camera's resolution is exceptionally high: 4,096 × 4,096 pixels. Compression saves file space, but can degrade the image, for reasons that are made clear on Day 8.

The 13-inch monitor typically displays 640 pixels horizontally by 480 pixels vertically. Therefore, the fine quality image should display correctly on the 13-inch monitor. Larger monitors incorporate a feature called *Multiscan*, which means that they can be set to varying resolutions. If you set a 17-inch Multiscan monitor to the same 640 × 480 pixels as the 13-inch monitor, the individual pixels displayed on the monitor will be much larger, because they are trying to fill the larger area. If you set the monitor to a higher resolution, perhaps 1152 × 870 pixels, the individual pixels will be much smaller. Will the image change? No. If you shot it at 640 × 480, it will display properly at that size. Increasing the resolution forces the same amount of information to spread out over more pixels.

Gamma Value

Gamma value is the method of adjusting the brightness of an image as it appears on the monitor. The reason it's necessary is that monitors don't always look the same. The brightness of the monitor image depends on the electrical voltage that energizes the pixels. This can vary, even on the same screen. As the monitor gets older, it has a tendency to drop voltage, causing the screen to darken. During power shortage times, your friendly electric company may institute a "brown-out," lowering the voltage it sends out. Your monitor will show a smaller, darker image as a result.

Rather than changing all the light and dark pixels by the same amount to make an image appear brighter, correcting the gamma adjusts light and dark pixels differently, so as to maintain the relationship of light to dark. The gamma value default is 1.0. When you lower it to fewer than one, you darken the image. Raising it to more than one will lighten the image.

If you're interested in getting the most accurate color in your digital pictures, you need to calibrate your monitor's gamma value. There are several ways to do this. Users of Adobe Photoshop 4.0 for Macintosh are provided with a Control Panel for global monitor calibration. It's shown in Figure 5.16. The Windows version of Photoshop includes monitor calibration but only within the application.

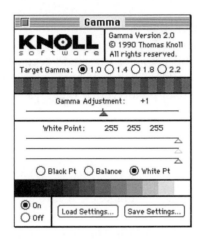

Figure 5.16

Macintosh Gamma control.

If your screen isn't showing the correct colors or brightness, your pictures won't look correct. Because the camera takes pictures with accurate color, you know that when something doesn't look right onscreen, it's the screen that's at fault.

Telling a Story

Photojournalists know the value of research. Before they shoot a story, they do their homework. If they're shooting an event, they find out (as much as they can beforehand) exactly what will be happening. If it's a parade, perhaps they'll call the organizers and get a list of participants, the order of march, and any historical tidbits about the parade. If it's a ceremony or performance of some kind, they'll get an advance copy of the program in order to anticipate which aspects of it will make a good story.

They scout locations ahead of time, whenever possible, and look for the best vantage points. If crowds are anticipated, they may bring a sturdy camera box to stand on, or a folding stepstool. They check regulations in advance. No flash photography in the cathedral? They'll use the slowest shutter speed and widest lens aperture possible.

> **TIP**
>
> If flash cameras are restricted where you're shooting, but your camera has a built-in flash, cover the flash with a piece of black tape. Even if you forget to turn the flash off, you won't disturb the atmosphere and embarrass yourself.

During all this advance preparation, they're also planning their shots. What is it about the event that makes it unique or newsworthy? Is it a sad occasion or a happy one? Why is it being photographed at all? Is this a situation that merits documentation for historical reasons, such as a riot or a civil war? Does it qualify as "human interest"? Will they be looking for a series of pictures to tell the story, or for the single, revealing moment?

Photo Essay

Shooting a series of pictures about a single subject produces what's called a photo essay. Like a written essay, the photo essay should flow in a logical sequence from point A to point B, with an introductory photo, one or more pictures that provide the exposition, and a conclusion. When you set out to create a photo essay, think about what you want to say before you decide how to say it. Are you explaining a process that has a logical sequence of events?

Let's analyze a mythical photo essay called "The Birthday Cake" as an example. In the first picture, a mother and child are in the supermarket studying the display of cake mixes. The child points to one particular mix. In the second picture, they're in the kitchen, studying the instructions on the box. The third picture shows a close up of the batter being mixed. In the fourth, mom is putting the cake pans in the oven while the child is licking the bowl. In picture five, the cake is frosted and they are writing "Happy Birthday, Daddy." In the sixth, and last, Mom and child stand on either side of Dad, who's grinning in the candle light and preparing to blow out the candles.

You can plan all of these shots ahead of time, even sketching out the probable composition of the shots. Then you would know, for instance, that you want to be to the right of the child at the cake mix display, so he's not pointing off the page. You take a variety of shots, both close up and more distant, so you have a good sense of the environment they're in. You have followed the process well enough that someone else could duplicate it and get the same result. The happy faces in the final shot tell us how the participants feel about the subject.

If your photo essay deals with a less structured topic, try to find a way to give it a structure. Instead of, for instance, a general look at the problems of homelessness, you may consider "A Day in the Life…" of a homeless person. This theme gives you a chronological structure to work with, and by focusing on one person, you help viewers to empathize. Your message is therefore much stronger.

Not all essay topics lend themselves readily to structure. Occasionally, you'll encounter a situation that practically begs to be photographed, but seems too general for an essay, like "Springtime in North Carolina." Ask yourself what it is about this topic that appeals to you. Perhaps it's the colors of the flowering trees, or the way the runoff from the mountain snow makes the waterfalls and streams flow faster. Maybe it's a particular local landmark that's especially lovely during this season. Find a way to tie your pictures together using one of these common themes, like the flowering trees, or the local landmark. If every picture has a tree in bloom, or was shot in and around the landmark site, there's a structure… perhaps not as tight as the previous examples, but structure nonetheless.

Figures 5.17 and 5.18 show two of the pictures from an essay I shot on one such topic. All the pictures in the series were taken at the Biltmore estate in Asheville, NC. It's a fabulous mansion, built in 1895, and the largest single family home in the US. Biltmore House was the home of George Washington Vanderbilt, grandson of the "Commodore."

Figure 5.17

Overview of the Biltmore estate establishes the general tone for the essay.

Figure 5.18

Now we can focus in on small but interesting details.

Release Forms

If you create a photo essay with recognizable people and intend to publish it, you may need to have your subjects sign a model release form. This is a legal document that allows you to use their pictures for commercial purposes. Some model releases specify that the model will be paid a given sum or a percentage of the proceeds from the sale of the picture. Others provide for a token payment, usually one dollar.

Camera stores generally stock a basic model release form in pads of 50. If you take the legal boilerplate from one of these, you can customize it with your name and address, and print your own release forms that will look much more professional. Many model releases also include text such as this:

> "I acknowledge that the photography session was conducted in a completely proper and highly professional manner, and this release was willingly signed at its termination."

This gives you some protection against potential lawsuits, but if you have any concerns at all about a "situation" developing, be sure there's another responsible adult present who can support your innocence.

There are a few conditions under which you don't need a model release:

- *News events.* Any situation that is considered a news event does not require model releases.

■ *Ability to recognize person.* You also don't need a model release if the person you're showing isn't recognizable. The criterion is simple. Could his mother recognize him in the picture? If not, you're home free (see Figure 5.19).

Figure 5.19

This group of scuba divers didn't need to sign releases.

Regarding news events, you need to be a little bit sensitive about what's news and what's not. Freedom of the press gives you the right to publish pictures of people without their consent, but only for news reporting. You can't use the pictures for commercial or advertising purposes, and you can't use them to libel someone. People who are unwilling participants in a news story, for example the victim of a holdup, fire, or similar catastrophe, have also given up the right to privacy because the public's "right to know" supersedes it. Of course, these situations give rise to lawsuits, and the courts are more likely to side with the victim than with the photographer.

People who are "in the public eye," as in the entertainment business or in politics, have given up some of their "right of privacy." Their public appearances are news, simply because of who they are. Photos of Michael Jackson or Madonna walking down the street are news, because they rarely walk around in public. Sports figures, whether they're playing their sport or hanging out at the local pub, are equally newsworthy. You could photograph them for the local paper and be within your rights as a news reporter. You couldn't, however, sell the pictures to a non-news publication, or put them on bubble gum cards or T-shirts. That would be a violation of their rights to their own likeness. For your own protection, if you have any doubt at all about using a picture, get a release form from the subject.

What about obscenity? The boundary between art and pornography has been drawn and redrawn so many times and crossed so often that it's been reduced to a muddy pit. Still, you can look at a picture and know immediately what's what. Obscenity laws make it illegal to send certain materials through the mail. Attempts to enforce similar standards on the Internet are still being challenged and will undoubtedly add to the bank accounts of many attorneys on both sides of the question before it's resolved. What should you do as a photographer? It's up to you. Nudity, per se, isn't obscene. Nude photos, with appropriate releases, can be published. No one says they can't. But quite honestly, most of what's published on the Internet and elsewhere isn't intended as art. Does it violate community standards? Let's put it this way… If there were a community whose standards it *didn't* violate, you probably wouldn't want to live there.

Assignment

Using a news-oriented magazine and a fashion magazine, find several pictures that communicate a clear message to you. Analyze how the photographer achieved the communication. Using the skills you have learned so far, shoot a single picture or photo essay that attempts to communicate the same mood or message.

Controlling the Environment

- Working with natural backgrounds
- Using backdrops and props
- Propping a shot
- Improving on nature
- Using special tricks for food
- Dressing for portraits
- Taking outdoor portraits
- Designing photos for type and image enhancement

Even though you can improve your digital pictures *after* you've taken them, you can save considerable time and effort by doing as much as you can to improve the scene *before* you shoot it. Today, let's look at specific techniques and tricks for improving portraits and product photography at the photo shoot, as well as how to shoot pictures that will be digitally enhanced and have type applied later on.

Natural Backgrounds

Few beginning photographers have the good fortune to work in fully equipped studios. Most of us simply do the best we can with what we have available. Because you are using a small, lightweight digital camera, you can go almost anywhere and grab pictures that would be impossible with a heavy view camera and tripod, and difficult with a 35mm SLR and a heavy bag full of lenses. Your digital camera lets you roam freely and shoot unobtrusively.

One of the best and least expensive ways to get around the need for a studio is to photograph people outdoors or in their favorite setting. If you are assigned to get a portrait of the boss for your company's newsletter, for example, let him sit at his desk and do whatever he usually does, while you snap candid photos that show him in action. Or take him for a walk around the premises. Is there a sign out front he can lean on (see Figure 6.1)? A workroom he can do something in? Can you put a hard hat on him and take him into the factory? These settings will result in much more natural portraits.

Figure 6.1

Insert Steve Jobs here.

One advantage of shooting portraits outdoors is that natural light is often more flattering than artificial light. Look for a bright, overcast day for the most even light. Strong sun/ shade contrast will make wrinkles and "character lines" much more obvious. This is great if it's what you're trying to achieve, but if you want a picture that removes years from the subject rather than adding them, softer light is preferable.

Find a location in which your subject will be comfortable. An elegantly dressed woman wouldn't look right in the woods, but a formal garden or the terrace of a mansion like the one shown in Figure 6.2 would be a perfect setting. If you're photographing children, take them to a playground and catch them on the swings or in the sandbox, or maybe even upside down on the monkey bars. Because your camera is digital, you can shoot whatever catches your eye, and not worry about wasting film.

When you intend to use natural settings for commercial work, you may need to get permission from the owner. City parks and playgrounds or state or national parks can generally be used without a special permit. Amusement parks and theme parks are a different matter. You can take as many pictures as you want at Disney World, as long as you don't use them commercially. Other parks, especially those featuring copyrighted characters, will have similar restrictions. If you're shooting on private property, get a release from the owner before you start. It will save you time later, if the pictures are good enough to sell.

Always scout locations before you take a model or a portrait subject to them. Try to go at the same time of day that you'll be shooting and under the same weather conditions. If you don't like what you see, figure out what's wrong. Do the shadows fall in the wrong direction? Then substitute early morning for late afternoon, and you're set.

Consider what changes you can make in Photoshop or a similar program, before you rule out an otherwise ideal spot. Is the grass not quite green enough? You can touch it up later, by putting more green into the picture. The mountain is perfect, but there's a power line cutting across the valley? It's easy to drag a piece of sky over it. You can move a fence that's in the wrong place, or edit out the pieces of the picture that don't contribute to it. You may not be able to change your natural environment, but you will be able to fix most of the problems later with Photoshop.

As you gain familiarity with Photoshop and similar programs, you'll discover many of the digital tricks you can do with them. For instance, if you want to use an outdoor background on a day when the weather isn't cooperating, it's not difficult, because you're working digitally. Whenever you see a nice location, take some pictures. File them by location, weather conditions, and time of day. When you have a portrait subject that you want to put into the background, shoot him or her against a plain-colored backdrop in the studio. Use even lighting so the subject is well-exposed. In Photoshop, remove the background from the portrait and then position your subject appropriately against the outdoor location. You'll learn how this is done, step by step, next week on Day 10.

One of the most useful tools for shooting portraits outdoors can be a couple of sheets of foam core board. Take a can of spray glue (Scotch SprayMent Adhesive is perfect for this) and mount sheets of aluminum foil, shiny side up, to one side of the board (see Figure 6.3). Leave the other side white. Now you have a couple of lightweight reflectors.

Figure 6.3

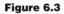

A few wrinkles won't affect the reflecting power.

Position one reflector so that it adds a little light on the shaded side of the subject's face. Set the other one down in such a way that it bounces a bit of light off the subject's hair. Use the white side of the card for a softer reflection, or the foil side for a brighter one. You may need a couple of spring clamps from the hardware store to hold your reflectors in position. You can prop the reflectors against your camera bag, a spare tripod, a tree, or whatever is convenient. Be resourceful. If your actions have attracted a couple of interested bystanders, let them hold the cards.

Indoor Settings

Although it's easy and fun to do your photography outdoors, the reality is that much of what you may be called upon to photograph demands a studio setting. Perhaps you need to take pictures of small parts for a catalog, or you're interested in flower or food photography. Or maybe, like me, you live in a part of the country that's only suitable for outdoor work for a couple of months of the year. In any case, you need to either build or improvise a studio. If all your work can be done on a tabletop, count yourself among the very fortunate. A tabletop studio is easy to set up, inexpensive, and takes very little space.

The main things you need are a sturdy table, a tripod for the camera, and a couple of lights. Should they be strobe (flash) lights or floodlights? Forget about strobe lights, unless you have a high-end digital camera, such as the Canon, Dicomed, or Nikon. These will work with electronic flashes. Low-end digital cameras don't have a way to synchronize the external flash to the shutter. Besides, if you're just learning about lighting, floodlights are a much better choice. You can spend as long as you like setting up your lights, and you can see the effect of everything you do.

You can pick up a basic kit with a couple of light stands, a pair of clamp-on reflector flood sockets with bulbs, and even barn doors and a diffuser screen for under $200. If that's too much, visit the hardware store and buy a couple of clip-on sockets with reflectors, a couple of 75 or 100-watt bulbs, a roll of duct tape, a pair of thick gloves, and some wire (not plastic) screening. If you shop carefully, you should get this material for under $50. The household sockets and reflectors are about the same size as the ones meant for photography, but they may not tolerate bulbs over a specified wattage. If you can use 100-watt bulbs, you should have more than enough light, but 75-watt bulbs are probably adequate for most purposes.

WARNING

Those reflectors get *hot!* The gloves aren't just for show. They enable you to move the reflectors around without getting too badly burned. Turn the lights off when you don't need them and *never* lean a reflector lamp against anything flammable.

You'll need something to clip the lights onto, but here, too, you can use your imagination. Perhaps there's a step ladder handy or a couple of chairs with backs the right height.

For a relatively small investment, assuming your studio has a solid ceiling (as opposed to suspended acoustical tile), you can buy several "polecat" poles. These are spring-loaded

poles with a rubber tip on either end that you wedge in between the floor and the ceiling. They can hold lights, backdrop paper, or almost anything you need to hang from them.

If you cut several circles a bit larger than your lamp reflector from screen wire, you'll have a nice set of diffusers. Attach them with duct tape or clamps when you want a soft, even light without an obvious highlight. Figure 6.4 shows what this looks like. Rotate the circles to control the amount of light passing through the mesh.

Figure 6.4

A home-made diffuser on a clip-on flood light.

As for the tripod, it needn't be so big and heavy that your digital camera looks like a toy perched on top of it. There are dozens of lightweight but sturdy tripods with heads that pan, tilt, and raise up and down at the touch of a finger. The main reason for the tripod is so that you can set your camera up for a portrait or tabletop session and concentrate on what you're shooting, rather than concentrating on holding the camera still. Remember that it's okay to move the tripod around. Some photographers seem to think the tripod is nailed to the floor, and having set the camera up once, they won't move it again until they're ready to put it away.

Using Backdrops and Props

The bare tabletop and the wall behind it are almost never suitable backgrounds for the kinds of things you need to photograph. Using seamless paper is an easy way to get a neutral background. You can buy 12-yard long rolls of 26" wide paper for under $20 in any of about 40 different colors from your photo store. They'll be happy to sell you a rack to hang them from, but you can also make your own rack with a couple of uprights and a broom stick or two to hold the paper rolls (see Figure 6.5). If you clip the bottom edge of the paper to your table with a couple of clothespins, you can make it hold a nice, even curve where it changes from horizontal to vertical. With proper lighting, there will be no noticeable transition in the photo from table to background.

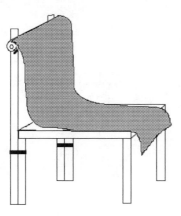

Figure 6.5

The paper is heavy enough to hold a curve if you don't crease it.

If you have more room, and need to photograph larger objects or people, the same type of seamless paper comes in widths up to 140". Wider rolls are a good deal more expensive, so you'll want to treat them carefully. Keeping the background clean is easy if you make sure no one walks on it in regular shoes. You can have your model or portrait subject wipe the soles of his shoes just before he steps onto the paper.

Another handy background that no one should be without is a piece of black velvet. Two yards of good quality velvet should cost about $25. That will be plenty of material for tabletop photography. It drapes beautifully, and can be side lit to pick up its nap, or front lit for an absolutely flat effect. Figure 6.6 shows a piece of art glass photographed against a black velvet background. Placing it against the velvet drape eliminates a source of awkward reflections.

Figure 6.6

Glass is difficult to light.

Finding Interesting Backgrounds

One of your best sources for background material is a building supply store. Home Quarters and Home Depot are two of several coast-to-coast chain stores that carry a tremendous selection of tabletop and background materials. Check out displays of floor and ceiling tiles, embossed metal panels, plastic grids, wallpapers, plastic laminate sheets, wood parquet flooring, industrial carpeting, and whatever else strikes your fancy.

Don't forget about fabric stores, sign shops, art supply and stationery stores, and even the corner grocery store as sources for backgrounds. A sheet of heavily textured watercolor paper might be just the thing for setting off porcelain plates. If you have to photograph a collection of spoons, it might be fun to set them up on a tray of cereal, or you could photograph the spoons filled with interesting colors and textures, such as curry powder and lentils. Your only real limit is your own creativity.

Props for All Occasions

How much you spend on props and backgrounds and how many you collect really depends on what you need to photograph. If you're interested in doing food or fashion photography, your prop closet will be huge. If you are interested in landscapes, either because they're pretty or because you sell real estate, you won't need much in the way of props at all. Maybe a broken branch to hold in the corner of the frame as you shoot. And, again, because you're working in the digital realm, you have the option of adding a background after you take the picture. You can redesign the one that's there by changing its color, or posterizing it. You can photograph objects against plain white or black, and then add a textured background, a gradient, or whatever seems appropriate. You can even create a fantasy background in a fractal landscape program like MetaTools' Bryce, and put your objects into it. You might also use a 3-D modeling program to create props that didn't exist when you shot the photo. The possibilities are endless, because you needn't stick to reality.

Finding the props for a photo session can be a career in itself. There are people who specialize in props for still photography and film or video "shoots." They arrive with a van or even a trailer truck full of goodies, and even though they've studied the script or the art director's sketches to know exactly what's needed, they are also prepared for any and all contingencies. For example, if you want the model to carry a book, the prop people will have an assortment of books in different sizes and colors, plus paper and markers or paints to whip up a custom cover if necessary. If you need "clutter" for an executive's desk, they'll supply the appropriate amount of paperwork, pens, telephone, knickknacks, and family portraits in (dulled) silver frames.

Where do they get all this stuff? The same place you will—yard sales, garage sales, department store close-outs, Goodwill, begging from your friends and family, and so on. As soon as you know what you need, consider who might have it and ask to borrow it. Set up a relationship with local antique and craft dealers. Find a friendly furniture store who will let you send your own truck to borrow merchandise for a day. Be sure that you make a point of returning it on time and without any damages. When possible, give the store a credit line in the information about the pictures or at least a copy of the photo that used their stuff. It's not uncommon to see a microscopic line of type along the edge of a printed photo that reads something to the effect of "Furnishings courtesy of DecoRama Antiques, fruit from Harvard Gardens, make-up by Ms. Peggi, models from the Models Collective." It's the next best thing to getting paid, especially for people such as the fruit-stand owner who may never come any closer than this to stardom.

When you shop for props, look for items that will contrast with the backgrounds that you use. If you are planning to buy or borrow dishes for a food presentation, find out first what kind of food is involved. You probably wouldn't serve spaghetti or fried eggs on your formal dinner service at home. Don't photograph these items on the fancy dishes, either. Look for plates and utensils that will be appropriate for what's being served. After all, you only need one or two of each, you don't need the full service for twelve.

Don't overlook accessories such as colorful napkins and place mats or an interestingly shaped salt shaker that can improve a composition. Keep a few fresh flowers on hand, as well as a selection of fruits and vegetables for garnish—even to use as props in non-food related pictures. If you have to photograph a set of dishes, they'll be more interesting if one or two are being used for something. Put tea in a teacup and a crisp brown croissant on a plate, and you've added some interest and appeal to your picture.

Improving on Nature

You won't find models or actors willing to face a camera without make-up. They know the importance of emphasizing their best features or covering up even a tiny flaw. Ordinary people have good points and flaws, too. If you're doing portraits, even just of family and friends, make sure they're putting their best face forward. The cute little kid with the dirty smudge on her nose won't thank you for that picture when she's a sophisticated teenager, and Uncle Harry, who's just a bit sensitive about his bald spot, will not appreciate the shot that has sun reflecting off of it.

Keep a comb and a small powder compact in your camera bag if you photograph people. Any neutral color of face power will do. Dust it on shiny noses, foreheads, chins, scalps, or wherever is needed. Then wipe off the excess with a tissue. If you can see color, you have used too much make-up. People who are used to being photographed will generally provide their own make-up. You can certainly suggest more, or less, as you see fit.

Expect to do some retouching on most portraits. Even though you check everything before you shoot, you're likely to notice stray hairs, a shiny nose, or some other imperfection when you study the picture afterward. Here again, digital photographers have a big advantage. You can improve a sagging chinline, soften a wrinkle, or add a little extra color to a pale subject with just a few mouse clicks.

Dulling Spray

Dulling spray serves the same purpose for glass and metal that talcum powder does on skin. It stops the annoying reflections that create a hot spot in your picture. If you need to photograph anything made of chrome, stainless steel, or clear glass, you should always

keep a can on hand. You can buy it at photo and art supply stores. Krylon and Marshalls are the most common brands. Use it sparingly, and be sure to wipe off the residue afterward. Figure 6.7 shows the "before" and "after," using dulling spray on a shiny metal object. Don't suppress every highlight, or you'll make the product look like it's made of suede instead of metal.

Figure 6.7

Dulling the excess highlights gives a better picture.

If you don't have any dulling spray and need to knock out a single highlight, almost anything sticky or greasy will do. I've used hairspray, Vaseline, suntan oil, butter, and wax. The goal is just to apply a thin film of something that will break up the light.

Tapes

There are a half dozen different kinds of paper and cloth tape that are almost indispensable in the photo studio. The first is plain old cellophane tape. The second is masking tape, and the third is called either gaffer tape or duct tape, depending on whether you buy it from the photo store or the hardware store. Gaffers are the people on a film set who move lights and cables; they need very strong tape to hold things in place. Although the usual color is a sort of silvery gray, gaffer tape also comes in black and white—at a premium price. The hardware store variety will do just as well.

Another item that should be in your kit at all times is a roll of black crepe tape. Look for Scotch brand, type 235. It's exactly like familiar beige masking tape, only made with black paper. It is used to fasten things down unobtrusively and to mask light-reflecting surfaces that aren't in the picture but are casting unwanted glare.

You'll find more uses than you can imagine for double-stick tape in both thin and thick (foam tape) varieties. Use the foam tape to set something just a little bit away from the background. Build up several layers, if necessary. Thin, double-stick tape is the answer for keeping pieces of a still life together, if they might otherwise get blown or knocked around. Use it, in little bits, to arrange the grapes in a bunch so that they drape more elegantly over the edge of the bowl.

Although not exactly a tape, those little sticky note papers are another "must have" item. Aside from their use for posting notes, the low tack adhesive on the back is just right for picking up stray cat hairs or bits of lint without disrupting a critical arrangement. Yes, you can retouch them out in Photoshop, but think of the time you save if they're not there at all.

Clothing and Make-Up

Professional photographers who shoot portraits have learned the hard way that it's important to consult with the portrait subject ahead of time about clothing, make-up, and hair styling. Naturally, the choice of clothing is determined to some extent by the purpose of the portrait. The CEO had better not wear jeans and a T-shirt for the photo in the annual report, even if she usually dresses that way. The author posing for a book jacket photo might want to dress according to the kind of book it is. Writers of romance novels tend to favor long, fluffy dressing gowns or formal wear. The author of those famous detective novels always wears a black leather jacket, baseball cap, and jeans, perhaps because he's trying to look like one of his characters. Remind men not to get their hair cut sooner than two or three days before the session, so they don't have that white line around the edges that a fresh haircut often gives.

The Glamour Drape

If you have female portrait clients who want to look elegant and aren't sure what to wear, you can provide the perfect "one size fits (and flatters) all" glamour outfit. All it takes is a yard of velvet. Make a diagonal cut from one corner, as shown in the diagram in Figure 6.8.

Cut in to center

Figure 6.8

Making the glamour drape

To use it, fold the cut edges under and position the V neckline appropriately. Bring the points back around the subject's shoulders and fasten them with a paper clip or clothespin. Adjust the drape to reveal as much or as little as the lady desires. Figure 6.9 shows how the drape looks in use.

Figure 6.9

Wearing the drape.

If you're hiring models for a project, you're expected to either provide their clothes or pay an allowance if they use their own outfits. Costumes of all kinds can be rented from theatrical costume shops, but if you need ordinary street clothes or sportswear for your models, have them bring a selection of clothing they're comfortable in. Be sure to specify appropriate footwear if their feet are in the picture. You can often borrow clothes and accessories from local shops, just by giving them a credit on the published photo. Something as simple as "Model's outfit from the Uneek Boutique" will do. Be sure that anything you borrow is returned promptly and in good condition.

Clothes that don't fit right can be "taken in" with a couple of spring-type (Bulldog) paper clips, as in Figure 6.10. Keep masking tape on hand to lift off lint, stray hairs, and loose threads. Never let the model drink, eat, or smoke wearing borrowed clothes. It's an invitation to disaster.

Figure 6.10

These are lighter than clothespins and won't pull the fabric down.

Food Photography

Taking pictures of food has provided a good income for many commercial photographers. If you have experience with desktop publishing, you may be able to carve a lucrative niche for yourself producing menus with digital photos of the entrees. Foods are fun to photograph, although you can't always count on eating the leftovers afterward. Frankly, some of the tricks to make things look good also make them inedible, but in a picture, it's appearance and not taste that matters.

Of course, there's another side to this issue. If you are photographing a specific product like a can of soup for an ad, you can't cheat and add more meat and veggies, and you can't fill the bowl with marbles to raise the existing ones up to the surface. There are "truth in advertising" laws and statutes at federal, state, and even local levels. The Federal Trade Commission is the regulating body that determines what's okay and what isn't. In general, anything you do to a "generic" food shot is okay. Anything you do that changes the appearance of a specific product, which is the subject of the ad, is probably not okay.

This is not to say that you can't put the item's best foot forward. For example, if you are going to photograph a steak dinner for a restaurant menu, you need to use the same steaks and potatoes and whatever else is on the plate when the restaurant serves it. And you need to use the same plate. Using a smaller plate to make the meal look bigger isn't fair.

But now the fun starts. You take the steak and potato, or actually a dozen or so of each, back to your studio. If you have a home economist or food stylist working with you, s/he will prepare the food and arrange the plate. Otherwise, you'll be chief cook and bottlewasher, as well as photographer.

After you mash the potatoes, cool them. Mix butter and flour together in equal parts to make a stiff paste which you can chill and shape into "butter pats" for the potato. Glaze the carrots with Krylon spray and sprinkle some parsley flakes on them for texture. Lightly broil the steak on top so that it has an even brown tone. Use a propane torch to toast the edges, being careful not to char it. For a richer brown color, dilute Gravy Master coloring with water. Using a spray bottle, give the meat a misting of darker brown. Take a hot iron or a red hot metal skewer and burn in "grill" marks (see Figure 6.11). Finally, a few dots of glycerin will make the meat look juicier. If there's a piece of parsley on the plate, choose the lightest one you can find, because parsley always photographs darker. Color Plate 6.1 shows the finished meal as it will appear on the menu.

Figure 6.11

Today's subject is tonight's dinner.

Tricks of the Trade

Your studio kitchen should include a good set of knives and paint brushes, and along with the usual cooking tools, a small butane or propane torch, a hair dryer, and as many different service pieces, plates, napkins, and utensils as you can manage. You need

paprika and dried parsley for garnish, as well as a good supply of fresh garnish materials. Soy sauce, Gravy Master, or even molasses can be used to turn meats or roast poultry brown. The torch browns meringues and chars the edges of a steak.

When you need to have food appear to be steaming hot, the best way to achieve the look is to use a tea kettle—out of camera range, of course. Tape a piece of plastic or rubber hose to the spout of the kettle and aim the steam so that it rises directly behind the cup of coffee or whatever else is supposed to be steaming. Shoot from a low enough angle that the source of the steam isn't obvious. Use a strong side light to emphasize the steam.

Some foods are especially hard to handle. Cut fruit won't turn brown if you soak it in a mixture of cold water and lemon juice before using it. If you don't have lemon juice, or if it makes the fruit look too yellow, you can also used crushed ascorbic acid (vitamin C) tablets dissolved in water. Egg yolks are easier to handle if you let them stand for several hours or overnight. They'll firm up enough so that you can move them where you want them. To restore the shininess of a freshly opened egg, paint the hardened yolk with glycerin.

Always prepare at least two of every food item you photograph. That way, if you don't notice a flaw in the item until it's ready to shoot, you still have a back-up.

Glycerin

You can buy glycerin at the drug store or from a shop that sells candy making supplies. Either way, a bottle of glycerin is a vital tool for the food photographer, and a helpful one for many other purposes. Whenever something needs to look wet, glycerin photographs better than water alone. Use it with an eyedropper to make water spots on chrome, stainless steel, or plastic. Experiment with mixtures of glycerin and water to make bigger or smaller drops, and remember that glycerin in alcohol simulates bubbles.

A drop of glycerin on a model's or actor's cheek is the Hollywood solution for tears. If you don't dilute it, glycerin will stay put fairly well.

If glycerin drops are too big, and you want to achieve a dewy, moist look on the surface of a piece of fruit or other food item, use a plant mister with plain water. Just spray the surface lightly before you shoot.

Designing Photos for Type and Image Enhancement

Fine art photographers and news photographers don't have to deal with type. Editorial and advertising photographers do. Type makes very specific demands on its background, and you need to understand how to design and shoot pictures that lend themselves to the application of typography. Also, with so much being done to our digital images after they leave the camera, it's often necessary to plan the shot(s) so they'll work as a composite, be amenable to filters and other kinds of manipulation, and give you the results you hoped for when you first visualized the finished job.

Planning for Type

Ads sell something. Magazine articles entertain, instruct, or inform. Either way, they use words as well as pictures. When you add type to a page, you're adding another element to the layout, and it's not a quiet one. Type is visually "busy." It grabs your attention, even if it's in a language you don't understand or in characters you can't even decipher. Figure 6.12 has a "typical" ad, for a typical product. I've set the type in a font called Klingon. Notice that, even though you have no idea what the letters say or how to pronounce them, your eye is drawn to the type. The product is the *second* thing you notice, not the first.

Some type faces are cleaner than others. That is to say they're plainer, less busy, or less distracting. Helvetica and Futura are often used in ads because they are clean, easy to read, and still graceful. Heavy faces, such as Cooper Black, can be used to balance a graphic, but may be too heavy for headlines of more than a couple of words. Placing type under or alongside a photo is almost always easier than running it across the picture. Figure 6.13 shows a typical ad layout, in the style that was made popular by the Volkswagen ads that first appeared in the late 1950s and early 1960s. The "Think Small" campaign that was introduced by Doyle Dane Bernbach changed the face of American advertising and gave the photograph a new importance as an artistic element within the ad, rather than strictly as a product shot. The square picture, white space, and short headline make this ad visually arresting.

Figure 6.12

The Klingons probably don't understand our ads either.

When the type in an ad actually touches or sits on the picture, you run into many more headaches. In these cases the photo is often what's called a bleed, meaning that it runs right to the edge of the page and "bleeds" off, rather than having a margin between the edge of the ad and the edge of the page. Whether or not you can do this depends on the format of the publication in which the ad is running. Some magazines and newspapers still don't want to deal with bleeds. Others charge extra for them.

When type goes over the picture, be sure to discuss the colors for the lettering and the photo layout. Nothing is worse than shooting a beautiful picture with the background fading into a perfectly graduated gray and then finding out that there's black type over it. The type becomes illegible, and you don't look too good as a photographer.

A double-page spread has its own set of headaches for the photographer, as well as for the art director. You must design the photograph in such a way that nothing important gets lost in the *gutter*, which is the center of the spread where the two pages join. Depending on how the magazine is printed and bound, the gutter may make it hard to see part of the page.

Figure 6.13

Advertising photography is a very well-paying profession.

Script is often used over a photograph, especially in ads with "feminine" appeal or when elegance is implied. However, in such a case, the background must be absolutely uncluttered; otherwise, the type will be impossible to read.

How much type the ad demands is another consideration, and one that the art director must figure out with the copywriter. Writers *can* be given a space to fill and a word count and told to write precisely XX number of words. Most of them don't mind this technique, and actually welcome a specific assignment. However, it's just as common for the writer to start the process of creating an ad by writing a few paragraphs of copy and then handing it to the art director to "illustrate." The best approach, of course, is to work as a team, developing the concept, copy, and pictures jointly.

The Do-it-yourself Ad

You may not have the luxury of working with a creative team. Many small business owners end up doing their own advertising, at least in the beginning. With computers and desktop publishing tools readily available, it's not difficult to turn out reasonably professional looking work. If you're the writer and art director, as well as the photographer, you've already worked out how much type to use, its position on the page, and probably even its color, weight, and style. You've got at least a rough sketch like the one in Figure 6.14 to show the photo layout and the approximate position of the type. All you have to do is set up the shot and make the picture.

Figure 6.14

Tissue roughs help you see how to compose the picture for the ad.

As you set the objects to be photographed into position on the background and light them, be aware of shadows that may fall into the type area and of anything else that might cause a problem when you put the picture and the words together.

Catalogs

Shooting objects for catalogs can be a major headache, or it can be quite simple. The only difference is in how much advance preparation you have done. Digital photography is a natural choice for catalog work, since you can place the pictures directly into a page layout program, and crop and adjust them there. Both Adobe PageMaker and QuarkXPress support Photoshop filters and plug-ins.

Catalog pages can, of course, be laid out in many different ways. If you have many related objects, it may make sense to put them all in one picture with the descriptions underneath (see Figure 6.15). If the objects in your catalog aren't closely related, or need more than a few words of description, it may be more effective to use a separate picture of each one with its description and selling copy next to it on the page. Figure 6.16 shows one way of doing this. Notice that the objects are positioned to lead the reader's eye to the related copy. This is important. Otherwise, the catalog turns into visual clutter, and the reader probably won't find what he's looking for. The catalog ends up on the floor, and you end up unemployed.

Figure 6.15

Catalog page with many items.

From our CATalog...

Kitten on the Keys: This keychain will hold all your keys safely. Overlapping ring design is 100% secure, and the pewter kitten will stand guard. Order several. They make great gifts! #KY100 $ 10.00

Eye of the Tiger: He'll watch your stamps, pills, or whatever you keep in this pretty enameled box. About 3" long. Imported from Sri Lanka. #BX233 $6.50

Paw Printer: This little leopard's a rubber stamp. He'll walk across your letters and right into your heart. STI 100 $4.00

Figure 6.16

Catalog page of single items.

If you design the pages in advance, you'll know exactly which items to shoot in a group and which way to face the individual items. While it's true that you can flip the pictures in almost any graphics program, anything with type on it, or anything clearly "right-handed" or "left-handed," won't look correct when it is reversed.

Considerations for Image Enhancement

It's true that you can do a lot to save pictures that didn't come out as well as they should have. Photoshop, LivePicture, and similar programs are used to rescue less than perfect work a lot more often than they are used to make a good picture great. Some pictures just don't turn out as expected. You thought you were standing straight, but the horizon was tilted to the right. Somehow, you didn't see the trash can that crept into the edge of the picture. Or maybe you did see things in the picture that you couldn't avoid shooting. Perhaps the trash can was chained to a pole, and you could neither move it nor shoot to

get rid of it. In any case, the best you can do is to plan your shot so that you give yourself a little bit of space around the offending object and then crop it out of the picture later or replace it with something different.

When you're planning to make composites of several photos, sketch out your intended result first, so that when you shoot, you can keep areas clear that will have a second layer added.

If you want to drop an object into a background that you've already shot, follow these simple steps.

1. Place it on seamless paper and light it so there are no shadows on the background.

2. Then, in your graphics program, select the background and delete it, leaving the object ready to paste on the new background.

3. Either copy the object to the clipboard and paste it into the new picture, or move it to a separate layer, and paste the background on a different layer beneath it.

You'll learn a lot more about compositing and working in layers next week in the chapters on Photoshop. This technique, dropping out the background and replacing it, is very similar to the "blue-screen" trick that Hollywood film studios have used for many years to insert actors in front of otherwise impossible backgrounds. By photographing actors in front of a blue backdrop, they can later filter out the blue and replace it with a piece of film shot somewhere else, a matte painting, or whatever composite background they decide to use. Films such as the *Star Wars* series have used many composite backgrounds, and the current (1997) re-releases have electronically added more new scenery and action in previously unexciting composite scenes.

Assignment

Set up and shoot a still life, using available light. It should contain at least one food item and one non-food item. Shoot it "as is." Then, use whatever techniques you think are necessary to improve it. Keep the before and after pictures.

Painting with Light

- Using available light
- Balancing daylight and artificial light
- Using built-in flash
- Setting up studio lighting
- Using special lighting tricks
- Using cookies and gobos
- Disguising flaws with light
- Working with children and other animals
- Lighting for tabletop photography

Without light, there would be no image. Things would exist, but we couldn't see or take pictures of them. We have two different kinds of light to work with. We think of them as daylight and artificial light, but it would be more practical to think in terms of available light and added light.

Using Available Light

By definition, available light is whatever light falls on the subject without your turning on any additional lights. When you are outdoors, available light comes from the sun during daylight hours. It may also come from any other light sources that happen to be present, such as the neon lights on the strip in Las Vegas or the coals from a campfire. Available light can come from a single point source, which can be as dim as a candle flame or as bright as the blinding brilliance of a welder's torch. It can come from a source as broad and featureless as a cloudy sky. Each of these kinds of light is different, and each light affects the things on which it falls in a different way.

Available light has several advantages. It's there. It's free. More important, it's the real thing. When you use available light instead of artificial light, you're more apt to capture the real feeling or mood of the place and time where you're taking the picture. You haven't added anything to the scene except your point of view. Available light pictures seem more authentic. Because available light comes in an infinite variety of colors, qualities, brightness, and moods, your pictures will also have more variety than if everything were evenly illuminated by two crossed floodlights. When you learn to make use of available light, you're not tied down to a suitcase full of light stands, cords, bulbs, and lamps—nor to a studio. You can go anywhere and shoot whatever you see. Portrait subjects will be more comfortable and more relaxed because they're not staring into bright lights. Digital cameras are particularly effective at taking pictures with available light because they are more sensitive than typical color films. Sensitivity of photographic materials is measured according to standards set by the American Standards Association and the International Standards Organization. The typical outdoor color print film has an ASA/ISO film speed rating of 200. The typical digital camera has an equivalent sensitivity to ASA/ISO film speed 1600, so it can capture images under almost all light conditions.

Of course, with all these advantages, there has to be a disadvantage. It's a major one, and the reason is obvious. With less light, the image quality isn't as good. Pictures can come out dark or underexposed. There's less detail in the image. Everything appears to be a bit fuzzy. You can't enlarge the picture as much, and you can't adjust the contrast and brightness to compensate without losing either the highlights or the shadow detail, or both. Still, within the computer, you can compensate for low light much more easily and more successfully than the conventional photographer, who is stuck with whatever film happens to be in the camera.

Larger Source = Softer Light

There's a reason that photographers love overcast days. It's because a cloudy sky produces an even, shadowless light that's great for taking pictures outside. Buildings, trees, and people are bathed in softly diffused light that falls off gradually. Colors seem brighter, as if lit from within. Look at the beach scene in Color Plate 7.1. Even though the sky is thoroughly overcast, the waves sparkle, and the sand has a rich golden color. On a day like this, the light waves are diffused as they pass through the layer of clouds. Individual rays of light are bent and diverted so that instead of all coming from the same source, they seem to come from many different sources, as if there were a dozen suns behind the clouds instead of just one.

Clouds are the major source of diffused light, but you can often find a similar quality of light on a foggy day or in smoke. Light in a snow storm is brighter and even less directional, because it is reflected back up from the snow on the ground, as well as down from the sky. Figure 7.1 shows a picture taken outdoors on a snowy day. Notice that the branches of the tree appear to be lit from beneath, as well as from above. This occurs because light reflects off snow. Beach sand and water have somewhat the same reflective properties.

figure 7.1

View from my front porch, 4/1/97. They call this spring?

Soft light tends to wrap itself around objects. This propensity to wrap increases when the size of the light source increases. The wrap is directly proportional to the size, angle, and distance of the source. The more diffuse the source, the more of this wrapping effect you'll see. Wrap increases when you move the light closer to the subject.

Smaller Source = Harder Light

"Hard" light is the opposite of soft light. It's not necessarily brighter but has more glare. It brings out greater contrast. In terms of artificial light, a hard light is a spotlight with quite literally hard edges. You can see its outline on the floor, as opposed to the diffused light of a floodlight. In terms of available or ambient light, an example might be the candle flame, which lights a small area and throws the rest into shadow.

Outdoors, the sun is the main source for "hard" light. Sure, it's 93 million miles away, and a lot more diffused than a spotlight. Still, bright sun can be thought of as a point source. It is light filled with contrast. It casts hard shadows. It is directional. These aren't drawbacks, just features that you have to recognize and work with, or work around, as the case may be.

You can't soften hard light. Your best bet if you must shoot outdoors when there's bright sun is to watch the time of day and plan your pictures for times when the shadows interfere least with whatever you are shooting. At noon, the light is pretty much directly overhead in spring and fall. Any shadows will be cast straight down, as in overhanging edges of buildings, and so on. These shadows shouldn't present too much of a problem, and they may actually help the rendering of the surface. In the winter and midsummer, even at noon, the sun is at an angle, so there will be a little more shadow to contend with. It's worse in the winter because the sun (at least in the Northern Hemisphere) is at a lower angle.

Shadows point west in the morning and east in the afternoon, so if a building facade is in shadow in the morning, come back after lunch. It should be quite different. If the building is situated in a way that the side you need to shoot has long shadows in both morning and afternoon, it's probably better to wait for a cloudy day.

Balancing Daylight and Artificial Light

Daylight and artificial light have different color temperatures. They appear to be different colors, even though both are theoretically white light. When color rendition is critical, try to avoid mixing them, because daylight tends to be much hotter (more blue) than artificial light. Sometimes, you may encounter a scene that has both, such as an interior with some light coming in the window and a room light on, as well. Figure 7.2 shows an example of this situation.

The cat is backlit by the window and picks up some additional highlights from a desk lamp. There is no good way to balance the two kinds of light in this shot, unless you can cover the entire window with a sheet of filter material to convert the blue daylight to room light. Instead, you might choose to make your color corrections later in a program such as Photoshop that enables you to select parts of the picture with a "magic wand" and apply filters and effects only to the selected area. The other alternative, and sometimes the better one, is to decide that the effect of the two kinds of light enhances the picture, and doesn't need to be "fixed."

Figure 7.2

The effect of two kinds of light can be more interesting than just one.

It's the film emulsion, not the camera, that makes the difference in conventional photography. There are indoor and outdoor films, but only one set of CCDs. So, the digital camera pictures may need more color compensation.

Using Built-in Flash

Many of the current digital snapshot cameras include built-in flash units. These aren't especially powerful, but are helpful in low-light situations or as fill light when you're shooting outdoors in shade. Typically, they have an effective range of no more than 12–15 feet. If you're at a sporting event, a play, or a concert and are more than 15 feet from the action, don't even try to take flash pictures. All you will do is distract the performers and other audience members. Your flash won't reach the stage or the field. Instead, turn

off the flash so the exposure meter will open the lens as wide as possible, and hope there's enough light for pictures. Stage performances are usually quite well lit, as are orchestral concerts. Single performers or small groups may not use bright enough lighting for pictures. Rock concerts are especially tricky, because the performers tend to go in for special lighting effects, which might seem brighter than they really are, and will probably affect the colors you see. Other things at a rock concert can also affect what you see...don't inhale.

The biggest drawback to the built-in flash is its tendency to produce red eye. This is the phenomenon of light reflecting back from the inside of the subject's pupils, revealing the network of blood vessels inside. To borrow a word from my teenagers, it's "gross." It happens mostly when the room is dimly lit, and the subject is staring into the flash. You can avoid it by turning up the general level of light in the room. This makes everyone's eyes close down a little bit, showing less pupil, and leaving less space for light to get in and out. It also helps if you have the subject look somewhere other than directly into the flash. If you're shooting an object with a shiny surface, don't use the flash. It will reflect as glare. The closer you are to the object, the worse the glare will be.

Having said all that, when *can* you use a flash? A flash is useful outdoors or inside when there is a single, strong light source in the room, to soften the shadows and help fill in some of the detail on the "dark" side of the subject. Figures 7.3 and 7.4 show the same scene with and without fill flash.

Figure 7.3

Without the flash on a cloudy day, the flowers are evenly lit, with no variation in tone.

Figure 7.4

With the flash, there's more variation.

Using Studio Lighting

Few beginning photographers have the luxury of a full studio. More often they use a corner of the office, den, or living room, or maybe the kitchen table. How much lighting you need depends on what you're hoping to accomplish. You can do a nice job on portraits and on most tabletop photography with just a couple of lights and possibly one or two white and/or foil-covered boards as reflectors. The trick with lights is not how many, or how bright, but where you place them.

Raising and lowering the light source changes the angle at which the light strikes the subject, which changes the position and size of the shadows it casts. Moving the light source from front, to side, to back affects the direction of the light and the position of the highlights. Moving the light source closer to or further away from the subject affects the intensity of the light, making it more or less bright.

As in theatrical lighting, photographers may refer to floodlights and spots or spotlights. The floodlight gives a broad, soft, diffused beam, while the spotlight has a hard, relatively narrow beam. If it can shine a circle of light on the floor, it's a spotlight. If it lights up the room, it's a floodlight. Ordinary household flashlights are effectively spotlights, while the bulbs you use in lamps and ceiling fixtures are essentially floodlights.

Choosing Lights

What kind of lights should you buy and how many? You really need two, but three is better. Rather than buying more than three lights, look at lighting accessories, such as light stands, barn doors, diffusers, and filter holders. These will do you more good than extra candlepower. Although many conventional photographers prefer electronic flash (strobe) lights, stay away from them. First, it is much harder to teach yourself lighting when your lights are only turned on for a fraction of a second. You can't see the effect they have until you look at the picture you've taken. Second, but even more important, low- to mid-range digital cameras don't have a flashsync input. You won't be able to use the strobe with anything less than a high-end Nikon, Canon, or Kodak digital SLR.

Decide whether you want to look professional, or just get the job done. If appearances count, go to a camera store and buy lights and light stands that are intended for a photo studio. They'll cost more but are sturdy, reliable, and thoroughly "pro." If saving money is more important than how things look, buy your clip-on lights at the hardware store, discount store, or five-and-dime. Figure 7.5 shows the selection at our local hardware store. They'll give the same amount of light—a 75-watt bulb is a 75-watt bulb, no matter what it's screwed into (although you'll pay less for the sockets). You should look for 75- watt reflector flood bulbs, instead of 75-watt household bulbs, though. It's not so much that they give you more light; they just aim it closer to where you want it.

Figure 7.5

Low-cost lighting solutions.

The main differences between photo store lights and hardware store lights is that the better ones (that's pronounced *more expensive*) have wooden handles so that you can aim them without burning your fingers, and they often have ceramic sockets instead of stamped tin ones. They'll last longer, and they are a little safer. The cheap ones could possibly start a fire if you left them on all day.

> **TIP**
>
> Don't buy a bulb that's labeled reflector spot. It will give you a hot spot in the middle of the picture because it focuses the light.

In either case, get the kind of light fixtures that have a metal reflector bowl attached. Whether you're working with "real" or improvised light stands, get (or make) some sandbags. A 5–10 pound sandbag on the base of even a flimsy metal stand will keep it from tipping over as you aim your lights, and it will save you major headaches with broken bulbs. Another thing you need is a heavy duty extension cord (or several of them). It's one of Murphy's Laws that where you need the light is just beyond the reach of the cord.

A couple of sets of barn doors are a helpful addition to the light kit. They clamp onto the reflector, and are simply a pair of metal doors that flap open and shut in front of the light, giving you the capability to block some of the light from the bulb. They let you put the light where you want it and keep it from going where it's not needed. You could, for instance, position a light with a barn door flap so that it hits the model's face without casting a shadow behind her onto the backdrop.

As you get more heavily involved in studio photography, you may want to invest in additional lights. Quartz broadlights, snoots, and a 5" quartz focusing light will be the most helpful additions to your kit. The broadlight is used to light a broad area, and can be controlled with its attached barn doors. It uses a 500-watt quartz bulb, is very bright, and gets very hot. The snoot is a hood that fits over a light to produce a tiny spot of light. It is used mostly for hair highlights, as a catch light to liven up a portrait subject's eyes, or to put a highlight on the edge of a glass or some other single object in a still life.

Keys, Accents, and Fills

A given light source can fill any of several functions. The principal source of illumination is called the *key light*. It's the light that does most of the work. It casts the shadows, if any, and is the main source of illumination for the shot. The *fill light* is used to fill in the shadows enough to bring out necessary detail. It doesn't (usually) eliminate the shadows,

just lightens them a little. *Accent lights* are used, obviously, to put a small highlight to accent a particular spot, such as a model's hair or the rim of a glass. A *background light* is aimed at the background, either from behind the subject or off to one side. It lightens the background so the subject doesn't blend into it. Bounce lights are any lights that are bounced off a reflective surface. Quite often an umbrella reflector is used with a bounce light shining into it, to give a soft non-directional light. You can also bounce light off a ceiling, a light-colored wall, a white card, or even the front of your own shirt, if you're working close to the subject. Your basic clip-on flood lights can serve any of these functions. It's the position of the light relative to the subject that gives it its name, not any special kind of bulb.

Placing a Key Light

When you're doing a "normal" portrait, the key light generally is placed at a 45-degree angle to the front and about 3–4 feet above the subject. The following figures show diagrams of possible lighting setups. In the first one, Figure 7.6, the key light is to the left of the camera, and covers the portrait subject. The fill light, to the camera's right, is placed slightly behind the subject, aimed so that it falls on his shoulder and hair. Figure 7.7 shows the portrait shot with this lighting setup.

Figure 7.6

Lighting a portrait.

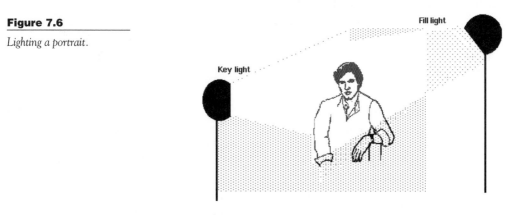

Depending on the subject's clothing and hair color, and the color of the background, you may not need to add a background light to the setup. If you do, let it hit *just* the background and keep it either low or high so there will be some gradation across the surface.

Figure 7.7

*Portrait shot with key light
and fill light lighting setup.*

Figure 7.8 is an even easier setup, with just one light. By putting the light slightly to the right of the camera, and the subject several feet out from the background, you can eliminate the shadow that would otherwise be cast on the background by the single light. Figure 7.9 shows the resulting portrait.

Key light

Figure 7.8

*The key light does all the
work here.*

Figure 7.9

Portrait with a single (key)
light.

When your key light comes from the front, it's called front lighting. That's pretty obvious. Equally so are side lighting and back lighting, at least in terms of where you place the key light. What is less obvious is how you can use side lighting and back lighting for portraiture. These lighting techniques are not for everyday use but can be useful for special effects.

Side lighting, for example, brings out the texture of skin and hair. Although middle-aged women would not find it flattering, it can give a sympathetic portrait of an older person, highlighting the character lines acquired by many years of living. Back lighting can be used to show off an unusual hairstyle; or with a small fill light on the face, it can create a moody, shadowed portrait. You can even let the subject hold up a piece of white paper or a book as if she's reading it, in order to get the necessary fill on her face.

Cookies, Flags, and Gobos

In lighting terms, cookies, flags, and gobos all refer to more or less the same thing. These are all items that you put in front of a light to cast a particular kind of shadow or to block a small area of light. You can make them out of spray-painted, black aluminum or out of black matte board. Or you can do as most of the pros do and grab whatever is handy and hang it up with a piece of tape.

Why do you use them? There are several good reasons. You might use a flag, which is a small piece of black card, to block a single offending highlight. Cookies and gobos tend to be larger than flags, and usually cast a specific kind of shadow. You might cut a cookie that resembles a venetian blind, or a spray of leaves, and use it to add interest to a background. These can be as simple as a torn piece of heavy paper, or a scrap of cardboard cut into a jagged shape with some holes poked in it. You're only using its shadow, so the cookie itself needn't be a work of art.

If you want to simulate a window, build a gobo in the shape of a window and let the light shine through it. Again, it needn't be anything fancy, and it certainly doesn't need glass. Just the suggestion of a couple of right angles and a crossed piece of molding will be enough to indicate window panes, especially if you also tack a bit of lace curtain on it. Figure 7.10 shows what this looks like.

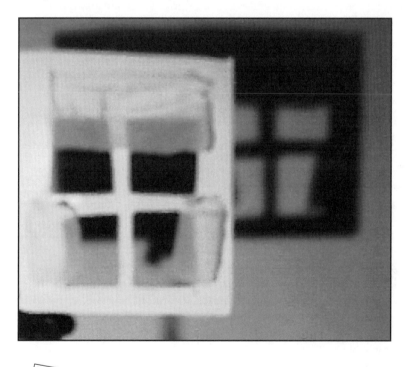

Figure 7.10

A window gobo made from a piece of foam-core board and a paper napkin.

NOTE

Gobo is short for go-between. If you hang around with people who do sound instead of picture, you'll also hear the term used to describe the soundproof barriers used to isolate the drummer from the other musicians or actors in a radio drama.

Portrait Posing

The first rule for getting a good portrait is to make sure that your victim, er, subject, is comfortable. The room should be neither too cool nor too warm. Remember that the lights add heat, and turn them off when you don't need them. Background music may help your subject to relax, as long as it's not too loud. Chatting with the person as you get ready to take the picture will almost always help, but only if you're at ease yourself. If you're relaxed and confident, your subject will be, too, but if you are nervous about your abilities or your equipment, the subject will pick up on that and stiffen up. I've heard more than one person say that posing for the passport picture was more painful than the pre-travel shots.

People tend to be more comfortable sitting than standing. Unless there's a reason for a full-length shot, let the portrait subject sit on something. There are all kinds of posing benches, adjustable height stools, and similar pieces of furniture that you can buy for the purpose. You can also use an ordinary chair (if you don't mind the back of it showing in the picture), a piano bench or stool, or a bar stool. (Some portrait subjects find this one the most familiar.)

TIP

If you want a comfortable seat that adjusts and doesn't cost too much, go to a music store and ask to see drummer's thrones. (Yep, that's what they're called.) They're sturdier than the ones sold for portrait studio work, because rock and roll drummers tend to kick them around. They adjust for height, and rotate easily so that your subject can shift from a left to right profile without moving the seat.

You may also want to invest in, or build, a posing table. You can drape them with velvet or spray them black to be unobtrusive. Commercially made ones are built with black felt over plywood, and will hold Velcro-tabbed fabric. The cutout side goes up against the subject, and gives him a place to put his arms. If you have a subject who wants to lean his head on his fist, perhaps to disguise a double chin, the table lets him rest his elbow so that it doesn't wobble or look awkward. The table is also useful when you want to have someone leaning toward the camera. He can rest his arms on it as if on a desk and not look, or feel, as if he is about to fall over.

Head-on portraits are probably the most common ones. They're certainly the most direct and revealing. Unless the subject has perfectly even features, however, they may not be the most flattering. The usual portrait lens is a short telephoto, and it tends to flatten out the face somewhat. Noses and chins take the worst of it. Noses, in particular, can be really strange when viewed directly. The pert, uptilted nose on the pretty girl tends to look

more like a pig's snout—and even worse, you seem to be looking up into her nostrils. Just turning her head a few degrees to one side or the other can make a big difference (or you can have her look very slightly downward). Be careful about having people look down, however, because doing so emphasizes any flabbiness around the chin or neck.

Profiles are tricky. Again, if the subject has perfect features, or at least interesting ones, it can be a good pose. Faces with "character," specifically the lines, bumps, and wrinkles that we all get as we get older, can be wonderful subjects for portraits. To bring out the lines, use light from below. Have the subject actually looking down into the light, as in Figure 7.11. It's not a trick to use every day, but if the subject is willing and has the right kind of face, it can be very effective.

Figure 7.11

Dramatic lighting for a face with character.

When you are shooting a picture of two people together, as in the stereotypical mother and child or newly engaged or married couple, try to find poses that let them look at each other, rather than at the camera. Position them so that one person's key light is the other's fill. Groups of three should be posed to form a triangle. When you are photographing a small family group informally, have the parents sit on the ground with their legs bent and facing toward the outside of the frame. Pose one child behind and between the parents, while the other child sits in front of one parent's legs. If there are more children, put the third one in front, and the fourth can share the standing space behind the parents. Never have a very tall person standing behind a kneeling one. It throws the balance of the group off.

If you need to do a more formal group shot, have two or three of the group seated, and the rest standing behind them. Disguise the tall group member by having him sit. If feet aren't showing, and no one else is tall enough to stand behind him, have someone stand on a phone book or low stool to add a couple of inches.

Because digital cameras tend to be small and possibly unimpressive to executives who are used to posing for studio portraits with a view camera or other large format camera, emphasize your flexibility. Move around, and shoot the group from several angles. Move in and out. Take *lots* of pictures. It will distract them, so they won't think you're just using a snapshot camera.

The Flattering Portrait Trick

I've forgotten which elegant dowager once quipped, "You can never be too rich or too thin." Although you can't do much to add to your clients' bank accounts, you can subtract several pounds from their faces with this trick.

Have the subject sit facing you, but turned just slightly, so she's looking over your shoulder rather than straight on. When you look at her, you want to see one ear, not both. You'll notice that the broad side of her face is toward you (see the sketch in Figure 7.12). Figure 7.13 shows an actual portrait shot with this lighting set-up.

Figure 7.12

Set the light so it falls on the side of the subject's face that's away from you.

Figure 7.13

Short lit portraits are more flattering.

When you light her, use one light, but don't aim it at the side of her face that is toward you. Instead, aim it at the side you see less of, the "short" side, rather than the "broad" side. This trick is called, appropriately, *short lighting*. When you light the broad side, it is called *broad lighting*. Broad lighting puts the emphasis on her ear and cheek, making her look chubby-faced, even if she's not. In the case of someone who *does* have a wide face, broad lighting is extremely unkind. News photographers use this technique frequently on politicians they disagree with. Former President Nixon was a prime example. His already impressive jowls were frequently magnified by the lights.

TIP

There's a myth that probably goes all the way back to Daguerre, that saying "cheese" as the picture is taken produces a happy smile. If you catch the subject at the exact fraction of a second when he says "chee..." you'll get to see some teeth, possibly, but not an expression that's worth recording. Forget cheese. Ask female subjects to say "peaches." It forms their lips into a pleasant expression, if not a smile. You want them to appear relaxed and comfortable, after all, not grinning. Ask male subjects to say "beer." They'll smile naturally after saying it, and that's when you shoot.

Children and Other Animals

Kids and critters are two of the most appealing photo subjects you'll ever encounter. They're also the most difficult to work with. The best way to get good pictures of children is to give them something to do and then get out of the way by using a telephoto lens. Use natural light whenever possible because flash is distracting, and kids are easily distracted without outside help.

Babies

Babies are fairly easy to photograph, if you catch them when they're awake and not too hungry. A little advance preparation will make baby pictures a cinch. If you follow these basic steps, your baby pictures will be a success.

1. Start by gathering your props. Roll a pillow tightly in a crib blanket to make a bolster cushion for the baby. If she's able to sit up, use the cushion behind her for support. If not, lie her on her stomach with her chest propped up on the roll.

2. Put a favorite rattle or toy in her hand.

3. Be ready to grab the picture when she realizes she's holding it, and smiles or looks surprised.

4. For another cute picture, take a receiving blanket and drape it over her head so she appears to be looking out from under it.

5. Hold a toy up high and wave it so she looks up. Get down on her level, instead of shooting down at her.

6. To get her attention, use the rattle, a squeak toy, or other soft noises. Don't make loud noises that will frighten her.

Because of their skin tones, Caucasian and Asian babies generally look better against a blue background than a pink or yellow one. Darker skinned infants are equally cute on any light color. Very young babies are best photographed asleep. After all, it's what they do best.

Smiles are great, but babies and children, like the rest of us, have other moods. A serious portrait, or one where the child is about to burst into tears, can also be very effective.

Toddlers

Once they become mobile, toddlers want to move. Your task will be to guess where they're going to go and position yourself to capture them as they fly by. It's comparable to photographing a parade or bicycle race. Find your best view and wait for the action.

> ### TIP
>
> Children of all ages become antsy if you take more than a few seconds to set up the shot, so prepare yourself and the camera first. Then ask them to do whatever you have in mind.

Older Kids

As children get older, they become self-conscious. They may reflect this as shyness and even refuse to be photographed, or they may develop a tendency to "mug" for the camera. Neither attitude gives you much to work with. Observe children from a distance as they're engrossed in some activity and shoot them with your telephoto lens when they're unaware of you. Again, this is a good time to catch them in motion. Soccer games, basketball, skating—whatever their chosen sport—it's bound to be a good opportunity for pictures. Attend the practice sessions as well as the games, and watch for kids on the sidelines as well as those in the middle of the action. You might discover that the real story at the Little League game isn't the star center-fielder, but rather the second-stringer, whose function is to cheer for everyone else.

Pets

The advantage to shooting your own pets is that they know you, and aren't likely to be scared of you or your camera. The disadvantage is that they've come to associate things you do, such as calling their names, with getting a treat or going out for a walk. Bits of food will generally get their attention, but might not be a good reward for a dog prone to drooling. Try using a squeaky toy or a piece of rustling cellophane to keep the animal alert. Whenever possible, photograph the animal on a neutral background to avoid clutter in the picture, such as a sheet or rug. Outdoors, try for grass or perhaps a carpet of leaves.

Dogs who have had obedience training will sit or lie down on command and remain alert. Those who haven't may need to be held or photographed asleep. Cats are even more difficult. Some will pose for you and seem to enjoy the attention. Others, like the cat in Figure 7.14, interpret your reaching for the camera as a signal to wash their hindquarters or hide under the bed.

Figure 7.14

Cat refusing to cooperate with photographer.

Farm and Zoo Animals

In the case of farm and zoo animals, you have even less control over the background, and in most cases, you must shoot from a distance. At the llama farm, I was allowed in the pasture with the animals, but most of them had no intention of letting me get close. Fortunately, the Casio 300 and Kodak DC50 have telephoto lenses, so I was able to shoot Figure 7.15 from a good 50 feet away.

Figure 7.15

A Llovely Llady Llama.

Be aware of the location of other animals in the picture. Interactions are great, but more often than not, you will get a wonderful portrait of one animal, but an awkward position on the other(s). You may be able to fix this with careful editing, but as always, starting with a better picture means that you will end up with a better picture.

Wildlife

Sadly, the current models of "affordable" digital snapshot camera just don't have long enough lenses for serious wildlife photography. The bald eagle, bear, moose, or other critter that you might be fortunate enough to see out in the wild will be too far away to show up as more than a dot in the picture. If you have access to a high-end camera, such as the Kodak DCS 420 (and are brave enough to take a $10,000+ camera into the woods), use a tripod and a long telephoto lens to capture your subjects as closely as you can.

If your interpretation of wildlife includes the kinds of animals you needn't go on safari to see, the digital camera is ideal. Digital cameras make less noise than conventional cameras, and won't frighten the ducks at the local pond or the chipmunk eating the nuts you've set out on the ground. If you're going to try to shoot pictures in a park or similar spot, pick a time when there are few people around to frighten the animals and birds. Early morning is usually good. Take a bag of dry cereal or some other food that will appeal to your subject, and be prepared to sit very still and wait for a long time. Before you settle down, look over the area where you'll be shooting, and remove anything like trash or cigarette butts that you wouldn't want in the picture. A camera such as the Casio 300 or the Ricoh RDC-2 is ideal for this kind of photography because you can hold it in your lap and position the viewscreen so that you can see and snap your pictures without excess movement.

Before you shoot, imagine your subject stacked four-high within the frame. If the stack fills the frame, it's big enough to shoot. Otherwise, you are too far away, or the critter is too small.

Motion in a Still Picture

When you are photographing subjects that are habitually in motion, such as animals and children, it's helpful to be able to show that movement as one of their characteristics. Photographs freeze time. When you take a picture of something in motion, generally your shutter speed will be fast enough to stop the motion and freeze the subject wherever it was in space at that particular fraction of a second. What you get is a still image of something you know to be in motion—the basketball players in mid-leap, or the child running across the soccer field. But, if everything in the picture is perfectly clear and in

focus, how can you be sure the balls and the players in mid-air aren't suspended on piano wire, and the child hasn't posed with his feet spread apart? Obviously, you can't, although common sense suggests that the picture is probably real, rather than faked with wires.

To really show motion, you need to have something moving. If you force a slower shutter speed by using less light, you'll have a longer exposure, and the jumping basketball players will be blurred. Unfortunately, you can't turn down the sun in the playground. But you can add a little bit of blur to the ball and one of the players in a digital darkroom program, and create the same effect after the fact. Figure 7.16 shows an example.

Figure 7.16

An active game of basketball made even more so, digitally.

Tabletop Lighting

When you shoot small objects on a table, or on a kitchen counter, or on a piece of seamless paper, it's called tabletop photography—even if there's no actual table involved. Most people use either of two approaches to tabletop lighting. Either they treat the objects as if each one was a portrait subject, putting the camera in front of them and using a key light

and a fill light. Or else, they handle them as essentially flat things, banging lots of light on them and shooting down at them from above. Either way works. Mixing the two, doesn't.

A third way of dealing with tabletop lighting is the most practical, and the most creative. Treat each set of objects as a unique problem and find a satisfactory solution. Sometimes, it will be to use two crossed lights. Sometimes, it will be to shoot straight down. Sometimes, it may be to put the object to be photographed on a sheet of Plexiglas and light it from underneath. This is a common trick of food photographers who need to make a glass of wine or beer look good. Lighting it through the bottom of the glass gives a glow that can't be managed any other way, and really makes any carbonation stand out.

> **TIP**
>
> If you need to shoot something that is carbonated and you want to see lots of bubbles, have an assistant drop a few grains of sugar into it just before you take the picture. It activates the bubbles. Practice first, so that you see how little (or how much) to use.

Shooting Tables

Of course, you *can* use any sturdy table, desk, or other flat surface, but there are also special shooting tables designed for tabletop photography. They have a few advantages. One is height. You can typically adjust the height of the surface from 32" to 37", saving your back when you have many items to photograph. Also, the backdrop is built-in. These tabletops are designed to hold a sheet of thin, frosted Plexiglas or Formica in gentle curves to mimic the seamless paper backgrounds, and they fold up into a bundle of metal sticks and a roll of plastic when you want to use the floor space for something else.

Using translucent Plexiglas as a base and background enables you to place lights behind or beneath the shooting surface to eliminate shadows. Some of the custom tables also have light-stand adapters, and one has a dome on top in which you can place an overhead light.

The main reason for using any of these tables is that you can do catalog and product shots easily and quickly. When all you need is a basic "object on plain white background" photo, it takes only a few seconds per shot to position the object, shoot it, remove it and replace it with the next one. With the camera set up on a tripod, all you need to do is move the product around and press the shutter button. Nothing could be easier or faster, especially if you have an assistant to keep track of which items have been shot.

The Jewelry Tent

Some products just don't lend themselves to this kind of "assembly line" photography. For one reason or another, they're more difficult to light. Jewelry is a good example. Shiny, round objects, such as roller bearings, are another. They pick up odd reflections, and these reflections often translate to distorted edges or black or white blobs in the middle of the object.

Using dulling spray may be okay on a machine part, but it's definitely taboo on a tennis bracelet worth several thousand dollars. Besides, jewelry is supposed to shine. The trouble is, each stone in the bracelet has 42 facets, the purpose of which are to reflect light back at you. Multiply the facets by the four dozen stones in the bracelet, and you have a lot of little bits of light bouncing around. Fortunately, there is a way to get good pictures of jewelry and other glittery objects. It is done with a translucent tent. You can either make one yourself out of any suitable white fabric, or buy a premade model in white rip-stop nylon that attaches to the commercial shooting tables previously described.

Tenting Tonight...

1. To build your own jewelry tent, start with a piece of white, translucent fabric a bit wider than the width you want your tent to be, and a bit longer than twice the height plus the depth (see Figure 7.17).

2. Cut a camera flap at the front of the tent. Hem, or use iron-on tape to finish the edges if the fabric is one that will shed loose threads otherwise.

3. Cut side panels to fit, and stitch them at the top of the tent.

4. Construct a framework of wooden dowels or aluminum tubing to support the tent. Joining the legs on three sides, as shown in the figure, will help keep it stable. You may want to sew pockets into the edges of the tent flaps to hold the support rods, or you can construct a free standing support and simply drape the tent over it.

To use the tent, set it up and position your lights so they shine through the sides of the tent, as in Figure 7.18. Place the jewelry or shiny objects inside the tent, and poke the camera lens (and viewfinder, if your camera doesn't let you see through the lensßß) through the camera flap in the front of the tent. There should be softly diffused, shadowless light on the item and its background. Remembering the discussion of soft light earlier in this chapter, you should be able to see how the soft, extremely diffused light within the tent wraps around the objects you're shooting. If you're seeing shadows, adjust the lights until they disappear. Be careful not to let the bulbs touch the cloth, lest you scorch or melt the cloth, or start a fire.

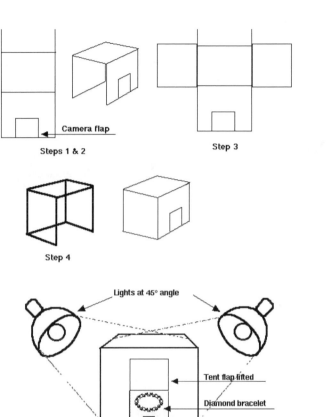

Steps 1 & 2

Step 3

Step 4

Camera flap

Figure 7.17

The jewelry tent can be made of any translucent fabric, but nylon or dacron sail material is ideal.

Lights at 45° angle

Tent flap lifted

Diamond bracelet

Camera

Figure 7.18

After you position the camera, let the tent flap down to block reflections from behind you.

The tent is also good for silverware, mirrors, or any other reflective surface that would pick up the lights, the camera, you, and whatever else is in the room.

Don't reach for the tent automatically whenever you have a shiny object. You can occasionally put reflections to good use. For example, you can stick a colored card out of camera range, but place it where it will be "seen" by the silverware to add a glint of color to a place setting. More often, though, reflections are a nuisance for the photographer to deal with.

One of the advantages of using a digital camera for tabletop work is that you can stop part way through the job and upload your pictures to the computer to see what you've really got. Even on cameras like the Casio, which shows you your pictures as you take them, it's hard to tell whether the detail is there or if the lighting is the way you visualized it. In

the studio, you have the luxury of checking your work immediately. This is something conventional photographers can't do, unless they have a crew of darkroom assistants standing by to process and print their films as they shoot. Chalk up one more big point for working digitally!

Assignment

Shoot portraits of a friend, experimenting with different light placement. Study the results to see what worked and what didn't. Ask your friend which s/he prefers.

Set up, light, and shoot a dinner place setting with a glass of wine.

Saving and Uploading Your Pictures

- Getting from the camera to the computer
- Understanding file formats and file sizes
- Choosing storage media
- Using file compression
- Managing your picture files

The pictures have been beautifully composed, perfectly lit, and carefully shot. They're waiting in the camera's memory or on a flash card. Now what? How do you get them out of the camera into the computer, and what do you do with them once they're on your hard drive?

Getting from the Camera to the Computer

When you bought your camera, you got a fistful of stuff along with it. There were probably a couple of floppy disks or a CD-ROM included in the bundle, along with the manuals. And there should have been a cable, or possibly a couple of different cables, depending on what kind of camera you bought. Let's take a closer look at these items.

If your camera is the kind that can play back pictures onto a TV screen, you'll have a video cable with one (or two if it's a Ricoh, which handles sound as well as picture) RCA-type plug on one end and a mini headphone plug on the other (see Figure 8.1). If you don't have one of these cables, it simply means that your camera wasn't designed to play back directly into a TV set.

Figure 8.1

This cable goes from the camera to video inputs on the TV set.

The cable you need to get the pictures into the computer is a different one. It will have whichever kind of plug your camera uses on one end, and either a mini DIN 8-pin (Mac) or D sub 9-pin (Windows) connector on the other end. On the Macintosh, the plug goes into either the printer or (preferably) the modem port. Either way, it's an RS-422 serial port. On a Windows PC, you must use an RS-232C serial (COM) port. If your CPU has a 25-pin serial port connection, you'll need a 25- to 9-pin adapter. These plugs are shown in Figure 8.2. If you have any doubt about where to plug the cable in, check both your computer manual and camera manual before you start plugging.

If your COM ports or Mac modem and printer ports are already in use, you have the choice of unplugging and replugging every time you need to download pictures, or you can buy a switch box, which is a box that plugs into the appropriate port. It has several connectors and a rotary switch so that you can plug the camera into slot A and the modem or other device into slot B; then you can switch between them easily without swapping plugs. Because the plugs and cables tend to be somewhat delicate, the more often you unplug and replug them, the more you shorten their lives. The switch box costs between $10–20, depending on the number of inputs; consider a switch box to be money well spent in terms of time saved.

Figure 8.2

Mac and Windows camera cables.

WARNING

Make sure that you use the right cable between a Mac and the switch box. Ordinary modem/printer cables fit the sockets, but they may not have all the pins wired. Look for a special "switch box to CPU" cable that has all the pins connected.

If you haven't already done so, you'll also need to install the software that enables the computer to read the signals from the camera and download them as pictures. The program may be on a floppy disk or on a CD-ROM. If your computer can't read a CD-ROM, the camera manufacturer should be able to supply you with the same program on floppy disks.

Your camera may come with downloading software only or with additional program(s) for image manipulation. Adobe PhotoDeluxe is probably the most common of these, but you may get a copy of LivePix, PhotoMaker, or Apple's PhotoFlash for QuickTake instead. (You'll find out how to use these in the next chapter, on Day 9.)

Follow the installation instructions for your computer and operating system. On the Macintosh, you generally just double-click the installer for the appropriate (68XXX or PPC) version and wait while the program unstuffs itself. Figure 8.3 shows a typical Mac installer in action.

Figure 8.3

A typical Mac installation.

Windows machines make installation a little more complicated, but because authors of software know that, you'll find complete instructions for Windows 95/NT and/or Windows 3.1 installation included with the instruction book or on the disk.

After you install the software, you generally have to do some configuring. Figure 8.4 shows the Mac Preferences window for Casio's QV-Link software. Other downloading programs have essentially the same kind of preferences settings.

Figure 8.4

The Casio QV Link Preferences box for Macintosh.

The Windows version of the QV-Link asks you to choose a COM port (1–4) and then to test communications at various speeds until the computer and camera agree on a compatible speed. It's comparable to running a modem, in that respect.

If your camera comes with different software for downloading its images to your computer, you'll also have instructions for installing and using it. All of the information for transferring pictures to the computer should be included in either the camera manual or the software manual. (These may even be two sections of the same booklet.)

Transferring an Image

With the software installed and the camera connected to the computer, you're ready to proceed. Because Kodak's PhotoEnhancer is fairly typical of the image handling software you're likely to use, let's use it as an example. After you start the application, you'll see a menu bar. (The Mac version is shown in Figure 8.5.) Open the Camera menu.

Figure 8.5

The PhotoEnhancer Camera menu.

If you have a DC 20 or DC 25, your copy of PhotoEnhancer is the "Special Fun Edition," which is slightly simplified and includes templates for calendar pages, greeting cards, and other goodies. To retrieve pictures with it, use the button on the opening screen shown in Figure 8.6. The figures that follow all use the Macintosh version of the Kodak PhotoEnhancer software. A Windows version is also supplied. If you are using a different program, don't worry. All of the basic steps are the same.

NOTE

Nearly all of the digital cameras currently on the market support both the Windows and Macintosh platforms. The exception (as of this writing) is the Canon PowerShot 600, which comes only with Windows software.

Figure 8.6

This is the PhotoEnhancer Special Fun Edition for the DC 20/25.

Make sure that your camera is turned on and then choose View Slides in Camera from the Camera menu. In a few seconds, up to a minute or so depending on how many pictures are in the camera, you'll see a page of imitation slides, like the one in Figure 8.7. Double-click any picture to open it up to full size.

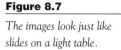

Figure 8.7

*The images look just like
slides on a light table.*

To save your pictures, either save individual shots by opening them and then saving (or choose Save All from the File menu). If you are going to work on your pictures in some other graphics program, you'll need to export them first, instead of saving them in the camera's format. *Exporting* simply means saving them in a format other than the one that program normally uses. The Save As command on the File menu gives you a choice of PICT, TIFF, JPEG, or EPSF.

File Formats and File Sizes

How can you decide which file format to save pictures in? What's the difference between PICT, TIFF, JPEG, and EPSF? What about PCX, GIF, and BMP? The whole business of file formats is very confusing to the novice, and it's made even more so when you discover that certain programs support some of these formats, but not all, and that some cameras have their own file formats, which can only be opened by their own specific programs. Casio, for example, uses a format called CAM, which can't be opened except with the Casio QV Link software. On the other hand, the Apple QuickTake conveniently saves images as compressed PICTs, which can then be opened by any graphics program. (This is a definite advantage for QuickTake users, because Apple's own PhotoFlash program tends to crash frequently.)

A digital photo is a scanned image. Therefore, by definition, it is a bitmap, which means that the image is saved and described, pixel by pixel. PICT, BMP, PCX, and TIFF are all bitmap formats. Virtually all Macintosh graphics programs can open PICT files. BMP is the most widely used bitmap file format for Microsoft Windows applications. PCX is the standard bitmap format for PC Paintbrush, and it is used by many other IBM PC applications as well. TIFF, which stands for Tagged Image File Format, is common to both Windows and Mac platforms, and works well for images that must be transferred cross-platform. TIFF files are standard in the printing industry for scans and for any

graphics that must be printed out on high-resolution printers or imagesetters. Bitmaps can also be converted to EPSF (Encapsulated PostScript File) format, for use with PostScript printing devices. As a bottom line, if you are working on a Mac, save the file as a PICT. If you are using a Windows PC, save the picture as a BMP file.

After you've finished working with your photo, you may need to save it in a different format. If your picture will be going into a web page, you'll need to convert it to either a JPEG (Joint Photographic Experts Group) or GIF (Graphic Image Format) file. These are the two graphics formats that web browsers can interpret. If your photo is going to be used for desktop publishing or as part of a printed document, you may need to convert it to a TIFF or EPSF (PostScript) file for use with PostScript printers. If you have no idea what any of this means, be patient. We'll discuss exporting pictures to other media on Day 14.

Saving File Space

Uncompressed bitmap files tend to be quite large. A typical (compressed) image saved directly from the camera to the hard drive will occupy approximately 60K of disk space. The same image, uncompressed and saved as a 32-bit color PICT, requires 858K of space. As a TIFF image, it's even larger—908K. Finally, as an EPSF file, it fills up 3 MB of disk space. Why so big? The TIFF file includes a compressed version of the picture, plus information about the colors used in it. The EPSF version translates the entire picture into the PostScript printing language. Given today's gigabyte hard drives, this isn't quite as much of a problem as it used to be. However, just opening or copying a file that large is time-consuming. Sending it on the Internet would be ridiculous. That's where file compression steps in and becomes critical.

There are two ways to compress a file: lossless and lossy. Lossless compression is exactly what it sounds like. The file is compressed, but all of the information in it is retained. Nothing is lost. LZW compression is an example of lossless compression. (The initials stand for Lempel, Ziv, and Welch; the three guys who invented it.) GIF files use the LZW compression system, with a limited color table. Colors are indexed and limited to a total of 256, no matter how many were in the original photo; so even though there's theoretically no loss of data, there may be a loss of color data if the original picture had more than 256 colors or shades of gray. The file described previously shrank to 99K as a GIF document.

> **NOTE**
>
> GIF, pronounced either as gift without the T or like the peanut butter (Jif), is a graphics handling system originally developed for CompuServe in 1987. It was meant for cross-platform sharing of whatever pictures their subscribers cared to post to CompuServe's libraries. Because the GIF standard was developed back in the days when 8-bit color (see Day 5) was standard, color loss wasn't a problem. Nobody could display more than 256 colors anyway, so it didn't matter whether the picture originally had more. When a GIF file is displayed on a monitor that's capable of 24-bit (16.7 million) colors, it still has only the 256 colors it came with.

Lossy compression makes the file smaller, but loses some of the information. JPEG is a lossy compression system that retains all the colors. JPEG enables you to select how much compression (and therefore how much data loss) you'll allow. JPEG stands for Joint Photographic Experts Group, the folks who created the standard. As you might expect, it's geared toward displaying photographs, and therefore handles any sort of continuous tone (full-color or grayscale) image very well. Figure 8.8 shows how Photoshop enables you to set the amount of compression when you save a JPEG file.

Figure 8.8

You can have a small file or a complete file, but not both.

```
                    File Format
         ┌─ Compression/Option : ──────────────
○ PICT   │ ○ Standard        □ Alpha Channel
         │ ○ JPEG   Quality:  [ Excellent ▼ ]
         │ ○ Other  [Choose...]
         ┌─ Compression/Option : ──────────────
○ TIFF   │ □ Alpha Channel
         ┌─ Options : ─────
○ EPS    │ □ ASCII    Very low   Mask
         │ □ Preview  Low
         ┌─ Options : ─  Fair
         │             High
◉ JPEG   │ Quality:  ✓Excellent
         ┌─ Options : ─────
○ J6I    │ Quality:  [ Fair      ▼ ]

○ PhotoStudio (fastest)     [ Cancel ]  [ OK ]
```

A high-quality JPEG version of our typical file ended up as an 88K document. The low-quality JPEG version was only 30K, but looked just as good onscreen as the high-resolution PICT. Part of the reason for this, of course, is that the screen in question is on a 24-bit color monitor, so you're seeing as many of the 16.7 million possible colors as were visible in the original scene. If you were using a less color-enabled screen, such as an old VGA monitor from an early PC, the low-quality JPEG image would probably look better than a GIF version of the same picture, but not as good as the full-color JPEG version.

Why would the low-quality JPEG come out better than the GIF? The answer to that brings us to the matter of color quantization or color reduction. To display an image with more than 8 bits of color, the program you're using has to choose which 256 colors to display out of all the possibilities. To do this, it uses an algorithm that looks at all of the possible colors and finds the closest matches for them. In effect, if your picture has a lot of blues in it and no yellows, instead of a standard palette that would have a full range of yellows, it ignores them and adds as many extra blues as it can. Figure 8.9 shows a greatly magnified view of a GIF, along with a piece of the full-size picture. In this picture, which has been converted from color to grayscale, you can see quite clearly how the number of tones has been reduced to only a handful of grays. This kind of quantization is extremely efficient in terms of file size, but still displays quite well, as long as you don't try to enlarge the image as much as we have here.

Figure 8.9

Notice how the pixels have been grouped into bands of grays.

If the program displaying the picture finds more colors than it can match, it "dithers" them. Dithering is a process that fools your eye into seeing colors that aren't there. It works by placing very different colors on adjacent pixels, letting your eye effectively blur them into one.

As an example, suppose that you had a picture of a bunch of purple grapes on a multicolored plate. Rather than displaying all the shades of purple, as well as all the greens, blues, reds, yellows, and so on, if you were to enlarge the picture to the point where you could see individual pixels, you'd notice that you had red and blue pixels side by side,

making up the various purples. The dithering algorithm looks at colors to see which ones are necessary and which ones can be interpreted from others. Then it creates a palette of the necessary colors and adds, in order of frequency of use, as many of the additional colors as can be fit within the constraints of 255 allowable colors.

The following table shows the file format options and their results.

Table 8.1 File Formats and Compression

File Format	File Size	Type of Compression
Raw data (high-quality 640×480)	66K	Compressed PICT
PICT (32-bit color)	858K	None
PICT (8-bit color)	330K	None
TIFF	908K	None
EPSF	3.1 MB	None
GIF	99K	LZW, Lossless
JPEG (Low-quality)	30K	Lossy
JPEG (High-quality)	88K	Lossy

Which One to Use?

Okay, you have options. But how do you save the file? If ever there was a case of "Different strokes for different folks," this is it.

If you're planning to do any additional work with the file, save it in an uncompressed form. The reason for this should be obvious. Starting out with the best possible quality will give you a better end product. If you start with a JPEG compressed image, work on it, and then save it again as a JPEG, you're starting with less than a full set of data; each time you save it, you compress it again and lose some more. Before long, the loss becomes obvious.

BMP or PICT are generally your best choices for images that you'll be tweaking in Photoshop or Live Picture, or some other graphics program. The files will be large, but you can save them in a compressed form after you're done editing, color-correcting, and making whatever other changes you decide to try.

If the file is going directly onto the Internet on a web page, you must save it as either a GIF or a JPEG. Web browsers, as of this writing, don't natively accept graphics formats other than GIF and JPEG. A new graphics format called PNG has recently been

introduced for web use. It's not really in the mainstream yet, and most of the current generation of graphics programs don't support it at present, but it's expected to replace both GIF and JPEG within a year or two.

Make it a GIF if the picture has 256 colors or less. The GIF format is best used for line drawings, cartoons, type, and 8-bit color artwork. GIFs generally tend to display well on-screen, even on an 8-bit color or grayscale monitor, but they often don't print well. Color Plate 8.1 shows a piece of a GIF color image with its 256 color palette. This photo of a black-and-white cat against a gray-and-brown background fits well within the definition of limited colors.

JPEGs are better for photographs, because the colors aren't limited, but they don't handle sharp contrasts as well as GIFs. For example, a line of black pixels next to a line of white pixels reproduces perfectly as a GIF, but comes out blurry as a JPEG. This is because of the way the JPEG standard looks at compression. It is designed to mimic the way the human eye sees images. We're more sensitive to variations in brightness than in hue. So, when compressing an image, the JPEG standard maintains more of the grayscale data than the color data.

Interlacing is a method used with both GIF and JPEG formats to make an image appear to display faster on a web page. Here's how it works: The file is divided into pieces called *scans*, which are saved in a scrambled order, so that as the picture loads, lines 1,4,7,10, and so on are painted first. Then, lines 2,5,8,11 and finally lines 3,6,9,12. The effect is that the picture appears in bands from the top down and then fills in. Interlaced GIFs use what's called GIF89a format. The similar format for JPEG is called Progressive JPEG. Photoshop 4.0 can save files as progressive JPEGs. When you save the file, you're asked to choose how many scans (3,4, or 5) it will use to display the picture.

TIP

GIF images often have a colored border or frame around them, and there's no reason why they shouldn't. The border looks nice, and because it's all one color, it "costs" very little in terms of file space. However, JPEGs treat the color border differently, so the border actually adds greatly to the amount of file space needed. Also, because there's so much of the same color, if the color display needs to be quantized down to 8 bits, the program will think the color is important and will waste multiple color palette entries on it, thus lowering the number of available colors for the actual image and degrading it unnecessarily. If you're converting a GIF to a JPEG, crop the border off before you attempt to save it.

Other Formats

Most image editing programs give you a choice of several other formats, as well as GIF, JPEG, and PICT or BMP. Agfa Photowise for Macintosh, shown in Figure 8.10, gives you additional choices of Windows Bitmap (BMP), TGA (Targa), PCX, or TIFF. Targa is a format developed by TrueVision, makers of several PC video boards, and used by a number of PC/Windows painting and image editing programs. PCX is a standard PC format used by PC Paintbrush.

Figure 8.10

Why does a Mac program give you so many PC choices?

For desktop publishing applications, save your work in whichever format your desktop publishing program prefers to import it. TIFF and EPSF are both widely supported, but Macintosh applications, such as Adobe PageMaker, will also import PICTs, and even GIF and JPEG images. Although you wouldn't want to try to print from a JPEG or GIF, programs such as PageMaker 6.5 also save pages in HTML format for the World Wide Web or in Acrobat PDF format for cross-platform use. Compressed images are not only acceptable for these purposes, but they're mandatory.

> **NOTE**
>
> If you intend to use Adobe Photoshop plug-in effects on graphics you have placed directly in PageMaker, they must be placed as TIFF files.

Storage Media

After a few photo sessions, your hard drive is going to get crowded, especially if you've saved your files as PICTs, TIFFs, or BMPs. Because you can't just file the negatives away and stick the prints in an album, as you can with conventional film, how can you save your pictures for future use and display the best ones? Well, you could look for a bigger hard drive. Several makers are offering 9 GB internal or external hard drives, as of Spring

1997, and the next jump will probably be 12 GB drives. That will hold a lot of pictures, or whatever else you need to save. What you won't save is money. Drives of that size will cost about $2,000.

Floppy disks aren't the answer. A 1.4 MB floppy holds at most three uncompressed images. To store a hundred pictures would cost you about $20. A better answer might be a higher capacity removable media drive, such as Iomega's Zip drive, which uses 100 MB disks that are about the same size and twice the thickness of a conventional floppy. A single Zip disk will hold about 300 uncompressed images at a cost of $12. The drive itself has a street price of $150, as of this writing.

If storing images in hundred megabyte batches isn't good enough, the next step up is the Jaz drive with removable storage in gigabyte cartridges. If you shop carefully, you can buy Jaz disks as low as $90 each, and one Jaz disk will hold 30,000 images. That's a good deal more than most of us will ever shoot. The Jaz drive will cost you about $500 at today's prices. Either the Jaz drive or the Zip drive will function with your laptop, and both weigh about two pounds, making them acceptable traveling companions when you take your digital camera on a trip.

Another alternative is to consider a recordable CD system. Magnetic media, including the Jaz and Zip cartridges, isn't failure proof. If the cartridge gets physically damaged or exposed to a strong magnetic field, you've lost everything on it. CDs aren't absolutely fail proof either, although their only enemies are fingerprints and scratches. As long as you follow the handling instructions, your images should last for many years. The recorders are priced anywhere from $700 to several thousand dollars, depending on speed and features. Recordable disks cost about $7–10 each and can hold about 650 MB of data. Of course, after you've written on them, you can't erase. You can only add more data. Figure 8.11 shows a sampling of removable media.

Figure 8.11

Lots of ways to store your photos.

Magneto-optical drives are yet another popular choice. They're rugged and rewritable. They're also relatively inexpensive. The Olympus SYS.230, typical of this type, is under $360. Each 230 MB magneto-optical disk holds about 700–750 images, and the drive itself weighs only a couple of pounds and can travel with your laptop.

Streaming tape isn't a good choice for storage, unless you are only using it as a backup. The drives and tapes are relatively inexpensive compared to other media, but they're slow. Saved images take a long time to load. More to the point, the tapes are more prone to damage than other media, and therefore less permanent. Table 8.2 shows the storage capacity and cost per megabyte of the various storage media.

Table 8.2 Storage Costs Per Megabyte of Data

Type of Storage	Capacity	Approximate Cost Per MB
Floppy disk	1.4 MB	$.25
External hard drive	9 GB	$.23
Zip disk	100 MB	$.15
Jaz cartridge	1 GB	$.09
Magneto-optical	230 MB	$.09
Recordable CD-ROM	650 MB	$.02

Using File Compression with Saved Images

When you're just learning to use tools like Photoshop, it makes a certain amount of sense to work on a duplicate copy of your original photo rather than on the original image. You can keep archived copies of your original camera files in a compressed form and go back to them whenever you want to try something new. If you use the JPEG compression, however, you're going to lose image quality every time you decompress and recompress. Using a program like Aladdin's StuffIt, or the excellent shareware program CompactPro, you can cut your storage needs without any data loss. These file compression programs use lossless compression to save disk space. The unstuffed file is identical to the original because everything taken out is put back.

How File Compression Works

File compression programs work by simple substitution. Let's consider a line of text that reads: *These three trees are beeches.* To compress it, you can look for patterns. Every time you see the combination "th," you can substitute a *. Every time you find the "ee" combination, you can substitute !. And every time there's an "es," you can use @. So, you'll have: *@e *r! tr!s are b!ch@. Instead of 25 letters, you're down to 18, or a 28% saving.

Graphics files, of course, don't shrink as well as text files do. Photographic images are probably the hardest files to compress, simply because there's so much data and so little of it is repetitive. If your picture has large areas of flat color, it will compress better than a photo that has lots of detail. There are more identical pixels. It also depends on what kind of file you're stuffing, and whether there's extraneous data or repeated patterns that can be compressed. Figure 8.12 shows several different kinds of graphics files saved in StuffIt. These are all the same image in different formats. Savings range from zero for the GIF, which is already stuffed by using the same LZH compression scheme that StuffIt uses, to 88% for the TIFF, which has lots of duplicate information.

	Apple QuickTake 150			
22 Items	502.2 MB in disk		526 MB available	
Name	Size	Kind	Label	Last Mo
Picture 9	50K	PhotoFlash™ document	—	Thu,
Picture 9 copy	83K	Adobe Photoshop® 4...	—	Wed,
Picture 9 copy/jfif	83K	JPEGView document	—	Wed,
Picture 9.GIF	50K	GIFConverter 2.2.8 d...	—	Wed,
Picture 9/pict sp	858K	Aldus SuperPaint doc...	—	Wed,
Picture 9/pict sp.Color-TIFF	908K	GIFConverter 2.2.8 d...	—	Wed,
Picture 9/pict sp.GIF	99K	GIFConverter 2.2.8 d...	—	Wed,
Picture 9eps.export	3 MB	Aldus SuperPaint doc...	—	Wed,
Picture 9jpg	66K	JPEGView document	—	Wed,
Picture 9sp/8	330K	Aldus SuperPaint doc...	—	Wed,
Picture 9tiff.export	908K	Aldus SuperPaint doc...	—	Wed,

Figure 8.12

All these files are the same picture saved in different formats.

Managing Your Picture Files

When you have only a few pictures to keep track of, it's not a difficult task. You can simply start a Zip disk for photos, or a folder on your hard drive, or save them to whatever storage medium you've chosen. But, as you add to your collection and find more and more images that you want to keep, it becomes increasingly difficult to tell what's what. To compound the difficulty, when you save raw camera files, they're generally saved with some generic

name, such as "Image 1" or something incomprehensible such as "r0100001.jpeg 2." If you're lucky, your camera's image retrieval software (the disks or CD-ROM that came with the camera) includes a slide sorting system, such as the Ricoh PhotoStudio software shown in Figure 8.13. Kodak's PhotoEnhancer, which comes with the Kodak DC40 and 50, has a similar "slide table."

Figure 8.13

The Ricoh browser.

Some, but not all, programs will create custom icons for your pictures, based on the images. Here's a set of Kodak pictures, viewed as icons on the Mac (see Figure 8.14). The images are small and not terribly easy to see, but if you know what you're looking for, these will help you find it.

Figure 8.14

The icons are thumbnail size views of the pictures.

Of course, you can also go through your picture files and rename them with titles that are more helpful than "Image 2" or a string of numbers. At the same time, you can sort them into separate folders titled by the subject, event, or date you took the picture—whichever of these will help you most in finding it six months down the road. However, this is time-consuming, and not totally reliable.

Suppose that you like to photograph flowers, and you label more than one picture as "red flower." How can you tell which is the begonia and which is the cactus? You might be able to see the difference in the thumbnail-sized icon. But you might not be able to see it—especially if you're trying to find one particular shot of red begonias out of a dozen that you shot on the same day.

This is one case in which a scrapbook type of program can be helpful. There are many of these available, both as shareware and as commercial programs. The two scrapbooks discussed below are, unfortunately, only published in Mac versions at this time, but Windows users should check out Softkey's "Clipart" and MGI PhotoSuite, which also gives you the capability to create albums, as well as to do some editing of your images. The CorelDRAW! suite includes a MultiMedia manager that also acts as a scrapbook for your photos, artwork, and sounds.

Windows users should be aware that the card file can also hold images as well as data. This may not be the most convenient place for long term storage, but you might find it easier to place pictures that you plan to work on into this file for speedy retrieval.

Now Scrapbook

Even though the Mac has a built-in scrapbook, there are many good reasons to use a program such as Now Utilities' Now Scrapbook. It's more powerful, and you can keep as many separate scrapbooks as you want, for different kinds of images. You can even do editing right in the scrapbook, saving the time and nuisance of opening a graphics program if you only want to crop an image before pasting it into a document. You can download the complete set of Now Utilities from http://www.nowsoftware.com and try them out for yourself before you buy.

When you first open Now Scrapbook, you'll see a window like the one in Figure 8.15, only with nothing listed (unless you have opened a sample catalog). To add items to your catalog, use Import from the File menu, or simply drag your items onto the open scrapbook. In addition to PICT, Paint, TIFF, EPS, and QuickTime movie files, the scrapbook can hold text files and AIFF and System 7 sound files.

Items in the scrapbook catalog can be displayed either as thumbnails, as shown in Figure 8.15, or at their full size. Use the left-hand set of buttons to choose between the thumbnail and full view; you can also choose between the list of items in the catalog and detailed information about a single picture. Figure 8.16 shows an example of the detail view. You can type any kind of information, comment, or keyword relating to the picture in the text box and then use Now Scrapbook's Find feature to locate your pictures by the text. The date and time shown in the detail view refer to the time when the picture was put into the catalog, not when it was taken.

Figure 8.15

The Now Scrapbook program can handle as many different scrapbooks as you want to create.

Figure 8.16

Describe your picture, date it, or enter keywords to help you locate it.

The Clipboard Editor, shown in Figure 8.17, gives you the tools to crop and resize your pictures or to enlarge the image and copy just a small piece of it, if you want.

When you export a file from the Scrapbook, you can convert it to a GIF, TIFF (for either Mac or PC), JPEG, or PICT. All these choices are on the pop-up menu that appears in the window when you select Export from the File menu. Pictures you put into the scrapbook are stored in it, so scrapbook files can become rather large. Of course, if you have saved pictures into the Now Scrapbook, you needn't keep them elsewhere on your hard drive. Deleting duplicate copies can save you some space.

Extensis Fetch

If you're willing to do a little extra work when you set up your scrapbook, retrieving an image can be as easy as thinking up a word to describe what you're looking for and typing that word. Fetch, from Extensis, isn't exactly a scrapbook. It doesn't hold your pictures. Instead, it maintains a catalog of thumbnails with pointers to the original images. A single Fetch catalog can hold as many as 100,000 items, and you can create as many Fetch catalogs as you need.

If you have several different projects going at once, it would be sensible to keep a different catalog for each one. Images that you use in several different projects can be put in different catalogs without duplicating themselves and taking up unnecessary space, because the catalogs only point to the disk locations of the original files. These catalogs can even be shared among workgroup members as long as they all have the Fetch application installed.

When you first start Fetch, you'll be asked to create a new catalog, because none currently exist on your hard drive. Then Fetch will present you with the Add/Update dialog box shown in Figure 8.18. Select from the list the kinds of files you want Fetch to catalog for you. You aren't limited to graphics files, either. Fetch can also handle movies and sounds, QuickTime and QTVR files, and text files.

Figure 8.18

First, select the files to catalog; then click Continue.

Add/Update Options		
		File Types
Modification Method:	Add and Update ▼	✓ Adobe Acrobat v2
Include Path as Keyword:	Folder and file name ▼	Adobe PageMaker v4
Thumbnail Type(s):	32-bit ▼	Adobe PageMaker v4 Template
Compressor Criteria:	Any ▼	Adobe PageMaker v5
Compressor Type:	Best Overall ▼	✓ Adobe PageMaker v5 Template
	Quality : High (3.0)	✓ Adobe PageMaker v6
	Color : Color	✓ Adobe PageMaker v6 Template
		✓ Adobe PageMaker v6.5
☒ Extract Keywords	☐ Edit Keywords	✓ Adobe PageMaker v6.5 Templ...
☒ Extract Description	☐ Edit Description	Adobe Persuasion Player v3
☒ Extract Thumbnail		Adobe Persuasion v3
		Adobe Persuasion v3 Template
☐ Use "Exclusions" File		
☐ Mount Remote Volumes		
[Save As Default] [Default]		[Done] [Continue...]

To add files to the catalog, the easiest way is to drag a folder, or even a disk icon, onto the Fetch icon. Fetch will scan the selected folder or disk and add any files it finds of the type(s) you have selected in the window in the Add/Update box.

What makes Fetch useful, though, is its keyword search system. You can assign as many keywords as you want to each image and then use the Find dialog box to enter a keyword; or by selecting More Choices, you can find as many as four different keywords. You then choose whether the keyword you're looking for does or does not match, start with, contain, or end with the word you've entered. When you are searching by more than one term, you can also specify whether the additional terms are required or optional, "and/ or." This kind of search is called a Boolean search. Figure 8.19 shows a typical keyword search.

Figure 8.19

The search terms are on pop-up menus.

My New Catalog ◆ Find			
Find items whose			
☒ [Keyword ▼]	[does ▼]	[match ▼]	[green]
[More Choices]		[Clear]	[Find]

When you're assigning keywords to your pictures, think in terms of the most helpful single word descriptions. Try to maintain consistency. If you have a bunch of pictures of women, don't key one as "female" and the next as "woman." Using "vertical" and "horizontal" in your keywords can save a lot of time if you need a particular shape of picture for an ad or catalog page. Make sure that you're spelling your keywords correctly, and that you're not using the singular and plural forms ("woman," "women") interchangeably. Project titles, dates, and similar information may make useful keywords, but only if you can keep track of what you shot and when.

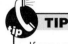
TIP

If you get stuck, use Command+' (apostrophe) as a wild card to retrieve everything in the catalog for a visual search.

You can use Fetch to move images from one storage medium to another and, if you intend to maintain the usefulness of your catalog, this is how you *should* move the images. Otherwise, you'll break the links to the originals, and the catalog will be useless.

Assignment

Upload your previous assignments to your computer. If you have a scrapbook program, sort your pictures into the scrapbook, assigning keywords. If you don't have a scrapbook program, design a system for yourself with folders for different kinds of images.

In the Digital Darkroom

- Software for image enhancement (Mac and Windows)
- Basic clean-up
- Color balancing
- Cropping
- Simple retouching

The hardest part is done. You've taken pictures and moved them from the camera into the computer. Now the fun begins. You can fix up the pictures that didn't come out quite as you'd intended, and you can use any of your photos as a jumping-off point for a piece of digital art.

In this chapter, we'll take a quick look at several different photo-manipulation programs. Don't worry if you don't have all of them. You should, however, have *one* of them. (It should have been included with your digital camera.)

At this point, you may not understand every last word or know how to use everything I'm talking about in each program. The point of this chapter is not to teach you how to do all the tricks, but rather to give you an idea of what's possible with image-manipulation programs, and some of the great fun you can have with the software that you'll eventually want to buy. Think of it as a vacation before we dig deep into Adobe Photoshop, which we'll start in the next chapter. So in the meantime, sit back and enjoy the show, and think about the things you can do to your own photos with these tools.

Software for Image Enhancement

There are essentially two kinds of image editing programs: quick and easy, or slow and complex. The good news is that this is one case where you don't necessarily need to spend a lot of money to get a good product. Of course, you *can* pay literally hundreds of dollars for a program such as Photoshop or LivePicture for editing your digital images, but you can just as easily pay considerably less money for LivePix (a scaled down version of

LivePicture), PhotoStudio, or MacSoft's PhotoMaker. Another cheap option is to use the software that came with your camera. The Kodak cameras all ship with PhotoEnhancer, while Casio and Agfa supply a copy of Adobe PhotoDeluxe. Ricoh ships its own Ricoh PhotoStudio. Any of this software can do a fine job of cropping and basic color correcting, and they all include some special effects filters to get you started.

PhotoDeluxe

Adobe PhotoDeluxe is a terrific program with an annoying interface. It can do almost as much for your photos as its big brother, Photoshop, can do. There are two ways to use it: either by following its procedures step-by-step, or by being bold and jumping in on your own. When you start up PhotoDeluxe, you must choose between Guided Activities and On Your Own (see Figure 9.1). Even if you don't own PhotoDeluxe, read this section anyway. Many of the procedures are the same in other programs, and you'll get an idea of what's possible.

Figure 9.1

The Windows version looks similar to the Mac version shown here.

Guided Activities directs you to choose from Touch Up, Transform, or Cards and More, which is a collection of templates for placing your pictures on calendar pages, report covers, and so on. When you choose Touch Up or Transform, you will be directed to open one of your previously saved images or to choose one from some other source; then you will be lead through the process of improving the picture.

To select a photo from those you have downloaded, choose Open File and then use the window to locate and open one of the saved pictures (see Figure 9.2). You can also import a picture from the camera by choosing Get Digital Photo, or you can work on a sample picture or a scanned image.

Having opened a picture to work on, you simply follow the numbered tabs. PhotoDeluxe will walk you through how to correct the color, the contrast, and other possible "fixes" for your picture. Instant Fix applies what PhotoDeluxe calculates as standard corrections, bringing contrast and brightness to a middle range. It will improve a picture that is a little bit under- or overexposed, but it should be avoided if you are looking for a special effect. In Figure 9.3, Instant Fix turned the ocean storm back into a sunny day at the beach (also see Color Plate 9.1).

Figure 9.2

Use Get Digital Photo if the camera is connected to the computer.

Figure 9.3

Auto Correct does what PhotoDeluxe thinks is needed. You may (or may not) agree.

You can skip Auto Correct and go on to make your own corrections. What you can't do, however, is skip any of the numbered tabs or go back if you change your mind. That's one of the minor frustrations of this interface, and why you may prefer, as I do, to ignore it and choose to work on your own.

On Your Own with PhotoDeluxe

When you're working on your own with PhotoDeluxe, you still need to follow steps in a logical order. First, you must bring in the picture that you want to work with. Then click Modify to open up the tools. Clicking any of the tabs will give you access to the related tool buttons. To get easier access to all of PhotoDeluxe's tools, go to the File menu and select Long Menus. You can choose tools from the menus, from the icons (tool buttons) that PhotoDeluxe places on the screen, or by learning and using the Command key

combinations that are listed on the menus. For example, ⌘+3 does the Instant Fix, and ⌘+E gives you the Eraser tool.

Figure 9.4

Increasing the saturation will darken those clouds.

You'll also notice a set of tools on the left side of the screen. The plus and minus magnifying glass buttons let you zoom in and out to make your picture bigger or smaller. Below them is the selection tool menu. This is actually a pop-up menu of selection tools in various shapes. Most of these will be familiar to anyone who has used any other graphics program. Selection rectangles, circles, and squares let you drag and select parts of the picture, using those particular shapes. By default, these shape selection tools draw the selection boundary from the edge. In some cases, it's easier to draw a selection circle or oval from the center. To do so, hold the Option key (Macintosh) or Alt key (Windows) while you drag.

The Color Wand tool is called the Magic Wand in most other programs that have one. It's used to select pieces of the picture according to the color of individual pixels. You can make it more or less sensitive by changing the tolerance setting in the File> Preferences>Cursors dialog box. To make it more discriminating, (fewer shades selected), use a lower number. Numbers over 20 seem to be too generous, and you may end up selecting the whole picture.

It's not obvious to the first-time user, but you can apply corrections to just part of a picture, by selecting only the area that needs to be changed. Suppose that you want to darken the clouds in a beach scene. If you choose the Color Wand and click it on the

cloud you want to darken, you can then go into the Hue/Saturation window and move the sliders until you like what you see onscreen (see Figure 9.5). Be sure to check the Preview box so that you can see the effects of your changes.

Figure 9.5

Move the slider to adjust the color of the selected area.

We can make multiple selections by selecting one area, clicking the Add wand, and selecting a second area. The first area will also stay selected. To deselect everything that has been selected, we simply click the None button. To deselect one part of a multi-area selection, we can click the Reduce wand; then click the part of the selected area to deselect.

The other useful tool on the left side of the screen is called Layers. Working with layers lets you create a collage of several photos, even adding text or drawings, without affecting the original photos in any way. You can think of the layers as transparent sheets of cellophane on which you place your pictures, drawings, and words. You can view them as a stack and rearrange the layers to bring up or hide parts of the picture. PhotoDeluxe enables you to add as many as five layers to an original image—for a total of six.

Creating a Layered Document

To create a collage of two or more pictures, first we must prepare the one that will be the background. We will do whatever is necessary to crop or resize it, correct the colors and brightness, and give it any other attention it may need. Then, we will put it on hold to save it. (You can have only one photo active at a time, so you must save the first one before you go to the next.) Next, we will prepare the second photo in the same way.

To put a picture on hold, we click the Save/Print button. Click Save; then click the Hold Photo button. Next, we're asked to give the picture a name. The photo will be saved to a special subdirectory on our hard disk so that we can move on to work with other pictures for the collage. Eventually, we should have all the pieces of the collage on hold.

We will retrieve the background picture first by opening the Hold Photo window. Clicking the blue bar opens up a gallery of thumbnails of all the pictures on hold (see Figure 9.6). We can either double-click the picture we want, or select it and click Paste Layer. Then we type a name for the layer, specify layer options, and click OK.

Figure 9.6

Choose the background to open as the bottom layer.

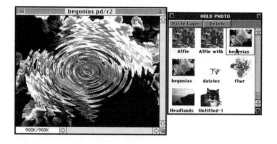

Repeating this procedure adds another layer with the second picture. After we create a new layer, it appears in the Layers area as the topmost layer. We can either create a new layer by pasting a photo from the Hold Photo window or by using the Layers area to create a blank layer. Some features, such as the Text tool or the Drop Shadow button, automatically create new layers for you.

If we decide to make further adjustments, we can hide any layer by clicking on the Eye icon to close it. The active layer is the one that is highlighted. To make a different layer active, click on it. In Figure 9.7, a second layer is added to the picture. Color Plate 9.2 shows the finished picture in color.

Figure 9.7

The layer with the single flower is the active one.

Special Effects in PhotoDeluxe

PhotoDeluxe comes with a selection of special effects. There are various degrees of blur, stretch, ripple, and other distortions, as well as a few of the filters from Kai's PowerTools. The background in the flower picture in Figure 9.7 was turned from an ordinary bed of flowers into a reflecting pool with the ripple effect. Combining several effects can be even more interesting. Figure 9.8 shows one of my favorite pictures of Reebok, the black-and-white cat. First, I used the KPT charcoal edges filter to turn him into a line drawing. Then I used the circular blur. Finally, I crystallized the blur to restore some of the character of the line drawing.

Back in the Guided Activities section, you have the option of making your PhotoDeluxe creations into posters, report covers, calendar pages, greeting cards, and so on. You can

also paste "decorations" on the pictures from a collection of clip art bits that is found under the File menu. Although none of these items are in any way professional-looking, they're fun to play with.

Figure 9.8

Remember, if doesn't work as you intended it to, you can Undo it.

PhotoEnhancer

Kodak gives you a copy of PictureWorks PhotoEnhancer along with your digital camera. Which version you get depends on how much camera you buy. The DC20 and DC25 ship with a "Special Fun Edition," while the DC40 and DC50 come with the regular edition. The two, alas, aren't interchangeable. If you have a DC50, you must use the regular edition. If you have a DC25, you can only use the Fun Edition. You can't open DC25 images with the DC50 version of the software, unless you have previously saved them as PICTs or .BMPs.

Kodak also includes Picture Easy with its DC20 and DC25 cameras. It is a very easy, but not very functional program for viewing your pictures. Figure 9.9 shows the screen as I'm preparing to save the pictures I've retrieved from the camera. Unfortunately for those in search of quality, it saves them as JPEG files. You can display them and print them, but this program doesn't include any tools other than the capability to rotate a picture from horizontal to vertical. If your pictures need any kind of clean-up, cropping, or other enhancement, you'll have to reopen them with PhotoEnhancer.

Fortunately, even the Fun Edition of PhotoEnhancer has powerful tools for image handling. We can either choose "SmartPix," which lets us enter the lighting conditions at the time we took the picture and corrects it automatically, or we can choose "By Example" and work our way through a series of thumbnails with differing degrees of

correction applied until we find the one that looks most correct. Figure 9.10 shows PhotoEnhancer Fun Edition in use.

Figure 9.9

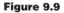

The capabilities of this program are very limited.

Figure 9.10

Click either the SmartPix or By Example icon to start the process of correcting the image.

Correcting By Example is the most accurate process, and also the most fun. You can see exactly what changes each degree of correction will make. Figure 9.11 shows the Filter By Example window. We can slide the square window around to see different parts of the image and then evaluate the nine thumbnails based on which one gives us the best overall correction. We can change the focus, exposure, brightness/contrast ratio, and the color balance. Use the Variations pop-up menu to determine whether the individual steps in each set of changes are large or small; choose Fine, Coarse, or something in between.

PhotoEnhancer comes with a fairly limited tool set. Figure 9.12 shows the tools. Most of these should be familiar, but there are a couple of surprises. The brushes will lighten or darken whatever you paint over with them. The effect builds as you repeat it. Don't overdo it because Undo only undoes one action. If you've gone over the same spot several

times, you can only undo the last pass. To select more than one area with the Magic Wand, hold the Shift key as you click.

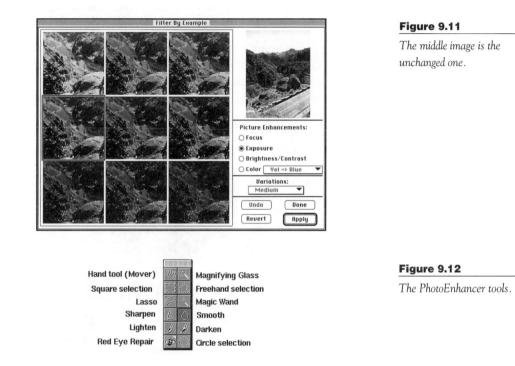

Figure 9.11

The middle image is the unchanged one.

Figure 9.12

The PhotoEnhancer tools.

You can't paint over something you want to hide, but if it's surrounded by an easily cloned background, you can cover it up by selecting a different part of the picture and pasting it in. Use the Smooth tool to help disguise the pasted area.

Ricoh PhotoStudio

PhotoStudio is a very versatile program, and is quite possibly the best feature of the Ricoh camera. It's nearly as powerful as Adobe Photoshop, and even includes a printer calibration system that's simple to use and gives you a virtually perfect, color-accurate print of whatever you see on your screen. It also comes with a browser that will display your pictures as a slide show, as well as cataloging them in a scrapbook-type format for you.

PhotoStudio is also the software for downloading images from a Ricoh RDC-1 or RDC-2 camera. As such, it can copy single images, sounds, and single images with sound. It can't copy the RDC-1's motion scenes. It also can't copy pictures directly from the PC card to a Macintosh. If you have saved images to a card, you must use a PCMCIA card

reader or the PCMCIA card slot available on some PowerBooks to download these images. Windows users can download still images or sounds from either camera to the computer via the COM1 port, but they cannot download continuous images without a card reader.

Figure 9.13 shows the PhotoStudio interface. Notice the full tool set, and the exceptionally easy-to-use Color Picker. Again, most of these tools should be familiar to anyone who has used any other graphics program. The light bulbs are PhotoStudio's idiom for lightening and darkening a piece of the image. In photographer's terms, these are called dodging and burning in. Dodging, in the darkroom, keeps light from exposing the paper, so that part of an image remains lighter. Burning in means putting extra light on part of an image, to make it darker.

Figure 9.13

PhotoStudio in use.

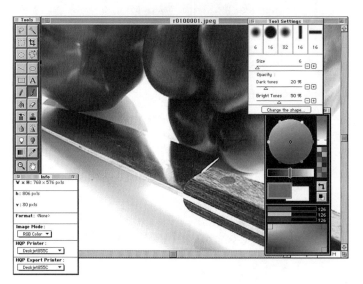

Most of the tools in PhotoStudio can be adjusted by using the Tool Settings window. The painting tools, sharpen and blur, and the dodge and burn tools can all be adjusted for size and for other relevant qualities, such as opacity or pressure. If the Tool Settings window isn't visible, you can open it under the View menu, or double-click the tool you want to use, to make settings available. The program includes over 40 different special effects and enhancements to let your creativity run wild. You can emboss a picture, turn it into an Impressionistic oil painting, apply a fisheye lens, and do literally dozens of other tricks, most with a simple mouse click or two.

PhotoStudio's browser works much like Now Scrapbook. It shows a thumbnail of each image, as in Figure 9.14. You can reptile the pictures and add comments if you want. To

see fewer, but larger thumbnails, click on the square button icon at the top of the window. The magnifying glass enables you to zoom in on a single picture.

Figure 9.14

The PhotoStudio browser displays thumbnail images of your pictures.

The best news about PhotoStudio is that (if you use Windows) you didn't have to buy a Ricoh camera to get a copy. You can download a free trial version (30 days or 100 openings) from `http://www.arcsoft.com/trialps2.htm`.

If you do choose to buy it, the price, including a copy of Kai's Power Goo for Windows, is under $100. The Mac version, called PhotoFix, is distributed by MicroSpot USA and can be downloaded in demo version from `http://www.microspot.inter.net/`. It sells for $139.

High-end Digital Darkrooms

There are, of course, some very sophisticated and complex programs that will do more for your pictures than any of the ones we've looked at so far. Adobe Photoshop is the standard by which all other such programs are judged. It does everything—and then some. The only drawbacks are that it's expensive (street price $550), and because it's so full-featured, the learning curve is steep. If you want the tools without the price tag, PhotoDeluxe is a good choice, as is Ricoh's PhotoStudio.

If you already own a painting program, such as Fractal Painter, Adobe Illustrator, or even SuperPaint, you can use it to do retouching and many special effects, as well. Fractal Painter is especially rich in tools to convert your photos to mosaics, Impressionist paintings, or texture panels. In fact, in some cases you can do much more to a picture in Fractal Painter than you can do in Photoshop.

The other high-end photo manipulation program worthy of consideration is LivePicture. This program has the advantage of costing less than half as much as Photoshop, but it does

209

most of the same things, and some users of both actually prefer LivePicture. The user interface is designed to let you toggle between two sets of LivePicture tools: creative and mechanical.

The creative tools enable users to work with brushes, marquees, and path tools. The path tools create paths, which can be used as masks and stencils. The program can also insert text into a picture. You can select brush size palettes, brush speed, and a selection of specialty brush modifiers, including noise controls, pastels, and water color. All of the creative tools are available in every layer. The mechanical tools can crop and position images. They are available at any time to rescale, rotate, skew, and flip one or more layers.

Like Photoshop, LivePicture is complex enough to have a fairly steep learning curve, but it's worth mastering. Version 2.6, which will be released as this book goes to press, promises additional features, including many more filters and the capability to use Kodak's FlashPix technology.

Easy Fixes

Some pictures are perfect when you take them. Most could stand a little tweaking to make them even better. It's an unfortunate characteristic of the digital camera that pictures are often over- or underexposed. The metering system used in most cameras is good, but because it was originally designed for film emulsion, and not for a charge-coupled device, it's not quite attuned to the same sensitivity and contrast ratio. (At least, that's my theory.) The bottom line is that some pictures are a bit darker than you intended. Others are lighter in some areas, and too dark in others. But because we're working in the computer, and not in the darkroom, such problems are easy to correct.

Auto Corrections

Let's start with a picture that's a little too dark. PhotoStudio's AutoFix command lightened it, but turned it a little too blue. The Kodak PhotoEnhancer SmartPix made it too red. PhotoDeluxe Instant Fix did the best job of adjusting the exposure without losing the color balance. Figure 9.15 and Color Plate 9.3 show the original and the fixes.

You can do a better job of correcting it by *not* using the AutoFix method, but instead taking the controls and adjusting the image until you're happy with the results.

In PhotoDeluxe, you can start with the Color Balance, as in Figure 9.16. With Preview enabled, adjusting the sliders on the screen lets you see the effect of each color change immediately. The original had too much red and magenta in it. By adding the compliments of those colors, cyan and green respectively, you can bring the colors back into balance. A little extra blue counters the yellow that the green has added, and the picture looks much better.

Figure 9.15

*Image B was corrected
in PhotoStudio, C in
PhotoEnhancer, and D
in Adobe PhotoDeluxe.*

Figure 9.16

*You can either move the
sliders or enter numbers in
the boxes.*

Brightness/Contrast and Hue/Saturation and Lightness enable you to make additional adjustments. Brightness lightens the image, while Contrast emphasizes the lightest and darkest tones in the picture. Most digital photos seem to benefit from one or two points of additional contrast and a little extra brightness. It makes the image seem sharper. Hue and Saturation relate to the amount of color in the picture and the actual "blueness," "redness," and so on of the color (see Figure 9.17). You can experiment with these controls until you're satisfied with the result.

The Sharpen filter, used once, adds contrast between adjacent pixels. Used more than once, it adds an unfortunate "jaggie" look to the image. Be careful not to overdo it. (It's especially noticeable on diagonal lines.) If the program you're using has a Blur filter, you can use it to undo the effects of sharpening, if you decide you don't like the artificial quality it sometimes adds.

Finally, using the Remove Dust/Scratches filter can smooth out any little bumps or off-color spots in the image. Set the sliders to determine how big a bump or dust particle you

want to smooth over. Set the radius as small as possible. Even at 3 pixels, as shown here in Figure 9.18, it blurs the detail on the cherub unacceptably.

Figure 9.17

Be sure that Preview is checked so that you can see what you're doing as you do it.

Figure 9.18

If there's no obvious dust, skip this step.

Cropping

What looked like a great photo when you shot it may be disappointing when you see it onscreen. A lot of times, the trouble is composition. Even though you've learned the rules, you might forget your lessons in the excitement of discovering the definitive view of the Grand Canyon or finding the perfect cloudy seascape. Chances are that the picture's right there in front of you, but it needs a little recomposing. That's when it's time to reach for the Cropping tool.

Cropping enables you to rebalance a picture that just misses being right, or one where you forgot the rule of thirds and put the subject dead center. It lets you compensate for the tilted horizon by rotating the entire frame until the ocean is level and then squaring up the edges again. These are legitimate tricks that all good photographers use.

Let's fix a downhill ocean. Figure 9.19 shows the original picture, which I've opened in PhotoStudio. It's an okay portrait, but I must have been standing on a hill when I shot it (and standing too far back, at that). Certainly, there's more space in the picture than it needs.

The first step is to rotate the picture so that the horizon is more or less flat. That's easily done with the Rotation tool. You can drag a horizontal line across the image to check it against, if you're not sure you can level it by eye. Figure 9.20 shows the rotated image.

Cropping the picture more tightly not only gets rid of the crooked corners, but also improves the composition greatly. Use the Cropping tool to select the area to keep; then click within it to eliminate the unwanted parts. Just drag the cropping boundary across the image. You can also use the "handles" on the cropping box to move it in or out. If you're unsure about how much to remove, you can crop in several steps until the picture

looks "right." Now, all it needs is a little color correction, which I'm applying in Figure 9.21, and it's done. I've taken this from an unacceptable picture to a decent one in three steps and about three minutes, total.

Figure 9.19

I guess the tide was going out.

Figure 9.20

Now he's sitting up straighter, too.

Figure 9.21

PhotoStudio's "before and after" images make color and brightness adjustments easy.

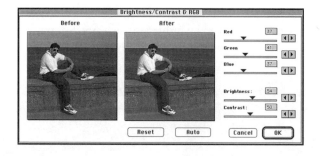

Cropping is one way to turn a very ordinary picture into a more interesting one. But digital darkroom programs give you many ways to remake a picture. Figure 9.22 shows a nice shot of yellow flowers against a dark background. It's well lit, reasonably well composed, and worthy of any first-year art student, but it's not very exciting. Because we've opened it in PhotoDeluxe, let's see what some of their special effects tools can do to it.

Figure 9.22

An okay picture, but not a great one.

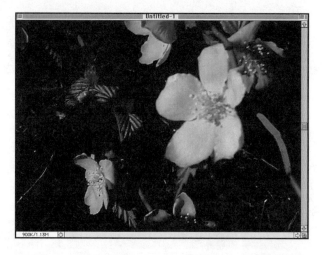

Georges Seurat was the French Impressionist responsible for "pointillism," which reduces a picture to a set of colored dots. Doing this to our yellow flower is easy. All we need to do is to apply the proper filter. But the dark area on the left of the picture doesn't translate well. Copying one of the smaller flowers to fill in that space makes the pointillist version of the picture shown in Figure 9.23 much more interesting.

Dots are only one of the possibilities. You can trace the flower's edges and remove the background, turning it into a delicate pastel drawing. You can reduce it to a pattern with the Vortex filter. You can combine the ripple and wind effects to add movement to the picture. You can use the Soften filter to throw the image out of focus; then use the Crystallize filter with moderately large crystals to give a sort of stained glass effect. Color

Plate 9.4 shows a selection of these images. Don't worry if you haven't a clue about how to apply these effects. You'll learn all about filters, how to use them, and how to do all kinds of special effects in the next three chapters.

Figure 9.23

Dots can be interesting…

Simple Retouching

Sometimes there's a spot in the picture that you just didn't notice when you shot it. Maybe it's a cigarette butt on the grass or a beer can in that babbling brook. Sometimes there are things in the picture that you noticed, didn't want, and couldn't do much about, like telephone or power lines, or your daughter's awful boyfriend. Retouching these on a conventional print could take all day. Here again, the good news is that you're working with digital images. Corrections are simple. It's a three-step process. First, you select the parts of the picture that you want to get rid of. Then you delete them. Finally, you fill in the gaps with a cloned background. Here's what the process looks like in a very simple version.

The original photo of a snow-covered tree has a set of snow-covered power lines running across the top of the picture. I could try cropping the top of the picture, but I'd still either see a piece of the wire on the right, or I'd have to cut off the top of the tree. Neither of these is an acceptable solution. So, instead, I'll remove the wires and not cut off any of the photo.

Using the Color Wand, I can select as much as possible of the offending wires (see Figure 9.24). Then I can simply delete the selected parts by pressing the Delete key. If a few bits of the line are left, I can either try again to select them and delete them, or I can use the eraser to get rid of them.

Figure 9.24

First, select the wires.

I'm left with an image that has a nice tree, lots of snow, and several white strips through the top of the page. I have several possibilities for filling these in. I could use the smudge tools and just spread the background sky to cover the holes. But that might not look natural. Instead, I can clone a background. Although PhotoDeluxe lacks the Rubber Stamp tool that Photoshop has, you can still copy and stamp pieces of the picture. In Figure 9.25, I have selected a piece of sky. Holding the option key and dragging enables you to place the selected piece of sky wherever you want it. Each time you let up on the mouse button, a copy of that piece of sky is "planted" right where you dropped it. After filling in all the spaces, you can go back over it with the Smudge tool to smooth out any differences in color.

Some pictures need more help than others. The snapshot in Figure 9.26 was taken at a party and suffers from a half dozen different problems, including glare, cluttered background, and miscellaneous unattached body parts. Figure 9.27 shows the same picture after editing. First, I cropped away the unnecessary pieces on the right, including someone's hair and someone else's leg. Then I got rid of the distracting white T-shirt that hung over the edge of the counter by copying pieces of the wood grain and moving them up carefully to keep the grain and the grooves lined up as much as possible. There was

a piece of the counter edge showing on the right, so I copied it and dragged it across to put an edge all the way across. By darkening the background, I put more emphasis on the woman modeling her birthday presents.

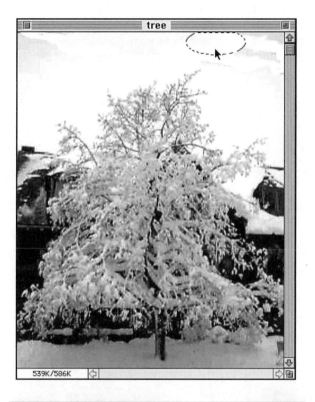

Figure 9.25

Cover the gaps with whatever background is available.

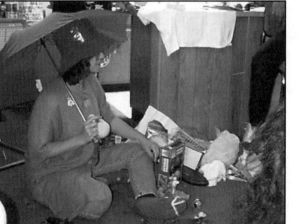

Figure 9.26

The large white areas are distracting.

To replace the white areas on the floor, I used the Eyedropper to pick up shades of blue from the rug. Selecting the area to be filled and pouring paint into it gave a very even blue tone, so I sampled a couple of other colors and spritzed over the area with the airbrush tool to make the color less even. I used the dodge and burn tools to lighten her face and darken parts of the background that were unimportant to the picture. Finally, I removed a couple of unrecognizable items from the floor by copying the carpet over them. Where one covered a piece of her shirt, I copied a triangular piece of shirt fabric and moved it into the empty space.

Figure 9.27

The finished picture is still cluttered, but not as badly.

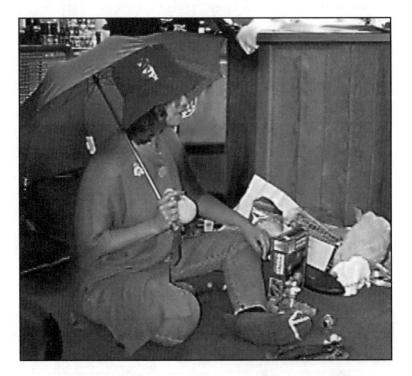

Fixing Red Eye

As you know by now, red eye results when a portrait subject looks directly into the flash and his or her eyes reflect the light back from the retinas. It's ugly. About the best thing you can say for it is that it's easy to fix.

To repair red eye, enlarge the picture so that you can see the individual pixels that make up the eye. Depending on the size of the person, or pussycat, in the picture, anywhere from 200–400% should do it. In black and white, it's a little bit hard to see the red area, but in Figure 9.28, the Magic Wand is pointing to it. Select the red. Use the Eyedropper

to pick up a more appropriate eye color and either pour it in with the paint bucket, or draw it in, a pixel at a time, with the pencil, if you're not sure you can pour into a small space. Color Plate 9.5 shows the cat with no more red eye.

Figure 9.28

Fixing something small is easier if you work with a magnified image.

Digital Craftsmanship

Now you have seen many of the things you can do with your camera and your computer. You've had an overview of the simple image processing programs and what they can do to improve your pictures. Starting tomorrow, we're going to dig into Photoshop, the granddaddy of all digital darkroom programs. If you don't happen to own Photoshop, don't despair. As you saw in this chapter, most of the same techniques can be applied with simpler programs as well. It's not the tool that determines the quality of the work, as much as it's the craftsperson who uses it. With all you've learned so far, you're well on your way.

Assignment

Experiment with the tools in your digital darkroom program. Import a picture and practice cropping, color changing, and using all of the tools available to you. Remember to work on a duplicate, rather than your only original copy of the picture. Have fun with it! The more exploring you do, the better...

Getting Started with Adobe Photoshop

- Using the tools
- Using image controls
- Levels
- Curves
- Brightness/contrast
- Hue/saturation
- Retouching with brush, pencil, and stamps
- Removing unwanted objects from pictures
- Working in layers
- Using masks
- Masking the background
- Masking an object

Many photographers and graphic artists admit to having a "love/hate" relationship with Adobe Photoshop, just as many writers do with Microsoft Word. On one hand, it's the absolute state-of-the-art for image manipulation. On the other hand, it's a difficult program to master, and one that demands a great deal of patience, as well as a great deal of RAM. Because it has been the model for most of the other digital darkroom programs, even if you're not a Photoshop user, this chapter will teach you some tricks that will carry over into other darkroom and graphics programs you *do* use.

Using the Tools

The tool palette is the basis for everything you do in any graphics program, not just in Photoshop; however, Photoshop gives you a second way to access the tools. Instead of clicking on the tools you want to use, you can type a single letter shortcut to select each tool.

NOTE

There's a hidden screen in the Photoshop About box. To meet the Big Electric Cat, hold down the ⌘ key (Mac) or the Control key (Windows). Hold down the Option key (Mac) or the Alt key (Windows) to see a list of everyone who worked on the project. Don't miss the last message on the list.

Figure 10.1 shows the tool palette with callouts to indicate the names of the tools and the shortcut keys that can be used to select them.

Figure 10.1

The Photoshop tool palette.

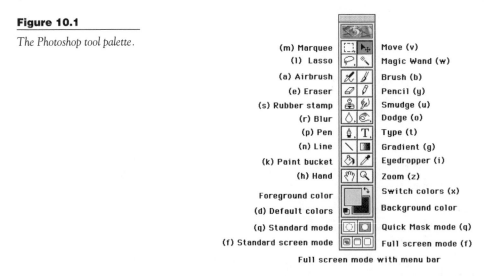

(m) Marquee — Move (v)
(l) Lasso — Magic Wand (w)
(a) Airbrush — Brush (b)
(e) Eraser — Pencil (y)
(s) Rubber stamp — Smudge (u)
(r) Blur — Dodge (o)
(p) Pen — Type (t)
(n) Line — Gradient (g)
(k) Paint bucket — Eyedropper (i)
(h) Hand — Zoom (z)
Foreground color — Switch colors (x)
(d) Default colors — Background color
(q) Standard mode — Quick Mask mode (q)
(f) Standard screen mode — Full screen mode (f)
Full screen mode with menu bar

Selection Tools

The selection tools are at the top of Photoshop's tool palette. There are three: the Marquee, the Lasso, and the Magic Wand. These tools are extremely important to understand because you can't modify part of an image unless you first select it. A selected

area is indicated onscreen by a blinking selection border, called a *marquee*—after the movie theater marquee lights that appear to be in motion. The Marquee and Lasso tools work by dragging the tool over the part of the image that you want to select.

The Marquee and Lasso icons have additional tools on pop-up menus, as shown in Figure 10.2. Hold the mouse button down as you point to the icon, to make the menu pop up. (This is true of all pop-up menus.) The Rectangular marquee makes a rectangular selection. Use the Elliptical marquee to select a circular or oval area. The Single Row and Single Column marquees are especially helpful, because they select precisely one row or column of pixels, the length of the box that you drag. The last tool on the marquee menu is the Cropping tool. (You can also open it by typing the letter C.) Like the Marquee selection tools, you click and drag to select an area. There are two differences, though. First, the Cropping tool also places "handles" on the Cropping marquee that you can click and drag to fine-tune the size of your cropped image. Second, when you double-click inside the selected area, everything outside it is cropped away.

Figure 10.2

The Tool palette pop-up menus.

To cycle quickly through the Marquee tools without using the pop-up menu, press the Option key (Mac) or Alt key (Windows) while you click the Marquee icon. Each click will bring up the next tool in line.

The Lasso tool gives you two choices: a freehand lasso that you can drag into any shape, or a polygon lasso that draws straight lines in any shape you want. To draw a polygon selection box, hold the Option (Mac) or Alt key (Windows) and click where you want line segments to begin and end.

Tool Options

You can further influence the way these tools work through the Marquee Options palette, shown in Figure 10.3. The Shape menu simply gives you another way to switch marquee shapes. Under the Style menu:

■ Normal determines the proportions of the rectangle or other marquee shape by dragging.

- Constrained Aspect Ratio sets a height to width ratio for the marquee. Use it when you want to select a perfect square or a specifically proportioned rectangle.

- Fixed Size lets you enter a size for the selection box before you begin to drag it.

When you use the Fixed Size tool setting, remember that the pixels per inch depend on the resolution of the image. If you've set the resolution to 72 dpi, then a one-inch square selection box would be 72×72 pixels. If the resolution is at 300 dpi, the same one-inch square box would be 300×300 pixels.

Figure 10.3

This Tool Options palette changes according to the tool selected.

Feather Edge is used when you don't want an absolutely straight line selection. As the name suggests, it softens the edges of a selection. Figure 10.4 shows the effects of different feathering amounts. Softening the edges of a selection is helpful when you're pasting an object into a background, and you want it to blend in, rather than sitting on top of the background.

Anti-aliasing is available in the same Tool Options box when a nonrectangular marquee is selected. It helps prevent jagged edges in selections with rounded or diagonal lines. Anti-aliasing works by partially filling in pixels at the edge of the selection so they are partly transparent. This creates the illusion of a smooth edge. It's particularly helpful when you are cutting and pasting pieces of a collage. Be sure to turn on anti-aliasing before you make a selection. You can't add it afterward.

Figure 10.4

Comparison of different feathering amounts: None; 6; 12; 24 pixels.

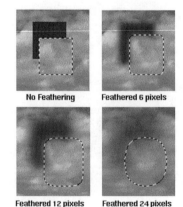

No Feathering Feathered 6 pixels

Feathered 12 pixels Feathered 24 pixels

The Magic Wand Tool

The Magic Wand tool selects portions of an image based on the colors of the pixels. If you want to select an area of similarly colored pixels, for example, a yellow flower, you can use the Magic Wand tool instead of using the Lasso tool to trace around its edges. Obviously, it's much quicker and less prone to error (see Figure 10.5).

You can determine the sensitivity of the Magic Wand by setting a tolerance in the Tool Options box.

1. Select the Magic Wand tool. Double-click it to open the Options box.
2. To select only the closest matching pixels, set a low tolerance number. To select more of the variations of a color, set a higher tolerance.
3. Click the Magic Wand on the area that you want to select.
4. To select additional colors, without losing the current selection, hold down the Shift key as you click other areas.

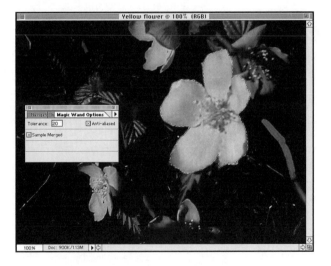

Figure 10.5

I've selected the entire flower.

The Select Menu

There's also a Select menu, shown in Figure 10.6, which gives you access to some even more powerful selection options.

Making Selections

Select All, obviously, selects the entire page. It's the same command that's probably familiar to you from your word processor or other programs. None cancels any selection you've made. Inverse is ideal when you have an object surrounded by a multicolored background, and you want to change the background. Select the object; then choose Inverse and everything *except* the object will be selected. You can delete, change colors, apply filters, or do whatever you want to the background, leaving the original object unaffected.

Figure 10.6

The Select menu gives you several ways to make and modify selections.

Selecting by Color Range

Color Range opens the Color Range dialog box (see Figure 10.7), which enables you to select a particular color from an existing selection or from the entire image. Suppose that you want to turn the yellow flowers into pink flowers. The first thing you would do is to select all the yellow. You could do this with the Magic Wand, or with the Lasso, but it is faster and easier to do it with the Color Range tool.

Open the Color Range dialog box and select Yellows from the Select menu. Click the Selection button to display the selected areas in the Preview window. Choose Grayscale to see the selected color as a grayscale channel. Choose Black or White matte to display the selected color areas against either of those backgrounds, or choose Quick Mask to see the selected area in mask form. Click OK to confirm the selection.

Figure 10.7

Using the Color Range box to select by color.

1.1 Singing Beach, Manchester-by-the-Sea, MA. Casio QV-100 digital camera. The fast shutter speed stopped the motion of the waves.

3.1 Statue, Biltmore Estate, Asheville, NC. Kodak DC50 digital camera. Using the statue to block the sun made an interesting silhouette.

4.1 Water tank, SC. Kodak DC25 digital camera. Shooting up from underneath the ladder gives a different perspective. Applying Photoshop's watercolor filter turned the photo even more abstract.

4.2 Roadside shrine, SC. Casio QV-300 digital camera. Set up at the site of a traffic fatality, this scene has universal appeal when abstracted in Photoshop.

4.3 Mural with pedestrian, Brookline, MA. Agfa ePhoto 307 digital camera. The rule of thirds applied: the center of the man walking past the wall lands on the lower right third of the picture.

4.4 Mount Tamalpais, Marin County, CA. Casio QV-100 digital camera. Shot from a moving car, just as the sun broke through the storm clouds.

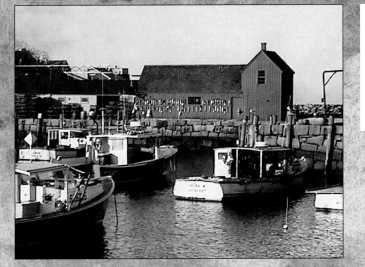

5.1 Motif #1, Rockport, MA Kodak DC50 digital camera. The colorful fishing shack is a great subject, and one of the most photographed and painted buildings in New England.

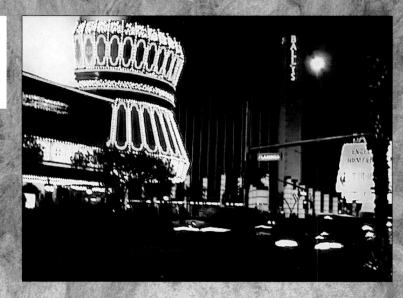

5.2 Weeks Footbridge, Charles River, MA. Casio QV-300 digital camera. Taken on a sunny day (!), this picture was artificially "fogged" in Photoshop.

5.3 Las Vegas, NV. Casio QV-100 digital camera. The corner of Paradise Rd. and "the Strip" is colorful 24 hours a day.

5.4 Photoshop's Color Picker shows numbers for all four color models. However, choosing the color that looks right is easier than entering numbers.

5.5a and 5.5b Kodak DC50 digital camera. These two plates show the effect of a pink filter on the colorful stuffed animals.

6.1 Kodak DC50 digital camera. Food photography is one of many kinds of commercial photography worth exploring as a career.

7.1 Gloucester, MA. Ricoh RDC-2 digital camera. Cloudy days are great for shooting colors.

8.1 GIFs use only the colors that are actually present in the image.

9.1 Gloucester, MA. Kodak DC50 digital camera. Another stormy day at the beach. You can adjust the color later to make the sun shine.

9.2 Floating begonia. Digital composite, in PhotoDeluxe. Circular ripples made the bottom layer and a single flower adds a point of interest.

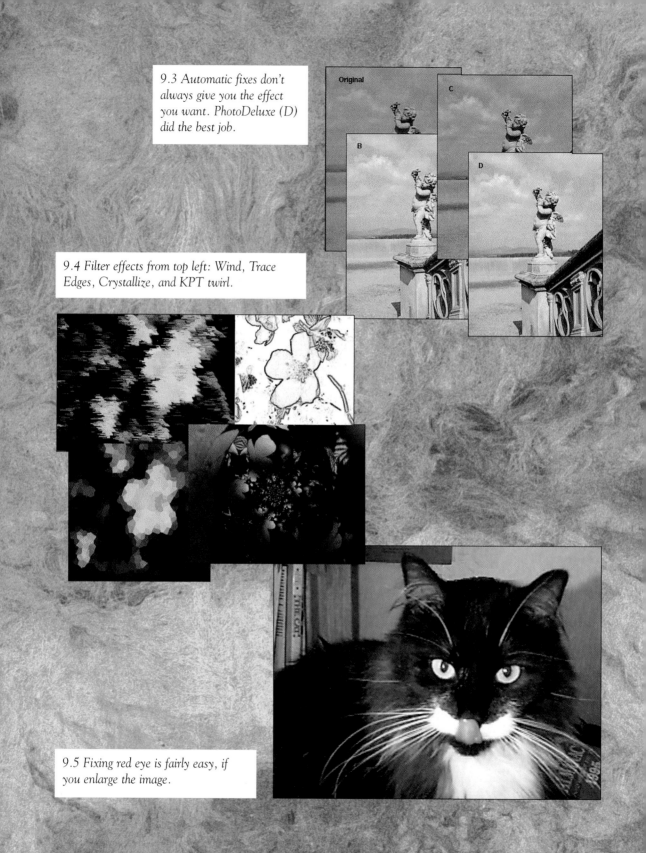

9.3 Automatic fixes don't always give you the effect you want. PhotoDeluxe (D) did the best job.

Original

B

C

D

9.4 Filter effects from top left: Wind, Trace Edges, Crystallize, and KPT twirl.

9.5 Fixing red eye is fairly easy, if you enlarge the image.

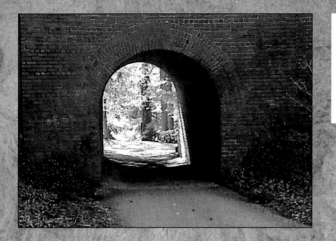

10.1 Biltmore Estate, Asheville, NC. Kodak DC50 digital camera. Photoshop's Rubber Stamp tool "grew" the ivy on the right side of the wall.

10.2 Golden Gate Bridge, CA. Casio QV-100 digital camera. This is the unprocessed image, as the camera saw it.

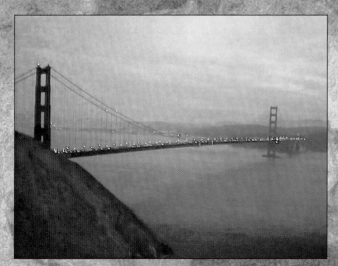

10.3 Golden Gate Bridge, CA. Casio QV-100 digital camera. The same image adjusted matches my recollection of the colors.

10.4 They started out as pink flowers…

10.5 We liked them better in yellow.

10.6 When you learn how to play with colors, you can make autumn happen at any time of year.

11.1 Mountain view, SC. Casio QV-100 digital camera. Posterization made this a much more interesting picture.

11.2 Ivy leaf with Dry Brush filter applied.

11.3 Ivy leaf with Rough Pastels on coarse canvas filter applied.

11.4 Cactus flowers with the Accented Edges filter applied.

11.5 The Water Paper filter turned this photo of a tree in the woods into a nice abstract "drawing."

11.6 The sunlit wood made a nice composition, even more interesting when slightly abstracted with the Photoshop Diffuse filter.

11.7 The cat from Color Plate 9.5 convolved into brass buttons, with Kai's Power Tools.

12.1a In the "before" pic-
ture, it's a mansion…

12.1b but "after" Photoshop
and some digital magic, it's a
shack.

12.2 With red as the base
color and blue as the blend
color, these are the results of
the Photoshop blending
modes.

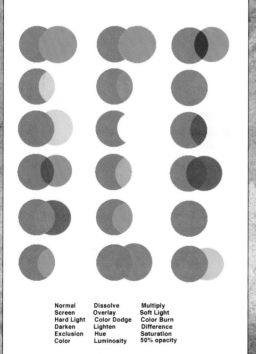

Normal	Dissolve	Multiply
Screen	Overlay	Soft Light
Hard Light	Color Dodge	Color Burn
Darken	Lighten	Difference
Exclusion	Hue	Saturation
Color	Luminosity	50% opacity

12.3 Drop shadows make the letters appear to float,
sorta like clouds…

12.4 Adding a color wash behind the lettering helped make it more legible.

12.5 The background photo of pasta twists emphasizes the message in the lettering.

Cats don't need reasons.

13.1 This Duotone was made from red and blue inks instead of the usual red and black.

13.2 Deep canyon near Hoover Dam, NV. Posterized and solarized in Photoshop.

13.3 Cabin in the woods, Easley, SC. Duotone conversion in Fractal Painter.

13.4 Expo Park, San Francisco, CA. Combining effects can be interesting, or it can totally destroy the picture.

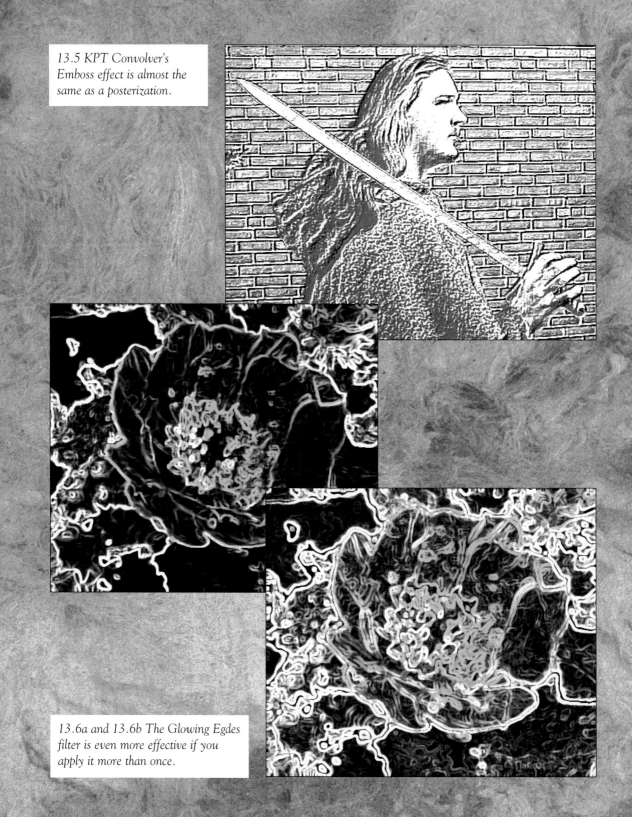

13.5 KPT Convolver's Emboss effect is almost the same as a posterization.

13.6a and 13.6b The Glowing Egdes filter is even more effective if you apply it more than once.

Modify

Select>Modify gives you four different choices:

- **Border:** select a border around the area, rather than an entire area, by defining the pixel width of the border.
- **Smooth:** smooth a selection by a defined number of pixels.
- **Expand:** grows the selection by a defined number of pixels.
- **Contract:** shrinks the selection by a defined number of pixels.

Use the Border option when you want to select, for example, a frame around the edge of an image. Decide how wide you want it to be, and enter than number of pixels in the window. Then you can delete the selection to reveal a background color, pour paint into it, or do whatever else you have in mind. Use the Smooth option to round off the edges of a Magic Wand selection, or to make a lassoed selection less lumpy. Use Expand and Contract to make your selected area bigger or smaller.

If you've selected, for example, a flower stem, and you want to make it a few pixels thicker, set the Grow option to grow it by two pixels, and each side of the selection will move two pixels further out. Then you can add the appropriate color. Remember, selection alone doesn't *do* anything. You must apply a change to the selected area or nothing will happen.

When you use Grow, it increases the "fuzziness" of your selection by expanding the range of selected colors to include the next closest ones. By using Similar, you will find all the colors in the image that are the same as the ones you've selected, and it will select them, too. For instance, if I make my selections based on one yellow flower and then select Similar, Photoshop will select all the flower parts in the image that contain the selected yellows. Save Selection lets you save the selected color as an alpha channel mask. You'll learn about using masks later in this chapter.

Brushes, Pencils, Smudges, and More

Now that you have learned how to select parts of the image, what do you want to do to them? You have tools to paint, draw, erase, and do some digital wizardry that conventional artists and photographers can only dream of.

Painting Tools

The Paintbrush and Airbrush tools work exactly as they do in any other graphics program. (Their icons on the Tool palette look like a paintbrush and an airbrush.) You can set a brush size and shape, the opacity, the flow rate for the Airbrush, and other parameters in the Tool Options box. (Double-click either the Paintbrush icon or the Airbrush icon to open the Tool Options box.)

Brushes share a palette with color and swatches. To open the Brush palette, choose Window>Show Brushes, but Photoshop has a few tricks up its sleeve. Choose Load Brushes from the menu that pops up from the Brush palette and then open the Brushes and Patterns folder that is inside the Goodies Folder. You'll find several sets of brushes there, including the ones shown in Figure 10.8. You can also define your own custom brushes and save them for future use by using this menu.

Blending modes affect the way the brush applies paint to a picture. They're set in the Paintbrush Options window. Normal is the default, but if you click and hold the mouse button on the down pointing arrow next to it, you will see the full list of modes. The best way to learn what they do is to experiment with them. Blending modes work by changing the base color, which is the original color in the image. The blend color, which is applied by the painting or editing tool, affects the base color in a way that is determined by the blending mode, and it can produce a result that is not always obvious from the name of the mode. Some modes apply the blend color translucently, while others apply it opaquely. Some modes mix the colors, while others subtract one from the other.

Figure 10.8

Be sure to check related menus for all tools. You'll often find goodies there.

TIP

Photoshop supports pressure-sensitive digitizing tablets, such as the Wacom and Calcomp series. These will give you a much more brush-like painting tool. With a little practice, you'll feel as if you're using a real paintbrush. The stylus pressure function can also be used with the Pencil, Airbrush, Erase, Rubber Stamp, Smudge and Blur, Sharpen, Dodge and Burn, and Sponge tools.

Pencil

The Pencil and Eraser are also fairly standard to all graphics programs. (Like all proper icons, they look like drawings of themselves: a pencil and an eraser.) The brush settings determine pencil width as well as brush width, so you can have a very thin pencil line or a fat one. The Pencil and Eraser tools have the same options as the Paintbrush tools described above, including blending modes. With Auto-erase enabled in the Tool Options box, the Pencil can also act as an eraser. The first time you click, it's a pencil. If you click again, it turns into an eraser of the same size and shape as the pencil. Don't forget that the Eraser will erase to the background color if you are working on the background layer. If you're working in another layer, the Eraser will erase to transparency. You can also use any of the brush shapes as an eraser. Just click on one with the Eraser tool enabled.

Rubber Stamp

The Rubber Stamp tool is a tremendous help when you need to replace part of a picture with something else. It enables you to paint a copy, either exact or modified, from one part of a picture into another part of the picture or even into a different picture. There are several Rubber Stamp options, which are shown on the pop-up menu in Figure 10.9.

All the Clone options make an exact copy of the image. The Pattern options enable you to select a pattern and use the Rubber Stamp tool to stamp that pattern, aligned or not, as many times as you want. From Saved restores the picture to its last saved version in the locations where you click the Rubber Stamp. Impressionist simply creates a somewhat spotty stamp.

In Figure 10.9, there is ivy growing on the left side of the wall, but none on the right. You can use the Rubber Stamp to copy ivy from one wall to the other. To select an area to stamp, hold down the Option key as you click the mouse. Then move the stamp pointer to where you want to place the stamp and click. The crosshairs indicate the part of the image that is being copied. Color Plate 10.1 shows the result.

Figure 10.9

The Rubber Stamp options.

Smudge

The Smudge tool (its icon looks like a pointing finger) has no photographic counterpart. It gives the effect of dragging your finger through wet paint, and it comes in handy when you need to blend colors or smooth out a line. Press Option (Mac) or Alt (Windows) to finger-paint in the foreground color by using the Smudge tool. The Smudge tool is almost identical in behavior to the smeary brush tools in Fractal Painter.

Blur and Sharpen

The two focus tools, Blur and Sharpen, can be used to adjust the focus on selected objects within an image. The Blur tool looks like a drop of water. Click and hold to bring up the Sharpen tool, which looks appropriately like the point of a tack. Don't use this tool to sharpen or blur the entire image. Instead, use the Sharpen or Blur filters on the Filter menu (Filter>Sharpen or Filter>Blur). Doing the job one piece at a time could take all day. If you only want to touch up an edge or perhaps apply a little blur to something that's too obtrusive in the background, however, this is the easiest way to do it. Use the Tool Options window (double-click the tool to open it) to set the amount of pressure, which determines how much blur or how much sharpness is applied. Then drag the tool over the area to be refocused, and it's done. Drag it again if you want more of the effect.

Dodge and Burn

The Dodge and Burn tools, and the Sponge, unlike the Smudge tool above, do have counterparts in the darkroom. The Dodging tool is used to block light from the enlarger. It is a cardboard circle on a wire, which the photographer holds so that it casts a shadow

on the paper that is being exposed to make a print, thus keeping an area lighter than it would normally be. Keeping it in motion, which is easy with the thin wire, gives the dodged area a softer edge.

The dodge function in Photoshop works the same way, lightening the area over which you hold the tool, and doing so with soft edges.

Burning is precisely the opposite of dodging, and it is done either with a piece of cardboard with a hole punched in it, or simply by the photographer's hand blocking all but a small bit of light. It is this latter image that gives us the Photoshop Burn icon of a hand blocking part of the light. Unlike the traditional tools, though, Photoshop's Burn tool can be applied only to highlights, shadows, or midtones. As many darkroom technicians have discovered, dodging and burning can easily be overdone. Be prepared to undo or even to revert to a saved version if things get out of hand.

The Sponge tool, believe it or not, also has its analogy in "real" darkroom work. When a print isn't developing as well as the photographer hopes it will, she may pour some fresh developing solution on a sponge and apply it to specific areas of the print that are lacking in detail. The fresher, more concentrated solution will bring out the darker tones. Photoshop's sponge works in the same way to bring up the color saturation in an area. You can also use it to desaturate by choosing desaturate in the Tool Options box. Figure 10.10 shows the effects of dodging, burning, and sponging on an image. The first sample had nothing done to it. The second sample used the dodging tool to bring out the leaves that were hidden in shadow. In the third sample, the flower petals are burned to darken them. In the bottom sample, the sponge was used to intensify the color without darkening it.

Figure 10.10

From the top: the original image, Dodged, Burned, Sponged.

Line Tools

The Straight Line tool should be familiar to anyone who has used any sort of graphics program. It draws lines. If you hold the Shift key, it draws them straight across, up and down, or at a constrained 45-degree angle. It also draws really neat arrows with customizable points.

Shaping an Arrow

You can shape the point of the arrow any way you want it—short and fat, long and thin, cut in on itself, or tapered like a spear point. Here's how to do it:

1. To reshape an arrow, first check arrowheads in the Line Tool Options box and indicate whether you want them at the start or end of a line, or both.

2. Then click the shape button to open the arrow shape box (see Figure 10.11). Arrow dimensions are based on percentages of the line thickness. If you set the line thickness to 10 pixels, and the length and width to 500%, you'll get arrows that are 50 pixels long by 50 pixels wide.

3. Concavity determines where the arrowhead ends. If you leave it at zero, the arrow bottom will be straight across. If you set it at 50%, the arrow points will taper upward to the shaft. If you set it at minus 50%, you'll get a nice spearhead instead of an arrow.

4. When you've designed an arrow you like, drag the Line tool on the picture to place it.

Figure 10.11

Arrows of all kinds.

The Pen (Path) Tool

The Pen tool is a bit more complicated. It doesn't draw lines on your picture. Instead, it draws *paths*. A path is, in effect, a line drawn on a piece of tracing paper laid over your picture. Paths are used to make selections or to define a smooth-edged area for pouring paint. Paths are made up of segments, which have anchor points at the beginning and end. A curved path segment is defined by direction lines, which determine the degree of curve and the direction it takes.

The Pen tool icon opens a pop-up menu with several different kinds of pens (see Figure 10.12). The basic Pen tool draws smooth-edged paths. The arrow represents the direction selection tools, which let you select and move paths or segments of paths. The pens with plus and minus symbols enable you to add or delete anchor points from paths you have drawn. The last symbol indicates the Convert Anchor Point tool, which enables you to convert curved line segments to straight line segments and to make straight segments into curves.

Figure 10.12

Pen tools and the Path window.

The Paths palette shows thumbnails of the paths you create, and enables you to select, show, hide, or otherwise work with paths. Buttons at the bottom of the palette let you fill a closed path with a specified color, a pattern, or a saved piece of a picture; stroke color onto a path; convert a path to a selection border; or delete paths you've finished using.

The Rubber Band option, available in the Tool Option window when the pen tool is selected, enables you to preview path segments before you commit to drawing them. As you move the pointer, the program will display the segment that will be created. To accept it, press the mouse button, and it becomes an actual path segment.

NOTE

When there's no option for a particular tool, the Tool Option window will say "No options for the tool." Click on this message to get a different, funnier one.

The Type Tool

The Type tool sets type (which probably comes as no surprise), but the Type tool actually has other functions. When you select the Type tool, your cursor changes to the type insertion I-beam, but as soon as you click it to indicate a place to start typing, you open the Type Tool dialog box shown in Figure 10.13.

Figure 10.13

Type a phrase in the box.

```
┌─────────────────── Type Tool ───────────────────┐
│  Font: [ Benguiat Frisky        ▼]    ( OK )     │
│  Size: [36] [ points ▼]               ( Cancel ) │
│  Leading: [42]                                   │
│  Spacing: [0.5]                                  │
│  ┌─ Style ──────────────────┐  ┌─ Alignment ──┐  │
│  │ ☒ Bold      ☐ Outline    │  ● ▭  ○ ▥       │  │
│  │ ☒ Italic    ☐ Shadow     │  ○ ▭  ○ ▥       │  │
│  │ ☐ Underline ☒ Anti-Aliased│  ○ ▭  ○ ▥      │  │
│  └──────────────────────────┘  └──────────────┘  │
│  ┌──────────────────────────────────────────┐   │
│  │ The Type Tool sets                        │   │
│  │ type...Duh!                               │   │
│  └──────────────────────────────────────────┘   │
│  Show: ☒ Font ☒ Size                             │
└──────────────────────────────────────────────────┘
```

Use the checkboxes, buttons, and windows to set type attributes, and the pop-up font menu to select a font. Type is placed as bitmap characters, so you need to use TrueType fonts or Adobe Type Manager to prevent "jaggies." Bitmap type is rendered at the same resolution as the image, so if your image is at 300 dpi, the type will be, too. Conversely, if your image is rendered at 72 dpi, the type will also be rendered at 72 dpi, which may make it look uneven. The other drawback to bitmap type is that you can't edit it after you have placed it. You can only reposition its starting point with the Move tool.

If you have a lot of type to apply, Photoshop may not be the best application to do the job. Consider using Photoshop to prepare the picture and then importing it into PageMaker or QuarkXPress to add more than a few words. For best results with type rendering, use PostScript fonts and a program that supports them.

The Gradient Tool

The Gradient tool lets you build gradients of two or more colors, which you can use to fill selected areas or lay down as a background for other images. You have a choice of

linear or radial (circular) gradients. This option and the type of gradient are determined in the Gradient Tool Options box (see Figure 10.14). You can also create your own, from scratch. You can even edit the gradients to make their color changes occur at specific points.

Figure 10.14

Gradients are fun to play with.

If you haven't selected a specific part of the image to fill, the gradient will be applied to the entire active layer. You can make the gradient as transparent as you want by specifying an opacity percentage in the Tool Options window. Enabling Dither gives you a smoother blend.

The Paint Bucket

The Paint Bucket is one of the simplest tools to use. Select it and click the part of the image you want to fill. All adjacent pixels that are similar to the one you clicked on will be filled with the color or pattern you selected. Tolerance determines how similar they must be in order to be filled. Paint Bucket options include anti-aliasing for a smoother line, degree of opacity, and whether you are pouring paint or a pattern.

The Eyedropper

The Eyedropper tool, as previously noted, makes color selections. In addition to using it to select an object by color, you can use it to select a specific paint color to match another color onscreen. Any color you click will become the selected foreground color.

The Grabber

The Hand, or Grabber tool, is used to move menus and palettes around onscreen. You can stack your palettes out of the way when you need to see what's on the screen under them. You can also use the hand to move the image around inside its window.

The Magnifying Glass

The Magnifying Glass lets you take a closer look at your image, or work on a magnified view. Click it on the image and it zooms in. If you hold down the Option key (Mac) or the Alt key (Windows) as you click, it zooms out again. It covers a range from .16% to 1600% of the image, but both ends of this scale are pretty much useless.

Using Image Controls

It's very rare that a picture you take into Photoshop (or any other graphics/digital darkroom application) doesn't need some tweaking. Image controls are the levels, brightness, saturation, color balance, and contrast, which you can vary digitally to make a dull picture bright, to rescue an underexposed shot, or to play with creating science fiction landscapes, if you like.

To get the maximum effectiveness out of the image controls, you really need to understand how they work, and what it is that you're doing when you increase the brightness, desaturation, and so on. The bottom line is simple enough: they all work by mapping existing ranges of pixel values to different ones. Some controls, like Brightness/Contrast, apply the same adjustment to every pixel in the image, or at least to every pixel you have selected. If you increase brightness by 10, you add 10 points of brightness to every pixel. This may be fine for the highlights, but it may wash out the shadows. Other controls, specifically the Curves control, can give you the option of adjusting any of 16 different ranges of pixel value, from pure white highlight to pure black shadow.

TIP

> Before you start changing the colors in your photographs, it's important to make sure that your monitor is calibrated properly and that the monitor and printer match each other, particularly if you're going to make color prints of your pictures.

Corrections

The Golden Gate Bridge is very pretty at twilight, but very hard to get a good picture of. My original shot, in deep purples and black, is moody and interesting, but really doesn't show the scene the way I remembered it. Color Plate 10.2 shows the bridge as it came from the camera. Color Plate 10.3 shows it after some basic corrections were made to restore detail to the hill and the pink tones to the sky.

When you're going to attempt to correct a picture, always begin with the program's automatic corrections. In Photoshop, you'll find Auto Levels under the Image menu (Image>Adjust>AutoLevels). If Auto Levels doesn't suit your intentions, undo it and try something else.

It's a good idea to make your corrections either on a copy of the image or to use Adjustment Layers. This, in effect, applies your corrections as cellophane overlays on the picture. To start an adjustment layer, use the Layer menu (Layers>New> Adjustment Layer) shown in Figure 10.15. It will open the New Adjustment Layer dialog box shown in Figure 10.16.

Figure 10.15

The Layer submenu.

When you select a type of adjustment, such as levels or color balance, you'll open the dialog box that makes that adjustment. The Levels dialog box, shown in Figure 10.17, uses a histogram to indicate the levels of highlights, shadows, and midtones in the picture.

Figure 10.16

There's a pop-up menu listing the kinds of adjustments you can make.

Figure 10.17

The Levels dialog box.

Setting Levels

The Levels dialog box remaps the theoretical darks and lights to match those of the image. With the Levels dialog box open, set the highlights and shadows to the lightest and darkest tones by moving the levels input sliders on each end of the histogram to the first group of pixels on that end. For instance, if the black triangle points to empty space, and there are a cluster of histogram lines to the right of it, move the triangle to the right so it lines up with the dense part of the cluster. Doing so will map those pixels to black.

Doing the same on the white side, moving the triangle to the left, will map those pixels to white. To view the new histogram, reopen the Levels dialog box by selecting Levels from the Adjustments box. You can see that the end points have changed, and the histogram has stretched out to reach the new ends, which may cause gaps in the histogram.

Setting the endpoints correctly usually adjusts the midtones, too. If you feel further corrections are necessary, as they may be if the image is especially dark or light, then adjust the middle image slider. The gray triangle controls midtones, the black controls the darks, and the white triangle controls the highlights. You can fine-tune all three of these until you're happy with the result.

Be sure to click the Preview box to see your changes onscreen as you make them. If your highlights originally had a noticeable color cast, perhaps a yellow or pink tinge, then setting the Levels will get rid of it.

You can use the Output Levels slider, at the bottom of the Levels box, to reduce or increase the contrast in the image. Moving the dark triangle to the right will lower the contrast. Moving the white triangle to the left will increase it. Don't overdo this correction. A few steps will make a huge difference.

To adjust Levels, follow these steps:

1. Open the Levels dialog box (Image>Adust>Levels). Click the Preview box so you can see changes as you make them.
2. Find the point on the left side of the histogram at which the clustered lines become dense and start to peak.
3. Drag the black triangle to this point.
4. Find the point at the right of the histogram where the lines start to peak.
5. Drag the white triangle to this point.
6. Decide whether the image looks right. If not, moving the white triangle to the left will lighten it. Moving the dark triangle to the right will darken it.
7. Click OK when done.

Setting Curves

Curves, like Levels, adjusts the tonal range of an image. The difference between the two is that Curves makes the adjustment in up to 16 steps, instead of just three steps for dark, middle, and highlights. When you open the Curves dialog box (Image>Adjust>Curves) you see a graph instead of a histogram. The horizontal axis stands for the original brightness values of the pixels, and the vertical axis represents the new brightness values.

The diagonal line is there to indicate that nothing has been changed yet. The pixels all have the same input and output values.

To adjust the curve, start with Auto and click the Auto button. If you don't like the result, press Option (Mac) or Alt (Windows) to change the Cancel button to Reset, which will undo the Auto setting.

To locate a particular point on the graph, move the pointer to a place on the image that needs adjustment. You'll see a circle on the graph that shows the position of the pixel you're pointing to. Move that part of the graph up or down to change the brightness or color, as appropriate. Figure 10.18 shows the Curves dialog box, adjusting the bridge picture.

Figure 10.18

Drag the curve to move it.

Adjusting Brightness/Contrast

You can also adjust the Brightness/Contrast Layer in its own dialog box. Open the dialog box by choosing Brightness/Contrast from the pop-up menu in the New Adjustment Layer dialog box (Layer>New>Adjustment Layer). When you open an adjustment layer for Brightness/Contrast, you'll see a dialog box with two sliders (see Figure 10.19). Slide them to the right to increase brightness or contrast, and to the left to decrease it. Most digital photos are improved by having the contrast and brightness increased by a few points. It tends to make the images look sharper. There's no particular reason why CCDs should produce lower contrast images, or duller ones, than film cameras do. I have found that tweaking the contrast and brightness very slightly gives me pictures that I am generally happier with.

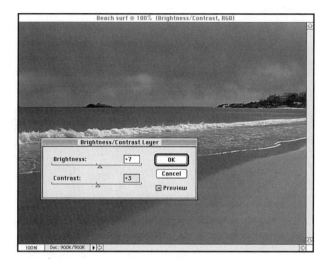

Figure 10.19

Adjusting contrast in the Brightness/Contrast Layer dialog box.

Adjusting Color Balance

Color Balance is most often used when the entire picture appears to be off-color. Perhaps everything looks too green or too red, either because of some peculiarity of the lighting or because you over- or underexposed the picture. Through a bit of digital magic, you can adjust the levels of a particular color in an image, even turning the greens to pinks or the reds to blues if you want. Here's how to do it:

1. Open an Adjustment Layer for Color Balance and choose shadows, midtones, or highlights to determine which tonal range to make the changes on. If you notice a color cast to the white highlights, start there.

2. Click Preserve Luminosity to keep from changing the brightness values as you change the color. Doing this will help maintain the overall tonal balance in the image.

3. Be sure that Preview is checked so that you can see your changes.

4. Decide which color is overpowering the image. Does it have a green cast? Then drag the Magenta/Green slider toward Magenta.

5. Drag a slider toward a color to increase it or away from a color (toward its color wheel opposite) to decrease it (see Figure 10.20).

6. Click OK when done.

241

Figure 10.20

Adjusting color balance.

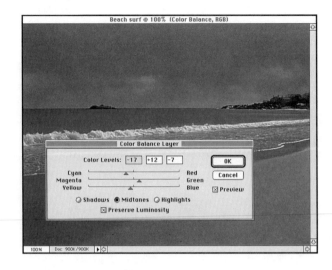

Adjusting Hue/Saturation

The Hue/Saturation Layer dialog box (Layer>New>Adjustment Layer>Hue/Saturation) has a set of color swatches down the left side (see Figure 10.21). Each of these color swatches represents one of the additive or subtractive colors in the same order you find them on a color wheel: red, yellow, green, cyan, blue, and magenta. The Sample swatch at the bottom of the box shows the foreground color as a default, but you can change it to reflect the color you want to change by clicking that color in the image. If you want to change these pink flowers to yellow, you can use the master slider to make the change, since it's a radical one. Smaller changes, such as adding more blue to the pink or warming it up with a bit of yellow, can be accomplished by using the single color sliders. To see the effect of turning the flowers from pink to yellow, see Color Plates 10.4 and 10.5.

If, for example, you want to adjust the amount of cyan in the image, click cyan. Drag the Hue slider until the color appears the way you want it or type a specific value into the Hue window, if you're dealing with precision colors. The numbers indicate the degrees of rotation around the color wheel from the originally chosen color. A positive number indicates clockwise rotation around the color wheel; a negative number indicates counterclockwise rotation.

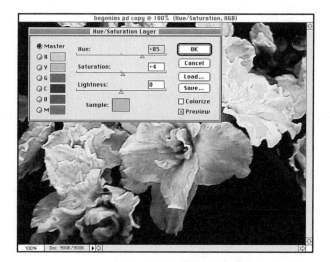

Figure 10.21

The Hue/Saturation Layer dialog box.

 NOTE

The only reason this might come up is if you're working on something like a corporate logo, where someone has previously specified an exact shade of the color and the specific Pantone ink to achieve it, or if you must make your work match something else previously done.

Saturation

Saturation refers to the amount of pure color versus the amount of gray in a particular shade. When you drag the Saturation slider to the right, you increase the amount of color. When you drag it to the left, you decrease the amount of color. If you drag it all the way to the left, you remove all the color. Lightness, obviously, lightens or darkens the entire picture, or the piece you've selected.

Merging the Adjustment Layers

After you have added corrections to your original image on adjustment layers, you need to merge the layers in order to make the corrections part of the image. Merging layers

combines several layers into one. Doing so keeps the image size manageable, because each layer adds to the file size. To merge a layer with the layer beneath it follow these steps:

1. Make sure that both layers you want to merge are visible. Use the Layers palette to verify that the eye symbol is present, indicating a visible layer.

2. Be sure that the layers you don't want to merge at this time are *not* visible.

3. Select the top layer. Choose Merge Down from the Layers palette menu, or from the Layer menu at the top of the screen. This merges the top layer with the one below it.

4. To merge all visible layers, select Merge Visible.

When you merge the visible layers, all of the adjustment layers will be applied to the image. Applying the changes as adjustment layers has several advantages for the novice Photoshop user. You can evaluate the effects of your changes one at a time, and you can undo them easily if you're not happy with the results.

Extensis Intellihance

Is all of this image adjustment stuff just too confusing? There's a way out that will give you well-adjusted pictures every time. It's a Photoshop plug-in filter called Intellihance, from Extensis (see Figure 10.22). It works by measuring the amount of contrast, brightness, saturation, sharpness, and despeckle in your original image, comparing these against its preferences table, and adjusting them, as needed. You can compare the corrected version against the original one by clicking Option (Mac) or Alt (Windows). You can also do additional tweaking within the program.

Figure 10.22

Intellihance does the work for you.

You can set Intellihance according to your own likes and dislikes. If you prefer images with a little more contrast, change the default setting from Normal to Snappy. You can also choose to flatten highlights and/or shadows. These may be helpful if you are printing a picture and want to let the paper color come through as the color of the highlight.

Intellihance can be purchased from any software retailer for under $100. It can also be downloaded from the web in a demo version, and upgraded online, by phone, or by mail. Go to: `http://www.extensis.com/products/Intellihance/`.

Working in Layers

You've already looked at layers as a way of image correction, but that's hardly the only way to use them. Layers are useful for combining images, for adding type, and for masking parts of an image when you want to alter one part of it without affecting the rest.

The Layers palette (Window>Show Layers) helps you manage multilayer images. It shows you all the layers you have created, including a thumbnail so that you can see what is on each one. Thumbnails are updated as you work. You can resize the palette to see more layers or use the scroll bars to move through the layers if you have too many to display at once. Photoshop lets you create up to 100 layers, in theory. In practice, this is far too many layers to manage conveniently, and it would take tremendous amounts of memory and disk space to manage them.

> **TIP**
>
> If you have many layers in your document, merge them before you close it. Otherwise, your file will be very large.

There are two ways to create a new layer. Use the New Layer command on the Layer menu or simply click the New Layer button at the bottom of the Layers palette menu. It's the button between the Mask button and the Trash (Delete) button (see Figure 10.23).

If you have made a selection in an image with one of the selection tools, you can quickly turn it into a layer with these steps:

1. Use the Magic Wand, or another selection tool, to select part of the image.
2. Type ⌘ + J (Mac) or Control + J (Windows).
3. The Layer will be created, numbered by default, and placed as the active layer on the Layers palette.

Figure 10.23

Click the New Layer button to start a new layer.

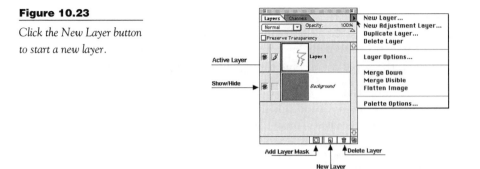

Editing can only take place on an active layer. If the layer is active, you can use the painting and editing tools on it, and you can copy and paste to it. Remember that the opacity you have set for the active layer will affect the opacity and mode settings for any tools you use. If, for instance, you're trying to apply a transparent color with the airbrush on a layer that's 100% opaque, your color will not be transparent.

You can drag layers on the palette to change their order or use the menu commands to bring a selected layer forward, send it back, or send it to the bottom (except for the background) of the stack. The background layer can't be moved.

To delete a layer, select it and click the trash can icon button or drag the layer to the trash can button. You'll be asked to confirm your action. If you are *absolutely* sure you want to delete it, and don't want to confirm the deletion, press Option (Mac) or Alt (Windows) as you delete. This prevents the confirmation box from appearing.

Blending modes affect the way that pixels on a layer blend with those on underlying layers, in the same way that the blending modes used with brushes affect the background on which they're applied. If you paint with a brush in Normal mode on an active layer that's set to dissolve mode, you will see the same effect as if you'd painted directly on the background in dissolve mode.

Using Masks

Masks are used to block out an area that you don't want to change while you apply a correction, a filter, or another effect to the rest of the image. Masks can be thought of as the opposite of selection areas. When you use the selection tools to select part of an image, in effect, you are masking the rest of the image.

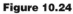

Quick Mask is Photoshop's way of creating a temporary mask. To create a mask quickly, follow these steps:

1. Start by selecting an area to mask around. Use whichever selection tool is easiest. (In most cases, it will be the Magic Wand.) Don't worry if your selection isn't perfect, but try to get the edges of it as well as you can.

2. When you have selected the area, click the Quick Mask mode button at the bottom of the toolbox. As you see in Figure 10.24, it places a color overlay over the protected parts of the image. The 50% red color is the same as the traditional rubylith film that print shop retouchers have used for many years for a similar purpose. In this case, only the two central leaves were selected.

Figure 10.24

Click the Quick Mask button to make the mask.

3. If your mask has holes in it or needs touching up, select a painting tool from the toolbox and paint in the image window. A small brush is good for working around the edges of the mask or filling in pinholes where the selection wand missed some of the image. Painting with black will add to the masked area. Painting with white will remove part of the mask. Painting with gray or a color creates a semitransparent or partially effective mask.

4. When the mask is the way you want it, return to the toolbox and turn off Quick Mask mode. The unmasked area will be selected, so that you can proceed to apply whatever changes you want. Changes affect only the selected area. When you're finished type ⌘ + D (Mac) or Control + D (Windows) to deselect the selected area. In Color Plate 10.6, you can see the result of masking the two green ivy leaves and turning them red.

Layer masks give you control over how the different areas in a layer are masked or revealed. When you make changes on a layer mask, you can experiment as much as you

like because the layers don't become part of the image until you merge them. The layer mask appears as a separate thumbnail to the right of the layer thumbnail. The hidden portions of the image are black on the layer mask, and the active parts are white. When you choose Layer Mask from the Layer menu, you have the option of creating a mask to reveal the selection or to hide it. If you reveal a selected object, you are obviously masking the background. Conversely, if you mask the object, you reveal the background. The same menu also lets you disable a mask or remove it after you have created it.

Retouching with Photoshop

Retouching a picture in Photoshop really isn't much different from doing it in PhotoDeluxe or any of the other simple image handling programs. The only difference is that the tools are a little better, and you have a little more control. Photoshop's Rubber Stamp isn't necessarily any better or easier to use than simply copying and pasting a piece of picture from one spot to another, except that you can have the stamped areas automatically aligned instead of doing it by eye.

Retouching, after all, is simply replacing something with something else. If you're fixing red eye, you're replacing some red pixels with dark ones. If you're removing Uncle Harry from the picture, you're replacing him with pieces of the background. Sometimes you have to remove the background, too.

Grandpa wanted a picture of his two grandsons, but the boys are both away at college most of the time, and not available to pose for portraits. I had a digital snapshot I took on a rare occasion when they were both together, but the background was awful, and one of them was fooling around. Could this one be saved?

Figure 10.25 shows the original picture. Pretty awful... I started with the Lasso and worked around their heads and shoulders, circling and removing the background. What I wasn't able to select and delete, I erased. Finally, I went into Quick Mask mode, enlarged the picture, and painted around the edges to complete the mask. When I had both boys selected with no background, I cut them out and pasted them into a new page (see Figure 10.26). But they still don't look right without anything behind them.

Figure 10.25

Complete with bunny ears...

Figure 10.26

Plain vanilla kids.

Since they've never been to San Francisco, I decided to give them a free trip. I found a picture that made a nice background and simply pasted them in front of it. Then I used the Smudge tool to gently blur some hard edges. I used the Despeckle filter to smooth out skin tones that had gotten uneven. Figure 10.27 shows the final result. Grandpa will be pleased, and I didn't have to pay for plane tickets.

Figure 10.27

Two dudes, California dreaming...

Assignment

Using one of your still life pictures, remove an object and retouch the empty space by using masks and layers.

Photoshop Filters

- Applying filters
- Kai's Power Tools
- Alien Skin Eye Candy
- Extensis Photo Tools
- Finding and using shareware filters

Filters are what make Photoshop fun. Photoshop's built-in filters let you apply all kinds of special effects—from ordinary ones like blurs and sharpening, to wind, pixelation, posterization, and more. When you start using third-party filters, such as Eye Candy and Power Tools, you get even wilder effects like turbulence, lumps, and whirlpools—and practically anything you can think of. You can even make your own filters with Filter Factory.

Applying Filters

Some filters turn your photos into drawings. Others turn them into an imitation of a terrazzo floor, a bas-relief, an embossed panel, or even a patchwork quilt. Many of these are, frankly, pretty awful. Remember when the Macintosh first came out, and gave us the ability to use shadow and outline lettering, and how we went overboard using it for totally illegible headlines? Well, you can achieve the same degree of wretched excess with filters, only maybe a hundred times more so, because you have color and patterns and shapes and all kinds of stuff to play with. It's easy to lose sight of what you were trying to accomplish when you start playing around with some of the filter effects. On the other hand, it's also possible to elevate a rather ordinary photo to something you could call "art." It's a matter of taste, in the same way that not overdoing the shadow lettering is. Perhaps the real "art" is knowing when to stop.

That said, let's get started. Applying Photoshop's built-in filters isn't difficult. All you need to do is select one from the list. Any filter name that's followed by an ellipsis will

open a dialog box, in which you'll have to set some parameters for the way the filter interacts with the image. Figure 11.1 shows the cutout filter from Photoshop's "artistic" submenu (Filters>Artistic>Cutout). Setting the options for a filter like this involves a certain amount of guesswork, but the Preview window shows you the effect of the filter on a small piece of the picture before you apply it all over.

Figure 11.1

We already applied this filter once, so you can see the general effect in the background.

To apply a filter to an entire picture, make sure that the image is on an active layer and choose the filter. To apply it to only part of the picture, use whichever selection tool is appropriate and select the part of the picture to be filtered.

> **NOTE**
>
> When you use filters, you need to be a little bit patient. Even on a fast computer, some filters can take several minutes to work. On an older, slower model, take a coffee break or walk the dog.

You can move the image around inside the Preview box if you want to see the effect of the filter on a particular area. You can also use the plus and minus symbols to zoom in or out on the image in the Preview box. If you see a flashing line beneath the Preview size (under the 100%, or whatever number it's reading), that means that Photoshop is still working on the image. When the flashing line disappears, the image in the Preview window will show the effect of the filter. It often takes a while, so don't assume the filter isn't going to have an effect.

If you decide that you like the preview, click OK to apply the filter. If it's going to take a while to filter the image, you'll see a progress indicator in the status window in Windows, or a progress bar on the Mac. When you see the full effect, if you decide it wasn't what you wanted, use Undo to undo it. As long as you haven't done anything else after applying the filter, you can go right back to the unfiltered image. If it's too late for

undoing, you can use Revert and go back to the last version saved. It's generally a good idea to work on a copy of your picture, rather than the original, when you're experimenting.

Applying a Filter

Most Photoshop filters work in a similar manner. To apply Photoshop filters, follow these steps:

1. With the image open in Photoshop, choose a type of filter from the Filter menu, and then a filter from the submenu. For example, Filter>Artistic>Dry Brush...
2. When the filter dialog box opens, set any options that the filter requires by moving sliders or entering numbers.
3. Use the preview window to see the effects of the filter. Click on the window and move the mouse to see other parts of the image.
4. Click OK when you're satisfied with your settings, to apply the filter.

Fading a Filter

If the effect seems right, but there's just a little too much of it, try the Filter>Fade command. Figure 11.2 shows the Fade dialog box. You can set an opacity and blending mode, which determines how the filter is applied. The blending modes work just like the painting ones. The modified pixels are blended into the nonfiltered ones, according to the method you select. Undo undoes the Fade command, too.

Figure 11.2

Fade lets you temper the effects of the filter you've applied.

NOTE

If you change your mind about using a filter while it's being applied, you can cancel the operation by pressing Esc (Windows) or ⌘ + period (Mac).

Using Color Selectively

You can often get interesting effects by applying color selectively to a grayscale image. Color Plate 11.1 shows the result of the following manipulations. First, I converted the image from color to grayscale. Then, I used the Poster Edges filter (Filter>Artistic> Poster Edges) on the whole picture. I chose this one because it thickened the tree branches according to their relative tones and posterized the rest of the picture into four levels. Then I added color back into the picture by changing the mode from grayscale back to RGB and using the Hue/Saturation adjustment (see Figure 11.3) and limiting the color to a dusky blue. The path to the Hue/Saturation dialog box is Image>Adjust>Hue/ Saturation. Once you're there, simply move the Hue slider until you find a color that you like.

Figure 11.3

Posterizing saved this picture.

Remember that you don't have to use the same effect all over the picture. You can select parts of the image to filter, or mask over parts that you don't want filtered. In Figure 11.4 I've selected one ivy leaf and applied the Find Edges filter only to it. Now I can select another leaf and try a different treatment, and perhaps turn the tree bark into something

else, as well. Each leaf, or each part of your image can be treated differently, by applying masks to areas you don't want to treat with a particular filter, or by using the selection tools to pick out areas that you'll apply a filter to.

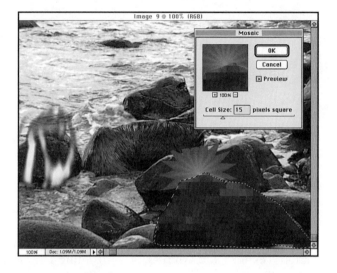

Figure 11.4

You could apply a different effect to each rock on the beach.

Texture Maps

Many of Photoshop's filters can apply texture maps or displacement maps to images. Texture maps and displacement maps are simply images with a particular pattern or texture, which can be merged with your image to produce a textured version. If you open a filter, such as the Glass filter, which uses a texture map, you will notice that it has several preset textures included. Among them are Canvas, Brick, Sandstone, and Burlap. When you apply the filter, you can choose to select any of the presets, or you can load a texture that you've previously saved. You can also use one of the ones that came with the program. You'll find them in the Photoshop plug-ins folder, in a folder called Displacement maps. Using the surface controls with these textures gives you the capability to make your picture look as if it was painted on canvas or seen through a piece of textured glass. In Figure 11.5, I'm loading a texture from Photoshop's displacement maps set. This particular texture makes a nice pebbled glass, much like the ones you find in old-fashioned bathroom windows.

Figure 11.5

As seen through pebbled glass.

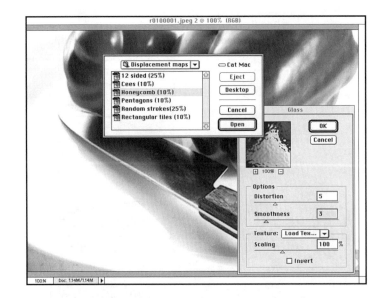

To load a texture, first choose and open the filter that you want to use it with. Conté Crayon, Glass, Rough Pastels, Texture Fill, Texturizer, Underpainting, Displace, Lighting Effects, and Custom are the filters that use texture or displacement maps. In the filter's dialog box, choose Load Texture from the pop-up menu; then find and open the texture image you would like to use. (The texture must be saved in Photoshop format.)

The Scaling slider lets you determine how big the bumps are in the pebbled glass or how coarse the weave is in the canvas texture. The Relief slider, in filters that have one, determines how deep the surface texture appears to be. Invert simply reverses the light and dark areas. In practical terms, things that appeared to bump "up" will instead bump "down." It doesn't make much difference on small patterns, but it can be seen on larger ones. Adjust the settings in the dialog box until you like the preview and then click OK to apply it.

NOTE

If you apply a texture, invert it and apply it again, you'll end up back at square one, having undone your original application.

Which Filter?

The list of filters is long, and the permutations seemingly endless—how can you decide what filter to use, if any? The first thing to decide, of course, is whether or not a filter will help the image deliver a message to the viewer. What was the purpose of the picture? If it is a shot of merchandise for a catalog, you can safely rule out the "artistic" filter effects and the distortion filters. They're not going to help you sell widgets. But that doesn't mean you shouldn't even look at the Filter menu.

Filters can be divided into several different types. You'll find them all listed under the Filter menu. The artistic filters include, not just the ones actually labeled "Artistic," but also the Brush Stroke series, the Sketch set, and the Texture filters. The "special purpose" filters include the Distort, Pixellate, Stylize, Video, and Digimark filters. A set that I think of as the "useful" filters includes Blur, Noise, Render, and Sharpen. These are the ones that you can use every day on all kinds of images.

Blur Filters

There are six different Blur filters, ranging from a mild and non-adjustable Blur and Blur More, to Radial Blur, which gives a zoom effect, and Motion Blur, which makes your picture look as if the camera had been rotating around the picture as you took it. Figure 11.6 shows the non-blurred image, and Figure 11.7 shows the effects of different kinds of blur on the same image.

Figure 11.6

The leaf with no filter.

Example a is the basic Blur filter. It adds only a slight fuzziness. Blur More, in example b, is noticeably softer. Gaussian Blur, in example c, is the first of the "settable" blurs, and in this example it has been assigned a radius of 1.4 pixels. Larger numbers would, naturally, blur to a greater extent. Example d shows the Motion blur, with an angle of 45 degrees and a distance of 40 pixels. The effect is intended to be that of moving the camera that particular distance at that angle while the picture is being taken. In example e, the Radial blur amount is 64. I've asked for the zoom, rather than the spin effect, and have moved the blur center to the base of the leaf. Finally, example f shows the Smart Blur filter. With Smart Blur, you can set the radius and the threshold amount for the blur while watching the Preview window. When you have the effect you want, click OK.

Figure 11.7

The Blur filter collection.

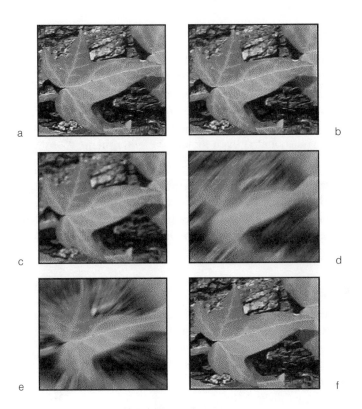

a

b

c

d

e

f

Noise Filters

The Noise filter adds an all-over speckled effect, sort of like the colored specks you see on a TV screen when the station's gone off the air. You can decide whether you want just a touch of it, to disguise flaws on the surface of an object, or enough to reduce the whole image to a bunch of dots. Despeckle is more or less the opposite of noise. It looks for pixels that don't match those adjacent ones and blends them in, effectively removing single pixel specks from the image. If you have pieces of dust more than one pixel wide to remove, use the Dust and Scratches filter. Median, like Despeckle, averages the nonconforming pixels into those around them, but does it according to the limit you set. In general, the effects of these filters are hard to distinguish from the mild blur shown above, except that Despeckle and Dust blur only the dust specks and not the entire image.

Sharpen Filters

Sharpen is probably the filter you'll use most often. It's certainly my favorite. It rescues pictures that are a little bit, or even a lot, fuzzier than you want. It works by finding areas

in the picture where color changes occur and enhancing the contrast. The set includes Sharpen, Sharpen Edges, and Sharpen More. Figure 11.8 shows the differences these three filters can make. Example a is unfiltered; b uses Sharpen; c shows Sharpen Edges; and example d uses Sharpen More. If you find it hard to see differences, look at the veins in the leaf.

a b

c d

Figure 11.8

The Sharpen filter collection.

Applying Unsharp Masks

The final filter in the Sharpen set, Unsharp Mask, deserves some additional explanation. Unsharp Masking is a film compositing technique used traditionally to sharpen edges in a photo or a scan. It compensates for the blurring that often occurs during the sampling and printing process by looking for adjacent pixels with a specified difference in brightness (Threshold) and increasing their contrast by an amount you can specify. Applying the Unsharp Mask filter is recommended by many graphics experts as the final step in image processing, no matter what else you have done to the picture. Figure 11.9 shows the Unsharp Mask dialog box.

Figure 11.9

To really see the effect of this filter, increase the magnification of the preview window to 200%.

259

To sharpen an image with the Unsharp Mask filter, follow these steps:

1. Open the Unsharp Mask filter via Filter>Sharpen>Unsharp Mask.

2. When the dialog box appears, be sure to check Preview so that you can see the effect of your settings on the entire image.

3. Choose an amount to determine how much to increase the contrast of adjacent pixels. For high-resolution printed images, 150% is a reasonable setting. (It may look a lot more drastic onscreen than it does in print.)

4. Set a radius to determine how many pixels surrounding the edge pixels will be affected by the contrast sharpening. A radius between 1 and 2 is a safe choice.

5. Set the Threshold to define how much difference there has to be in adjacent brightness values in order for the filter to recognize the difference as an "edge" and sharpen it. The default threshold (0) sharpens everything. Settings between 2 and 15 are reasonable.

6. Click OK when done.

Artistic Filters

There are a bunch of artistic filters, and the general intent of all of them is to give your pictures a less computerized look. Most do it by imitating other media. Whether this conflicts with artistic integrity or just adds another dimension to the work is probably a question for art critics and philosophers to decide. Is a digital photo doctored to look like an oil painting on burlap as "artistic" as an actual painting on burlap? Maybe. Will making your photo look like it's printed on canvas or painted with a ragged brush help communicate? It might. Don't forget, Undo and Revert work with these filters, too, if you get carried away.

There are 15 different filters under the category of Artistic. (And since I can't describe every one of them, I'll touch on a few of my favorites.) You'll find them listed under the Filter menu. Each one has its own dialog box in which you can set variations on the theme. Color Plate 11.2 shows the Dry Brush effect, and Color Plate 11.3 shows the same picture with the Rough Pastels on coarse canvas effect applied. Figure 11.10 shows the settings for the latter effect.

The Brush Strokes filters, as you'd expect, all attempt to simulate paint of one kind or another. See Color Plate 11.4 to find out what Accented Edges did to a picture of a pink cactus flower. Figure 11.11 shows the dialog box settings that turned this photo into a watercolor.

Figure 11.10

The Rough Pastels filter dialog box.

Figure 11.11

The Accented Edges filter dialog box.

Most of the Brush Stroke filters add some degree of noise or texture to an image. Some, like the Sprayed Strokes filter shown in Figure 11.12, also let you define a direction for the paint to flow. This one gave us the choice of left or right diagonal, vertical, or horizontal. Filters like this one, which take a few seconds to compute, don't give you a full screen preview. You have to move the Preview window image around to guess what the result will be. Be prepared to undo and try again with different settings, if you don't like the first result. If you use the filter command shortcut, ⌘+F (Mac) or Control+F (Windows), you'll just reapply the filter without changing it. Remember that you have to select the filter from the menu again or add the Option key (Mac) or the Alt key (Windows) to the shortcut combination to open the dialog box and change settings.

Figure 11.12

The Sprayed Strokes filter dialog box.

Sketch Filters

Like the Brush stroke filters, the Sketch filters give your photo a hand-drawn character. The difference is media. Instead of trying to simulate paint, the Sketch filters imitate such media as Pen, Pastel, Charcoal, and Conté crayon. Inexplicably, this category also includes Chrome, Bas-Relief, Torn Edges, and Plaster, to name a few of the stranger ones. There are 14 in all. Some are considerably more useful than others.

Most of these filters use the two colors you have set as background and foreground colors to create their effects. Chrome makes anything you apply it to into a mostly dark, pseudo-metallic mass. Out of this set, the only ones I've found useful are the Conté crayon and Water Paper filters. Color Plate 11.5 shows the Water Paper filter at work on a forest scene.

Conté crayon works best (and looks most authentic) if you set the foreground color to one that the crayons usually use, such as black, sepia brown, or sanguine (reddish brown). It also works best on a very simple subject. Figure 11.13 shows a Conté crayon rendering of the steps up the side of a water tank, viewed from below. The curves and pattern lend themselves well to this treatment, although more complex subjects, such as the forest scene, turned into a random pattern of red-and-black blobs.

Figure 11.13

Conté crayon settings.

Stylize Filters

If you thought chrome or plaster were unusual treatments for a photograph, how about Emboss or Extrude, or maybe Glowing Edges? These filters can reduce the photo to something rather abstract. Like the Conté crayon filter, they are more successful when used on simple subjects. They work by finding and enhancing contrasts, and in some cases by reducing the pixels to blocks of similarly colored ones. Diffuse puts fuzz on edges. It doesn't soften them, though. This is hard-edged fuzz. The effect is shown in Color Plate 11.6, applied to the gears from an old mill wheel. The same gears are shown in Figure 11.14 with the Glowing Edges filter applied.

Figure 11.14

The Glowing Edges filter makes objects look as if they're outlined in neon.

Solarize has the same effect as the darkroom trick it's named for. By exposing the partially developed film or print to a brief blast of white light, you invert the colors or blacks and whites in the original image. For example, blues become oranges and greens turn reddish. It's interesting, if not particularly useful.

Pixelate Filters

Like the Stylize filters, the Pixelate set are of very limited usefulness. Each of the seven filters in the set breaks down the image to some pattern of dots or color blocks. Again, you'll have better luck with these if you restrict their use to simple subjects and keep the dot size or crystal size small. Although you *can* turn the whole image into a handful of color blocks, you're likely to lose all resemblance to the original subject in the process.

Of the filters in this set, Pointillize is possibly the most interesting. It's based on the same algorithm as the Noise filter, and clumps pixels together by color and value, producing images like the one in Figure 11.15.

Figure 11.15

Use the Pointillize settings to determine how large the dots are.

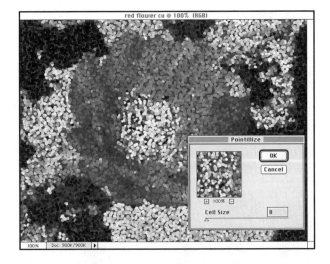

Video Filters

The Video filters have a very different purpose from any of the others. These are technical filters designed for television reproduction of images, and they are based on industry standards for color processing. As such, it's doubtful that you'll need to apply them unless you're creating art for a TV broadcast. The NTSC Color filter restricts the gamut of colors in the image to those suitable for TV reproduction, which is to say that it eliminates any that are oversaturated. The De-Interlace filter is used to smooth images that have been captured from live video, and it replaces half of the interlaced scan lines from the video scan with duplicated or interpolated lines, for a smoother image.

Digimarc Filter

This filter is one that you should use if you plan to put your pictures on the web, or if you intend to allow them to be used in any public way, such as uploaded to an online service library. The Digimarc filter puts a copyright notice on your work, indelibly, as part of the header and file information. Registering with Digimarc gives would-be users of your work a way to reach you via Digimarc's web site or fax back service.

Kai's Power Tools

Kai Krause is something of a legend in the field of computer graphics. He's the guiding genius behind Kai's Power Tools, Bryce, Convolver, Vector Effects, Final Effects, Goo, and probably many goodies yet to be announced. Power Tools 3, the current edition, is a "must-have" plug-in for Photoshop. It's a set of filters and other add-ons and tools that will let you do much more with your pictures than Photoshop alone.

The program comes with an *Explorer Guide* rather than a manual. There's much to explore, but as Kai says in a foreword, you really don't need to read the book. The interfaces are designed to be as intuitive and interesting as possible. The goal of these filters, along with doing interesting things to your photos, is to do interesting things to your mind and to your way of working with the computer. Kai's Power Tools, like all of the products mentioned here, can be purchased from your friendly software dealer. For more information, visit `http://www.metatools.com`.

When you install the KPT tools, they'll appear on the Filter menu, along with any other third-party plug-in filters that you may have installed.

Lens f/x

One of the coolest and most useful of Kai's tools is the Lens. If you think Swiss Army Knife, and turn it into a magnifying glass that does tricks, you'll have the beginning of an understanding of the Lens f/x. The tool is shown in Figure 11.16. Each of the lines and bumps and buttons on it does something. Clicking on the words Lens f/x opens the menu of effects available with this tool, enabling you to switch without going back to the Photoshop screen. Effects that the Lens applies are: Pixel, Gaussian, Noise, Edge, Intensity, Smudge, Glass Lens, and Twirl.

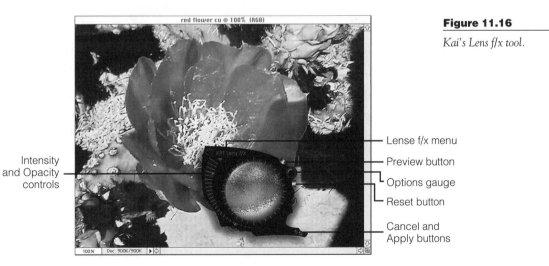

Figure 11.16

Kai's Lens f/x tool.

The gray marks along the left side, along with the two red balls on either end of them, control the intensity and opacity of the effect you're applying. The left side handles intensity, and the right side handles opacity. Clicking on either ball and dragging up

increases the percentage, while dragging down decreases it. The third ball, when present, controls the directionality of the effect. Clicking on this one and dragging it applies that direction to the effect, if it's an effect that can be directional. In the figure, we're using the pixel effect, which treats the image as if it were composed of grains of sand. These can be blown around and scattered, so directionality is available.

The top button is the Preview button. It toggles your view through the lens between the center of the image and whatever the lens happens to be on top of. You can drag it all over the image to preview the effect on different areas. You can also drag it across the rest of the screen to see what your menu bars and trash can (or recycle bin) look like with the effect applied. The lower button is the Reset button. It returns all the settings to their defaults. The gauge directly above the Reset button is the Options gauge. By pressing it, you can open the menu that lists options for applying the effect. You have, generally speaking, the same options you have when applying any other Photoshop effects: Normal, Darken, Lighten, Multiply, and so on. Remember that when you apply a KPT effect, you can still go back and fade it by using Photoshop's Fade settings.

When you have adjusted the effect the way you want it, click the small green dot at the bottom right of the lens to apply it. If you decide you don't want it, click the red dot instead, to cancel and return to the regular Photoshop screen.

Texture Explorer

This is Kai's texture generator. You can find it, like all of these KPT tools, under the Filter menu (Filter>KPT 3.0>Texture Explorer). It comes with a library of default textures, all of which are generated mathematically; hence they demand little in the way of memory or hard drive space. The Texture Designer interface is somewhat intimidating at first glance. The large square on the right is the source texture, and the squares surrounding it hold derivative textures, all recompiled each time you make a change. As you can see in Figure 11.17, you can use your own image as the source for texture generation. Clicking any of the initial 16 derivative textures makes it the source, and 16 new variations are generated, and so on until you get tired of clicking. If you find one you like, you can protect it by clicking it while pressing the Option key (Mac) or the Alt key (Windows). This will put a red line around it, protecting it and keeping it from changing when you next change the source texture.

Figure 11.17

The KPT Texture Explorer lets you turn your image into an infinite number of textures.

The collection of red and/or aqua balls on the left is the Mutation Tree. (Note the shadow of a tree beneath.) These balls represent the degree of mutation that the filter adds each time you create new texture sets. The bottom-most ball applies minimal mutation, and so on up the tree to the top ball, which is maximum mutation. This gives you results that don't even remotely resemble the source. Clicking the balls on the mutation tree results in new mutations, based on the same source.

The multicolored globe changes the gradients used to generate colors for the derivative textures. Each time you click the color ball, a different gradient will be applied. The strip below it shows the current gradient. Clicking the strip brings up a pop-up menu that lets you select a preset from hundreds that are included.

The words at the bottom of the screen each represent a control that affects the gradient on which your texture is based. You can change any of these by clicking and dragging right or left.

The three small windows near the top of the screen represent rotation, opacity, and glue. The Rotation window lets you rotate your source texture by clicking and dragging. The Opacity window lets you adjust the opacity of the gradient, making it more or less transparent, by clicking and dragging left or right. The same window also, when you double-click it, cycles through the sample backgrounds so that you can see the results of applying your texture to different kinds of images.

Spheroid Designer

The Spheroid Designer interface is a little weird. According to the book, it "...may seem like a bunch of balls dropped into a pile of mud..." but is "...actually a bunch of spheres droped onto an old, stale brownie." Hey, those are Kai's words, not mine. Weird, yes. Powerful, you betcha. The spheroid designer gives you pseudo 3-D modeling power in what's really only a two-dimensional program. You can take an image, convert it to a relief, and turn it into one, several, or hundreds of spheres, balls, little roundish things... whatever. Figure 11.18 shows the spheroid designer in operation.

Figure 11.18

Kai's Spheroid Designer makes any image into a three-dimensional version of itself.

The sample sphere at the center shows the work in progress. It's the equivalent of a preview window. The four smaller clusters of spheres around it are the light sources you can apply to your sphere. Click once on the larger ones to turn them on; then use the smaller, marble-sized ones to control the color, position, intensity, and highlight intensity of each light source. As with any of Kai's tools, clicking on the logo lets you see the effect in full-screen form. Color Plate 11.7 shows the cat spheres.

The three balls at the lower left of the screen control the curvature of the sphere, the glossiness and amount of ambient light around it, and the opacity. Clicking and dragging on these balls will change their settings.

TIP

Some of these operations can take a great deal of memory. If you can't place your sphere over the background you want, close that file and save it to a new, blank screen. Then you can merge the two images later.

There are many more dots and balls and other goodies to click in this interface. The clustered balls determine how many spheres you'll generate. The mutation tree in the upper left-hand corner of the screen, as in the texture generator, gives you random variations on your sphere. You can set bump polarity, height, rotation, and zoom with the four small dots below and to the right of the bump map panel. The best way to figure out what the various buttons and dots actually do is to experiment. You won't get bored with this tool, and even if you do nothing else for a week, you won't discover all of its possibilities.

More?

You want more? There are other KPT tools that do interesting and occasionally useful things. Glass Lens adds distortion to an image. Gradient Designer does what its name implies—only being one of Kai's tools, it does it with an interesting and unique interface. Page Curl makes your picture look as if it came from an old, dry book. Seamless Welder creates images that will wrap around a 3-D object with no visible seam. Twirl sends your picture through a tornado, variable as to intensity and direction. It also contains the Kaleidoscope filter, which makes your pictures look as if you're seeing them through an actual kaleidoscope (see Figure 11.19).

Figure 11.19

Conch house, Key West, through a kaleidoscope. (Photo by Joshua Rose)

KPT Convolver

If those initials seem familiar, they should be. Convolver is another Kai creation. You can think of it as Power Tools' more practically minded "brother." Convolver has two functions: corrective and creative. If you only use it for one of these, you'll be happy with your investment, and you'll be missing half the fun. Convolver can be purchased from your friendly local software dealer. Installation takes about a minute, and then you'll find it under the Filter menu.

The good thing about Convolver is not so much what it does, although it's extremely powerful and definitely useful. Its biggest feature is that it brings all the tools together. When you're tweaking an image, you don't have to keep going back to the menu to get new tools. Everything is right there. If changing the saturation affects something else, you don't have to go very far to fix it.

Figure 11.20 shows Convolver in Tweak mode. (Your other two choices are Explore and Design.) Tweak lets you fix an image that needs help, or make it into something unusual by changing all the colors and values. The large central diamond is the Preview window; the smaller one above it is called the Current Kernel Tile, and is used to select a portion of the image to mutate in Explore mode. Along the right side of the screen are the image controls. To apply one, click its button and drag right or left. Numbers will appear in the bar below the Preview window to tell you what settings you're using. Most of these tools can be applied as a negative, as well as a positive. Saturation, for example, starts at 100% when you first click the button. Dragging left lowers the saturation to amounts less than 100%, while dragging right raises it. How high? I stopped after 3200%.

Figure 11.20

Making multiple adjustments with Convolver.

TIP

Exploration is its own reward with Convolver, but there are more tangible ones, as well. To encourage you to poke around, the program includes some hidden tools. They're called stars, and the idea is that you'll get one after you've shown you really know how to use the program. Each one adds a new tool, when you're ready to apply it. It takes a while to work up to all five stars.

Design mode uses the image controls in pairs, taking the central diamond and breaking it into fifteen windows, each representing a combination of two image control effects in a different degree of variation. That sounds confusing, but it should become clear when you look at Figure 11.21.

Figure 11.21

Convolver in Design mode.

You'll notice an arrow along each axis of the diamond and a label denoting one of the effects. There are nine different options for each axis, and considering that they can go positive or negative, that makes 18 possible settings for each axis. Multiply that by 15 tiles of variations and 10 degrees of intensity for each setting, and you end up with a lot of options. The difference between Design mode and Tinker mode, other than the difference in the interface, is that Design mode has the image effects divided into logical pairs, while in Tinker mode you can adjust them individually.

One of Convolver's best features is the multiple Undos. You can Undo (⌘/Control+Z)—and, of course, Redo (⌘/Control+R)—up to 200 levels of changes.

Explore mode is the creative side of Convolver. It applies new mutations, based on a combination of colors and textures every time you click the mouse. Although it's not especially useful for cleaning up a poor-quality photo, it can turn a marginal picture into a work of art.

Alien Skin Eye Candy

Kai's not the only one who invents interesting plug-in filters for Photoshop. The guys over at Alien Skin have come up with a set of goodies, formerly called Black Box, but in this version renamed Eye Candy. Some of the Eye Candy effects are probably not for everyday use, unless your day job is designing covers for a science fiction magazine. Others, however, like Drop Shadow and Perspective Shadow, could be very useful. You can buy Eye Candy from your favorite software dealer or download a demo at www.alienskin.com.

The Alien Skin interface changes according to the effect you're applying, but the basic screen remains the same (see Figure 11.22).

Figure 11.22

Alien Skin Eye Candy has filters to do strange and wondrous things. We've added more fur to the cat.

In this example, the cat is most definitely having a bad fur day. Fur is one of the 21 Eye Candy effects, along with Smoke, Fire, Jiggle, Squint, Swirl, and a lot more.

Applying many of these effects requires first selecting an area to which the effect will be applied or adding a layer for it. A few, like Antimatter, simply do their thing. Antimatter's thing is to invert the brightness without affecting the colors or saturation value. Darks become light, and lights go dark.

How to Create Glass Distortion

Possibly the most useful of the Eye Candy effects is Glass. In Figure 11.23, I'm applying a sheet of bumpy glass over the mill gear picture. The glass effect is achieved by simulating three different effects: reflection, refraction, and light filtering. To use the Glass distortion effect, follow these steps:

Figure 11.23

Using Glass distortion.

1. Start with a simple image. Glass works best on uncomplicated photos. Select the Glass filter from the Eye Candy list (Filter>Eye Candy>Glass).

2. Set the Bevel width. This controls both the width of the smooth outer edge of the glass and the apparent thickness of the glass. Larger values, used with high refraction, will make your glass seem thicker. Smaller values, with low refraction, make the glass appear thinner.

3. Set Flaw spacing and Flaw thickness to create the ripples in your glass. Smaller spacing increases the frequency of flaws, while greater thickness makes them more obvious.

4. Click on the color box (the small square of color to the left of the word "Color") to select a color or shade of "dirt" for the glass. Clicking it opens the Color Picker. A very light gray suggests a dusty window without affecting the colors of the original picture. Use the Opacity slider to determine how much of a color tint is applied to the glass. Higher values add more color. Lower values enable the picture to show more clearly.

5. Set the smoothness. Higher values remove small ridges in the bevel.

6. Set the Refraction amount. Refraction is the most important control for "glassiness." It controls the amount that your picture is warped by the glass.

The scale runs from 0–100%, but only the low end of it will let your image remain intelligible. Setting refraction past 50% reduces the underlying photo to vague shapes.

7. Direction and inclination can be set by typing numbers into their boxes or by dragging the ball around until the lighting looks right. Highlight brightness and sharpness affects only the white highlights that appear on the "bumps." Higher values here give a glossier effect.

8. Watch the effect of each change in the Preview window as you make it. When you like what you see, click the check mark to confirm it and return to Photoshop, or just press Return or Enter. If the overall effect is too much, undo it and lower the settings, or use Photoshop's Fade command to moderate it.

As is true of any of these tools, the more you explore, the more you'll learn about working with them.

Extensis Photo Tools

You've already learned about Intellihance, the Extensis "smart" plug-in that automatically corrects exposure. Photo Tools is a comprehensive set of plug-ins that makes working with Photoshop easier and more pleasant. It includes a version of Intellihance, and it has several other goodies as well. The first thing PhotoTools does is to add another menu to your screen, with its own options and filters.

PhotoBars

The main goodie is called PhotoBars and it adds toolbar functions to Photoshop. Instead of fishing through menus or popping up the palettes in the tool box, you can just click on a tool icon at the top of the screen to get the command tool you want. More to the point, you can customize the tool bar to the way you work. Keep stuff hidden that you don't use often and put the buttons you press again and again in easy reach. And then there's SmartBar. It automates the process of building a toolbar for you by watching you work and assembling a list of the buttons and commands you use. Then, with a single click, you can turn the list into a toolbar. In Figure 11.24, SmartBars is running, and the PhotoBar toolbar is installed.

SmartBars is making a list of the tools I have used on this picture. When I'm finished with it, I'll look at the list and decide whether I want to use it as a custom toolbar for future projects. If so, I can save it by clicking in the PhotoBar menu and giving it a name. I can also edit it or add more tools by using the Toolbar editor. I can even generate custom icons for my favorite filters. Maybe a picture of Kai?

The custom toolbar

Figure 11.24

Extensis PhotoTools creates custom toolbars.

PhotoText

If there's one reason to buy PhotoTools, it's the type tool, PhotoText. As you probably noticed, Photoshop doesn't have a whole lot of flexibility or even real WYSIWYG (what you see is what you get) interface on typography. PhotoText makes up for this deficiency by letting you place type over a picture, while you're typing it. The PhotoText window is shown in Figure 11.25.

Figure 11.25

PhotoText is terrific!

You can set width and tracking for your type, adjust leading, and set anti-aliased, justified, flush left or right, or centered type at the click of a mouse, just as in any other good graphics program. Text handling was Photoshop's only deficiency, and this tool definitely fills in the gap. Even better, it's easy to use. Here's how.

1. Prepare your background first. Remember that a "busy" picture will make type harder to read, so fade it down or reduce it to two colors as I've done here.

2. Open the PhotoText window. Choose a font and size and click the T icon to place a text block.

3. Position the cursor where you want to start typing; then set your type. Drag the handles on the text block to make it larger, if necessary. Type is being set in a new layer, so you needn't worry about covering background elements.

4. Use the arrow icon or just press and hold the Option key to bring back the pointer tool, so you can move your text around on the screen, if you decide to reposition it.

5. Adjust the leading and tracking in the windows above the preview screen.

6. Change the color with the Eyedropper and Color Picker window.

7. If you're using larger fonts, (over 14-point) and want to apply anti-aliasing to prevent jaggies, click the anti-alias button, which is under the Color Picker.

8. When your page is designed as you want it, click the arrow icon (top button) to save it or the X button to cancel. Closing the window also cancels the type.

You can change type attributes on individual characters by selecting them with the Type tool, or on the entire text block by selecting it. Because the type is set on a new layer, you can easily apply Photoshop's Type Paths tool to turn it into a selection and use it for special effects. Headlines set in this way will look better than those done directly in Photoshop because they can be properly kerned and letter spaced.

Finding and Using Shareware Filters

It always amazes me how many talented and generous people there are out there who not only write useful software, but then turn around and give it away (or sell it for such a pittance that they might as well be giving it away). I am speaking, of course, of shareware, and the authors who spend many long nights polishing a program and then upload it to AOL or to the web. If you go searching in appropriate areas for Mac or Windows software,

you should find plenty of new and useful Photoshop plug-ins. I did a Lycos search on Photoshop filter, and got back a list of hundreds of sites that were triggered by that combination of keywords. Here are two good ones to get you started.

```
http://pluginhead.eyecandy.com/filplug.htm
http://the-tech.mit.edu/KPT/
```

Assignment

Take an ordinary photo and apply all Photoshop's filters to it. Experiment! Save the ones you like. As you work, keep a notebook of what you did to each example, which settings you used, and what combinations of colors, or textures, or multiple filters gave you good results. If something doesn't work, or comes out badly, make a note of that, too.

Compositing

- Making one picture out of many
- Replacing backgrounds
- Creating a photo montage
- Controlling transparency in overlaid images
- Adding type
- Using Photoshop and filters to alter type
- Kai's Power Goo
- Morphing

You can call them collages, montages, composites, patchworks, or assemblages... all these terms means the same thing—a picture that's made out of pieces of other pictures. Why do it? Why not? It's fun to create new pictures from old ones. And, often it's useful to be able to change a background, or to add something to a composition that wasn't originally part of it. There's also morphing, in which one picture changes over time to another. You've seen this effect many times in ads, on television, and in the movies. Now, you can do it yourself. Today let's take an in-depth look at the techniques for creating multi-image photos.

Making One Picture Out of Many

When you start thinking about combining images, you'll probably realize that there are some pictures more suitable than others for this kind of use. You could even classify some as backgrounds, others as objects, and some as the raw materials from which to create special effects. As you browse through your own pictures and look at collections of stock photos, some images will jump out at you, and you'll begin to see possible combinations.

What are stock photos anyway? If you're not familiar with the term, you should be. Stock photos are pictures that are made available to you, either royalty-free, or for payment

(usually the latter), to do with as you see fit. You can use them in your reports, in ads, practically any way you want, as long as you're not reselling them as is, or using them in any way that's libelous, defamatory, pornographic, or otherwise illegal. Be sure you read and understand the licensing policies before you use them.

Extensis PhotoDisc is typical of stock photo collections. The PhotoDisc collection includes over 50,000 pictures of everything you can imagine. A few samples are included on the PhotoTools and Fetch CDs. Figure 12.1 shows a page from their catalog. There's no reason you can't use these kinds of images in combination with your own. If you need something basic, like a slab of concrete to use as a background, it will be faster, cheaper, and just as effective to use one from stock. If you're looking for stock photo web sites, start your search at `http://www.s2f.com/STOCKPHOTO/index.html`. You'll find links here to every possible stock photography site.

Of course, as you wander around town with your digital camera in your pocket, you can start your own stock collection, too. In fact, it's one of the ways you can make money with your pictures, enabling you to invest the profits in more software and higher resolution cameras.

Figure 12.1

A typical catalog page of stock photos.

Putting Together a Composite Photo

Let's start compositing with a couple of images from the stock catalog. There's a mailbox we can use and some flowers. And I have a few more flower pictures elsewhere. How about a mailbox spilling flowers out the front like a cornucopia? You don't even need anything as powerful as Photoshop for this project. You can do it in PhotoDeluxe.

Let's take this process one step at a time.

1. Start by gathering the elements: the mailbox and the flowers. You can collect the flowers on a page and put them into the Hold file while you work on the mailbox. Type ⌘/Control+H to open the dialog box that saves a file into the Hold folder.

2. Now, we'll work with the mailbox file. The mailbox needs to have its door opened, and the background must be removed. The latter is the simplest task, so let's do that first. Select the mailbox with the polygon tool. Click Delete Background, and—poof! It's gone. If you missed a bit of it, use the eraser to get rid of it, as I'm doing in Figure 12.2.

Figure 12.2

No more background.

3. The next step is to move the mailbox up a bit so that when you open the door, you'll have a place for it to hang down.

4. Then, select the door and cut and paste it into an empty spot.

5. Now the fun begins. It will take some flipping and free rotating to make the door edge align properly with the bottom of the mailbox. This can only be done by trial and error, but within a minute or two we'll find the right combination. Figure 12.3 shows this stage.

6. The flowers, unfortunately, are on a white background, and so is the mailbox, making it impossible to tell which is on top. So, let's temporarily stick in a layer of a contrasting color and hide the mailbox. Add a layer by clicking the New Layer button. Choose Color Change from the Tools menu. Click the swatch in the Color Change box to change its color and click the image to change the color of the new layer.

Figure 12.3

Rotate and flip the door
until it looks right.

7. Now it's easy to select the flowers and delete the white background. Use Delete Background as in step 2. You can move the flowers into position over the mailbox by turning off the colored layer. Finally, we can duplicate some of the flowers and rotate them so they look like different ones (see Figure 12.4).

Figure 12.4

The job is done, a mailbox
full of flowers.

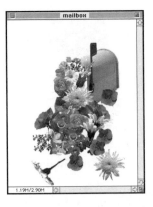

It still looks a little bare, so perhaps you can put in a colored background, either another photo, a flat color, or a textured color. The possibilities are endless, and quite a lot of fun to explore.

Replacing Backgrounds

Replacing a background isn't especially difficult. You have to isolate the object you're keeping from the background you're discarding, and then bring in the new background as a separate layer, which you slide underneath the other one(s).

As an example of what can be done, let's start with a difficult picture. I fell in love with this fallen down barn in rural South Carolina. Figure 12.5 shows the original picture. But, as real estate agents say, "Location. Location. Location." Let's give it an ocean view.

Figure 12.5

"For sale, cheap. Will relocate to suit owner."

First, I will take away everything that is *not* part of the shed. The quickest way to do this is to use the Polygon Lasso to select the shed. Then, choosing Inverse from the Select menu deselects the shed, and selects everything else in the frame instead. Press Delete, and it's history. On another photo safari, I found a millionaire's estate up in Manchester, Massachusetts. It seems as if the beach, which you can see in Figure 12.6, would be a nicer location for my shed.

Figure 12.6

Uh, oh... there goes the neighborhood.

Let's take the mansion out, first. Again, I will select it and delete. When I drop the shed into its place, you should notice two things. First, it's too big. Second, it's facing the wrong way. Flip horizontal (Image>Rotate>Flip horizontal) will turn it so the window faces the view (see Figure 12.7). And I'll use Scale (Layer>Transform>Scale) to reduce it to a more appropriate size. A little blending of shrubbery around the base and sky at the top, plus feathering the image by a couple of pixels (Select>Feather), makes it look like it's always been there.

Figure 12.7

The image has to make sense in its new location.

However, there's a strong shadow on the front of the shed because it was shot on a very sunny day. The beach scene was, alas, shot on a cloudy winter day. I have two choices here. I can lighten the shadow, or even lose it entirely. Or, I can adjust the background to make the beach look sunnier. Actually, there's a third choice that's an even better solution—to do a little of both. First, I'll lighten the shadows, and then I'll brighten the sand. To lighten the shadows on the building, I'll select just that part of the image, and make it an adjustment layer (Layer>New>Adjustment layer). Then I can apply Curves to just the shadow and make it match the rest of the building. Finally, I will merge all of the layers, and apply Curves again to brighten up the entire picture. Figure 12.8 shows the final picture, and Color Plate 12.1(a&b) shows the "before and after."

Figure 12.8

The final image.

The main things to consider in making composites are the following:

- Keep your backgrounds simple.
- Isolate the elements on different layers for easier editing.
- When you're done, merge the layers for a smaller file.

No matter which program you end up using to do your compositing, the process is the same (but the specific manipulations and tools are different), and the results are up to you. You can be as avant-garde and surreal as you want. Or you can do things like the flowers in the mailbox that are more commercially oriented.

Bringing in Elements from Other Sources

You're certainly not limited to photos when you assemble a photo montage. Consider the possibility of using a program such as Bryce to generate a background for your picture. Bryce is a fractal landscape generator. Instead of using a beach scene that you've shot, you can invent a beach on Mars for your bathing suit models or perhaps put your home in a golden meadow with towering mountains behind it.

Bryce has tools to create landscapes, water, and skies in any combination of color, material, and lighting quality you can imagine. The program comes from the same folks who make Kai's Power Tools and Convolver. You can buy it from your usual software suppliers, and it's often bundled with other MetaTools products.

If landscapes aren't what you had in mind, how about printing your pictures on chrome spheres or some other 3-D object? Check out Extreme 3D. Figure 12.9 shows a collection of balls on which I applied the infamous cat pictures. The next step with these would be to bring them into Photoshop and float them in a pond, or perhaps hang them on the Christmas tree.

Figure 12.9

You could put almost anything in here.

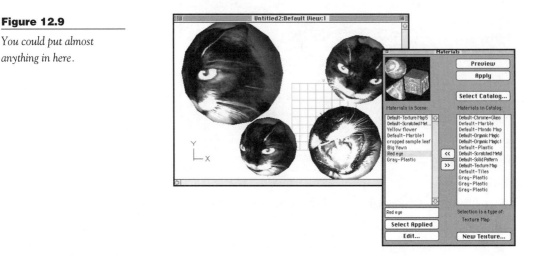

Controlling Transparency in Overlaid Images

It's extremely simple to paste one opaque image over another one. You just do it. Transparent images are harder to work with, although Photoshop makes it a little bit easier by giving you transparency control. When you're creating a multilayered picture, as in Figure 12.10, you have two ways to control the way the layers blend. One is the Opacity slider. You can set any degree of opacity, from 100% all the way down to zero, at which point whatever is on the layer has completely disappeared. You can also control the effect by using the Blending Modes menu. Blending modes apply both to tools that paint or draw (including the brush, airbrush, eraser, and pencil); and to layers. By applying different modes to different layers, you can control the way each layer overlies the others. You'll find a pop-up menu of blending modes on the Tool Options palette and on the Layers palette.

Figure 12.10

Various degrees of blend and transparency.

Blending Modes Explained

The blending modes act predictably, if you understand what it is they're actually doing, but the names are deceptive. If you apply them without understanding them, you may not get quite what you bargained for. When you blend two colors, you get a third, if you're physically mixing them. Red and blue, for instance, make purple. This isn't necessarily true in Photoshop.

Blend Modes That Don't Blend

Normal doesn't blend colors. If you paste one over the other, you have an overlap, not a blend. If you're blending them with Dissolve as the blending mode, you don't get a mixture. Instead, you will get a random replacement of red pixels with blue pixels, depending on which is more opaque at any pixel location. (Color Plate 12.2 shows all of these effects.)

Blend Modes That Lighten and Darken

Multiply would darken the red by the amount of blue in the pixel. Repeated layers of blue would make the red even darker. Screen does the opposite. Technically, it multiplies the inverse of the base and blend colors, giving you a result that's lighter. It's sort of like painting with bleach.

Overlay will either multiply *or* screen, depending on the base color. Colors blend by reflecting the lightness or darkness of the original color, to preserve highlights and shadows. Soft light and hard light also darken or lighten, but do so depending on the blend color rather than the base color. If the blend color is lighter than 50% gray, the image is lightened as if it were screened. If it's darker than 50% gray, the image is darkened as if it were multiplied.

Color Dodge and Color Burn look at the color information in both the base color and blend color and either brighten (dodge) or darken (burn) the base color to reflect the blend color.

Darken and Lighten can give very unexpected results. Darken looks at the colors of both base and blend and selects whichever is darker as the result color. Pixels which are lighter than the blend color are replaced, but pixels that are darker don't change. Lighten does exactly the opposite, replacing darker pixels with the lighter blend color. Difference subtracts either the base color from the blend color or the blend color from the base color, depending on which one has the greater brightness value. Exclusion is similar to Difference, but less pronounced.

Blend Modes That Mix Colors

Hue gives you a color with the luminance and saturation of the base color, but the hue of the blend color. Saturation retains the luminance and hue of the base color and uses the saturation of the blend color. If the saturation amounts are similar or the background saturation is zero, there is no change.

Color creates a result with the hue and saturation of the blend color and the luminance of the base color. It preserves gray levels and is especially useful when coloring monochrome images or adding an overall tint to color images. Luminosity gives you a result color that is the opposite of Color mode, with the hue and saturation of the base and the luminance of the blend.

The best way to learn to use these blending modes is to try one after another until you find the one that meets the objective you're trying to achieve with the picture. It may take a while. The algorithm for each blending mode is written so that they do what they were designed to do, but you may find that they don't do it quite the way you expect them to. If you refer back to the Color Plate 12.2, you can see that some blends give you shades of red or blue, a few even make shades of gray or brown. I can't stress too much how important it is to experiment with programs like Photoshop. Trying things out is really the best way to learn.

Adding Type

Not all composite photos have type added, but many do, and it may as well be interesting type. You've already seen the Photoshop Type tool and the Extensis PhotoText plug-in. What's left to learn? Photoshop still has a pretty good type trick up its sleeve. If a picture is worth a thousand words, how much is a word filled with pictures worth? Let's find out.

Half the battle is finding a picture to work with. The other half is finding a nice fat typeface that leaves plenty of room for your pictures to show through. I'm working on a logo for a company called Cloud Nine. Logically enough, I'm thinking about clouds, as I flip through my picture collection. When I find a picture that has nicely defined clouds, I open it in Photoshop and punch up the contrast a little bit more. Then I select the Type outline tool by holding the mouse button down as I select the Type tool from the Photoshop toolbox, and choosing the dotted line T. If I click it in the sky area, I can open the Type dialog box. I choose Cooper Black, making it bold as well for a few extra pixels worth of width. And I type the word "Cloud," as large as possible to fit in the area (see Figure 12.11).

Figure 12.11

Capturing a cloud.

When I close the dialog box and return to the picture, I have selection paths in the shape of the letters. After making sure they're centered over the clouds I want to capture, I copy the selection and paste it to a new layer. It's important to copy and not cut. If I use the cut command, I'll leave holes in my original picture, and that's no good because I have another word to grab from it. First, I adjust the color in the picture. The first clouds were pink, as at sunset. These clouds are more blue. Repeating the Type tool process, I enter the word "Nine" and take a different section of clouds.

The next step is to get rid of the original picture, since I don't need it any more, but the lettering *does* need a background. Clouds would probably be appropriate. I start by adding another layer and pouring it full of light blue paint. I also have to pour paint into the interior of the closed letters O and D. After making sure that my foreground color is white and my background color is an appropriate blue, I choose Render Clouds from the Filter menu (Filter>Render>Clouds) (see Figure 12.12). It uses a set of random number equations and a fractal generator to draw imitation clouds using whatever two colors are selected for background and foreground.

Figure 12.12

More clouds.

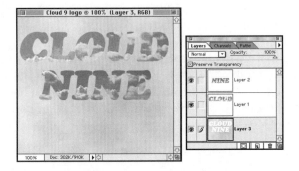

The rendered clouds just don't look very impressive, and there's not enough contrast against the lettering. I can make the clouds stand out a little more by adjusting the contrast and color balance. I can also put a drop shadow behind the lettering. Figure 12.13 shows Eye Candy's Drop Shadow effect, absolutely the right tool for this job.

Figure 12.13

Shadows made simple.

I can design the perfect drop shadow here, setting the angle for it, the distance from the letters to the shadow, the amount of blur, and even the opacity of the shadow. Finally, I'll crop it a little bit tighter, and it's done. Color Plate 12.3 shows the finished logo.

Extensis Photo Tools also has a very good drop shadow tool, which you can use with all kinds of objects, not just type. In Figure 12.14, I'm using it to add a colored shadow behind some lettering. You have many choices to make when using this tool. The first is whether the shadow follows only the edges of the object, or if it is solid. A solid shadow fills in the hollows in open letters, such as D and O. The X and Y offset let you position the shadow above or below and left or right of the object. The blur setting softens the edges of the shadow, with higher numbers being more blurry.

Figure 12.14

Not as funky as Eye Candy, but it works.

Opacity controls how much, if any, of the background can be seen through the shadow. Clicking on the color block opens up a palette of colors, and also gives you access to Photoshop's current background and foreground colors and the Color Picker.

Drop Shadows from Scratch

Putting a shadow behind your lettering makes it stand out from the page, giving a nice three-dimensional feeling. It's easy to do if you have the right tool. If you don't happen to have Eye Candy or PhotoTools, you can still make acceptable drop shadows for your lettering. Here's how to do it in Photoshop:

1. Select the Type tool to open Photoshop's type dialog box. Set the type for the lettering in any color you want to use, or use paths and cut your letters out of a photo. (By default, your type appears in whatever foreground color is chosen.) Figure 12.15 shows some very basic lettering.

Figure 12.15

I hid the background so that you could see the type.

2. Then change the foreground color to the color you want your drop shadow to be and set the same type again. Drag the shadow layer so that it's underneath the colored type layer.

3. Slide the shadow around under the type until it looks right. If you want a less focused shadow, select the shadow type and apply a blur filter (Filter>Blur) to it (see Figure 12.16).

Figure 12.16

Shadows make the lettering more visible.

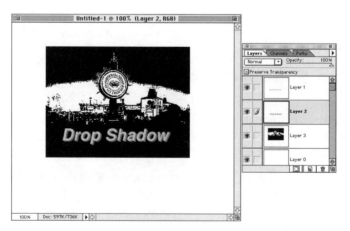

Working with Type and Filters

Drop shadows are only the beginning of the things you can do with, or to, your type. All the filter effects that work with pictures work with type, although many of them can make it difficult, if not impossible, to read. Legibility is a factor to consider whenever you combine type with photos. You'll have better luck if you stick with bold faces, particularly if you're planning to apply any kind of effect to them. Delicate fonts tend to get lost against a busy background, and don't have enough mass to let a surface texture show up.

Whenever you paste type into a new layer, it shows up with the Preserve Transparency checkbox checked. This is fine, unless you're going to try to apply a filter. As long as the box is checked, the filter won't have any effect. So, be sure you open the Layers window, if it's not already open, and uncheck the box. Otherwise, your filter experiments will prove highly unsatisfying.

By applying Photoshop's filters to a piece of type you can texturize it, add a glow, or totally destroy it. Getting a little wilder with Eye Candy, you can make the letters furry, or even set fire to them. See Figure 12.17 for some examples. From the top, I've used Extrude, Mezzotint, Ripple, Glowing Edges, Eye Candy Fire, Eye Candy HSB Noise, and Radial Blur.

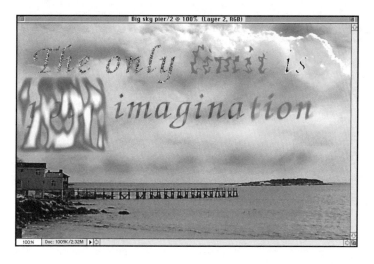

Figure 12.17

Some filters were more successful than others.

PhotoTools has a bunch of other tools that work very nicely with type. Color Plate 12.4 shows a poster I created from a picture of the two black cats sharing a desk chair. I turned the digital photo into a digital watercolor, in the French impressionist style, before adding the type. Because of the range of darks and lights in the background, it was impossible to find a color that stood out well enough against everything. So I used the PhotoTools PhotoGlow to put a wash of plain orange behind the type. They call this effect Solar Eclipse. It's one of several presets. You can also use the PhotoGlow window, shown in Figure 12.18, to design your own glow.

Figure 12.18

Make it a gentle glow or a radioactive one. It's up to you.

Type Twister

For funky type effects, there's one program that tops every other: Aldus Type Twister. If there's a program that's easier to use, and does more, I haven't seen it in some 12 years of computing. This has to be the best way to generate 3-D type effects. All you do is type the words you want to set into the text box and scroll through the Type Twister display until you see a style that grabs you (see Figure 12.19).

After you settle on a basic style, you can change the font, the colors, the orientation, and in many cases the shape of the type block. There are hundreds, if not thousands, of unique combinations. When you have the type the way you want it, simply click the Copy button, and your twisted type is placed on the clipboard, along with a PostScript version, ready to paste into Photoshop or whatever other application you are using. To see one possible use for Type Twister, check out Color Plate 12.5. You can get Type Twister from your favorite software dealer. It's also frequently bundled with other graphics programs or with Adobe fonts.

Figure 12.19

Let's Twist Again…

Bevels

Yachtsmen (and, one supposes, yachtswomen) pay outrageous sums of money to have their boats' names hand carved on beveled quarterboards and sternboards. You can, in effect, place your text on a similarly beveled signboard with PhotoTools Bevel maker. If you start with something flat, as I did in Figure 12.20, you'll get a beveled signboard, suitable for placing text.

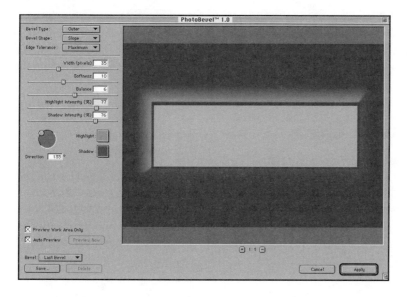

Figure 12.20

Sign here.

If you simply apply the bevel to your type, you will also end up with some very interesting three-dimensional type effects. The bevel can be rounded as well as angled, producing letters that look as if they were pushed up from underneath the picture. Figure 12.21 shows two different type treatments, both done with the Bevel tool.

Figure 12.21

Beveled type is flat on top, but deeply shadowed on the sides.

Photo Emboss also does cool things to both type and selected objects. Photo Emboss can make type look as if it's been squeezed from a toothpaste tube, or poked up from the background.

You can spend many hours playing with type. Just as a writer spends a long time looking for the right word, an artist can spend a long time looking for the right font, color, and position on the page. Both are important if the words are going to achieve maximum impact.

Kai's Power Goo

Goo? How can you take a product named Goo seriously? Well, you can't, and you aren't supposed to. Goo is strictly for fun. It comes with several of the lower-priced digital cameras, notably the Kodak DC 20 and DC 25, is sold alone, and is often bundled with other products. Goo, according to the folks at MetaTools, is the first of several products that attempt to turn some of Kai's Power Tools into stand-alone applications. It's certainly a worthwhile idea, especially for those who find Photoshop intimidating. Your kids can use it, and will probably think it's one of the best video games ever. So, what is it?

Goo is a morphing program, based on some of the Photoshop special effects from Kai's Power Tools. Morphing, in this context, means shape-changing. Goo gives you the tools to smudge, nudge, move, twist, bend, stretch, shrink, and change the faces of famous and

not so famous people, including your own friends and family. You can also combine the best, or more often worst, features of any two people, animals, or whatever you want. Goo comes with a library of over 170 politicians, animals, and miscellaneous people of all ages, shapes, and styles. That's just to get you started. You can, of course, bring in your own digital photos, even importing them directly from the camera if you happen to have a Kodak.

The Gooey GUI

When you first open Kai's Power Goo, you get to choose whether to explore Goo or Fusion. The opening screen, shown in Figure 12.22, is also the central point for opening new files, saving your work, and transferring from Goo mode to Fusion mode.

Figure 12.22

Goo starts here.

The Goo screen is basically a frame for the picture you're working on, with a semicircle of rainbow-colored buttons around it. Each button is labeled with its function. To activate one, click it and then click and drag the mouse pointer over the part of the picture you want to work on. Some movements are quite subtle, others drastic. Ungoo is the equivalent of Undo, and Reset, of course, returns the face to normal. In Figure 12.23, I've been doing a little bit of virtual plastic surgery on one of the British Royal Family.

Figure 12.23

What did the Princess ever see in him?

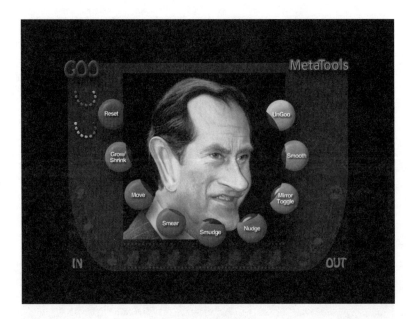

As you start to explore the buttons and sliders, you'll notice what looks like a filmstrip at the bottom of the screen. That's the basis for a "Goovie." Goovies are animated movies, which you can create as you tweak and twirl the faces on your screen. Each time you make a change, stop and click to save a frame. When you're done, clicking on the movie camera will start the Goovie playing back. It will go around in an endless loop, if you want, making Uncle Hector's ears and chin grow and shrink at whatever speed you like. Goovies can be exported as QuickTime or AVI movies up to 64 frames long. These can be played back with any program that handles the format, and can even be converted and placed on a web page as animation.

Fusion

When you open the Fusion screen, you can see two faces, instead of one, and one of them is repeated in the central work area. This is the basic face for the morph. Figure 12.24 shows the interface with a morph partially completed.

You can choose either face to serve as the basis, by clicking the arrows. Choose a feature to replace by centering the target cursor on the replacement. Click the paint button and paint the spot where the new feature should appear. As if by magic, it dissolves into the image. Use the hash marks around the paint and smooth buttons to vary the opacity of the incoming image.

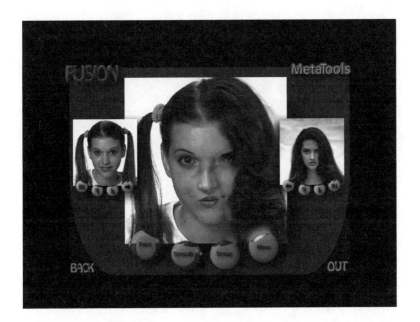

Figure 12.24

*Kids can grow up even
faster than in real life.*

If the tools in Fusion mode aren't sufficient for all the changes you want to make, copy over the features and then move the morphed face back into Goo mode to refine it. Goo is really fun to play with. You can spend hours turning your kitten into a tiger or your spouse into this week's Hollywood sex symbol.

Gryphon's Morph

Morphing isn't just kids stuff. It's a trick that advertising art directors and filmmakers have been using ever since digital technology made it possible. Mostly they've used one particular program, Gryphon's Morph, to do the job. Why? It was the first commercial morph software, and it remains the best.

It's easy enough to be useful to beginners at warping and morphing, and has plenty of features and gimmicks to provide a challenge to experienced professionals who think they've seen it all. The advanced morphing, warping, and "caricaturing" options that this software provides lets you produce extremely complex still and animated graphics. Using only a few simple tools, Morph is capable of generating startling high-end results.

Figure 12.25 shows the Morph screen. Morph has a small movable toolbox with seven tools: Selection Arrow, Pointer Tool, Connecting Line Tool, Scissors (Cut), Magnifying Glass (Zooms), Hand (Move Image), and Rotation Tool.

Figure 12.25

Morph isn't as pretty as Goo, but it has many more functions.

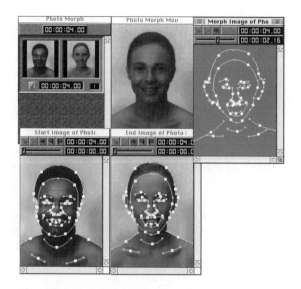

The editing screen looks like a storyboard, which is exactly what it's called. In fact, images in a Morph sequence may be printed out as a true storyboard. A source and a target space inhabit the storyboard, areas where you place source and target graphics. Your digital photos will import easily into Morph.

Morph operates in a very logical manner. You simply place points and lines around important elements of the source image (see Figure 12.26). These points and lines then show up over the target image, and they can be moved on the target image to align the most important elements. After the points are placed, Morph generates a preview that shows how the outlined elements will move from source to target shapes. When points and connecting lines are where they should be, Morph makes a movie that shows the source image transforming into the target. This is how all basic morphing programs work, but Morph's tools let you go far beyond the basics.

In addition to being able to generate a sequence of morphing images between two graphics, Morph enables you to carry on with as many additional images to morph as your computer's memory will support. New source/target pairs can be added to the sequence, points and connecting lines placed around their important shapes, and the whole process repeated again. Sample portraits of seven American presidents are included with the program to enable you to experiment with an elongated sequence, transforming one to the next in a series. All of this is accomplished without making the process any more difficult than it is in working with only two images. The final quality of the images can be selected from low, good, and better.

Figure 12.26

The cat's not a crook, either.

Warping

Morph can generate quality warps. A warp is simply a morph of one photo into a different, stretched, shrunken, or otherwise distorted version of itself. All aspects of the image can be altered by deft placement of the control points and their associated lines. You can generate a preview before you commit to the final rendering. By carefully placing control points and line guides around the elements to be altered, you can keep background elements of the image from moving. Any warped graphic can be exported as a PICT, Tiff, or Photoshop image.

Morphing

As part of the previewing process, still images can be generated from any intermediate frame in a morphing sequence, and you might choose to export any of these previews as a still image. The final quality and magic of a morphing sequence depends entirely upon how carefully the points and connecting lines are placed. The connecting lines have Bézier-like controls, so they can be shaped to conform to the selected graphic very closely. Morph also allows you to create a morphic movie or series of images from two animated sequences, the difference being that points and lines will require more movement as the animations progress. Birds in flight can become airplanes in flight, and running pigs can become bounding dogs. All it takes is a little practice and some dedicated time.

Caricatures

Unique to Gryphon's Morph is the possibility of creating photo-realistic caricatures—images that have exaggerated elements that transform them into photo-cartoons. Your digital photos are perfect targets for this treatment. A reference image is used to apply its features to a target image, and the resulting rendering is previewed and (if you like it) saved. No other morphing package offers this direct capability.

Because it has so many features, Morph takes a while to master. If it's the tool you need, you'll learn to use it. If not, or if you're not sure, start with Goo. It's easier, and less complicated to learn. If you like the idea, but find it doesn't do quite enough, you really need Morph.

Tools or Toys?

It doesn't really matter whether you think of programs like Goo and Morph, and even Photoshop, as tools or as toys. The point is to work with, or play with them, as often as you can. In this chapter, I've tried to introduce you to some of the cool things you can do with the right software, and a sense of adventure. There are a great many more. The possibilities truly are endless. Explore! Create! Have fun!

Assignment

Make a collage of at least four images. Place type over them, promoting yourself as a digital photographer. Use drop shadows, or whatever is necessary, to make the type stand out.

Special Effects

- Duotones
- Color inversions
- Pixelating
- Crystallizing and faceting
- Pointillation and mosaics
- Mezzotints
- Stylized effects
- Extruding and embossing
- Outlining, trace edges
- Swirls, distortions, and wind

Now that you have begun to learn your way around the digital darkroom, here are some advanced techniques to help you go even further with image manipulation. None of these methods are intended for everyday use; however, as occasional variations in your photo portfolio, they'll add interest to your pictures and show that you can do something beyond straight photography.

Duotones

Duotones, and their cousins, monotones, tritones, and quadtones, are quite simply grayscale images printed in various numbers of colored inks. The colors blend to reproduce tinted grays. Color Plate 13.1 is an example of a duotone, which uses red and blue inks to make a dark brick red in the same values as the grayscale it replaces.

There's a good reason for using duotones, rather than black ink, when you want a really good reproduction of a grayscale image. The bottom line is quality. A grayscale image can have as many as 254 shades of gray, plus pure black and white. The best a printing press

can do is to reproduce only about 50 levels of gray per ink. If you print in black (or any monotone color), your pictures automatically get compressed—each five steps of gray becoming one. So the image comes out looking a lot coarser than it would if two inks were used. When you convert the grayscale to a duotone, you add another 50 levels of gray, and immediately your image looks better and less compressed.

Duotones can be printed with a black ink and a gray ink, but it's more common to use black plus a color, giving a slight tint to the midtones and highlights. You can also make a duotone with two contrasting colors for a more unusual and colorful effect. Figure 13.1 shows the setup for the picture on Color Plate 13.1. If you're printing a newsletter or brochure with spot color, consider doing your photos as duotones. They'll look better and more professional than plain black-and-white pictures, and if you've got the color available, you may as well use it.

Figure 13.1

Making a duotone.

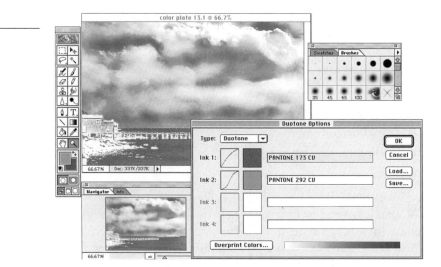

To convert this photo, I used red and a medium blue. They blended to make a rich, reddish violet. If I wanted to convert this picture to a tritone, I'd add a third, lighter color, perhaps a yellow or beige. To convert an image to a duotone, you can follow these steps. As always, make sure that you have a backup copy of your original picture before you make drastic changes to it.

1. First, you must convert the image to grayscale. Only grayscale images can be turned into duotones, monotones, and so on. Under the Image menu, choose Mode>Grayscale. If your image is in color, you will be asked if you really want to discard the color information. Click OK.

2. Choose Duotone from the Mode menu. (You may have noticed that it was grayed out as a choice before you converted the image to grayscale.)

3. Specify the kind of image (duotone, monotone, tritone, or quadtone) and the ink colors. This determines how many ink color windows are available to you.

4. To specify a color, click the box for the color. This will open the Color Picker to enable you to choose a color. If you want to specify Pantone colors, click the Custom color button to open the Pantone swatches. Darker inks should be printed before lighter inks, so make sure that the darker tone is at the top of the list.

5. Use the boxes at the left of the screen to adjust the curves for the two duotone ink colors. When you click the box, you'll open a curve graph specifically for that color. Unfortunately, there's no way to preview the result of your actions, so be prepared to experiment and undo, if necessary.

6. When you're satisfied, click OK.

Photoshop even comes with a set of duotone presets with the curves already adjusted for you. They're stored in the Photoshop Goodies folder. Although their color choices are unexciting, they'll give you a good feel for how a duotone's values should be assigned in the Curve window.

Tritones and quadtones, although they start with more colors, still end up as grayscales rendered in a single hue. The color applied to the grayscale values is simply mixed from three or four colors instead of two. It has a richer appearance and more detail, but otherwise is substantially no different.

If you want an effect that breaks the picture down into two colors, posterize it to three levels using the Posterize command under the Image>Adjust menu. You'll end up with the picture rendered in whatever you have set as your background and foreground colors plus white. Adding more levels lets Photoshop add more colors.

Color Inversions

Colors don't have to be natural. Image handling programs, from Photoshop all the way down to the simplest ones, give you ways to recolor your pictures. Replace Color, a Photoshop dialog box found under the Image>Adjust menu, makes it fairly simple to turn an ordinary landscape into one with purple hills and pink sand (see Figure 13.2).

Figure 13.2

*Purple mountains majesty
and a tutti-frutti plain.*

To use it, open the dialog box. Use the Eyedropper to select a color to replace. This function works by creating a mask based on the colors you select and then adjusting the Hue, Saturation, and Lightness values to make the color change. If you click the Selection button, you'll be able to see the mask you're building in the Preview window. Masked areas appear in black; partially masked areas will appear to be in various levels of gray, based on their relative opacity.

Remember that you can Shift+click to select additional areas. When you have everything selected that you want to change, move the Hue, Saturation, and Lightness sliders until you have created a color you like. Click OK to replace it.

Another way to do a color change is to first posterize your image in order to reduce it from many levels of color down to a few. You should experiment to see how many levels of posterization work best with your picture. If you're happy with the posterized colors, you needn't do anything else to the image, but if you're not, you can selectively replace them by using the technique described below. In the example in Figure 13.3, I had to use seven levels to keep the nice sun flare. With any fewer, the differences in the sky tones were too minor, and they all turned white.

Figure 13.3

*Posterizing can be very
effective.*

Changing Colors in a Posterized Picture

After you have found the right number of levels, select them one by one to change their colors, using the Magic Wand and Select>Similar command. Change the color in the foreground and use the Paint Bucket tool to pour it into the selected areas.

Color Plate 13.2 shows the colorful result of some further manipulations with the same picture. Having posterized the image, I used the Solarize command from the Stylize filters. Solarizing made the picture very dark, because it inverts everything, but the colors were interesting. To keep the colors without losing the image, I used the Fade dialog box (see Figure 13.4) to fade the solarized image until I got the picture I wanted.

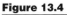
Figure 13.4

Fading an effect lets you decide how much of the original picture you want to keep.

Chromatica

Chromatica is a Photoshop plug-in that simplifies the business of selecting and changing colors in an image. Unlike standard selection tools, which look at color pixel-by-pixel, it sees color in a more "human" way by noting the boundaries between different regions of color and different grayscale value regions within the image. Using these colors, it creates a color map of what the program calls *isocontours*, which are organized into a color track containing all the structural and color information from the image. The color track can then be stretched, compressed, or swapped with a different one to produce unique effects on your digital images.

TIP

Many graphics programs other than Photoshop will accept Photoshop plug-ins like Chromatica, including some of the low-end photo editing programs, such as Adobe PhotoDeluxe and PhotoStudio. If you use both Photoshop and another program that uses the same filters, just direct your other program (usually from Preferences) to the Photoshop plug-ins folder.

Chromatica actually has two plug-ins. The first is ChromaColor, which includes the selection functions (see Figure 13.5). The tool that resembles crosshairs is the Selection tool. You can center it on a single pixel or click and drag it to make a large selection box that will select all the color within it. The Eraser can be used to adjust your selection by removing or adding pieces of the image. The Hand tool, as always, moves your image inside the window, and the Magnifier zooms in or out. Press Option (Mac) or Alt (windows) and click the Magnifier to see more of the picture.

Figure 13.5

*ChromaColor's working
screen.*

Selecting colors is almost automatic. If you click the Contiguous Selection, ChromaColor selects only pixels that are physically touching the original color sample. Otherwise, it will select every occurrence of the selected color in the image. The color wheel shows the range of color selected. The Hue, Saturation, and Value sliders give you even finer control over the color or range of colors selected.

Recoloring an Object in ChromaColor

To recolor an object, you must first select the color to change. Then you choose a new color for the object and apply it. Simple, especially when ChromaColor does most of the job for you. To change the color of an object with ChromaColor, follow these steps:

1. Use the ChromaColor mask tool to drag a selection box over the object whose color you want to change. If you didn't select the full range of color, hold down the Shift key and make additional selections (see Figure 13.6).

Figure 13.6

*The selected area turns
gray. The color wheel shows
the range of colors selected.*

2. If you have selected more of the color than you intend to change, use the eraser to remove whatever is necessary. (Hint: it works faster if you zoom in so you're erasing larger pixels.)

3. When you've refined the selection, click the ChromaColor tab to open the color screen.

4. Click the Target Color button to open the Color Picker, or choose Custom to select a spot color and then click OK (see Figure 13.7). The color will change in shades to equal the dynamic range of the original. If the color you picked isn't quite what you intended, use the sliders to fine-tune it.

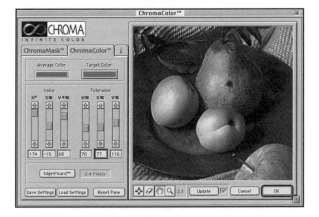

Figure 13.7

The color is changed.

5. To smooth the edges, click on the EdgeWizard button. A wider-edge width will give a longer blend between the object and the background, while a narrow one will give a more definite edge. A setting of .5 pixel is recommended for hard-edged objects.

6. Click OK to return the recolored object to Photoshop or whatever program you are working in.

ChromaPalette

ChromaPalette, which is the other Chromatica plug-in, enables you to extract the colors from any image and replace them with the colors from any other image. You have complete control over the number of colors that you extract and how the colors are swapped. It's done by remaking the ColorTracks that ChromaPalette creates for each image.

You can use ChromaPalette to explore how nature uses colors, and then you can apply them to paintings that you do from scratch or to a photo of a man-made object that you want to make look more natural. It's also a way to replace or edit colors in an object that has so many colors that selecting them one-by-one for replacement would be technically impossible, or at least very time-consuming. Finally, if you're doing corporate graphics and need to make sure that the same color scheme is used for everything, setting up the company colors as a ChromaPalette setting will guarantee that you can always apply the precise shades the CEO has approved.

To use ChromaPalette, start with an image whose colors you want to extract. Open the ChromaPalette window and click the Create Palette button. You'll see a dialog box like the one in Figure 13.8. It will tell you how many colors ChromaPalette has detected in your image. You have the option of creating a palette by using all these or a lesser number of colors. Smaller numbers take less time, both to create and to apply.

Figure 13.8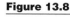

Think small.

To change the Palette, load one of ChromaPalettes preset palettes, or one that you have previously created and saved. Choose Load Palette and locate one from the list in the Chromatica Palettes folder. If you don't like the result, try others until you get one that works with your picture. Click OK when done.

Pixelation

When one is "pixilated," according to my dictionary, he's inebriated, but in a charming, bemused, whimsical, pixieish way. Pixelation can be equally whimsical and bemusing, if applied to the right subjects. Misused, it just turns everything into a bunch of dots. Pixelation happens when similarly colored pixels are clumped together to form larger units, which may be square (pixel-shaped) or round, or rounded off by anti-aliasing to

whatever form they take. It happens, unasked for, if you're printing a picture at too low a resolution. You end up with large pixels forming jagged shapes that look like they've been built out of a child's plastic block set.

When it is controlled, the effect can be quite interesting. Photoshop includes a set of Pixelation filters, which produce different effects all based on the notion of clumping together similar pixels. It's best to apply these effects to simple subjects and to those with strong contrasts.

The Pixelation filter set includes Crystallize, Pointillize, Mezzotint, Facet, Fragment, and Mosaic. To reach the Crystallize filter, follow this path: Filter>Pixelate>Crystallize. This will open the Crystallize dialog box, in which you can set a cell size for the individual crystals.

In Figure 13.9, I've separated the flower and the background into two different layers and used the Crystallize filter on both, although crystallizing them at different amounts. The concrete background uses a crystal size of six, while the flower has a crystal size of four pixels. Smaller numbers will give you a more interesting image. Large ones break the image into only a few cells and it usually becomes unrecognizable.

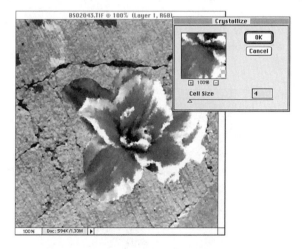

Figure 13.9

Crystallize works best when the crystals are small.

It's easy to overdo these effects. Figure 13.10 shows what happens when you take the settings about as far as they can go. As you can see, I've totally lost the flower. All that's left are some patches of color that used to be concrete, flower, and shadow. It may be a nice bunch of colors, but it doesn't tell us much about the begonia. And if the picture doesn't communicate something, why bother?

Figure 13.10

There's always Undo...

Other Pixel Effects

Kai's Power Tools includes a set of pixel effects, applied via the Lens tool. These are quite different from the Photoshop ones, because they don't clump the pixels together, but instead spread them around. Kai explains this effect as blowing sand around the picture. In Figure 13.11, the tool has been applied twice. The background in this picture is a patch of round mosaic tiles.

Figure 13.11

Blowing in the wind....

This effect was too busy and overpowering for the flower so, after making sure they were on a separate layer, I applied a strong directional blast of wind just on the tiles. The resulting effect toned them down quite nicely. Then I used a less potent and nondirectional

pixel effect on the flower, so it would have just enough pixelation to go with its background. I tried a higher setting, but it made the edges of the flower look as if some insect had chewed holes in them.

Pointillism and Mosaics

As a former art student, it's fun to go back and recall the first time I was introduced to the work of Georges Seurat. It was a revelation (especially coming out of studying some of the "sloppier" French Impressionists) to see these dabs of paint all neatly clustered, forming elegant scenes from a distance, and up close forming equally elegant abstract patterns. It would be nice if the Pointillism filters did the job as neatly and scientifically as M. Seurat. They don't.

This is, however, one case where the smallest setting doesn't work as well as some of the larger ones. I first tried the picture in Figure 13.12, using three pixels as the dot size. I got a spotty picture, as I expected, but it looked more like video noise rather than pointillism. Using a slightly larger dot size produced an image a little closer to what I was looking for. But when I tried a much larger size, around 25, I ended up with baseballs.

Figure 13.12

Dots interesting…got the point?

Fractal Painter for Mosaics and Other Cool Effects

There's a mosaic setting in the Pixelate effects, but all it does is to make larger pixels out of the smaller ones. The result is the sort of thing they use to hide the faces of the people being arrested on all those late night police shows. If you want a true mosaic effect, use Fractal Painter. It recreates the look of glass or ceramic tiles set in cement, which is what a mosaic really is. Figure 13.13 shows a Painter mosaic, based on a photo. You can be as fanciful as you like with these, changing colors and filling in backgrounds.

Figure 13.13

Mosaic cat.

The truth is, you can do just about as much with Painter as you can with Photoshop, including all the color correction and image manipulations. Painter's tools include all kinds of brushes, chalks, smudges, felt pens, water rakes, and more goodies than you can imagine. You want pointillism? Click on the Seurat tool, and it happens instantly. Do you prefer Van Gogh? There's a tool for that look, too.

Painter's way of creating duotones is especially easy and effective. As you can see in Figure 13.14, you can set the two colors for the duotone in the Apply Screen window. You can preview the effect as you vary the percentages of both colors. To see the results of this manipulation, check out Color Plate 13.3.

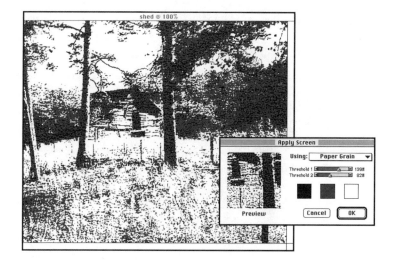

Figure 13.14

Cabin in the weeds.

Mezzotints

Mezzotints are another kind of pixelation, and one that Photoshop handles nicely. The term comes from the art of engraving copper plates to make etchings. Mezzotints rely on patterns of small lines, dots, or scratches to make areas of light and shadow on the image. Digital mezzotints come in several variations. You can choose from dots, horizontal lines, or vertical lines in various densities. Mezzotints tend to look more like the real thing when applied to duotone or grayscale photos, but if you have a very colorful picture, breaking it up into dots in this manner might also be effective. Figure 13.15 is a typical mezzotint, made from a fairly contrasted grayscale photo.

Figure 13.15

Golden Gate Park.

Even though I chose a photo that had good contrast and detail, it kind of fell apart as a mezzotint. But fading the mezzotint as an overlay over the original photo, as shown in Figure 13.16, gave a much more legible result.

Figure 13.16

Golden Gate Park revisited.

Stylized Effects

If mezzotints, Pointillism, and Impressionism take us back into the 19th century, art history–wise, some of the extruding and embossing and digital tornado effects are sending us directly into the 21st. Some, however, combine nicely with the techniques we've already learned. Color Plate 13.4 shows the same piece of architecture as in the preceding pictures as a mezzotint, only I've combined embossing with adding tritone color. The result could almost have been hammered out of copper.

Embossed Effects

Embossing creates the appearance of a raised surface by adding highlights and shadows around the edges of objects. Unlike some of the techniques we've explored, it's not necessary to restrict its use to simple objects. In fact, textured objects are generally more interesting. Embossing removes most of the color from the photo, however, so don't be surprised to see your images turning gray. Figure 13.17 shows the embossing dialog box. Notice that you have several settings to make.

Figure 13.17

"Youse de emboss, boss."

The angle setting refers to the angle from which the light is hitting the picture. You can set it either by moving the hand on the clock icon or by typing numbers into the box. It assumes that the positions corresponding to three o'clock and nine o'clock are zero and 180 degrees, respectively. The pixel height actually refers to the width of the highlight and shadow, which create the perception of embossed height. The percentage setting determines the strength of the light, and affects the overall contrast level of the picture, as well. If you set it too high, you'll get blue highlights and orange shadows.

KPT Convolver also has an interesting emboss mode. Unlike the Photoshop Emboss filter, it retains color, after a fashion. Convolver takes the image and reduces it to four colors, or fewer, depending on the complexity of the subject. It then calculates the relief amount and angle. You can adjust these as much as you like, either by clicking and dragging the control buttons or by using the Convolver's Design mode and experimenting with various settings, as I'm doing in Figure 13.18, until you find a combination that seems to work. The Convolver results are shown in color in Color Plate 13.5.

Embossing, however, does look quite different when you apply it to a very simple subject. The still life of peppers and a knife, shown in Figure 13.19, takes to embossing very well, except that the highlights on the peppers turn into holes in the embossed image. If this happens to a picture you're working on, undo the embossing. Go back and fill in the highlights with the color that surrounds them. As long as there's relatively little contrast between the areas, you won't end up with a hole. Similarly, you may want to tone down dark spots that could turn into bumps. If you forget, you can go back and edit them out afterward, but it's usually easier to do it first. If you fix flaws before you apply the effect, you won't have to go back and fix them afterward.

Figure 13.18

A more colorful embossing.

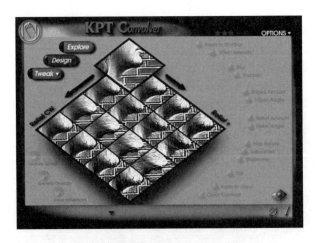

Figure 13.19

Fixing the bumps first would have helped.

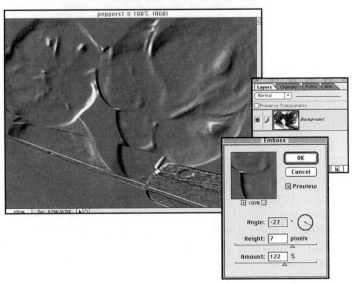

Extruding

Extruding is somewhat related to embossing, but more three-dimensional. The Photoshop Extrude filter lets you select square blocks or four-sided, pointed pyramids in sizes from 2–255 pixels. The square blocks may be opaque or translucent with the image on the front face, giving you a picture that seems to be seen through a sheet of Lucite cubes (see Figure 13.20). Extruding has, quite honestly, limited usefulness.

Figure 13.20

The Cubist approach.

Edge and Contour Effects

These two effects sound as if they should look alike. They actually do look somewhat alike, with Find Edges being much more pronounced than Trace Contour. Find Edges removes most of the colors from the object and replaces them with lines around every edge contour. The color of the lines depends on the value at that point on the original object, with lightest points in yellow, scaling through to the darkest points, which appear in purple. It makes the picture look like a rather delicate colored pencil drawing of itself. Find Edges becomes more interesting if you apply it more than once to the same object. Figure 13.21 shows a picture of a lemon with its edges traced twice.

Figure 13.21

The first tracing lacked character, but doing it again made the lines heavier.

Unfortunately, there's no way to set the sensitivity of the Trace Edges filter. In practical terms, this means that you have to prepare the picture before you trace it. Begin by despeckling, so Photoshop won't attempt to circle every piece of dust in the background. If you don't want the background to show, select and delete it, or select your object and copy it to a separate layer first.

Glowing Edges

Glowing Edges is more fun; first, because it's prettier, and second, because you can adjust it to have maximum impact on your picture. Glowing Edges turns the edges into brightly colored lines against a black background. The effect is vaguely reminiscent of neon signs. You can vary the intensity of the color and the thickness of the line.

In Figure 13.22, I've applied Glowing Edges to a photo of a red cactus flower. In Color Plate 13.6 I've applied the same effect a second time. It works especially well with "busy" pictures like this one with lots of edges. The more it has to work with, the more effective the filter is.

Figure 13.22

Some of the color remains, but the background goes black.

Trace Contours

Trace Contours also works better on some pictures if you apply it several times. The Trace Contour dialog box has a slider setting for the level at which value differences are translated into contour lines. When you move the slider, you are setting the threshold

at which the values (from 0–255) are traced. Experiment to see which values bring out the best detail in your image. Upper and lower don't refer to the direction of the outline. Lower outlines specifies where the color values of pixels fall below a specified level; Upper outlines tells you where the value of the pixels are above the specified level.

Figure 13.23 shows a picture I shot at night on the Las Vegas "Strip." After much experimenting, I determined that the setting shown here gave me the most coherent picture. Lowering the level much more gave too many lines and made unimportant surface details into contours. Raising it much beyond this point removed too many contours, and the picture stopped making sense.

Figure 13.23

Neon lights make an interesting drawing.

It's also fun to use an abstract picture like this as a jumping-off point for further abstractions. Adding Eye Candy's Squint filter, as I did on Figure 13.24, makes this into a very different picture. Putting a sheet of digital "glass" over it would bring in a different kind of distortion, as would smudging, or the Crosshatch filter, or any of a dozen other things you might do to it that would also "work." Choosing which effects to try and which to keep is a pastime that can entertain you for hours.

Figure 13.24

Squint blurs the lines.

Swirls, Twirls, and Wind

It's not an effect you'd use every day, but some of the swirling pixel effects can be quite a lot of fun to play with, and can do some neat and unexpected things. Wave turned this picture (see Figure 13.25), originally a clump of flowers, into a cubist abstract, reminiscent of Piet Mondrian. The figure shows the Wave settings, which include your choice of sine, triangle, or square waves; number of wave generators; and the height and width of the waves.

Figure 13.25

Square waves produce squared lines.

You can't really tell what the settings are going to do until you apply them. The key to success here is to be prepared to undo and redo, tweaking the settings until you get a picture that you like.

Twirl

Twirl gives an effect much more like what you might expect. In Figure 13.26, it is applied to the same picture as the previous effect. This time, I let it create a whirlpool, although I could have settled for a very gentle twist, as if there were a soft spring wind blowing the flowers, instead of a tornado in the planting box.

Figure 13.26

Better batten down the hatches!

Shear

You may wonder if any of these effects have any practical application. That's up to you, and how you use them. Obviously, some effects are intended to be comical, and they succeed. But sometimes what you need is a funny effect. Figure 13.27 shows an ambulance in a hurry, thanks to the Shear filter. Before I applied the filter, traffic was at a standstill. Now, it seems to be moving again.

Figure 13.27

What a time to be stuck in traffic!

The Shear filter adjusts the image by moving the vertical axis from a straight line to a curve. You can apply as much or as little shear as you need. Clicking on the line will add more points. Because Shear only works from the vertical axis, rotate the picture 90 degrees if you need to bend something up or down.

If you want a more serious sense of something in motion, use Eye Candy's Motion Blur (see Figure 13.28). To use it, first you need to select the item(s) that are moving. I used the Polygon Lasso to select the ambulance; then I cut it out and moved it to a new layer. Applying the effect simply requires setting the sliders until it looks right.

Figure 13.28

Now, only the ambulance is getting through.

Applying a small twist to just part of the picture is generally more effective. That way, you can see immediately that something is out of whack. In Figure 13.29, my view of life in California, I used the Twirl filter and then simply rubber stamped the debris falling from the vortex of the twirl.

Figure 13.29

I call this creation "Twist and Shout."

There are more filters, and even more will be introduced by the time you're reading this. How do you use them? The same way you use these—by experimenting, trying things to see what happens, trying combinations of filters, and recognizing what you like and what you don't like.

Assignment

Experiment with effects. Try one over another, or applying one and then tracing it—then crystallizing the trace, and so on. Take a picture you don't like, or one that's frankly not very good, and make it into a work of art.

The Final Product

- Placing photos into other documents
- Using photos on the web
- Making pages load faster
- Photo-quality printing
- Working with color printers
- Service bureaus
- Delivering work to clients, ad agencies, magazines
- Where to sell your work

You're almost through. By now, you know your digital camera inside and out. You know how to take great pictures, and how to use the digital tools to make them even better. There couldn't be any more to learn, could there? Well, maybe a few things…

When you've made a really great picture, what do you do with it? Do you call everyone in the family or at the office to come and look over your shoulder? Yes, so do I. But that's just the first step. Sharing your work, whether it's for commercial purposes or for fun, is part of the reason for doing it. You're not communicating if you're just talking to yourself. So, how do you get it out there? In this final chapter, I'll tell you about putting photos on web pages, the ins and outs of printing, and how to send a digital photo by email.

Placing Photos into Other Documents

If you use PageMaker or another desktop publishing program, then you already know about importing photos. Did you know that you can put your pictures into a spreadsheet, into a PowerPoint presentation, or into a word processor document, such as a letter or a report? Did you ever think of putting pictures into a proposal? How about into a recipe?

On a customized postcard? For example, pictures in a database could be employee ID photos, parts and supplies being inventoried, your dog's vet records, surgical records and reports, or practically anything else you can think of.

There are just a couple of things to keep in mind. The first is that pictures add to the size of the file. Don't make them any larger than they need to be. Crop out unnecessary backgrounds. Reduce them to 8-bit color, or even to grayscale if that will be sufficient. Second, save them in a format that your database, word processor, or DTP (Desktop Publishing) program handles well. For the Macintosh, that means PICT, EPS, MacPaint, or TIFF. For Windows users, it's .bmp, .eps, .tif, .pcx, .tga, or .pic.

Putting Pictures on Word Pages

Putting a picture into a Microsoft Word document is as easy as finding the picture you want to use. Follow the path Insert>Picture to open a dialog box like the one shown in Figure 14.1. Choose your photo, decide whether you want it saved as part of the document or as a linked file, and click OK. It will be placed into your Word document at whatever location the cursor is in. If you use a different word processor, you may need to look elsewhere for the picture placement dialog box, but the actual process of placing it will be very similar to that described here.

Figure 14.1

Placing a picture in Word.

Putting Photos in Other Kinds of Documents

Adding a picture to a database is just as easy. First, create the database, in whatever program you're comfortable with. Figure 14.2 shows one I built in ClarisWorks to keep track of the dogs' training and competitions. I resized the pictures on a draw page in the same program, and simply copied and pasted them into the appropriate cards.

Figure 14.2

Using photos in a database.

Conversion Programs for Mac and Windows

It's simple enough when all you have to do to make a picture format compatible is to copy and paste it. Sometimes, though, you need a different format than you have. You could open Photoshop and resave your picture in some other format, but that's a nuisance. Instead, for the Mac, there's Graphic Converter. It's an excellent shareware program, and can be found at most FTP sites and in online service and user group BBS file libraries. The cost is relatively high for shareware ($35), but that is for a lifetime license, and the program gets updated every time there is a new format. It saves in an awesome number of formats, including many for Windows, SGI, and other platforms. Figure 14.3 shows it in use, saving a file.

Graphic Converter also has basic tools, a magnification window, and a few special effects built in. More important for digital photographers, it seems to be able to open most raw camera files. (Unfortunately, it will only show thumbnails from the Kodak DC-25.)

Graphic Workshop for Windows 95, and Graphics Workshop for Windows 3.x are similar shareware programs for Windows users. Graphic Workshop enables you to convert image files among the most popular file formats, making it possible to use image files from virtually any source in such programs as Ventura Publisher, Windows Paintbrush, PageMaker, Word, WordPerfect, CorelDRAW!, Deluxe Paint, and so on.

Figure 14.3

This one is strictly Mac.

The current release of Graphic Workshop for Windows has a fully resizable window and a menu interface. Its thumbnail mode allows you to preview images as you select them. Context-sensitive help will get you through any difficulties you encounter. The JPEG support in Graphic Workshop can squeeze a lot more images into a small space. Finally, it includes a powerful keyword-search database of images that makes finding graphics, even in large collections, fast and easy.

Using Photos on the Web

At last, the *real* reason why you bought this book... I haven't told you how to put your pictures on the web before this, because as a good cyber-citizen, I wanted to wait until you knew how to make pictures that were worth sharing. There's enough junk out there already.

The questions you need to ask before you put pictures on the web are include the following:

- Why am I putting this picture up? Does it relate to the rest of my page?
- Do I have the right to display this picture? (If your picture shows recognizable people, do you have model releases?)
- Do I mind if someone else uses it? Copyright notices don't do much to prevent thievery. If you create a particularly nice piece of art, it's almost a certainty that people will appropriate it and claim it as their own.

The Big Three: PNG, GIF, and JPEG

Aside from the questions above, you also have a technical question to think about. What format should your picture be in? You have three choices, as of this writing: GIF, JPEG, and PNG. There has been discussion of adding more formats that web browsers will recognize, mainly because there's an ongoing possibility of legal problems with the GIF patents. It seems that, back when CompuServe first introduced GIFs as a way to save and display graphics online, they used a compression system called LZW. This compression scheme had been patented by the Unisys company, prior to CompuServe's applying for a patent on the GIF technology.

Early in 1995, someone in the legal department at Unisys finally discovered that it had patents on the LZW system, and started looking around to see if anyone was using it. Oops! Everyone was—not just CompuServe members, but virtually every piece of graphic art that got sent to a bulletin board system (BBS) or uploaded to an online service database was in GIF format. The Unisys lawyers saw dollar signs, and paid a call on the CompuServe lawyers. CompuServe suddenly announced that programs implementing GIF would require royalties.

About this time, the World Wide Web was just opening up to ordinary people, rather than colleges and science and research facilities. The first of the graphical web browsers, Mosaic, came on the scene, and it could read GIFs and also a relatively new format called JPEG.

JPEG (pronounced "jay-peg") is a standardized image-compression mechanism. The initials stand for Joint Photographic Experts Group, the committee that wrote the standard. JPEG, having been written by photographers, is designed for compressing either full-color or grayscale images of natural, real-world scenes. It works well on photographs, naturalistic artwork, and similar material, but not as well on lettering, simple cartoons, or line drawings. JPEG handles only still images, but a related standard called MPEG handles the same compression tasks for moving images, such as QuickTime movies.

JPEG has many advantages for the digital photographer. It was designed to handle photos, unlike GIF. The GIF format restricts you to 256 colors. JPEG can handle as many as there are in the picture, even millions, if it was a 32-bit image. GIF is faster to decode and on a small, limited color piece of art, GIF compression makes a much smaller file because it only needs to carry information about the colors that are actually present in the art.

JPEG is "lossy," meaning that the decompressed image isn't quite the same as the one you started with. There are lossless image compression algorithms, but JPEG achieves much greater compression than is possible with lossless methods. Your pictures really won't

look significantly different, however, because of the way JPEG does its compression. JPEG is designed to exploit the limitations of the human eye, notably the fact that small color changes are perceived less accurately than small changes in brightness. JPEG compression carefully monitors the brightness of individual pixels and matches it, but averages the color changes among blocks of pixels. It takes a very well-trained eye to notice the JPEG errors. If you plan to machine-analyze your images, the errors introduced by JPEG may cause problems. Most people never see them, but artists are more apt to notice any unevenness in color. If you do see them, on a web-bound image, just think how much download time you're saving by using JPEG and accept the trade-off.

A useful property of JPEG is that the degree of lossiness can be varied by adjusting compression parameters. Whenever you save a JPEG image, you're asked to choose the file size and quality. Figure 14.4 shows how it's done in Photoshop.

Figure 14.4

Bigger and better, or smaller and worse—the choice is yours.

This means that the image maker can trade off file size against output image quality. You can make *extremely* small files if you don't mind poor quality. They're useful if you want to index your Zip disks of digital photos, but you wouldn't want to work with them. Conversely, if you aren't happy with the output quality at the default compression setting, you can raise the quality until you are satisfied, and deal with the larger file sizes as best you can.

The PNG format is the newest file format to be accepted on the web. PNG stands for Portable Network Graphics, or "Pretty Nice Graphics," or "PNG, Not GIF," depending on whom you ask. It claims to provide lossless compression to as much as 30% smaller files than GIF. It also offers interlacing, 24- and 48-bit true color support, and a long list of features that are too technical to comment on. Because it's still very new, not all programs can save in the PNG format. Photoshop 4.0 can handle PNG files, and can save in this format. Graphic Converter, previously described, can also convert files into PNG.

Putting Pictures on Your Home Page

It shouldn't be the toughest part of the project. There are at least a dozen good web publishing programs for both Mac and Windows. But for a lot of folks, it seems like the business of actually putting together the page and getting it uploaded to the web server is the big stumbling block. The days when you needed to know HTML are over. You don't have to program your web page, if you can lay it out in a program like PageMaker. The application will look at your layout and translate it into lines of code for you. Most of the time, it translates smoothly, with little or no editing required. Figure 14.5 shows one of my web pages laid out in PageMaker.

Of course, you can also add images the old-fashioned way (circa 1996) with any text processor, if you happen to enjoy writing HTML code. (I'm told some people do...) Where you want the image, insert HTML code like this:

```
<IMG SRC="myImage.jpg" ALIGN=TOP WIDTH="244" HEIGHT="211">
```

The width and height should be the size of your image in pixels, and you'd substitute the real name of your picture for "myImage.jpg". If you want, you can vary the alignment (MIDDLE, BASELINE, and so on) or add pixels as a BORDER or HSPACE or VSPACE between the image and accompanying text. It's also considered good practice to add alternative text with a command like <ALT="Picture of our Factory">, so users with slow Internet connections can read the text instead of downloading the image.

Figure 14.5

This is Hacker's home page.

There are, of course, some tricks to be aware of. For instance, you can paste buttons, lines, and graphic goodies into your web page, if you have created them in another program and saved them as PNGs or GIFs. You can't simply create them in the page layout program, even though it seems as if that would be much easier. HTML won't recognize them, nor will it recognize anything other than the handful of fonts and sizes it knows. (There's a reason why everybody's pages look alike.) If you try to make an HTML conversion and the program finds graphics it can't handle or other problems, it will warn you, so you can go back and straighten things out.

Another point to remember is to prepare your photos first. Crop them tightly. Keep them small on the page, if possible, and save them as JPEG files. Actually, PageMaker (and probably most other web publishing programs) will make the conversion for you, if you forget. But doing it yourself lets you decide what quality and file size compromises you're going to make.

Finally, before you upload your page, open it in your web browser. It should look exactly the way it will when other people see it. Compare Figure 14.6 with the PageMaker version in Figure 14.5. If you discover type that doesn't quite fit, a missing graphic, or some other problem, you can fix it before you upload. You can also check the HTML code, if you're curious, by choosing View>Source from the Netscape menu.

Figure 14.6

It looks fine in Netscape.

Making Web Pages Load Faster

The bottom line is, you can't make web pages load faster. The page will load only as fast as the server can send it, and the recipient can receive it. Those are both beyond your control. What you can do, though, is to make sure that your page is arranged so there's something to see while the graphic loads. Bring up a Welcome headline first and then add the background. If there's a graphic that will take some time to load, bring up a block of text before it. The load time for the picture will seem much shorter if the person waiting has something else to read or think about. Frames are nice, but they can often cause web browsers to crash, especially when there's also a sound effect or animated goodie that loads automatically inside the frame. Using an interlaced GIF or progressive JPEG image, so the picture loads in stripes, rather than one line at a time, helps create the illusion that the image is coming up faster on the screen.

> **NOTE**
>
> If you want to learn more about HTML and Web publishing, check out *HTML Web Magic* by Ardith Ibanez and Natalie Zee, published by Hayden Books. It's a very well-done, understandable approach to HTML.

Color Printing

All color printers, regardless of type, work in the same way. They mix three pigments—cyan, yellow, and magenta—to produce all other colors. These colors serve as the basis for all color printing. When all three colors are mixed equally, the result is a type of black. Many color printers add a real black for a richer mix. The resulting system is called CMYK, or process color.

Color printers can take several forms: they can use liquid or solid ink sprayed on the page (inkjet and phase change inkjet), solid wax that is melted on a page (thermal wax), and pigments that are burned at different temperatures to produce the colors (dye sublimation). Some laser printers mix powdered toner in the four process colors. Printers are categorized by how they apply their pigments, so I'll talk about dye sublimation printers, thermal wax printers, color laser, and inkjet printers.

Like monochrome inkjet and laser printers, color printers apply pigments by overlaying dots of their primary colors. Thus, a red dot is composed of a yellow dot overlaid by a magenta dot. Eight colors are relatively easily produced by overlaying two primary colors together for a resulting palette of cyan, yellow, magenta, black, red, green, blue, and white (the application of no pigment).

Other colors are created by a process called dithering. Color dithering is the application of the primary color dots in complex patterns that create an optical illusion that one is seeing other colors. It is very difficult to hide the dot patterns, since all the dots are the same size and different pattern arrangements can cause different qualities of results. Only high-end printers can apply color to continuous areas of paper and avoid the dotting affect.

The other way that color printers gain the effect of various color hues is through color half-toning. This is mostly used to print scanned images. First, the image is separated into its cyan, yellow, black, and magenta components (called color separations). Half-toning is the use of dots of different sizes to represent the different amounts of gray in a picture. Color half-toning varies the amounts of cyan, yellow, magenta, and black in each separation to gain the illusion of various colors. Each separation screen is rotated to a different angle, causing their dots to overlap and form small circles called *rosettes*. Because the rosettes and dithering are noticeable to the naked eye at 300 dpi, you need a 600 dpi or better color printer to give you an acceptably accurate proof of color balance and detail in a color photo.

Photo-quality Printing

The technology of color printing has changed more drastically over the past couple of years than almost any other aspect of computing. You can now buy color printers for home and office use that are very close to photographic quality. Color inkjet printers at 600 dpi cost less than $500. Color laser printers are in the $5000 range, down from three times that only a year or two ago.

Professional level printing is still a job for the service bureau or print shop, but you can certainly print pictures for your own use, for sharing with friends, or for general business use on any of the available color printers. For best results, use paper that is designed for photo-quality reproduction. It's whiter, slightly heavier weight, and smoother than the paper for ordinary laser or inkjet printing. You can even get glossy, "photo" style paper to make your digital photos look more like the drugstore variety.

Types of Printers

If you look through the computer catalogs that we're all constantly swamped with, you'll find dozens of different printers. They can be divided into several types. Some are more suitable than others for photo-quality reproduction.

Inkjet and Bubblejet Printers

Inkjet printers are the cousins of the original dot-matrix printers. Rather than using wires tapping a ribbon, inkjet printers spray ink out of microscopic nozzles in the print head. Bubblejet printers use a heating element to create bubbles that expand to force drops of ink to fall from the print head. Canon's printers are bubblejet printers. Other inkjet printers send an electronic signal to a piezoelectric diaphragm within the print head that forces a drop of ink to be ejected from the nozzles. The Hewlett-Packard DeskWriter series and Apple StyleWriter series use this technology. The colors of ink (cyan, magenta, yellow, and black) are all laid down on a single pass, causing fewer registration problems than printers that make four passes and lay each color down separately. Because the ink is a liquid, plain paper absorbs the ink, making clear images difficult to produce.

> **TIP**
>
> Harder-surfaced papers absorb less ink and produce better copies from inkjet/ bubblejet printers. Use them for color printing when quality is important. Look for papers marked High Quality Inkjet or Ultra Smooth Coated.

A second type of color inkjet printer uses a slightly different technology to lay down its colored dots. The phase change inkjet melts blocks of cyan, magenta, yellow, and black wax in ink reservoirs. The melted ink is sprayed onto the page through microscopic nozzles in the print head. Phase change inkjet printers also lay down the colored inks in a single pass. Because the inks are wax-based, they solidify much more rapidly than liquid inks dry, allowing these printers to print more easily on plain papers. The downside is that less ink is absorbed by the paper, and the use of a high-pressure roller to flatten the solidified ink gives you printed images that are not as sharp as regular inkjet.

Color Laser Printers

Color lasers apply color by using a four-chambered toner/developer unit containing cyan, magenta, yellow, and black toner powder. The image exposed by light onto the photosensitive drum takes on an electrical charge. Charged areas attract toner as the drum rotates past the developing unit. Because only one type of toner can be released at a time, the drum must make four passes past the developer to apply four colors. After each exposure, the paper is passed across the toner-coated drum. After the four passes, the resulting colored image's toner is fused to the paper by using a heated roller.

The major problem with this technology is registration errors. If the paper is not aligned perfectly onto the photosensitive drum, the colors will not be applied accurately, leaving fuzzy borders between colored areas. Color laser printers can print color at higher

resolutions than thermal wax or dye sublimation systems. Many printers also use resolution-enhancement technologies, such as Color PhotoGrade from Apple or Hewlett-Packard's Resolution Enhancement Technology, to sharpen the text or images by fine-tuning the dot sizes used to create the output.

Color Thermal Wax Printing

Thermal wax transfer printers use a system where wax-based pigments of each process color (cyan, yellow, magenta, and black) are positioned on a roll of transfer ribbon, one after another. The transfer ribbon is placed between the print head's thousands of heating elements and the paper. The heating elements in the print head are turned on and off, causing the different colors to melt onto the paper as dots. One color is applied for each of four passes of the paper over the print heads and transfer ribbon.

The same problem of registration that occurs in the color laser process occurs here—because if the paper is not aligned perfectly with the ribbon, colors will have fuzzy edges or areas of no color where the match was not made.

A newer technology used by Seiko's Professional ColorPoint PSF and Fargo's Primera Pro and Pictura 310 printers mix thermal wax transfer technology with dye sublimation technology. These hybrid thermal wax/dye-sublimation machines remove the thermal wax ribbon and paper and replace them with the dye sublimation's plastic film. These printers produce more realistic colors because the plastic film that is coated with process colors can produce continuous color, whereas the thermal wax system cannot. The system is cheaper than dye sublimation, since less-expensive thermal-wax paper can be used for rough proofs, and dye-sublimation paper can be used for final prints.

Color Dye Sublimation Printing

Dye sublimation and film recorders on the upper end of the color printing world don't have these drawbacks. Dye sublimation printing is performed by passing a plastic film coated with cyan, yellow, magenta, and black dye across a print head containing approximately 2,400 heating elements. Each heating element can produce 255 different temperatures, with more dye being transferred the hotter the element gets. The special polyester resin-coated paper is passed over the heating elements four times for the four dyes, and the dyes are sublimated into gases and diffused onto the coatings, producing dots of color. The variation in the density of the dyes that are transferred to the paper create continuous tones.

Film Recorders

Film recorders use red, green, and blue lights to produce images on 35mm slide film. A filter wheel produces the correct amounts of primary colors, which are then placed on the 4 × 5-inch Polaroid print or transparency film. It seems backward somehow to take a digital photo and end up with a film print, but these transparencies are used for the very highest quality color reproduction for slick magazine covers and coffee table art books.

Proofing

If you're working on a photograph that will be professionally printed, whether as part of a brochure, catalog, or some other major project, you'll find it helpful to print color proofs as you work. Proofing, however, isn't much use if your printer isn't calibrated. Be sure that you read, and follow, the instructions in your printer manual for color calibration. You will also get better results when you print if you pay attention to the printer settings.

Figure 14.7 shows the Print Options dialog box for the printer driver that came with my HP Deskjet 855C. Selecting the Color Matching option to Photographic produces a much better print. Leaving the setting on Auto or Text/Graphics makes most photos come out oversaturated.

Figure 14.7

Most color printers have a similar setting.

You can, of course, proof your work in grayscale, too. There are times when this may be helpful, for example, when you're checking linked files for a DTP program like PageMaker, and want to make sure that all the graphics are present and in the right places. In a case like this, grayscale is more than adequate. If your work is going to be reproduced in grayscale, always print a proof copy in grayscale first, to prevent any surprises. Color monitors are great, but they don't tell you that reds print dark, and blues sometimes tend to be lighter than reality.

Casio Photo Printer

How much printer do you really need? If most of your digital photos end up on the web, you might not need to invest in an expensive color printer. If you want pictures to send out to show Mom how the grandkids have grown, or if you need small photos for ID badges or similar uses, check out the Casio QG-100 Photo Printer.

It's a cute little box, about five inches square by four inches high (see Figure 14.8). You plug in your Casio camera, select the picture you want to print, push a button, and a light blinks. Then the printer goes "whirrr," and a tongue of paper sticks out the side. If you look you can see the yellow ink on it. Two more passes, for magenta and cyan, and the picture is cut off and spit out. You can peel off the backing and stick it on a letter, an ID card, or wherever you need a small photo.

Figure 14.8

The Casio QC-100.

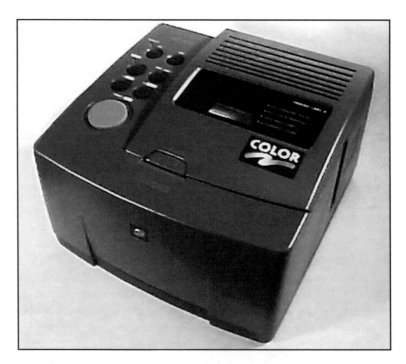

Small? Quite. The biggest picture paper they offer is 46mm, measured diagonally. That gives you a print that's about an inch and a half high. You can also get cartridges with picture paper in 36mm and 18mm sizes.

NOTE

The printer comes with this warning, "Avoid affixing labels to the following surfaces:

■ Surfaces exposed to direct sunlight or rain.

■ On humans or animals.

■ Other people's property or public property.

■ In parks, stations, or other public places."

Truly, words to live by....

Service Bureaus and How to Work with Them

Instant printers often masquerade as service bureaus, but don't be fooled. Service bureaus and trade shops are professional facilities for desktop publishers, artists, and others who need really fancy printing. They specialize in high-quality color printing, color negative making, and other prepress services. Many service bureaus started out as typography suppliers—setting phototype and making photostats and half-tone negatives, long before computers took over those functions. Today, the imagesetter is the primary piece of equipment for a service bureau. Imagesetters are capable of very high output resolutions and good-quality color separation. The Linotronic is a well-known brand of imagesetter, manufactured by Linotype-Hell. Imagesetters are also manufactured by Agfa, Tegra Varityper, Scitex America, and Optronics.

Trade shops, sometimes called *color houses,* are usually dedicated to high-end color reproduction. They use expensive proprietary hardware and software that is dedicated to color scanning, color separation, electronic page imposition, and high-resolution output to film recorders capable of large formats. These high-end systems are known as *color electronic prepress systems (CEPS).* As quality improves and costs drop, many trade shops are turning to less expensive midrange systems based on off-the-shelf hardware and software.

When you work with a service bureau or trade shop, it helps to know in advance what to expect and to be clear about what you expect from them. The following is a list of "dos and don'ts" that will save you both time and money, and prevent confusion.

- Fill out the service bureau worksheet or job order completely and accurately. These forms are available at the service bureau.

- Make sure that you and the service bureau are using the same software applications and that you have the same, or at least compatible, versions.

- Prior to taking electronic publication files to the service bureau, discuss with them issues such as trapping, overprinting, halftone screen ruling (lpi), and color separating. It is important to clarify who has the responsibility for setting up the software to perform these functions.

- Find out whether the service bureau prefers to work with native file formats (that is, Photoshop) or PostScript files. This can have a bearing on who performs trapping, sets screen rulings, and so on.

- Be sure to include all the computer files that are necessary to output your job. Do not include unnecessary files or duplicate files.

- Use the same font technology as that used by the service bureau. Adobe Type 1 fonts are standard. Don't give your printer-font files to the service bureau. It is illegal.

- Make sure that you have a backup copy of all files.

- Clearly label and number all disks or cartridges that you send to the service bureau. If you submit files on Zip, Jaz, SyQuest, or other removable cartridges, be sure they have your name and phone number on them. They should be returned to you when the job is done.

- Provide a directory of files and their disk locations.

- Don't be afraid to ask questions and clarify misunderstandings.

Sending Pictures by Email

One of the many good things about digital photos is that you can email them easily and conveniently. They're already in the computer. You don't have to scan them or go through all kinds of conversion nightmares. The current generation of mail handlers do the conversions for you. Just save the picture as a JPEG, or in any format your recipient can open, and attach the picture to your message. Figures 14.9 and 14.10 show how Netscape handles the task.

Figure 14.9

Attaching a picture.

After you write and address the message, attach the picture by locating it. Netscape will compress it into binary format for transmission across the Net. Then, sign on and follow whatever procedure you generally follow for sending mail.

Figure 14.10

There it is!

When the recipient gets your mail, the picture will be attached at the end of it and displayed if s/he also uses Netscape. Other browsers and online services, such as America Online, will ask you to download the picture before you can see it. If you know in advance that the recipient will be downloading the picture rather than viewing it in Netscape, it's a courtesy to send the file as compressed as possible, to shorten the download time. Two of the most common compression utilities are StuffIt for Macintosh and Pkzip for Windows.

I use this system to send work to clients, as well as cute cat photos to friends. As long as your Internet service provider doesn't crash and lose your mail, it's virtually foolproof, and it's usually faster (not to mention cheaper) than sending the job by overnight air courier.

Where to Sell Your Work

Are you ready to make a living as a digital photographer? Probably not. Very few people make enough money to live as freelance photographers, digital or otherwise. Don't quit your day job just yet, but there's no reason you can't at least make the effort to sell some of your work.

Newspapers

Start locally. Most cities and towns have local newspapers, and most local newspapers are glad to hire freelance "stringers" to cover events their regular photographer can't attend. Before you go to talk to the photo editor, put together some printed samples of your work. Strive for a good mix of people pictures, human interest shots, and news and sports events. They needn't be major happenings. The Scouts' pancake breakfast is news in a small town. So is the high school basketball game.

Make sure that the printer is properly adjusted and that the picture quality is as good as you can make it. Stress that your work is digital, and that when you cover a news event, you can send your photos by modem, ready to use, while conventional photographers are still in the darkroom. (Don't say this unless it's true, of course. If you don't own a modem, you can't do it.)

When you get your first assignment, be on time, prepared with extra camera batteries, any other equipment you expect to use, and a notebook and pen for caption information. Deliver your (perfectly composed, well-exposed) pictures well before deadline, and the next assignment is guaranteed.

Stock Photography

Do you like to travel? Why not finance your next trip by selling your travel pictures to a stock photography house? Of course, it's not only exotic locations that sell. Most of the stock photos that actually get used are of common everyday activities. Think about the ads you see in magazines and the pictures that illustrate some of the articles. Many of those are stock photos, shot by some photographer who grabbed the camera when his kids started washing the dog, or who had an assignment to shoot one photo and took a half dozen more of the same set-up from different angles. Textbook pictures, from kindergarten through college, are big users of stock photos, too.

Stock photos can be a byproduct of every photography session. If you're shooting your child's birthday party, get releases from the parents of the guests. (Model releases aren't required for editorial use, but they increase the salability of your pictures.) If you must chaperone the school dance, take a camera. Everybody lives near some interesting piece of scenery, whether it's an Iowa farm, a Minnesota lake, or an ocean vista. Shoot it in all kinds of weather conditions and light conditions. Build up your portfolio, so that when you're ready to sell it to a stock house you have something to show off. Be sure to save uncompressed files of your pictures. JPEGs are great for the web, but disappointing to an art director who wants every bit of detail possible.

When you are ready to actually sell your work, get a copy of *Photographer's Market, The Creative Black Book,* or *Literary Marketplace.* Your local library will probably have current editions. All of these books list stock photography houses and tell you who to call and what their specialties are. Also, if you live near a major city, check its Yellow Pages for stock photography. Check the web, too. I did a Lycos search and found (but didn't check out all of) 42,000 listings. Many of these are freelance photographers trying to sell their own stock photos via their web pages, but some are major sources for stock, and they're always willing to look.

Don't Be Afraid to Ask for Work

Visit the local instant printer, preferably at a time when they can take a few minutes to talk to you. Show a few commercially oriented samples, and ask to be referred to local artists, ad agencies, or anyone in need of photo services for desktop publishing. Since your pictures, unlike the conventional photographer's, are ready to put on the page, you have a major advantage.

Find desktop publishers to work with. Many home-based DTP operations advertise in the classified ads. These folks need your help, so make yourself available.

Summary

That's it. You know the tools, you know the tricks. All that's left is to practice your skills, as often as possible. Every picture you make teaches you something. Study your own work with as critical an eye as you can muster. Use that same critical eye on the pictures you see in print, on the web, even on TV. Keep on learning, keep on shooting, and never, never say "cheese."

Assignment

Make up a digital portfolio of your 10 best photos. If you have a web page, post it to the web.

And now, a genuine, never-made-here-before offer... If you want a personal critique of your final assignment, send me the address of your web page, or send me (stuffed for Mac, please) no more than five of your best pictures. Put "Final Assignment" in the subject line and send them to `momcat@earthlink.net`.

Please, be patient. If the response to this is overwhelming, it may take a few days to respond.

Appendix A

Buyer's Guide to Digital Cameras

Make and Model	Resolution	Features	Storage, Type (Fine/Normal) and #	Color Bit Depth	List Price
Agfa ePhoto 307	640 × 480	Flash, Photoshop plug-in	36/72	24	$504
Agfa ActionCam	1,528 × 148		PCMCIA/114	24	$6,995
Agfa StudioCam	4500 × 3,648		none, needs computer	36	$6,995
Apple QuickTake 150	640 × 480	Flash	16/32	24	$649
Apple QuickTake 200	640 × 480	Flash, LCD screen	PCMCIA 20/30	24	
Associated Press NC 2000	1,280 × 1,024		PCMCIA III	24	$15,915
Canon USA Powershot 600	832 × 608	Flash, zoom lens. PC only as of 4/1/97	18+	24	$949

continues

Make and Model	Resolution	Features	Storage, Type (Fine/Normal) and #	Color Bit Depth	List Price
Canon EOS DCS 3	1,268 × 1,012	Uses Canon EF lenses	PCMCIA	36	$16,000
Canon EOS DCS 1	3,060 × 2,036	Uses Canon EF lenses	PCMCIA	36	
Casio QV-10	320 × 240	Video out, LCD view-finder	96	24	$699
QV-30	320 × 240	Video out, LCD view-finder Mac, PC	96	24	$699
QV-100	640 × 480	Video out, LCD view-finder	64/192	24	$586
QV-300	640 × 480	Video out, LCD view-finder Tele/wide-angle lens	64/192	24	
Chinon ES 1000	501 × 370	Photoshop plug-in	PCMCIA Type II		$365
Chinon ES 3000	640 × 480	Zoom lens, flash	5/40+ PCMCIA	24	$1,095
Dycam 3	496 × 365		8/56	8	$695
Dycam 3XL	496 × 365		36/250	8	$895
Dycam 4	496 × 365		8/24	24	$795
Dycam 4XL	496 × 365		36/100	24	$995
Dycam 10c	640 × 480		5/40 + PCMCIA	24	$995
EPixPro	768 × 494	Mac, PC	PCMCIA III	24	
Epson PhotoPC	640 × 480	Accepts 37mm lenses, flash	16/160	24	$599

Make and Model	Resolution	Features	Storage, Type (Fine/Normal) and #	Color Bit Depth	List Price
Fuji DS-7	640 × 480	Video out, LCD view-finder	Internal	24	$588
Fuji DS-220	640 × 480	Accepts 37 mm lenses, flash, LCD screen	PC card		$695
DS-505	1,280 × 1,000		PCMCIA II	24	$12,780
DS-515	1,280 × 1,000		PCMCIA II	24	$16,020
Kodak DC 25	493 × 373	flash, LCD panel for review	Mini card storage		
Kodak DC 40	756 × 504	3x Zoom lens	PCMCIA		
Kodak DC 50	756 × 504	3x Zoom	PCMCIA		
Kodak DCS-410	1,524 × 1,012		PCMCIA III	36	$7,000
Kodak DCS-420	1,524 × 1,012		PCMCIA III	36	$10,995
Kodak DCS-465	3,060 × 2,036		PCMCIA III	36	$27,995
Kodak EOS* DCS 1	3,060 × 2,036		PCMCIA III	36	
Kodak EOS* DCS 3	1,268 × 1,012		PCMCIA III	36	
Kodak EOS* DCS 5	1,524 × 1,012		PCMCIA III	36	$11,995
Konica Q-EZ	640 × 480		2 MB card 4/32	24	
Minolta Dimage V	640 × 480	Tethered lens	32/80	24	
Minolta RD-175	1,528 × 1,146		PCMCIA III	24	$10,000
Nikon Coolpix 100	512 × 480	Flash	PCMCIA II	24	

continues

Make and Model	Resolution	Features	Storage, Type (Fine/Normal) and #	Color Bit Depth	List Price
Coolpix 300	640 × 480	LCD view-finder, flash	PCMCIA II	24	
E2	1,280 × 1,000	Uses Nikon lenses	PCMCIA II	24	$12,780
E2s	1,280 × 1,000	Uses Nikon lenses	PCMCIA II	24	$16,020
Olympus D200L	640 × 480		20/80	24	$600
Olympus D300L	1,024 × 768		30/120	24	$899
PentaCam	768 × 493		Disk	24	$8,270
Polaroid PDC 2,000	800 × 600		none, needs computer	24	$2,995
PDC 2,000/40	800 × 600		40	24	$2,995
Ricoh RDC-1	768 × 576	Records audio and video, LCD finder	PCMCIA	24	$1,800
RDC-2	768 × 576	Records audio	PCMCIA II	24	$999
Ritz DCC9500	640 × 480	Zoom lens, flash	PCMCIA	24	$859
Sony DKC-5000	1,520 × 1,144		internal 2	24	$15,000
Sony DSC F-1	640 × 480	Video out, LCD finder Wireless to PC	4 MB internal	24	$795

NOTE

Prices and model features were as complete and accurate as the information available as of 5/1/97. Because the industry is subject to change on a moment's notice, this chart should be considered only a general guideline, not a guarantee of finding any of these cameras at the listed price.

Digital Camera Manufacturers

Agfa Division, Bayer Corporation
100 Challenger Road
Ridgefield Park, NJ 07660-2199
(800) 685-4271
http://www.agfahome.com/ephoto/

Apple Computer, Inc.
One Infinite Loop
Cupertino, CA 95014
(408) 996-1010
(408) 996-0275 FAX
http://imaging.apple.com/cameras/cam-main.html

Associated Press
50 Rockefeller Plaza
New York, NY 10020
(800) 697-2537

Canon USA, Inc.
One Canon Plaza
Lake Success, NY 11042
(516) 488-6700
http://www.usa.canon.com

Casio, Inc.
570 Mt. Pleasant Avenue
Dover, NJ 07801
(201) 361-5400
http://www.casio-usa.com

Chinon America
1065 Bristol Road
Mountainside, NJ 07092
(800) 932-0374
http://www.dycam.com/chinon.html

Dicomed, Inc.
12270 Nicollet Avenue
Burnsville, MN 55377
(612) 895-3000
http://www.dicomed.com/

Dycam, Inc.
9414 Eton Avenue
Chatsworth, CA 91311
(800) 883-9226
http://www.dycam.com

Eastman Kodak Company
343 State Street
Rochester, NY 14650
(800) 242-2424
http://www.kodak.com

EPix Imaging Systems, Inc.
2953 Bunker Hill Lane, Suite 202
Santa Clara, CA 95054
(408) 562-0901
http://www.epiximg.com/

Epson America, Inc.
20770 Madrona Avenue
Torrance, CA 90503
(800) 289-3776
http://www.epson.com/homeoffice/cameras.htm

Fuji Photo Film, U.S.A., Inc.
555 Taxter Road
Elmsford, NY 10523
(800) 755-3854
http://www.fujifilm.co.jp/index.html

Konica U.S.A.
440 Sylvan Avenue
Englewood Cliffs, NJ 07632
(800) MY-KONICA
http://www.konica.com/

Leaf Systems, Inc.
8 Oak Park Drive
Westborough MA 01581
(617) 275-5150
http://www.scitex.com/lef_home.html

Minolta Corporation
101 Williams Drive
Ramsey, NJ 07466
(201) 825-4000
http://www.minoltausa.com/

Nikon, Inc.
1300 Walt Whitman Road
Melville, NY 11747-3068
(516) 547-4200
http://www.nikonusa.com

Olympus America Inc.
2 Corporate Center Drive
Melville, NY 11747-3157
(800) 347-4027
http://www.olympusamerica.com/digital/docs/digproduct.html

Polaroid Corporation
549 Technology Square
Cambridge, MA 02139
(617) 386-2000
(800) 816-2611
http://www.polaroid.com

Ricoh Consumer Products Group
475 Lillard Drive
Sparks, NV 89434
(702) 352-1600
(800) 225-1899
http://www.ricohcpg.com/home.html

Rollei
16 Chapin Road
Pine Brook, NJ 07058
(201) 808-9004
http://www.rolleifoto.com

Sony Corporation
Electronic Publishing & Photography Division
3 Paragon Drive
Montvale, NJ 07645
(800) 472-SONY
http://www.sony.com/

Glossary

A

Acquire: To transfer an image from a digital camera to a computer or to import it from another format into a program such as Photoshop.

Angle of view: Measured in degrees, the width of the area a lens can see.

Aperture: Opening, used interchangeably with f/stop to denote the diaphragm opening.

Artifact: Misinterpreted information from a JPEG or compressed image. Color faults or line faults that can be seen in the image.

Auto focus: Camera that uses an infrared light beam or sonar to set its own focus.

Available light: The light present in the room (or outdoors) without adding additional strobe or photoflood lights.

B

Bas-relief: In digital photography, an effect created by a specific Photoshop filter making the image look as if it were slightly raised from the surface.

Bit: Short for binary digit.

Bit depth: Refers to the color or grayscale of an individual pixel. A pixel with 8 bits per color gives a 24-bit image. (8 bits × 3 colors is 24 bits.) CCDs are colored in a pixel-by-pixel method, using the following guidelines:

- 30/32-bit color is billions of colors (only supported with high-end CPUs).
- 24-bit color resolution is 16.7 million colors.
- 16-bit color is 32,000 colors (this is the Macintosh Standard).

- 8-bit color is 256-color (this is the Windows Standard).
- 8-bit grayscale is 256 shades of gray.
- 4-bit, 64 colors or grays.
- 2-bit, black or white.

Bitmap: Means of describing and displaying a graphic onscreen, pixel-by-pixel.

Bleed: Picture that runs off the edge of the paper.

Blow-up: Slang for enlargement.

Bounce light: Light that is bounced off a reflective surface, such as a white card, aluminized reflector, wall, or ceiling.

Box camera: Simplest kind of camera, consisting of lens, shutter, film holder, and a viewfinder.

Burning in: To darken a small area of a picture. Comes from the way it's done in the dark room, by masking all but a section of the print and giving that piece additional exposure.

C

Card storage: Memory chip that can be used in many digital cameras to store pictures.

Catchlight: Light placed to reflect as tiny white dots in portrait subject's eyes.

CCD (Charged Coupled Device): A charged coupled device (CCD) converts light into proportional (analog) electrical current. The two main types of CCDs are linear arrays, used in flatbed scanners, digital copiers, and graphic arts scanners, and area arrays, used in camcorders, still-video cameras, digital cameras, and fast scanners.

Close-up lens: Lens allowing close photography, also called a macro lens.

CMYK: Color model that defines colors as percentages of Cyan, Magenta, Yellow, and Black.

Color balance: Means of compensating for too much of one color in a photo by adding its opposite. For example, if a photo is too red, you can add cyan.

Color temperature: A means of measuring the relative redness or blueness of a light source. Color temperature is measured in degrees Kelvin. Higher numbers produce bluer light. Typical incandescent bulbs are approximately 3200°K, while daylight is about 6500°K.

Compression: The reduction of data to reduce file size for storage. Compression can be "lossy" (such as JPEG) or "lossless" (such as TIFF or LZW). Greater reduction is possible with lossy compression rather than with lossless schemes.

Continuous tone: An image where brightness appears consistent and uninterrupted. Each pixel in a continuous tone image file uses at least one byte each for its red, green, and blue values. This permits 256 density levels per color or more than 16 million mixture colors.

Contrast: A measure of the rate of change of brightness in an image. High contrast implies dark black and bright white content; medium contrast implies a good spread from black to white; and low contrast implies a small spread of values from black to white.

Crop: To trim away unwanted parts of an image.

Cropping tool: In digital image software, a tool used to simulate the traditional knife or scissors used to trim a photo.

Cyan: With magenta and yellow, the three primary colors of additive or "print" color.

D

Daguerreotype: Photo process developed by Joseph Daguerre, producing a very grainy, gray or sepia-toned (brownish) image.

Data: The generic name for anything input to, output from, or stored in a computer. All data must be in digital format.

Default setting: A preset parameter in computer programs that will be used unless changed by the operator.

Definition: The clarity of detail in a photograph, dependent on resolution (pixel size) and contrast.

Depth of field: Means of describing the area of a photograph that is in focus.

Diffusion dithering: A method of dithering that randomly distributes pixels instead of using a set pattern.

Digital: Any system or device in which information is stored or manipulated by on/off impulses, so that each piece of information has an exact or repeatable value. Digital information is stored in bits, each bit representing on/off or one/zero.

Digital camera: A device that captures an image on a Charge Coupled Device or CCD so that it can be downloaded to and manipulated by a computer. It might also be called a "filmless" camera.

Digital image: An image composed of pixels.

Digitization: The process of converting analog information into digital format for use by a computer.

Disc: Term used to describe optical storage media (video disc, laser disc, compact disc), as opposed to magnetic storage systems.

Disk: Term used to describe magnetic storage media (floppy disk, diskette, hard disk), as opposed to optical storage systems.

Dithering: A method for simulating many colors or shades of gray with only a few. For instance, red and blue dots are dithered to make purple. Dithering allows a photo with millions of colors to be displayed on a 256-color monitor, and printed on a four color printer.

Dodging: Also called "holding back." In traditional darkroom work, a piece of cardboard or the photographer's hand blocks light passing from the enlarger to the print, lessening the exposure in parts of the picture. Digitally, the effect is to lighten part of the image without affecting the rest.

Download: The transfer of files or other information from one piece of computer equipment to another.

DPI (Dots Per Inch): The measurement of resolution of a printer or video monitor based on dot density. For example, most laser printers have a resolution of 300 dpi, most monitors 72 dpi, most PostScript imagesetters 1,200 to 2,450 dpi. The measurement can also relate to pixels in an input file or line screen dots (halftone screen) in a prepress output film.

Driver: A software utility designed to tell a computer how to operate an external device. For example, to operate a printer or a scanner, a computer will need a specific driver.

E

EPS (Encapsulated PostScript): A type of graphics file.

Export: To translate a file from its native format into some other format.

Exposure: "Taking" a picture, from exposing film to light. Also, a method of determining how much light and for how long.

Exposure meter: A device that measures available light and computes correct exposure.

Eye Candy: Photoshop plug-ins from Alien Skin.

F

F/stop: Measure of width of diaphragm opening, determining how much light passes through the lens. Smaller numbers are wider openings. F 3.5 is three times wider than F 8.

Fiber-optics: An optical system that uses glass or transparent plastic fibers as light-transmitting media.

File: A collection of information, such as text, data, or images saved, on a disk or a hard drive.

File format: A type of program or data file. Some common image file formats include TIFF, PICT, and EPS.

File server: A computer that serves as the storage component of a local area network and permits users to share its hard disks, storage space, files, and so on.

Film recorder: A device that is used to record a digital image onto photosensitive film.

Flash memory: A type of memory chip that can retain data after the system has been turned off. The advantage is that digital cameras with flash memory can have batteries go "dead" and yet retain image data.

FlashPix: Trade name for a new multiresolution image file format jointly developed and introduced in June 1996 by Kodak, HP, Microsoft, and Live Picture.

Flatbed scanner: An optical scanner in which the original image remains stationary while the sensors (usually a CCD linear array) pass over or under it. The scanned material is held flat, rather than being wrapped around a drum.

Floppy disk: Typically, a removable computer storage medium consisting of a thin, flexible, plastic disk, coated with a magnetic material on both sides. Today, virtually all floppy disks are 3.5 inches square. The 5.25-inch disk is obsolete.

Filter: A tinted glass or plastic lens that fits in front of a camera lens.

Fish-eye lens: Extreme wide-angle lens.

Fixed focus lens: Lens in which the focus is preset and not variable. It usually has a depth of field from about 10 feet to infinity.

Flashcard: A type of memory chip that can retain data after the system has been turned off. Digital cameras with flash memory can have batteries go "dead" and yet retain image data.

Focal length: Distance of the focal point or point at which light rays converge from the surface of a lens. Determines whether the lens is telephoto (long) or wide-angle (short).

Frame: Imaginary rectangle in which you compose a picture.

G

GIF: Stands for Graphic Image Format. File format originally used by CompuServe and now used on the World Wide Web for lossless image compression.

GIF89A: Newer GIF format that supports interlaced graphics (which draw on the screen in venetian blind-like stripes).

Grayscale: A term used to describe an image containing shades of gray, as well as black and white.

Green eye (see also Red eye): Condition seen in photos of cats, caused by light reflecting from the back of the eye.

GUI (Graphical User Interface): The reason you can edit pictures on a computer. Made a reality by Macintosh in 1984, and by Windows some years later.

H-I

Halftone: An image reproduced through a special screen made up of dots of various sizes to simulate shades of gray in a photograph. Typically, it was used for newspaper or magazine reproduction of images.

HiCon: Short for high contrast.

Index color: Reduced color mapping, 8-bit or less. Done to reduce images to their smallest size.

Interchangeable lenses: Found only on high-end digital cameras.

J

"Jaggies": Slang term for the stair-stepped appearance of a curved or angled line in digital imaging. The smaller the pixels and the greater their number, the less apparent the "jaggies." Also known as pixellization.

JPEG: Stands for Joint Photographic Experts Group, who developed the *de facto* standard for image compression in digital imaging devices. There are several versions of

JPEG, some proprietary. JPEG, also known as JFIF, takes areas of 8×8 pixels and compresses the information to its lowest common value. This is one of the reasons you can get so many images into the digital cameras. The results in decompression of the files can cause "blockiness," the "jaggies," or "pixellization" in some digital images. The higher the compression ratio, the more the pixellization or blockiness that occurs. The greater the pixel count, the less pixellization may occur. Progressive JPEG is similar to GIF89A, allowing animation.

K-L

Key light: The main light on a portrait subject or still life. The light that does the work.

Long lens: Another name for a telephoto lens.

Lossless compression: Reduces the size of files by creating an internal shorthand that rebuilds the data as it originally was before the compression. Thus, it is said to be nondestructive to image data when used.

Lossy compression: A method of reducing image file size by throwing away unneeded data, causing a slight degradation of image quality. JPEG is a lossy compression method.

LPI (Lines Per Inch): The frequency of horizontal and vertical lines in a halftone screen.

M-N

Mask: A defined area used to limit the effect of image-editing operations to certain regions of the image. In an electronic imaging system, masks are drawn manually (with a stylus or mouse) or created automatically—keyed to specific density levels or hue, saturation, and luminance values in the image.

Megapixel: 1,048,576 pixels (about a million pixels)

Morphing: A special effect used in motion pictures and video to produce a smooth transformation from one object or shape to another.

Normal lens: A lens that sees approximately the same angle of view as the human eye.

O-P

PCX: File format used by PCs for graphics.

PICT: File format used by Macintosh for graphics.

Pixel: Short for picture element. One dot on a video screen.

Pixellation: A special effect based on altering groups of pixels by color or value.

Plug-in: The plug-in architecture was first popularized by Adobe Photoshop and is now the *de facto* standard for all major imaging programs. This is the preferred choice of operation in both Macintosh and Windows computers. Plug-in technology has spread to other applications, such as Netscape Navigator and Macromedia Director. Not all plug-ins work with all products, and none work cross-platform.

Pointillism: Style of painting popularized by Georges Seurat but dating back to China several centuries BC. The image is composed of small dots of color, which appear to blend together as the viewer looks at them.

Posterization: Consolidating all the grays in a grayscale picture down to just a few levels, which can then be colorized to give areas of flat color.

PPI (Pixels Per Inch): A measurement of resolution used for digital devices, including cameras and scanners, as well as for monitors.

Q-R

RAM (Random Access Memory): The kind of memory used by the computer to handle its processing. Programs like Photoshop demand as much as 10 MB of RAM, in addition to the system software requirements.

Red eye: Phenomenon caused by light reflecting off the interior surface of the human or animal eye. Produces red glare in eye. Green eye is a phenomenon observed chiefly in cats (all species, from tiger to house pet). Green glare is produced by light reflecting off taurine crystals in the back of the cat's eye.

RGB (Red Green Blue): System used by computers to help measure and manage color.

ROM (Read Only Memory): Where the computer stores its operating instructions. See also RAM.

S

Sharpness: Refers to whether or not an image appears to be in focus. Sharpness can be enhanced in programs such as Photoshop by increasing the contrast of pixels on the edge of an object.

Shutter: Device that opens and closes to allow light to pass through the lens.

SLR (Single Lens Reflex): A type of camera, usually 35mm.

Speed (ASA/ISO): A way of rating how light-sensitive a film is. ASA stands for the American Standards Association, and ISO stands for the International Standards Organization, which determine the standards for film speeds. Digital cameras rate their CCD sensitivity as equivalent to a given ISO.

Strobe: Electronic flash can be part of camera or separate and triggered by the camera shutter.

T-U-V

Twain: A standard for communications between scanners, imaging devices, digital cameras, and computer software. Twain enables you to import (acquire) an image into your software. This is the interface of choice on the Windows platform.

Vignetting: Blurring the background of a picture to make the subject stand out.

W-X-Y-Z

Wide-angle lens: A lens that sees more of a scene from side-to-side than a normal human can.

WYSIWYG: Stands for "What You See Is What You Get" (pronounced *whizzywig*). The term refers to the graphical interface that lets you see onscreen what you will be able to print.

Zoom lens: Lens on which you can change the effective focal length. Many cameras can zoom from a wide-angle view to a telephoto view.

Index

Name _____ Title _____

Company_____Type of business _____

Address _____

City/State/ZIP _____

Have you used these types of books before? ☐ yes ☐ no

If yes, which ones? _____

How many computer books do you purchase each year? ☐ 1–5 ☐ 6 or more

How did you learn about this book?_____

 ☐ recommended by a friend ☐ received ad in mail

 ☐ recommended by store personnel ☐ read book review

 ☐ saw in catalog ☐ saw on bookshelf

Where did you purchase this book? _____

Which applications do you currently use? _____

Which computer magazines do you subscribe to? _____

What trade shows do you attend? _____

Please number the top three factors which most influenced your decision for this book purchase.

 ☐ cover ☐ price

 ☐ approach to content ☐ author's reputation

 ☐ logo ☐ publisher's reputation

 ☐ layout/design ☐ other _____

Would you like to be placed on our preferred mailing list? ☐ yes ☐ no e-mail address _____

☐ **I would like to see my name in print!** You may use my name and quote me in future Hayden products and promotions. My daytime phone number is: _____

Comments _____

Hayden Books Attn: Product Marketing ◆ 201 West 103rd Street ◆ Indianapolis, Indiana 46290 USA

Fax to 317-581-3576 Visit out Web Page http://WWW.MCP.com/hayden/

Fold Here

BUSINESS REPLY MAIL
FIRST-CLASS MAIL PERMIT NO. 9918 INDIANAPOLIS IN

POSTAGE WILL BE PAID BY THE ADDRESSEE

HAYDEN BOOKS
Attn: Product Marketing
201 W 103RD ST
INDIANAPOLIS IN 46290-9058

THE MACMILLAN INFORMATION SUPERLIBRARY™

Free information and vast computer resources from the world's leading computer book publisher—online!

FIND THE BOOKS THAT ARE RIGHT FOR YOU!

A complete online catalog, plus sample chapters and tables of contents give you an in-depth look at *all* of our books, including hard-to-find titles. It's the best way to find the books you need!

- ● STAY INFORMED with the latest computer industry news through our online newsletter, press releases, and customized Information SuperLibrary Reports.

- ● GET FAST ANSWERS to your questions about MCP books and software.

- ● VISIT our online bookstore for the latest information and editions!

- ● COMMUNICATE with our expert authors through e-mail and conferences.

- ● DOWNLOAD SOFTWARE from the immense MCP library:
 - Source code and files from MCP books
 - The best shareware, freeware, and demos

- ● DISCOVER HOT SPOTS on other parts of the Internet.

- ● WIN BOOKS in ongoing contests and giveaways!

Other DESIGN/GRAPHICS Titles

Designing Business
Provides the design/business communities with a new way of thinking about how the right design can be a strategic business advantage. It is the definitive guide to presenting a business identity through the use of traditional media vehicles and emerging technologies.

- CD-ROM (dual-platform) exhibits interactive prototypes of multimedia brochures, interactive television, and Web sites as developed by Clement Mok designs Inc., one of the most sought after interactive design agencies in the world
- Shows how effective communication is one way to out-think, out-plan, and out-perform the competition

Clement Mok
1-56830-282-7 ▪ $60.00 USA/$81.95 CDN
264 pp., 8 x 10, Covers PC and Macintosh, New - Expert
Available Now

Adobe Persuasion: Classroom in a Book
1-56830-316-5 ▪ $40.00 USA/$56.95 CDN
Available November 1996

Learning Adobe FrameMaker
1-56830-290-8 ▪ $60.00 USA/$81.95 CDN
Available Now

Adobe Illustrator for Windows: Classroom in a Book
1-56830-053-0 ▪ $44.95 USA/$59.99 CDN
Available Now

Adobe Pagemaker for Windows: Classroom in a Book
1-56830-184-7 ▪ $45.00 USA/$61.95 CDN
Available Now

Adobe Photoshop: Classroom in a Book
1-56830-317-3 ▪ $45.00 USA/$63.95 CDN
Available October 1996

Advanced Adobe PageMaker for Windows 95: Classroom in a Book
1-56830-262-2 ▪ $50.00 USA/$68.95 CDN
Available Now

Advanced Adobe Photoshop for Windows: Classroom in a Book
1-56830-116-2 ▪ $50.00 USA/$68.95 CDN
Available Now

The Amazing PhotoDeluxe Book for Windows
1-56830-286-X ▪ $30.00 USA/$40.95 CDN
Available Now

Branding with Type
1-56830-248-7 ▪ $18.00 USA/$24.95 CDN
Available Now

The Complete Guide to Trapping, Second Edition
1-56830-098-0 ▪ $30.00 USA/$40.95 CDN
Available Now

Design Essentials, Second Edition
1-56830-093-X ▪ $40.00 USA/$54.95 CDN
Available Now

Digital Type Design Guide
1-56830-190-1 ▪ $45.00 USA/$61.95 CDN
Available Now

Fractal Design Painter Creative Techniques
1-56830-283-5 ▪ $40.00 USA/$56.95 CDN
Available Now

Photoshop Type Magic
1-56830-220-7 ▪ $35.00 USA/$47.95 CDN
Available Now

Photoshop Type Magic 2
1-56830-329-7 ▪ $39.99 USA/$56.95 CDN
Available November 1996

Adobe Photoshop Complete
1-56830-323-8 ▪ $45.00 USA/$61.95 CDN
Available October 1996

Production Essentials
1-56830-124-3 ▪ $40.00 USA/$54.95 CDN
Available Now

Stop Stealing Sheep & find out how type works
0-672-48543-5 ▪ $19.95 USA/$26.99 CDN
Available Now

Visit your fine local bookstore, or for more information visit us at http//:www.mcp.com/hayden

MACMILLAN COMPUTER PUBLISHING USA

A V I A C O M C O M P A N Y

Technical

Support:

you need assistance with the information in this book please access the
owledge Base on our Web site at **http://www.superlibrary.com/
general/support**. Our most Frequently Asked Questions are answered
there. If you do not find the answer to your questions on our Web site,
you may contact Macmillan Technical Support **(317) 581-3833** or e-mail
us at **support@mcp.com**.

Creating Killer Web Sites

The book has an accompanying Web site, where visitors can see the pages in action, download the code for their favorite designs, see tutorials and examples not found in the book, and interact with the author. An estimated 100,000 Web site designers are hungry for this information; by August of 1996, their number is expected to double.

- Conferences about designing for the Internet are selling out, and designers are challenged as they make the transition from print to new media design
- Written by one of today's most noted Web designers
- The first book to teach the art as well as the craft of site design

David Siegel
1-56830-289-4 ■ $45.00 USA/$63.95 CDN

272 pp., 8 x 10, Covers PC and Macintosh, Accomplished - Expert
Available Now

Advertising on the Web: Planning & Design Strategies
1-56830-310-6 ■ $40.00 USA/$56.95 CDN
Available October 1996

Macromedia Shockwave for Director
1-56830-275-4 ■ $30.00 USA/$40.95 CDN
Available Now

Photoshop Web Magic
1-56830-314-9 ■ $45.00 USA/$63.95 CDN
Available October 1996

Virtus VRML Toolkit
1-56830-247-9 ■ $40.00 USA/$54.95 CDN
Available Now

Designer's Guide to the Internet
1-56830-229-0 ■ $30.00 USA/$40.95 CDN
Available Now

Internet Starter Kit for Windows 95
1-56830-260-6 ■ $35.00 USA/$47.95 CDN
Available Now

Internet Starter Kit for Windows, Second Edition
1-56830-177-4 ■ $30.00 USA/$40.95 CDN
Available Now

The Adobe PageMill 2.0 Handbook
1-56830-313-0 ■ $40.00 USA/$56.95 CDN
Available Now

Designing Multimedia Web Sites
1-56830-308-4 ■ $50.00 USA/$70.95 CDN
Available September 1996

Designing Animation for the Web
1-56830-309-2 ■ $40.00 USA/$56.95 CDN
Available September 1996

Designing Interactivity for the Web: How to Keep People Coming Back
1-56830-311-4 ■ $50.00 USA/$70.95 CDN
Available October 1996

Internet Publishing with Adobe Acrobat
1-56830-300-9 ■ $40.00 USA/$56.95 CDN
Available September 1996

Kids do the Web
1-56830-315-7 ■ $25.00 USA/$35.95 CDN
Available October 1996

Style Sheets for the Web
1-56830-306-8 ■ $35.00 USA/$49.95 CDN
Available September 1996

Web Page Scripting Techniques: JavaScript, VBScript, and Advanced HTML
1-56830-307-6 ■ $50.00 USA/$70.95 CDN
Available September 1996

World Wide Web Design Guide
1-56830-171-5 ■ $40.00 USA/$54.95 CDN
Available Now

Adobe PageMill 2.0: Classroom in a Book
1-56830-319-X ■ $40.00 USA/$56.95 CDN
Available October 1996

Shocking Low Prices! Save Up To 50% On Director,® Authorware,® And The FreeHand® Graphics Studio.

These Guys Want To Be Shocked.

Macromedia Shockwave

Here's Everything You Need To Do It.

Create and deliver electrifying education materials, from print to the Web.

Today's kids brag about baud rates. They work on new Pentiums or Power PCs instead of old Pontiacs. And they quote lines from Wired™ instead of Whitman.

Tough crowd.

But they're all yours if you have the Macromedia® Studios with Shockwave™. Products that help you create the hottest multimedia courseware and deliver it across campus or around the world.

You see, there's only one family of software for graphics and multimedia on the Internet. There's only one set of tools that helps you create everything from 2D to 3D to full-blown Web sites. There's only one name you need to know. Macromedia.

Take Authorware®, the educator's choice for interactive courseware and training—which now helps you create materials to be sent streaming across your intranet. Or the Director® Multimedia Studio,™ which sets the industry standard in multimedia. For illustration, page layout, font creation, hi-res image editing and 3D modeling, pick up the FreeHand™ Graphics Studio™. And the Backstage™ Desktop Studio lets you create powerful database-driven Web sites, with no programming or scripting required.

To top it off, we're introducing electronic documentation versions of Director and the FreeHand Graphics Studio. Just another way Macromedia makes multimedia and graphics affordable for both educators AND students.

So here's your assignment: see for yourself how Macromedia can electrify your courseware and shock any audience. Call for our free brochure, "Macromedia in Education: 12 Case Studies," as well as the latest Showcase™ CD. Then take advantage of our new low education prices—just $649 for Authorware,* $249 for the FreeHand Graphics Studio™, and $299 for Director™. And of course, don't miss our Web site.

The Macromedia Studios and Shockwave. Because when it comes to cutting-edge courseware, shock value is everything.

Call 1-800-220-5978
http://www.macromedia.com/

MACROMEDIA®
Tools To Power Your Ideas™

Digital Film For Digital Cameras

More Pictures Faster

Get the highest-performance, highest quality pictures with Lexar Media Digital Film. Lexar Media's CompactFlash™ processes picture files up to 4X faster than other flash memory, allowing you take more pictures faster.* Lexar Media CompactFlash also extends precious battery life by consuming up to 60% less power to, and is software programmable allowing product updates through software downloads from the Internet. And, all Lexar Media products are tested on virtually all digital cameras today assuring you of guaranteed compatibility.

CompactFlash and SmartMedia™

Lexar Media offers CompactFlash and SmartMedia in a value-packed **Digital Film Starter Kits** and stand-alone **Digital Film Packs**. The Starter Kits include a 385-page tutorial on digital photography, a CD ROM with over $200 worth of digital imaging software,and special offers for digital film accessories.

Call your favorite retailer or order direct from
Lexar Media, 47421 Bayside Parkway, Fremont, CA 94538.

Order Today
800-789-9418
www.lexarmedia.com

"The Digital Film Company"